Scansion in Psychoanalysis and Art

Scansion in Psychoanalysis and Art examines a strain of artists spanning more than a century, beginning at the dawn of photography and culminating in the discussion of contemporary artists, to illustrate various psychoanalytic concepts by examining artists working in a multitude of media.

Drawing on the theories of Sigmund Freud, who applied psychoanalytic methods to art and literature to decipher the meaning and intention of the creator, as well as Jacques Lacan's dissemination of scansion as a powerful disruption of narrative, the book explores examples of the long and rich relationship between psychoanalysis and the fine arts. While guiding readers through the different artists and their art forms – from painting and music to poetry, collage, photography, film, performance art, technology and body modification – Sinclair interrogates scansion as a generative process often inherent of the act of creation itself.

This is an intriguing book for psychoanalysts, psychologists and creative arts therapists who wish to explore the generative potential of scansion and the relationship between psychoanalysis and the arts, as well as for artists and art historians interested in a psychoanalytic view of these processes.

Vanessa Sinclair, PsyD, is a psychoanalyst based in Stockholm. Dr Sinclair is the author of *Switching Mirrors* (2016), editor of *Rendering Unconscious: Psychoanalytic Perspectives, Politics and Poetry* (2019), and co-editor of *On Psychoanalysis and Violence: Contemporary Lacanian Perspectives* (2018) with Dr Manya Steinkoler.

Art, Creativity, and Psychoanalysis Book Series

George Hagman, LSCW
Series Editor

The *Art, Creativity, and Psychoanalysis* book series seeks to highlight original, cutting edge studies of the relationship between psychoanalysis and the world of art and the psychology of artists, with subject matter including the psychobiography of artists, the creative process, the psychology of aesthetic experience, as well as the aesthetic, creative and artistic aspects of psychoanalysis and psychoanalytic psychotherapy. *Art, Creativity, and Psychoanalysis* promotes a vision of psychoanalysis as a creative art, the clinical effectiveness of which can be enhanced when we better understand and utilize artistic and creative processes at its core.

The series welcomes proposals from psychoanalytic therapists from all professional groups and theoretical models, as well as artists, art historians and art critics informed by a psychoanalytic perspective. For a full list of all titles in the series, please visit the Routledge website at: www.routledge.com/ACAPBS.

A Psychoanalytic Perspective on Reading Literature
Reading the Reader
Merav Roth

Psychoanalysis, Intersubjective Writing, and a Postmaterialist Model of Mind
I Woke Up Dead
Dan Gilhooley, Frank Toich

Poetry and Psychoanalysis
The Opening of the Field
David Shaddock

Affect in Artistic Creativity
Painting to Feel
Jussi Saarinen

Scansion in Psychoanalysis and Art
The Cut in Creation
Vanessa Sinclair

Scansion in Psychoanalysis and Art

The Cut in Creation

Vanessa Sinclair

LONDON AND NEW YORK

First published 2021
by Routledge
2 Park Square, Milton Park, Abingdon, Oxon OX14 4RN

and by Routledge
52 Vanderbilt Avenue, New York, NY 10017

Routledge is an imprint of the Taylor & Francis Group, an informa business

© 2021 Vanessa Sinclair

The right of Vanessa Sinclair to be identified as author of this work has been asserted by her in accordance with sections 77 and 78 of the Copyright, Designs and Patents Act 1988.

All rights reserved. No part of this book may be reprinted or reproduced or utilized in any form or by any electronic, mechanical, or other means, now known or hereafter invented, including photocopying and recording, or in any information storage or retrieval system, without permission in writing from the publishers.

Trademark notice: Product or corporate names may be trademarks or registered trademarks, and are used only for identification and explanation without intent to infringe.

British Library Cataloguing-in-Publication Data
A catalogue record for this book is available from the British Library

Library of Congress Cataloging-in-Publication Data
Names: Sinclair, Vanessa, author.
Title: Scansion in psychoanalysis and art : the cut in creation / Vanessa Sinclair.
Description: Abingdon, Oxon; New York, NY : Routledge, 2021. |
Series: Art, creativity, and psychoanalysis |
Includes bibliographical references and index.
Identifiers: LCCN 2020023829 (print) | LCCN 2020023830 (ebook) |
ISBN 9780367567262 (paperback) | ISBN 9780367567248 (hardback) |
ISBN 9781003099147 (ebook)
Subjects: LCSH: Psychoanalysis and the arts. Classification:
LCC NX180.P7 S55 2021 (print) | LCC NX180.P7 (ebook) |
DDC 700.1/05–dc23 LC record available at https://lccn.loc.gov/2020023829
LC ebook record available at https://lccn.loc.gov/2020023830

ISBN: 978-0-367-56724-8 (hbk)
ISBN: 978-0-367-56726-2 (pbk)
ISBN: 978-1-003-09914-7 (ebk)

Typeset in Times
by Newgen Publishing UK

For
Carl Abrahamsson

Contents

Acknowledgments	ix
Preface	xi
Introduction	1

PART I
Sowing seeds/setting the stage — **19**

1	A cut in time: the advent of photography	21
2	Reimagining the frame: the birth of modern art	37

PART II
Unleashing the unconscious — **55**

3	The art of noise	57
4	Psychoanalysis and Dada	72
5	Collage, photomontage and assemblage	85
6	Disrupting the expected: Marcel Duchamp	100

PART III
Revolution of mind — **113**

7	Surrealism/Acéphale	115

8 Double-bind: cutting the bonds of gender	133
9 The cutting edge: avant-garde and experimental cinema	147
10 The cut-up method of the Beats	161

PART IV
When art becomes life (and death) — 175

11 Acting out: pop, street and performance art	177
12 Cut from the collective: alternative communities	188
13 Body modification, polymorphous perversity and Pandrogeny	197
14 Technology, morbidity, death and the unexpected	209
Index	222

Acknowledgments

There are always many people involved in the creation of a book. I'd like to thank Kate Hawes at Routledge for all of her support in this process; George Hagman for welcoming me into his brilliant series; Genesis Breyer P-Orridge, Val Denham, Gail Denham, Annie Bandez, Charlotte Rodgers, Katelan Foisy, Vicki Bennett, Gustaf Broms, Trish Littler, Kasper Opstrup, Joe Coleman and Whitney Ward for their friendship and inspiration; Jamieson Webster, David Lichtenstein and all the colleagues who have worked with Das Unbehagen over the years for the sustenance of community; Paul D. Miller, David Gunkel, Aram Sinnreich, Eduardo Navas and Mark Amerika for introducing me to the world of *remix*; and, of course, my husband Carl Abrahamsson for his endless support, tireless motivation, inspiration and incredible work ethic.

Parts of this book have been published and/or presented in various formats throughout the years, as these ideas have taken shape and evolved into their current form. I would like to thank all of those involved in the following events and publications: "The Zeitgeist creating Psychoanalysis and Dada" first published in *The Fenris Wolf*, vol. 7 (2014, Edda Publishing) edited by Carl Abrahamsson; "*Das Unbehagen* of Duchamp, Dada and Psychoanalysis" in *DIVISION/Review: A Quarterly Psychoanalytic Forum*, No. 10, Spring 2015, edited by David Lichtenstein; "The Cut in Creation" first presented with Katelan Foisy at Morbid Anatomy Museum, Brooklyn, January 2016, hosted by Joanna Ebenstein and Laetitia Barbier; "The CUT/ in Ritual, Psychoanalysis & Art" presented at the *Occult Humanities* conference, New York University, Manhattan, February 2016, hosted by Pam Grossman and Jesse Bransford; "Cutting-up the Image of the Father/Reconstructing the Third" presented as part of the exhibition *Father Figures are Hard to Find* at NGBK, Berlin, April 2016, on invitation

from Markues Aviv and Luce deLire; "Polymorphous Perversity and Pandrogeny" was first published in *The Fenris Wolf,* vol. 8 (2016, Trapart Books) edited by Carl Abrahamsson, as was "Ritual and Psychoanalytic Spaces as Transitional, featuring Sangoma Trance States" co-authored with Ingo Lambrecht; "The Cut in Creation" presented at Maryland Institute for Contemporary Art, Baltimore, March 2017, on invitation from Mikita Brottman; "The Cut in Creation" co-authored with Katelan Foisy, published in *The Fenris Wolf,* vol. 9 (2017, Trapart Books) edited by Vanessa Sinclair and Carl Abrahamsson; "The Cut-up Method of William Burroughs and Brion Gysin" presented at the conference *Conjuring Creativity: Art and the Esoteric,* Fylkingen, Stockholm, April 2018, organized by Geraldine Hudson and Per Faxneld; "Inventing Ourselves: A Daily Practice of Cut-ups" published in *Black Mirror 2: Elsewhere* (2019, Fulgur Press) edited by Judith Noble, Robert Ansell, et al.; "Scansion in Psychoanalysis and Art: Another Royal Road" presented at *The Truths of Psychoanalysis* – the 11th meeting of the International Society for Psychoanalysis and Philosophy, Södertörn University, Stockholm, May 2019, organized by Cecilia Sjöholm, Anna-Karin Selberg, et al.; "Scansion as Applied in Psychoanalysis and the Arts" presented at the Swedish Psychoanalytic Association, Stockholm, August 2019, chaired by Urban Westin; "Some Applications of Scansion in Psychoanalysis and Art" presented at the High Seminar of the Department of Philosophy, Södertörn University, Stockholm, October 2019, on invitation of Nicholas Smith.

Preface

This study follows a line of artists spanning over a century, from the latter half of the 19th century through the *fin-de-siècle* Zeitgeist to the modern era and up through the dawn of the new millennium to the present day. This research follows a methodology that in its multitude of applications has been demonstrated to be a generative way of working with and through unconscious material and processes, cutting through ingrained systems of belief and oppression in order to attain new insights, ways of being and modes of becoming in the world.

The selection of artists and movements delineated herein is not intended to be a historical account nor a comprehensive list, as that in itself would be an impossible task. Rather, in this work I set out to trace the evolution of a technique – a strain of artistic thought and practice – as it has developed over time. Many of the artists included have influenced and inspired the next generation of creatives in both direct and indirect ways. Some of these artists consciously and intentionally implement the method of the cut, aware of its generative and subversive potential, while others may work in a more automatic, unconscious or even compulsive manner, rather than from a theoretical, philosophical or intellectual perspective. It is important to note that no matter in which way scansion is applied, the cut is a reflection of our state as divided subject; the process highlights this inherent fragmentation, and the potential result is the opening of a gap – a space of possibility and invention.

Introduction

The relationship between psychoanalysis and the fine arts is long and rich and, in fact, has been present from the very beginning. As Sigmund Freud (1856–1939) was developing the field of psychoanalysis, he applied his new and evolving concepts to the study of artworks and artists including Leonardo da Vinci (1452–1519)[1] and Michelangelo (1475–1564),[2] as well as to the study of sociocultural events and phenomena. Freud studied the individual, groups, culture and society at large. In "The Moses of Michelangelo," Freud began:

> I may say at once that I am no connoisseur in art, but simply a layman […] Nevertheless, works of art do exercise a powerful effect on me, especially those of literature and sculpture.
>
> (Freud, 1914, p. 211)

Freud tended to critique art the way one would analyze a dream: by taking apart the various components of the piece and making greater sense of the whole through the exploration of its parts. Freud felt that by applying the methods of psychoanalysis to art and literature, one might decipher the underlying meaning and intention of the creator, much as one analyzes the manifest content of a dream to unearth the latent content at play beneath the surface.

In this study, however, I am not concerned with analyzing the work of artists in this manner. I am more concerned with the process of creation itself – the creative act – rather than the aesthetic value, details or symbols of the artworks themselves. My focus remains on the process: the moment – the spark of inspiration – the artist expresses in and through the creation of a work of art. And the potential of this act to subvert; the capability art has

to challenge narratives, systems of control and oppression by dislocating the artist and the audience from the expected, the day-to-day, the norm that up until this point had been maintained as the status quo.

The advent of Jacques Lacan (1901–1981) brought the concept of *scansion* into psychoanalytic theory and practice. With this term, Lacan highlighted the potential power and value that disruption of the narrative may have. Concerning clinical practice, Lacan argued that it is best for an analysand to leave the session in a moment of engaged possibility, rather than at the end of a set period of time. The consistency of the same 45–50 minutes of a traditional session allows the analysand to learn when the time of the session is coming to an end, even if there is no clock or way of referring to the time physically present in the room.

Clinicians have observed a variety of situations in which analysands defensively – often unconsciously – utilize the frame of the standard 45–50 minute session. For example, an analysand might ruminate, mull over and rehash material from their day for 45 minutes, only to drop a bomb of information in the last moments before the end of a session. In this case, there is no time left in the static frame of a session to be able to properly address the material presented. Unconsciously, the analysand knows this, and in fact presented the material in a way to be able to release it while at the same time not having to fully confront it. In this way, the static session time has been used in a defensive manner, allowing the analysand to exit the session without really addressing the matter just raised.

In another scenario, an analysand may be slow to warm up in the beginning and then is able to open up more toward the middle of session – this is typically when those "Aha!" moments are experienced and deeper material is reached. Then, as the session nears its end, the analysand may seem to backpedal, refute or otherwise undo the insights just gleaned, as they put their defenses back into place in preparation to leave the session and return to the world outside. It may be argued that this is a necessary part of the process, as it may not be preferable for the analysand to reenter the social realm in such a raw, opened state, and that may make sense when a person is only attending sessions once a week. However, in analysis the analysand will likely meet with the analyst again in a couple of days, perhaps even the following day. Therefore the overall frame of the treatment – the trust and rapport that has been built between the analyst and analysand through the establishment of the treatment itself – plus the increased frequency of sessions typical in psychoanalysis, provides enough of a secure holding

environment for the analysand. As much of what happens in a psychoanalytic treatment occurs outside of the session in the analysand's day-to-day life, it may be argued that with this frame of frequency and rapport in place, it is not only safe but potentially even more productive for the analysand to leave the session in the midst of one of those "Aha!" moments rather than at the end of an allotted amount of time, after defenses have been put back into place. In this way, the analysand is more likely to continue to reflect on the material just experienced even after the session has ended, and the psychoanalytic work may continue on outside of session, as opposed to when an analysand leaves the session after having resutured the unconscious.

> What then seems difficult to deny is that while the conventional 50-min session provides a secure, regular and containing space within which patients may speak, what it forecloses are the prospective therapeutic benefits related to the effects of interruption and suspension, separation and non-resolution.
> (Pietrusza & Hook, 2016, p. 117)

This is a gross explanation of the idea behind Lacan's (in)famous *variable length session*, which many call the "cut session" or "short session" because although the theory is that the session could be any length from five minutes to two hours, since the end of the session comes not after an allotted amount of time but, rather, is based on the productions of the analysand's speech, the reality is that Lacan tended toward shorter sessions, as opposed to longer. Unfortunately, that is one of the drawbacks of (or arguments against) using variable length sessions in practice.

Whether one agrees with this idea of a cut session or not, we can still see the value behind this concept: the idea that in these moments when the analysand's unconscious appears more open – when slips of the tongue occur or jokes are made – there is value in marking these moments in some way to help bring them to the analysand's attention. Lacan developed methods to highlight these moments, using scansion as a way to punctuate or note these instances when the unconscious slips out. One way is by ending the session abruptly. However, one may also mark these moments through various other interventions, such as reflecting the analysand's own language, thereby marking a signifier by simply repeating a word. An intervention as simple as that creates a pause, a

disruption in the analysand's speech or narrative, and this moment may provide a place for potential reflection or insight on the part of the analysand. This moment – the space created by such an intervention – is a disruption, a scan, a cut.

The cut engenders anti-normalization. Anything normative fixes desire, including our identity/ego – itself a construct formed via a lifetime of identifications and projections. As one begins to believe this construct is indeed oneself, it may become rigid and even stagnant. Scansion is a means to shake up these stories we tell ourselves, and allow us space from them so that we may see there are alternatives, options and possibilities. When an analysand is speaking, I sometimes ask, "Whose words are those?" I've noticed that analysands are often actually reiterating narratives imposed upon them by parents, family and society, sometimes since birth; since before birth, even. We are born into history, language and social structures. Our words and positions are not our own. We are introjected into an interplay of interpersonal dynamics, projections, dreams, wishes and desires, as well as social systems, all of which precede us. Psychoanalysis allows for a space where we may take a step back for a moment, look at the forces at work and begin to be able to make choices from our position within these discourses, rather than feeling as if we are constantly caught up in them, enacting and reacting to dynamics at play of which we are not consciously aware but nevertheless affect us pervasively, from within as well as from without.

The method of scansion has been applied throughout the arts, music, literature and poetry as well as in psychoanalysis, and in many ways the effect is similar. Historically, in poetry *scansion* is a method of describing the rhythm of a poem through the breaking up of its lines or verses into feet; working on meter, marking the locations of stresses, accented and unaccented syllables, and so on. Adapted from the classical method of analyzing ancient Greek and Roman verse, scansion can be thought of in terms of "scanning" – examining a line or verse to determine its rhythm, and thereby revealing the underlying mechanics or structure of a poem.

> The purpose of scansion is to enhance the reader's sensitivity to the ways in which rhythmic elements in a poem convey meaning. Deviations in a poem's metrical pattern are often significant to its meaning.[3]

This method of scansion has been utilized in a similar way regarding the rhythm and form of pieces of music. After all, what is rhythm but a series of punctuations or cuts? If there were no cut, we would be left with one endless note or tone.

When framed in this way, one may see the similarities of scansion in poetry and music to those of Lacan's concept of scansion – as in disruption, deviation or cut – and also to Freud's concept of *evenly-suspended attention*[4] that the analyst is encouraged to maintain. Just as the reader scans a poem or piece of music to locate the underlying structure and rhythm, as well as deviations from that framework, the analyst attempts to maintain the free-floating attention conducive to noting patterns of transference, signifiers, slips, double entendre, displacement, condensation, metonymy and metaphor.

> By creating what might in poetry be thought of as a line break, scansion cuts analysands' speech, leaving them with a sense of ambiguity and multiplicity. The analyst does not directly interpret and thus, the last words of a session become not the very last words on a matter, but instead, jumping off points for the analysand's free association and unconscious productions.
> (Pietrusza & Hook, 2016, p. 108)

Scansion is another "royal road" to the unconscious, like free association and dreams. Resonant of the fundamental cut inherent in subjectivity itself, scansion highlights the divide between conscious and unconscious, self and other, dream and waking states. With his fundamental rule of free association, Freud encouraged the analysand to follow he/r train of thought wherever it led. In the course of our day-to-day lives, there are many thoughts and associations we reflexively push aside so that we may continue with the story we are relating to ourselves. We tend to work hard to maintain focus on the narrative we have developed of ourselves and the world, and we often adhere to it rigidly; even bending new information to fit within our preconceived structure, rather than daring to augment ourselves or our belief systems in order to integrate the fresh insights we've gleaned. The practice of free association encourages us to disrupt this tendency of ours. Freud implored us to follow these seemingly tangential trains of thought wherever they might lead, as they always prove to be relevant, even if the connection is not immediately clear.

In much the same way, Freud encouraged us to pay attention to our dreams. Rather than feeling as if we must retell the fragmented dream material in a concise and cohesive way, recognize these various dream scenes for the fragments they are. Instead of attempting to fit the various sequences of the dream into a coherent narrative that you may then relate to yourself and others, take each piece of the dream and associate to it. For example, if there is a specific person present in the dream, ask yourself of what might that person remind you. What quality or aspect of yourself could they symbolize? What comes to mind when you consider a particular color, number, word or phrase present in a dream? Each dream element is a condensation of a multiplicity of material from the past and present. I often think of dreams forming in the following way: something from your present, waking life reminds you of something from your past – although often unconsciously – and connects back to this element, thereby bringing it up to the surface to be attended to again. This likely occurs countless times throughout your day, and some of these components will appear in your dreams. Some may remain in the form you consciously recall them, as what Freud called *day residue*, while others may combine with various elements from your past – dreams, memories, people and places – and be presented as a conglomeration of these. Still others might appear in a disguised form: for instance, when a figure from your past is substituted with a less intensely charged person in the dream. These processes of dreamwork allow for deeply repressed material to once again rise to the surface and into conscious recollection, albeit in disguised and therefore more bearable ways. The *psychic censor*, as Freud called it, decides what is manageable and thus permitted, and what is not. Lacan even described the operation of the psychic censor as "censorship by scissors" (Lacan, 1978, p. 27).

The mental work of waking life is actually more akin to dreamwork than we tend to realize. In our waking state we are bombarded with an influx of information. Scenes caught in our periphery, words and phrases uttered, jingles and advertisements overwhelm our senses, all striking chords within us, bringing up information from the depths of our unconscious constantly throughout the day. In order to function in our daily lives, we have learned to block out this flood of sensory input coming at us from all directions. We tend to prioritize adherence to our narrative storylines as a means of keeping ourselves focused and "on track." But over time these tracks may become ruts, and like many symptoms, what started out as an

adaptive measure aiding us in maintaining focus may end up narrowing our view and therefore limiting our potential.

In this era of *biopower*[5] when people are being stripped of their humanity, reduced to numbers and units of production, it is more important than ever to reassert what's ours: our inherent creative potential. We have built the world around us. All of what we have created began as an idea, a spark of inspiration. Therefore it is possible for us to reinvent ourselves as well. Though it may often feel as if we are trapped, as if it is all beyond our control, it is not so – especially not on an individual level. As those who have been through the process of psychoanalysis know, what at one time felt inevitable or irrefutable may be revealed to be an ingrained pattern. This pattern may run generations deep, and we might very well be identified with it. We might have mistaken it for ourselves. But once we are able to see this, we already have that much space from it, indicating that we are not as aligned with it anymore. We may continue to feel caught up in it at times and may find ourselves engaging in old habits and patterns, but that is all part of the cycle of change. Just as it took many years for these patterns to become ingrained within us, it takes time to work through them and to create a new groove. Scansion helps cut us out of our ruts – out of these narratives we have been told and which we now tell ourselves – so that we may begin to think more freely, see other possibilities, and invent new ways of being in the world. Cut the chains that bind us, so to speak.

The cut has a multiplicity of meanings in language and culture, which is reflected in the variety of ways it is used in colloquialisms such as: to "cut a rug" or "cut a check." We're proud we "cut the mustard" when we have "cut our teeth" and have proven to be "a cut above the rest." But sometimes we have to "cut our losses" if we find we "didn't make the cut," and have "landed on the cutting room floor." A "cutting remark" may "cut like a knife," and you may insist that others "cut it out." Someone may be "a cut-up," a ham, clown or joker; others may not be so amused when you're "cutting it up" and ask you to "cut the crap," however, sometimes it's much needed comic relief, and they might just "cut you some slack." You may "cut a deal" to "cut a record" if someone has "cut you a break." Otherwise you may have to "cut out" and "take your cut and run." In that case, you can always cheer yourself up by "cutting up jackpots," trading tall tales with your friends, while enjoying some of James' famous Salt Water Taffy,[6] which is "cut-to-fit-the-mouth."

As a psychoanalyst concerned with the mind–body system as the interface for the subject in the world and the inscription of language on the body as the subject is inserted into culture, as well as the study of the cut-up method as applied in the arts, perhaps the most interesting signifier I've encountered in this research is the etymology of the word *anatomy*. Defined as the "study or knowledge of the structure and function of the human body," anatomy was learned from dissection. The word derives from the Old French *anatomie* and directly from Late Latin *anatomia*, from late Greek *anatomia* for classical *anatome*, meaning "dissection," literally "a cutting up" (from *ana* up + *temnein* to cut), itself derived from the Proto-Indo-European root *tem*: to cut.[7]

In the present study, I navigate a line of artists and intellectuals who create through cutting up, using scansion, juxtaposition, disruption – techniques that illuminate the underlying structures or dynamics of the unconscious, the inner workings of free association and dreams, displacement and condensation, metonymy and metaphor. I have chosen to begin with the advent of photography and move through the turn of the previous century, through the onslaught of modern art up to the dawn of the millennium and into contemporary artists of our time.

This book is divided into four parts. The first section, "Sowing seeds/setting the stage," delineates events that facilitated the Zeitgeist in which both psychoanalysis and the avant-garde as we know it first emerged. The advent of photography, and later film, created a huge cultural shift, providing perspectives never before gleaned. Artistic movements such as symbolism, impressionism, expressionism and fauvism paved the way for the century to come. Specific artists working before the turn of the century and World War I will be discussed.

The second part, "Unleashing the unconscious," discusses the founding years of psychoanalysis, as well as the burgeoning avant-garde art movements of the time, including cubism, futurism and Dada. As many artists and intellectuals fled their homelands in search of safety during the years leading up to the First World War, they congregated in neutral Switzerland. German and Romanian poets collaborated with Zürich natives, quickly coalescing into the Dada movement and the event that was the Cabaret Voltaire.[8] Developing and expanding the techniques of collage, photomontage, assemblage and readymades, the Dadaists' innovations in visual, conceptual and performance art, poetry and literature continue to influence contemporary artists to this day. After the First World War ended, these

artists and intellectuals disbanded, some dispersing into neighboring areas as others returned to their homelands. This only served to grow the reach of their international network even further.

The third part of the book, "Revolution of mind," begins with a look at surrealism, as many surrealist methods and modes of creating developed out of the Dada movement. As there is such extensive research into surrealism available, I have chosen to focus on a few specific instances that resonate with the work at hand. The splintering off of *Acéphale*[9] is mentioned, as is the publication of *Minotaure*,[10] which featured the early writing of Lacan. Certain artists of this period played with the concept of the double, often working directly with the body, exploring subjectivity, positioning, dynamics of relation, identity, sexuality and gender. This leads us into a discussion of experimental film and cinema as a total environment, followed by an exploration of various characters and happenings of the Beat generation.

The fourth and final section, "When art becomes life (and death)," focuses on the birth of pop, performance and street art; actions and happenings bringing artwork outside the walls of the gallery, as well as conversely bringing art from the streets into the art world. As many performance art collectives explored alternative forms of living, communal spaces and artist communities are also explored. As the persona and lifestyle of the artist became the focus, rather than exclusively the work of art produced, life and art merged ever more. This leads us to performance art in the form of body modification, as artists explore sexuality, gender and identity through the physical medium of their very selves. Finally, we move into the realms of the uncanny, technology, morbidity, death and transformation.

The first chapter, "A cut in time: the advent of photography," begins with a brief history of photography, as the invention may be seen as a disruption in itself. With this event, people were separated momentarily from the flow of daily life, able to capture a slice of time, hold it in their hands and reflect upon it. Never had this phenomenon been experienced before, as writing, painting, drawing and other forms of self-expression and documentation that could be argued to harbor an element of separation, also take time to create in and of themselves; thereby, the period of time it takes to create the product at hand becomes part of the process itself, integrated as an aspect of the completed work. However, once the technology had been developed adequately, a photograph took only an instant. When

Eastman Kodak released the Brownie (the first portable, hand-held camera available for the everyday person) in 1900, the average citizen had the power to capture any person, scene or situation they desired. This shift in perspective and the dynamics of power inherent within it may seem minor, as we are so accustomed to it today, but the effects of this power shift are quite remarkable. Rather than being inundated exclusively with images chosen by others – the government, media, journalists and other authority figures – power was placed into the hands of the individual as well. People could shoot, capture and express what they liked, showcasing what they found amusing, interesting or important, rather than having the appropriate subject matter dictated to them. In a similar way, psychoanalysis put the power of narrative into the hands of the individual. For the first time, the doctor asked the patient what s/he thought about he/r own symptoms, and the doctor listened. The analysand was given the opportunity to speak, rather than the authority simply determining how the patient felt and why, and what the course of action was to be.

As this shift in perspective took place in line with the introduction of photography, the art world began to transform as well. It was no longer necessary for artists to focus on being able to capture the exact realism of natural scenes and portraits; photographers were taking over this arena. Therefore, artists began to bring their own internal worlds out onto the canvas, expressing themselves in new and previously unimagined ways. The second chapter, "Reimagining the frame," delves into the birth of modern art. As technology continues to evolve, huge cultural shifts follow. This affects not only the sciences and means of production but also the arts and culture at large. The movements of the Pre-Raphaelites, impressionists, symbolists, expressionists, secessionists and fauvists unfold, with the artwork of William Morris, Edvard Munch, Paul Gauguin, Charles Baudelaire, Egon Schiele, Henri Matisse and Hilma af Klint, among others, discussed more specifically.

The third chapter, "The art of noise," considers the development of the avant-garde and technology in the years before the First World War, as the burgeoning field of psychoanalysis was beginning to take root. General reflections on cubism and futurism come into focus on the work of Italian artist Luigi Russolo, and the lasting impact his legacy has left on the world of contemporary experimental music. Russolo released his manifesto *The Art of Noises* (1913) delineating his theories and outlining techniques for construction of his *intonarumori* or "noise

organs." As the son of a watchmaker and organist, Russolo had the technical skills to build instruments. He creatively attempted to capture the sounds of the city, as machines, factories, trains and other new technologies sprung up around him, changing culture at a breakneck pace. Russolo's work has influenced a host of contemporary artists and musicians, including John Cage, Throbbing Gristle, Coil, Nurse With Wound, Aphex Twin and John Zorn, and today there is a whole genre of music called *noise*.

The fourth chapter focuses on "Psychoanalysis and Dada." As the First World War became imminent, many Europeans fled to Switzerland as it provided a neutral center amidst the war and chaos. At the same time, the field of psychoanalysis was growing, with psychoanalytic institutes being founded across Europe, as well as in New York. In 1916, German poets Emmy Hennings and Hugo Ball founded the Cabaret Voltaire in Zürich as a gathering place for artists and intellectuals of all nationalities and media, thereby birthing the Dada movement. Romanian poet Tristan Tzara joined the couple, becoming the first person known to create what he called "accidental poems" by cutting words out individually and placing them all into a hat, then pulling each word out one by one at random, reciting each as it was pulled. In this way, he created spontaneous poetry live on stage in front of an audience. Following the war, many emigrated to nearby areas or returned to their homelands; this migration formed a widespread network of artists and intellectuals. Tzara moved to Paris, where he joined Francis Picabia; the pair published Dada journals and magazines, and continued to organize group shows.

Other centers of Dada were solidified in various cities across Europe and North America, including Berlin, Cologne and New York. Artists who were part of these networks began experimenting with a variety of innovative techniques, such as "Collage, photomontage and assemblage," the subject of chapter five. These techniques proved to be quite effective in the creation of anti-war propaganda, as well as in the exploration of gender, identity and subjectivity, exemplified in the work of German artists John Heartfield and Hannah Höch, respectively. These artists challenged the nature, mode, method and purpose of creating artwork, as well as the appropriate means of displaying such works. Just as photography was at first rejected as a valid form of art, so then were collage, photomontage and assemblage. Critics at the time argued that found objects and materials were not adequate to create fine art; however, these artists and their

work persisted, and they are possibly more relevant and influential today than ever.

The sixth chapter, "Disrupting the expected," focuses on the work of Marcel Duchamp, who was part and parcel of a variety of more formal art movements, yet always considered himself outside, remaining more of an individual than part of a collective. Duchamp's whole life and career may be seen as a continual subversion of the expected. His career began at a young age, when a few of his early paintings were taken to America as collectors picked up some work from his brothers, Jacques Villon and Raymond Duchamp-Villon, to exhibit at the first Armory Show (1913). Following this event, Duchamp became an overnight sensation in the United States while remaining relatively unknown in his native France. He moved to New York where he cofounded (and quickly left) his own independent art organization, and after a brief but wildly successful career in painting, quickly switched to more sculptural and kinetic works, including his (in)famous *readymades*. Eventually he declared himself finished with the art world altogether, and dedicated his life to chess, while continuing to work on his masterpieces in private in the following decades.

Chapter seven is concerned with "Surrealism/Acéphale" as an example of the well-worn cycle of the revolutionary becoming the dogmatic authority. The surrealists were inextricably affected by the Second World War, as well as by the theories of Freud, and worked tirelessly to evolve techniques meant to free the unconscious from the binds of society and the conscious ego. However, once André Breton declared himself the leader of the surrealists, he inevitably became more and more intolerant of those he decided were not unleashing the unconscious in the "correct" manner and began ousting many prominent members from the movement, including Salvador Dalí and Max Ernst. Some who found themselves at odds with Breton founded their own groups, such as Georges Bataille with *Acéphale*. This type of "headless" community has continually been an ideal of avant-garde movements over the years. Tried and tried again, group dynamics tend to fall prey to authoritarian power structures and hierarchy, eventually leading to dissolution or downfall. An attempt to uphold this kind of non-hierarchical structure within the modern-day psychoanalytic community is described in a discussion of the contemporary psychoanalytic network Das Unbehagen.[11]

In "Double-bind: cutting the bonds of gender," the theme of the uncanny nature of the double is explored through the work of such artists

as surrealists Pierre Molinier, Hans Bellmer and Unica Zürn, as well as Danish "outsider artist" Ovartaci. These artists worked with the double in a variety of media, including performance, photography and sculpture, often staging scenes utilizing mirrors, dolls, mannequins and other anthropomorphic beings. Through these processes, the artists explored subjectivity, identity, formation, positioning, power dynamics, sexuality and gender, challenging societal constructs, pushing imposed boundaries and limitations, and bending and breaking the restrictive bonds of social conditioning.

Filmmaker Maya Deren often worked with mirrors and the double as well. A major player in experimental cinema, Deren toured across the United States, lecturing and screening her films. "The cutting edge: avant-garde and experimental cinema," explores Deren's work, as well as that of early instigators of independent cinema – including Harry Smith, Orson Welles, Kenneth Anger, Robert Frank and Jonas Mekas – as the New American Cinema emerged. Experimental cinema is inextricably intertwined with the Beat generation, as several proponents were major players in both fields. Landmark films, such as Robert Frank's *Pull My Daisy* (1959), narrated by Jack Kerouac, and his lesser known but equally powerful *Me and My Brother* (1968), starred groundbreaking American poets Allen Ginsberg and Peter Orlovsky, influencing future generations such as British filmmaker Derek Jarman and pioneering audiovisual artist Vicki Bennett, also known as People Like Us.

"The cut-up method of the Beats" is explored in chapter ten. In the late 1950s, the Beat generation was sweeping the United States from coast to coast. These poets and writers experimented with new forms of literature, poetry, sound collage, film editing and more; many of them were gay and began gathering in more openly queer-friendly hubs such as San Francisco, New York and Tangiers. For a time, a collective of these poets were living in what became known as "the Beat Hotel" in Paris. It is here that the direct cutting up and reassembling of language, previously explored by Tristan Tzara, was discovered anew by visual artist and writer Brion Gysin, who shared his finding and enthusiasm for it with creative collaborator William S. Burroughs. The pair continued to explore this technique for decades, outlining their experiments in the landmark work *The Third Mind* (1978) and continuing on in various forms until their deaths. Filmmakers such as Conrad Rooks and Antony Balch worked directly with Burroughs and Gysin, resulting in such films as Rooks's

Chappaqua (1966) and Balch's *Towers Open Fire* (1963), *The Cut-Ups* (1966) and *Bill and Tony* (1972).

Actions and happenings were in vogue in the 1960s and 1970s, as art left the container of the gallery and stepped out into the streets. Chapter eleven, "Acting out: pop, performance and street art," reviews the advent of these events and explores the work of performance art collectives, such as the Viennese Actionists and COUM Transmissions, as well as individual pioneers Yoko Ono, Marina Abramović, Ana Mendieta and Jean-Michel Basquiat. Around the same time, Andy Warhol began to shake up the art world in a different way, breaking down barriers between commercial and fine art, as well as creating experimental films with underground superstars, challenging perceptions of gender and sexual norms. Warhol not only put the camera in the hand of the individual but turned the lens around onto the artists themselves. No longer was art only about the work created; the artist's life, persona and personal history played an ever more important role. In this way, Warhol shaped the times in which we are currently living, as we've all received well beyond our "15 minutes of fame." More than ever, individuals are encouraged to curate the image of themselves projected into the world. With self-marketing online, digital and social media, we are implored to be "true" to ourselves, while simultaneously experiencing the implicit demand that our authentic-self brand be marketable, as we must ensure people are willing to pay money for it/us.[12]

Warhol had his Factory, just as many performance art collectives of the times engaged in alternative, communal living situations, which brings us to the twelfth chapter, "Cut from the collective: alternative communities." Exploring the evolution and outreach of such groups – especially in the UK, as Britain had a powerful, underground movement with collectives such as Crass and Thee Temple ov Psychick Youth (TOPY) – networking, living and working together, creating anarchic, Heartfield-inspired collages and photomontages, as well as distributing zines, pamphlets and manifestos, in addition to music and performance. The artists and their actions became an art form in itself, mobile and transient, able to insert themselves into the world and culture at any moment and location they so desired – an evolving, revolving artistic force of sorts. I also touch upon a few contemporary artists who were involved in such movements, including Val Denham and Annie Bandez, also known as Little Annie.

As the life of the artist became more of the focus, the human body began to be explored even more as a site of creative work in itself. Rather than

the artist having to create an external body of work, the reworking of one's own physical body (and therefore mind and identity) became understood as a mode of creative self-invention and expression. Chapter 13, "Body modification, polymorphous perversity and Pandrogeny," explores the body modification movement from the 1980s until today, as more artists and individuals turn to this mode of physical intervention as an avenue of creation, innovation and self-assertion. Additionally, this practice has seemingly infiltrated popular culture and mainstream society as more individuals – who do not necessarily frame the reworking of their physical bodies and personae as a form of art – continue to reinvent and rework themselves, molding their physical and behavioral identities to become more in line with the way they see themselves and wish to be perceived. This freedom of self-creation, sense of autonomy and agency is essential to our current times. Working with the real of the body in such a direct way lends to individuation of self through exploration of identity, sexuality and gender – themes we traverse via the work of performance artists Breyer P-Orridge and their Pandrogeny project.

Finally, we conclude with "Technology, morbidity, death and the unexpected," dedicated to artists who work directly with the morbid: remnants of death, decay, refuse, blood, bodily substances, disease, trauma, war and technology. Delving into the uncanny, unexpected and underexplored, I discuss the work of Australian performance artist Stelarc, who works with technological interventions in a direct way via his body and personhood, as well as contemporary Chinese artist Cai Guo-Qiang, who creates immersive experiences, engineering elaborate displays of fireworks, as well as creating paintings from the charred remnants of gunpowder explosions. I also consider a range of artists who work with the traumatic, violent, discarded, morbid or unexpected, including Alberto Burri, Kurt Schwitters, Joel-Peter Witkin, Francis Bacon, Joe Coleman and Charlotte Rodgers, as they stage surreal scenes and assemblages, touching upon something essential to life by traversing fragmentation, destruction, disability and remnants of death.

Throughout this study we explore scansion, the cut, fragmentation and disruption, which more often than not lead to reinvention, reconstruction and reconstitution. Through exploration of artists who create in this way, we may better understand the processes involved in the constitution of our very own subjectivity. Just over a century ago, our global society was forever changed as the First World War brought an onslaught of death and

devastation on a scale never before seen. The technology of those times simultaneously created more production and destruction than any previous generation had experienced. As the world dramatically shifted around them, avant-garde artists began to harness this fragmentation and innovation, and began working with it in an intentional way, expressing their inner experiences, which often mirrored and reflected the crumbling world around them. Since then, the avant-garde has been associated with this subversion – the breaking down of systems and dismantling of norms – facilitating new ways of seeing ourselves, one another and society, in order to better see ourselves as we really are: fragmented, in a state of perpetual destruction and creation.

Notes

1 Freud, S. (1910) "Leonardo da Vinci and a memory of his childhood." *SE* XI. London: Hogarth Press. pp. 57–137.
2 Freud, S. (1914) "The Moses of Michelangelo." *SE* XIII. London: Hogarth Press. pp. 211–236.
3 Editors of Encyclopaedia Britannica. (2019) "Scansion" [Online]. Encyclopaedia Brittanica. Available at: www.britannica.com/topic/scansion (Accessed: August 5, 2019).
4 Freud, S. (1912) "Recommendations to physicians practicing psycho-analysis." *SE* XII. London: Hogarth Press. p. 111.
5 McGowan, T. (2019) "The sex in their violence: eroticizing biopower." In Vanessa Sinclair & Manya Steinkoler (eds.) *Psychoanalysis and Violence: Contemporary Lacanian Perspectives.* London: Routledge. pp. 47–60.
6 James Candy Company. (2011) "James Candy Company" [Online]. Available at: www.jamescandy.com (Accessed: August 5, 2019).
7 Harper, D. (2006) "Anatomy" [Online]. Online Etymology Dictionary. Available at: www.etymonline.com/word/anatomy (Accessed: August 5, 2019).
8 Cabaret Voltaire. (2020) "Cabaret Voltaire" [Online]. Available at: www.cabaretvoltaire.ch/ (Accessed: February 4, 2020).
9 Elder, B. (2016) *"Acéphale"* [Online]. Routledge Encyclopedia of Modernism Available at: www.rem.routledge.com/articles/acephale (Accessed: February 4, 2020).
10 Goerg, C., et al. (1987) *Focus on Minotaure: the Animal Headed Review.* Geneva: Musée d'Art et d'Histoire.
11 Das Unbehagen. (2012) "Das Unbehagen: A Free Association for Psychoanalysis" [Online]. Available at: www.dasunbehagen.org (Accessed: February 4, 2020).

12 Malater, E. & Pietrusza, C. (2019) "The mysterious return of imposter syndrome." Presentation at *The Truths of Psychoanalysis*, 11th meeting of the International Society for Psychoanalysis and Philosophy, Stockholm. Available at https://sippispporg.wordpress.com (Accessed: November 15, 2019).

Bibliography

Alfandary, I. (2017) "The function and field of scansion in Jacques Lacan's poetics of speech." *Paragraph: A Journal of Modern Critical Theory*. 40:3. pp. 368–382.

Burroughs, W.S. & Gysin, B. (1978) *The Third Mind*. New York: Viking Press.

Freud, S. (1900) *The Interpretation of Dreams*. In *The Complete Standard Edition of the Psychological Works of Sigmund Freud (SE)*. IV–V. London: Hogarth Press. pp. 1–627.

Freud, S. (1910) "Leonardo da Vinci and a memory of his childhood." *SE* XI. London: Hogarth Press. pp. 57–137.

Freud, S. (1912) "Recommendations to physicians practicing psycho-analysis." *SE* XII. London: Hogarth Press. pp. 109–120.

Freud, S. (1914) "The Moses of Michelangelo." *SE* XIII. London: Hogarth Press. pp. 211–236.

Lacan, J. (1978) *The Four Fundamental Concepts of Psycho-analysis*. Translated by A. Sheridan. New York: W.W. Norton & Co.

Pietrusza, C. & Hook, D. (2016) "'You're kicking me out?' Scansion and the variable-length session in Lacanian clinical praxis." *Psychodynamic Practice*, 22:2, pp. 102–119.

Russolo, L., Pratella, F., et al. (2012) *The Art of Noise: Destruction of music by futurist machines*. London: Sun Vision Press.

Spielrein, S. (1994) "Destruction as the cause of coming into being." *Journal of Analytical Psychology*, 39, pp. 155–186.

Part 1

Sowing seeds/setting the stage

Chapter 1
A cut in time
The advent of photography

The advent of photography caused a revolution in perspective that those of us living today cannot fully grasp, as our culture is so extensively permeated with its effects that it's quite impossible to imagine what life was like before. Not only is photography an aesthetic or artistic medium, but it has become fundamental to daily social culture, as well as bureaucracy and governance; essential in identification, policing, forensics and the like. Digital culture, media, television, programming, film and the internet are all based upon the image; we can hardly imagine our lives without it.

A brief history of the development of photography:[1] in the early 19th century, there were several scientist-inventors working separately (unbeknownst to one another) on the development of camera technology: Nicéphore Niépce (1765–1833), Thomas Wedgwood (1771–1805), Louis Daguerre (1787–1851) and William Henry Fox Talbot (1800–1877) being the main contenders (Galassi, 1981, p. 11). In 1839 Daguerre patented the first camera, naming his photographic process the *daguerrotype*. He announced his invention by proclaiming, "I have seized the light, I have arrested its flight" (Zaczek, 2018, p. 198). Though beautiful in detail, Daguerre's method did not allow for duplicates or multiples of an image to be created. In 1841, Talbot revealed his method of producing multiple images, which he deemed a *calotype*. While not as fine in detail as the daguerrotype, the calotype allowed for multiple prints to be taken from a negative. Within a few decades, the camera went from a device primarily used in service of the vanity of the elite to becoming instrumental in government and bureaucratic systems, police filing, military reconnaissance and journalism, as well as for encyclopedic reference, anthropological records, medical science, art history, aesthetics, postcards, family

albums, formal portraiture and pornography. British art critic John Berger (1926–2017) has noted:

> The speed with which the possible uses of photography were seized upon is surely an indication of photography's profound, central applicability to industrial capitalism.
>
> (Berger, 2013, p. 49)

The first relatively inexpensive, popular camera was on the market by 1888, and in 1900 – incidentally the very year Freud published *The Interpretation of Dreams* – Eastman Kodak launched the Brownie: the first affordable, handheld, portable, point-and-shoot camera. "Simple enough for even children to use,"[2] the Brownie brought the photograph to the masses by placing it in the palms of their hands. The Kodak company had recently invented the roll of film, and created the Brownie to maximize their product. Additionally, Eastman Kodak offered to develop and post the rolls of film to consumers, allowing the average person freedom from the constraints of having to learn to work with chemicals in a darkroom to be able to enjoy their images.

The introduction of the Brownie revolutionized not only photography but society at large. Within a year after introducing the Brownie to the public, Eastman Kodak had sold a quarter of a million units, while several other companies also began creating and marketing their own similar model of camera. By putting the ability to harness images into the hands of the everyday person, individuals were given the power to decide for themselves what they valued in terms of what they wished to capture and remember in their own personal lives, rather than being subjected solely to images chosen and presented by others, such as the government, media and journalists.

In many ways, both Freud's development of psychoanalysis and the invention of the handheld camera turned the focus around onto individuals, placing the power in their hands. Rather than doctors, medical practitioners and other experts simply informing patients how they felt and why, individuals were invited to speak, and for the first time the doctor listened. In a similar way, the Brownie put the power into the hands of individuals as well. Instead of the media and other authority figures solely deciding what citizens should be inundated with and why, individuals gained control of which images they would like to capture, deciding

who and what was important to them, and which experiences they wished to remember and recall. This might seem like a simple move, but it is a highly significant shift.

Putting power in the hands of people in this way encourages autonomy, agency and self-reflection. Individuals are provided with the opportunity to begin to construct their own lives and narratives in new ways; ways more in line with how they wish their lives to be, rather than passively accepting the position to which they've been relegated based on social structures, class, gender, race, religion, ability, sexual preferences, family dynamics and so on. By telling their own story, Freud's analysands were handed the power to reconstruct their own lives in a way that made sense to them, rather than having their very being explained to them by others – often described as pathological, diseased, undesirable, hysterical, and the like. To have the opportunity to articulate one's own experience is a great power in and of itself and should never be underestimated. Feeling powerless and misunderstood can be devastating and may add to the already overwhelming feelings of helplessness, hopelessness and despair experienced in states of extreme duress. To put one's experience into words – to speak – has immense power and creative potential in and of itself.

Not so surprisingly, Freud himself was flooded with photographic images. The scientists, professors and medical professionals of his era were awash with this form of visual documentation as never before. Freud's own views were surely influenced by the culture of photography of his time, which inundated people of his social strata. In her book *Mirrors of Memory: Freud, Photography and the History of Art,* Mary Bergstein (b. 1952) writes:

> Because photographs were so frequently perceived as mirrors of memory around the turn of the 20th century, they have a special relevance to the imaginative vision of Freud. As light impressions, photographs seem to mimic – at least in a metaphoric sense – the mental phenomena of memories and dreams.
>
> (Bergstein, 2010, p. 9)

The photograph captures an instant, a slice of time, a moment: "visual residue, as traces 'taken' from the continuum of lived experience" (Bergstein, 2010, p. 15). Capturing that instant both holds it in our grasp and distances us from it at the same time. To stand behind the lens of a camera puts a

shield between the viewer and viewed, the voyeur and the object gleaned. In a way, photographs and postcards may produce both a familiarity with an item or place while concurrently creating a feeling of dissonance when confronted with the real object and its difference from our expectations and imagining. This may have influenced Freud's own thought process when observing himself, his dreams, his patients and the world around him.

No one captured this slice of time more literally than pioneering British photographer Eadweard Muybridge (1830–1904), perhaps the most influential photographer of the time. Muybridge's work is referenced as an influence by many artists throughout this study, and continues to influence artists, as well as the perception of society at large, to this day. His photographic studies are instantly recognizable, as he not only captured the movement of people, animals and events frame by frame, but also presented his images in succession as one image consisting of several, revealing what was until then impossible to perceive with the human eye alone: the stages of motion inherent in every move that we make. Seeing our own actions – as well as the micro-movements involved in such day-to-day aspects of our lives, which until then humankind hadn't understood or been able to perceive – revolutionized the way society viewed itself, and was a precursor to motion pictures.

This type of freeze-frame photography, capturing human expressions, movements and behavior, was also utilized in the Salpêtrière Hospital of Jean-Martin Charcot (1825–1893) in his (in)famous study of hysteria. Early on in his career, Freud spent time working in Charcot's hospital, and admired the man. Charcot focused on documenting the symptoms of his patients. As an artist and skilled draftsman, Charcot kept detailed drawings in residents' charts along with written documentation of symptomatology and patients' histories:

> Hysterical symptoms were reproduced at the Salpêtrière in a number of ways – as staged reenactments, sketches, wax and plaster casts, and photographs. Art became a method to immobilize the tumultuous fits of his patients and order the savage thrashing into a sequence of static images.
>
> (Hustvedt, 2011, p. 22)

Charcot also staged live demonstrations of hysterical symptoms and fits, which became popular outings for fashionable Parisians; medical students,

artists, actors, socialites and tourists alike flooded the Salpêtrière to witness the "madness" of the hysterics. The images are most striking and once viewed tend to stay with us – photographs of these women in the throes of such violent episodes. Like Muybridge's ability to capture man and animal alike in motion, Charcot's images froze his patients in successive stages of torment: catatonia, grimaces, seizures, emotional outbursts and paralysis all captured in his laboratory. Of note, the Salpêtrière is said to have housed one of the most cutting edge photographic laboratories in the world at the time, and Charcot was one of the first lecturers known to use a photographic projector (Hustvedt, 2011, p. 23).

It is possible that psychoanalysis may not have been able to have been developed if it weren't for the invention of photography first. This innovative viewpoint provided new perspective; subjects were suddenly able to observe a phenomenon or object – including themselves – while present, but simultaneously at a distance. This stimulated a new means of reflection, engaging and experiencing while concurrently detaching, providing a shift in perception not unlike the experience of being in an analytic session. Instead of being caught up in the current of our emotions, transferences and associations, the psychoanalytic endeavor allows us a bit of space from ourselves, observing our own minds as thoughts arise, as if through a lens. Thus we create a similar distance from the experience itself so that we may observe ourselves in a new way, not unlike the way a photographer observes the subject, or later the filmmaker frames scenes of a film. This is even reflected in the way Freud instructed us:

> So say whatever goes through your mind. Act as though, for instance, you were a traveller sitting next to the window of a railway carriage and describing to someone inside the carriage the changing views which you see outside.
> (Freud, 1913, p. 135)

There's also often an aspect of chance – of unpredictability – in the act of taking a photograph, especially as the technology developed and trends moved from a focus on portraiture to capturing images of life on the streets. As Roland Barthes (1915–1980) described in *Camera Lucida: Reflections on Photography* (1981), a photographer develops a sort of second sense about the moment to best take a photograph, reminiscent of the evenly-suspended attention Freud described as ideal for the analytic position, wherein certain

moments glisten like gems, as discrepancies and signifiers seemingly pop out from the otherwise flat surface of the imaginary. With practice, the analyst – or photographer – learns to act at just the right time to illuminate the moment the unconscious opens, when life at its most poignant or raw slips out.

Pioneering French photographer Henri Cartier-Bresson (1908–2004) described this phenomenon as capturing the *decisive moment* – that precise moment when one gains a glimpse of the inner workings of a scene; when it all seems to come together; when it is clear there is more at play than meets the eye. Cartier-Bresson himself expressed the process in a characteristically poetic way:

> To take photographs is to hold one's breath when all faculties converge in the face of fleeing reality [...] It is putting one's head, one's eye, and one's heart on the same axis.
> (Cartier-Bresson, 1999, p. 16)

As he traversed continents, Cartier-Bresson documented history in the making: the myriad faces of Africa in the 1920s, the fall of the Spanish Republicans in 1939, the liberation of Paris in 1944, the upheaval of India and the weariness of Mahatma Gandhi (1869–1948) just before his assassination, and the victory of the Chinese communists in 1949. Cartier-Bresson often seemed to be in the right place at the right time. His photographs quickly became iconic images of collective cultural memory. As Moroccan journalist and Cartier-Bresson's biographer, Pierre Assouline (b. 1953) describes, "The 20th century was that of the image, and Cartier-Bresson was an eye, a vision, of the century" (2012, p. 11).

American curator and art historian Peter Galassi (b. 1951) notes that although the surrealists were the ones who explicitly sought to blur the distinction between art and life:

> No one achieved this goal better than Cartier-Bresson [...] The tools of his art – the few rolls of film, a small camera held in the hand – required no distinction between living and working. There was no studio, no need to separate art from the rest of experience.
> (Galassi, 1987, pp. 39–40)

As we shall see, this is a consistent theme running through the worldviews of many of the artists in this study, most of whom held the perspective

that there is no separation between life and art. Life itself may be conceptualized as a work of art, the creative process incarnate, and we as active collaborators in the invention of ourselves and the society we build for ourselves to inhabit.

The surrealists took a new view to photography besides the purely documentary, gleaning messages and meanings not often transparent to the average onlooker, nor even necessarily to the photographer, often analyzing the contents of photographs the way one might analyze a dream. They observed that ordinary, everyday photographs – when uprooted from their practical functions – contain a wealth of unintended, unpredictable meanings. Cartier-Bresson masterfully captured these elements as well as a sense of liminality in his images, aesthetically integrating the unknowable in the known, the associations beneath the surface of the visual, the latent content underlying the manifest:

> It often happens that in our understanding of a work of art, it is the indescribable that lifts it beyond the scope of the most convincing analysis. Thus the effect comes from what the image does not reveal, the unseen world implicit in the photograph.
> (Assouline, 2012, p. 11)

Philosopher Walter Benjamin (1892–1940) posited that we discover the *optical unconscious* through photography just as we uncover the instinctual unconscious via psychoanalysis:

> Whereas it is a common-place that, for example, we have some idea what is involved in the act of walking (if only in general terms), we have no idea at all what happens during the fraction of a second when a person actually takes a step. Photography, with its devices of slow motion and enlargement, reveals the secret. It is through photography that we first discover the existence of this optical unconscious, just as we discover the instinctual unconscious through psychoanalysis.
> (Benjamin, 1999, pp. 511–512)

Observation and discovery of what may be happening between the scenes or lying just beneath the surface are not limited to the fields of psychoanalysis and photography, but rather are evident in an array of areas. Scientific discoveries shaped and swept popular discourse in the mid to late 19th

century, mesmerizing intellectuals, artists and revolutionaries alike. German physicist Heinrich Hertz (1857–1894) revealed the existence of electromagnetic waves, and in 1886, succeeded in transmitting these waves from a sender to a receiver, thus leading the way to wireless telegraphy and radio. X-rays, discovered by Wilhelm Röntgen (1845–1923) in 1895, made it possible to view structures underlying the visible world, and led to Röntgen being awarded the first Nobel Prize in Physics in 1901.[3] This discovery led French astronomer Camille Flammarion (1842–1925) to note this as further proof that "sensation and reality are two very different things" (Henderson, 1998, p. 6). These technological innovations revolutionized the act of seeing itself, illuminating aspects of reality that were previously invisible. The archeology, art history, anthropology and medical science of the time were all concerned with searching for clues to better understand the dynamics at play just out of view, as these advancements in technology and the potential of such discoveries were reflected in the art and literary movements of the times. Even a new genre of literature developed, that of the detective novel. It's no coincidence that these findings emerged relatively concurrently, as all reflect the Zeitgeist of the time.

Jacques-Henri Lartigue (1894–1986) was another photographer working around the same time as Cartier-Bresson. Lartigue captured distinctive images of the everyday – moments of revelation, surprise, accident and coincidence – in early 20th century France. He had a way of highlighting the sense of wonder that pervaded the turn of the century: a world that seemed full of possibility and opportunity, as ever evolving technologies heralded in a new era – what the French termed *la belle époque* – before the tragedy and calamity of the World Wars began to wreak havoc. Many of Lartigue's photographs focused on play and sports, such as horseback riding, bicycling, ice skating and early car racing, as well as flying machines, boats and other technological wonders of his time. Lartigue's work harnessed the whimsy, excitement and potential of the technological age, displaying an appreciation of the human ingenuity involved in the creation, engineering and execution of these devices. Despite living through both World Wars and the Great Depression, Lartigue somehow seems to have maintained this sense of possibility throughout his career.

Another master of capturing a sense of wonder was American innovator Wilson Bentley (1865–1931), who photographed and cataloged over 5,000 snowflakes during his lifetime. Growing up in rural Vermont, Bentley kept a daily record of the weather from childhood. At the age of

15, he was given his first microscope. Intent on documenting the incredible images he viewed through this microscopic lens, Bentley first began drawing the intricate patterns of snowflakes by hand. Soon, however, he found a way to fashion a microscopic lens to a bellows camera, and with this maneuver revolutionized the field of *photomicrography*. At the age of 20, he presented the world with the first ever photograph of a snowflake.[4] Not only was Bentley's work pivotal in expanding scientific understanding, his images were also visually stunning. Bentley first posited the now-undisputed notion that no two snowflakes are alike:

> "Under the microscope," he noted, "I found that snowflakes were miracles of beauty; and it seemed a shame that this beauty should not be seen and appreciated by others. Every crystal was a masterpiece of design and no one design was ever repeated. When a snowflake melted, that design was forever lost. Just that much beauty was gone."
> (Gioni & Bell, 2016, p. 74)

Before his death, Bentley donated his archives to the Smithsonian for posterity and created the book *Snow Crystals* (1931), which collected together 2,500 of his photomicrographic images.

Bentley's work is an enchanting example of the way in which an individual's drive may coalesce with the technology and Zeitgeist of the time to produce until then unimagined creations, and how sharing such discoveries with society at large may forever alter our collective understanding of ourselves and the world. Bentley's work uniquely combined his own desire with the art of the photograph, advances in the natural sciences, and a compulsion to make the invisible visible. He was a man with an obsession and a will, who developed a way to capture these moments; true slices of life that only exist for a fraction of time – sometimes mere seconds. In a similar manner, Freud harnessed the Zeitgeist of his time, developing a method of capturing the elusive traces suggested by the unconscious, through slips of the tongue, bungled actions, repetition, dreams, fantasies, puns and jokes.

The act of taking a photograph may be considered a ritual of sorts, momentarily shifting us out of our day-to-day. The photographer takes a step back from the routine of daily life to capture a slice of it. All rituals do this in a way, as we cut ourselves out of the habitual and consciously step out of the current of our lives in order to engage in another action, whether

it be the taking of a photograph, a moment of meditation, or entering an analytic session. Psychoanalysis may be seen as a ritual in this way as well, as we take a step out of our daily routines to analyze and reflect upon ourselves, our lives and the world around us, before reentering the social sphere.

Through his work as a pediatrician, British object relations psychoanalyst Donald W. Winnicott (1896–1971) championed the idea of the *transitional space:*[5] the space of play, experimentation, sublimation, artistic creation and psychoanalysis. Taking space for ourselves during the course of our day creates a place where we are able to create: a transitional space where one steps out of one's daily routine for 45–50 minutes, or a variable length of time, depending on the analyst's orientation. This ritual may occur once, twice or three times per week; classical analysts insist on four to five times per week – Freud sat with his analysands six times per week. Whichever the case may be, this ritual extraction from the daily narrative is a space where one is taken out of one's story and provided opportunity for reflection; in this sphere, one may begin to rewrite one's narrative before venturing back into it. The space of the analytic session allows us to question what we hold to be so sure, encouraging us to disrupt that which has been engrained within us: to wonder if we truly are the way we believe ourselves to be, or if "we" are really part of a script that has been handed down to us by others, and with which we have become identified. As we parse these storylines and begin to clarify patterns in relationships in love and work, we create space for the invention of something new, and we reenter the social armed with the potential to act and react in new ways more in line with what we wish to choose, rather than the ways we've been programmed to behave through years of social conditioning, projections, expectations and identifications.

Once viewed, it's difficult to forget the cut-throat images of the streets of New York City at night in the 1930s and 1940s produced by Arthur "Weegee" Fellig (1899–1968) – true slices of life, hardly seized in such a way before or since. Camera sleuth Weegee traveled the streets of Manhattan night after night, capturing images of accidents, crime scenes, murders, fires and other extreme events. This was the time of prohibition, increased gang violence and crime. Tenements were overcrowded and overflowing. Weegee was so overwhelmed with work that he installed a dark room/developing lab in the trunk of his car. Each night, from midnight onward, he listened in on calls to police stations – reports of Peeping

Toms, burglaries, domestic violence, hold-ups and car accidents. The later the night drew on, the worse the news – the early morning hours approaching dawn bringing the most severe tragedies, suicides and murders (Laude, 1985, pp. 3–4).

An ingenious creative, Weegee did not limit himself to journalistic photography. He often experimented with photography in a playful and surreal way:

> Since photography was invented [...] it has been used mainly to record the world and its peoples; in fact it has been a tool of the historian – and not the creative artist. Some photographers, and that includes me, have tried to make the breakthrough into the creative field.
> (Weegee & Speck, 1964, p. 5)

Over the years, Weegee achieved so much success with his creative work that he eventually left the police beat to pursue his artistic practice full-time.

One series that stands out as particularly noteworthy for the current study are Weegee's kaleidoscopic visions. As the description implies, Weegee shot images of his subjects through a kaleidoscope, thereby fragmenting, cutting and multiplying his subjects' features in the way only a kaleidoscope can. His portrait of Salvador Dalí (1904–1989) created in this manner is especially intriguing, as Dalí's signature mustache is cut, turned and reassembled in such a way that its reconfiguration resembles a starfish. His eyes are dislocated, cut from his face and multiplied so that two eyes become nine, which form a circle and seem to peer out at us from the circumference of the image – teeth distorted and mashing, nose displaced and disfigured. Dalí's most recognizable features become uncanny, distorted and deranged – one might even say grotesque – to such an extent that the familiar is turned into horror.

Another way in which Weegee bent perception was by creating plastic lenses that he shot through to engender distortions in his portraits, similar to the effects of funhouse mirrors or the caricatures drawn for tourists in public squares, boardwalks and fairgrounds. In his now classic book *Weegee's Creative Photography* (1964), the artist shared a variety of his techniques and methodologies, providing detailed instructions explaining how others could fashion such plastic lenses themselves, if they so desired.

What I have done creatively with the camera is a breakthrough, and a breakthrough which any amateur can follow up regardless of whether he uses a simple Box Brownie or a Hasselblad.

(Weegee & Speck, 1964, p. 5)

In many ways, this democratization of tools and methods was symptomatic of the times. As we'll see throughout this study, another theme that seems to run through the work of many of the artists included is the encouragement from the artists for members of the audience to try these techniques for themselves, thus promoting the view that art is for everybody, not just for the elite, skilled or formally trained. Rather, anyone can do it; everyone harbors an inherent creative potential that should be supported and facilitated. In line with the conception that life and art are one and the same, many artists encourage others to break out of their day-to-day routines and take the time to be creative in some way.

Another artist who took "slice of life" photographs of the streets of New York City was Diane Arbus (1923–1971). She changed the game by pointing her camera at the people she saw on the street – those who others may not have found to be traditionally attractive or ideal subjects – even photographing subjects considered to be taboo. Arbus created series of photographic portraits of circus performers, sex workers, the LGBTQ community, persons with differing levels of ability and those considered to be suffering from mental illness. Arbus showed the beauty in character, faces, persona and presentation, emphasizing inclusion and representation in her work. She is heralded for the shift in perception of what is considered to be acceptable and appropriate subject matter. This shift in perspective is in itself an essential cut: a break from the traditional, overarching narrative. Arbus captured wonder in the everyday, illuminated the beauty in the mundane, and found value in the people she passed on the street; all the while, she was conscientious and maintained consideration for her subjects, careful not to fetishize or objectify, but rather to distinguish. In this way, Arbus disrupted the conventional narrative that was traditionally provided and upheld until then – a conservative convention that the art world abided by without ever taking the time to consider or question: the demand that we focus on what has been deemed beautiful, sacred and vital, and disregard the rest. Like many inherited notions, this was accepted as truth without being challenged or called into question. Arbus moved away from this normative perspective, and in so doing allowed for a broader perception,

changing notions of accepted viewpoint and subject matter permanently. As Arbus so poignantly stated, "Nothing is ever the same as they said it was. It's what I've never seen before that I recognize."[6]

Drag kings and queens, sex workers, circus performers, swingers, nudists and people hospitalized for medical and mental illnesses, combined with Arbus's knack for graphically stressing the eerie absurdity of so-called normal New Yorkers she encountered, created a stark bouquet, a curious tableau of the Freudian concept *unheimlich* or "uncanny," which became a testament to her own unique and haunted vision. Unfortunately, over time Arbus became more and more consumed by her own distress and melancholia, and committed suicide in 1971.

Another artist of note whose life ended tragically early is American photographer Francesca Woodman (1958–1981). Woodman turned the lens around onto herself with particular focus on the body, creating a series of intimate portraits of self and other(s). Playing with framing, she often captured nude bodies truncated, decapitated or bent into unusual forms, forcing the viewer into a voyeuristic perception of her subjects in an unconventional manner. Woodman's choices of subject matter and experiments with focus and length of exposure often produced blurred images that were eerily ghostlike: uncanny portraits reminiscent of the spiritualist medium photographs of the previous century, truly "dream-like" in their presentation.

When Woodman is written about in popular media, her youth is almost always emphasized; so much so that I considered eschewing the topic altogether. Woodman produced thousands of images in her lifetime, 800 of which remain.[7] The sheer quantity of her work is itself remarkable, especially when one considers her short life. Her images are sophisticated, perceptive and daring, concurrently displaying vulnerability and strength, in addition to simply being visually breathtaking. What I find frustrating is the framing of her work in such a way as to feign shock over the ability of someone so young to produce such strong work; implicitly suggesting that young people don't have something important to say or that such skills can only come with age, as if they need to be taught or require many years of training. While this may be true for some artists, it is certainly not true for everyone; in fact, some may feel that training inhibits creativity or artistic vision. And the notion that young people haven't had enough life-experience to have something valuable to say or contribute to society does humanity quite a disservice. Young adults, adolescents and children are

generally quite perceptive, expressive and imaginative; it could be argued that it is social conditioning that tends to dull one's senses and creative impulses. Therefore, besides Woodman's uncompromising, original vision and mastery of her medium, perhaps another important takeaway from her work is to not underestimate others based on age, gender or any other factor. This narrative of "How could such a young girl create such stark and deep work?" does a disservice not only to Woodman in particular but to young people, women, humankind and society at large. Everyone has something to say. All we have to do is listen.

Notes

1 Bellis, M. (2019) "The history of photography: Pinholes and polaroids to digital images" [Online]. ThoughtCo. Available at: https://www.thoughtco.com/history-of-photography-and-the-camera-1992331 (Accessed: August 17, 2019).
2 Rosenberg, J. (2018) "Learn how the Brownie camera changed photography forever: How Eastman Kodak changed the future of photography" [Online]. ThoughtCo. Available at: https://www.thoughtco.com/brownie-camera-1779181 (Accessed: August 17, 2019).
3 Nobel Media AB. (no date) "The Nobel Prize in Physics 1901" [Online]. Nobel Media AB. Available at: https://www.nobelprize.org/prizes/physics/1901/summary/ (Accessed: February 21, 2020)
4 Heidorn, Keith C. (2011) "The Snowflake Man of Vermont" [Online]. Public Domain Review. Available at: https://publicdomainreview.org/2011/02/14/the-snowflake-man-of-vermont/ (Accessed: November 15, 2019).
5 Winnicott, D.W. (1971/2005) *Playing and Reality*. London: Routledge.
6 Arbus, D. (May 1971) "Five photographs by Diane Arbus." *Artforum*. 9 (9).
7 Kieffer, M. (2016) "Haunted genius: The tragic life and death of Francesca Woodman" [Online]. Culture Trip. Available at: https://theculturetrip.com/north-america/usa/new-york/articles/haunted-genius-the-tragic-life-and-death-of-francesca-woodman/ (Accessed: August 17, 2019).

Bibliography

Arbus, D. (1995) *Untitled*. New York: Aperture.
Assouline, P. (2012) *Henri Cartier-Bresson: A biography*. London: Thames & Hudson.
Barthes, R. (1977) *Image – Music – Text*. Glasgow: William Collins Sons & Co.
Barthes, R. (1981) *Camera Lucida*. New York: Hill and Wang.

Benjamin, W. (1979) *One-Way Street and Other Writings*. London: New Left Books.
Benjamin, W. (1999) *Selected Writings, vol. 2 (1927–1934)*. Cambridge: Belknap Press.
Bentley, W. (1931) *Snow Crystals*. New York: McGraw-Hill.
Berger, J. (1972) *Ways of Seeing*. London: Penguin.
Berger, J. (2013) *Understanding a Photograph*. London: Penguin.
Bergstein, M. (2010) *Mirrors of Memory: Freud, photography and the history of art*. Ithaca: Cornell University Press.
Bosworth, P. (1984) *Diane Arbus: A biography*. New York: W.W. Norton & Company.
Cartier-Bresson, H. (1999) *The Mind's Eye: Writings on photography and photographers*. New York: Aperture.
Chéroux, C. & Jones, J. (2017) *Henri Cartier-Bresson: Interviews and conversations (1951–1998)*. New York: Aperture.
Delpire, R. (1976a) *Henri Cartier-Bresson*. New York: Aperture.
Delpire, R. (1976b) *Jacques-Henri Lartigue*. New York: Aperture.
Freud, S. (1900) *The Interpretation of Dreams*. In *The Complete Standard Edition of the Psychological Works of Sigmund Freud (SE)*. IV–V. London: Hogarth Press. pp. 1–627.
Freud, S. (1901) *The Psychopathology of Everyday Life*. *SE* VI. London: Hogarth Press. pp. 1–279.
Freud, S. (1912) "Recommendations to physicians practicing psycho-analysis." *SE* XII. London: Hogarth Press. pp. 109–120.
Freud, S. (1913) "On beginning the treatment (further recommendations on the technique of psycho-analysis I)." *SE* XII. London: Hogarth Press. pp. 121–144.
Freud, S. (1919) *The Uncanny*. *SE* XVII. London: Hogarth Press. pp. 217–258.
Frizot, M. (ed.) (1998) *A New History of Photography*. Köln: Könemann.
Galassi, P. (1981) *Before Photography: Painting and the invention of photography*. New York: The Museum of Modern Art.
Galassi, P. (1987) *Henri Cartier-Bresson, The early work*. New York: The Museum of Modern Art.
Gioni, M. & Bell, N. (eds.) (2016) *The Keeper*. New York: The New Museum.
Henderson, L. (1998) *Duchamp in Context*. Princeton, NJ: Princeton University Press.
Hustvedt, A. (2011) *Medical Muses: Hysteria in nineteenth-century Paris*. New York: W.W. Norton & Company.
Laude, A. (1985) *Weegee*. Paris: Centre National de la Photographie.
Lubow, A. (2016) *Diane Arbus: Portrait of a photographer*. New York: HarperCollins.

Palm, A., Tellegren, A. & Woodman, G. (2015) *Francesca Woodman: On being an angel*. Stockholm: Moderna Museet.

Sinclair, V.R. & Lambrecht, I. (2016) "Ritual and psychoanalytic spaces as transitional, featuring Sangoma trance states." In Abrahamsson, C. (ed.) *The Fenris Wolf*, vol. 8. Stockholm: Trapart Books. pp. 281–289.

Smith, S.M. & Sliwinski, S. (eds.) (2017) *Photography and the Optical Unconscious*. Durham: Duke University Press.

Sontag, S. (1973) *On Photography*. New York: Picador.

Sussman, E. & Arbus, D. (2011) *Diane Arbus: A chronology (1923–1971)*. New York: Aperture.

Weegee & Speck, G. (1964) *Weegee's Creative Photography*. London: Ward, Lock & Co.

Winnicott, D.W. (2005) *Playing and Reality*. London: Routledge.

Zaczek, I. (2018) *A Chronology of Art: A timeline of Western culture from prehistory to the present*. London: Thames & Hudson.

Chapter 2

Reimagining the frame
The birth of modern art

As technological innovation evolves, it is reflected in the artistic and literary movements of the times; the standards and means of production, philosophy and practice of the arts and design are inextricably affected. Industrialization took place *en masse* throughout the 19th century, overhauling the functioning of day-to-day life for individuals, as well as irrevocably altering the societal landscape. As time progresses, technology persists, dislocating the subject ever more.

Just as the camera turned the lens onto the viewer, placing the tools of reflection in the palm of one's hand, so too were artists and writers influenced by the dawn of photography. For some painters, photography was integrated as a useful tool in the continued creation of more conventional artworks; for others, however, it forever changed the way they worked and viewed the world. Many creatives began to turn inwards, shifting toward an expression of their internal experiences, rather than remaining externally focused and continuing to attempt to replicate the details of the surrounding environment. In the mid to late 19th century, there is a notable shift toward self-reflection and introspection, as artistic and literary movements moved away from the linear or narrative form of previous traditions and turned their focus to subjective experience, emotions and dreams. The visual arts were revolutionized by the emerging abstraction of figures and forms – at first subtle but ever-increasingly bold – as new technology and techniques were utilized and even integrated into the creation of artworks.

The Pre-Raphaelites beckoned the dawn of the coming age of modern art. Preceding the upcoming impressionist and symbolist movements, this group of mainly British artists and poets arrived on the scene in 1848 – the "Year of Revolution"[1] as it was known. The very same year, *The Communist Manifesto* by Karl Marx (1818–1883) and Friedrich Engels (1820–1895)

was published, as the Irish continued to flee the Great Hunger and the California gold rush had just begun. Led by William Holman Hunt (1827–1910), Dante Gabriel Rossetti (1828–1882) and John Everett Millais (1829–1896), the Pre-Raphaelites chose their name out of admiration for what they considered to be:

> "the fresh, natural approach of early Italian art"; in other words, art before the time of Raphael (1483–1520), who had come to be known as "the epitome of academic art, which, by the mid-19th century, had come to seem stale and conventional."
> (Zaczek, 2018, p. 187)

It is more in approach than style that makes the Pre-Raphaelites precursors of artistic modernity. As their preferred style was highly and skillfully figurative, weaving in themes and vistas from a mythic view of history, they may easily be regarded as precursors of a figurative surrealist like Salvador Dalí but hardly of a brutalist like Pablo Picasso. The Pre-Raphaelites retracted from the bleak, materialistic and loud industrial expansion surrounding them, and into an inner sphere of narcissistic self-reflection. The romanticism engendered by the process of turning the gaze inwards meant a cut, not only with the coal-smelling, soot-covered reality of the everyday, but also with the empirical view of the human being as strictly a quantifiable unit. Where mechanical materialism itself was the main fuel in both the ruling capitalism and the opposing budding socialism/communism, the reaction became one of colorful poetry and romanticized timelessness.

Famed craftsman William Morris (1834–1896) began his artistic career among the Pre-Raphaelites. A master of design, Morris worked in a variety of media, including woodworking, furniture, wallpaper, textiles and stained glass.

> He strived to protect and revive the traditional techniques of handmade production that were being replaced by machines during the Victorian era's Industrial Revolution.[2]

Revitalizing an appreciation of fine workmanship in an age where standards of craftsmanship had arguably declined as a result of the commercial pressures of industrialization and demand for mass production, Morris's

imagery boasts of beauty, refinement and abundance, as his stylized floral arrangements burst forth with a combination of exquisite yet often subtle color and intricate, delicate detail. Morris often worked from a design block, which would be repeated during production to create the chosen pattern. He used woodblock printing most often for his wallpapers and textiles, and designed over 50 wallpaper patterns throughout his career, many of which remain in production to this day.[3]

Norwegian artist Edvard Munch (1863–1944) also worked prolifically in printmaking. Beginning his career early on, Munch set his intention to pursue art as a profession at the age of 17 (Falck, 2018, p. 9). Initially primarily a painter, he soon expanded into working with a variety of media and techniques, including etchings and woodcuts, creating prints and lithographs. Printmaking provided Munch the opportunity to create multiples of each artwork, allowing for variation in these reproductions, whether this be a slight shift of the lines or more overt changes in color, field and form. At times Munch would invert, reverse or overlay duplicates of the printed image; such modifications showcase the powerful effect of repetition, displacement and variation. When these works are presented side by side (as is often the case at the Munch Museum[4] in Oslo), the viewer is afforded the opportunity to experience the power inherent in these small deviations; as one image folds into the next, the observer may note the moments when the artist chose to alter the form, color or context of the work, either ever so slightly or at times startlingly.

Munch's evocative image *The Scream*, of which there are four basic versions, executed between the years 1893 and 1910, has perhaps more than any other artwork become associated with not only personal anxiety but also with a general existential Angst. Munch's original title of the image was the German *Der Schrei der Natur*, meaning "The Scream of Nature," leaving the viewer with a question of inspired ambiguity: is the artist referring to the scream of the outer or inner realm? His blending of violent modernism with intuitive rather than scholarly psychological insights has made Munch perhaps the quintessential creative "bridge" from 19th to 20th century art.

The work of Edvard Munch brings us to consider the phenomenon and conceptualization of *repetition*. Freud first wrote of the "compulsion to repeat"[5] in *Remembering, Repeating and Working-through* (1914) and continued to elaborate this concept throughout his career, most notably in *The Uncanny* (1919), *Beyond the Pleasure Principle* (1920) and

Inhibitions, Symptoms and Anxiety (1926). Over time, *repetition compulsion* became one of the cornerstones of psychoanalytic theory. There have been a variety of ways psychoanalysts have attempted to understand the insistence of repetition over the past century: as a vehicle for recalling unconscious material; a way to work through the repressed; an attempt at symbolizing the unsymbolizable; an avenue for addressing trauma; a way to bind impulses or develop a sense of mastery. Repetition may have an organizing, structuring function but may also become deadening: trapping an individual in a groove or rut, which may feel like a state of deadlock. Symptoms are often of a repetitive nature.

> In a general way, the repressed seeks to "return" in the present, whether in the form of dreams, symptoms or acting-out.
> (Laplanche & Pontalis, 1973, p. 78)

At the same time, perfect repetition is impossible and therefore inexact. When tracing and retracing, the lines will never exactly match up, and even in the unlikely scenario that they somehow do, there will always be difference: the setting, time, place or situation; your mood and circumstances vary. It is in these slight differences between repeated cycles or replications that a space is located – a gap, an opening, where the potential for creation or generation resides. In discrepancy, separation occurs, and with this separation, space for creation. Nothing can be created if there is no void to fill. Repetition is inexact, creating small deviations, differences where change may come into play. Small cuts create gaps, opening spaces that produce potential for something new to transpire, which then in turn may alter the greater system or structure at large. When viewed in this light, repetition may be seen as the scaffolding of the creative space.

This process brings to light not only a variety of functions of repetition, but also the generative potential inherent in its very impossibility. In other words, it may not be the sense of mastery that is popularly thought of as coming with repetition of experience that is essential, but rather the differential highlighted through the impossibility of repetition itself. When we engage in what is proposed to be a repetition of a previous act, the difference is marked, for no act can ever be repeated precisely. There will always be a shred of difference, a remainder.

We live our lives in a plethora of repetitions, whether they be patterns of thought, transference, behavior or otherwise. Even taking the mundane

example of routines of daily living: we wake up at the same time every morning, make our way through the morning regimen, take the same route to work, and so on. However, even in the monotony of day-to-day life, there are always differences. We may wake up at the same time each morning, but our mood is slightly different depending on how we slept, what dreams we had, and whether we recall them. Perhaps they were overtly sexual, and we awake aroused; perhaps we tossed and turned, and wake up tired and disgruntled, or in a panic from anxiety. We choose to adorn ourselves differently each day; even if our manner of dress is somewhat similar, there are always differences. We may take the same route to work, but the train might be running late, or traffic is particularly smooth or in a jam that day. Perhaps we decide to listen to new music on the way. We may stop in the same café every morning to pick up the same order of coffee, but each time is different: there may be a new barista, or the tables and chairs in the café are disheveled; the people in line may be carrying on a conversation that we overhear, or we notice a bold headline on the daily newspaper. Taking a moment to notice these subtle differences in the daily patterns of our lives is a cut in itself, providing a moment of space from being caught up in the habitual nature of our day-to-day routine – a moment of reflection.

We will see the power of the image cut from the day-to-day and repeated when we discuss the work of Andy Warhol (1928–1987) later in this study. Cutting everyday images from newspapers and magazines, Warhol replicated them *en masse* and presented them as works of art. This action had a powerful effect on the audience, as well as culture at large. Taking graphic images of automobile accidents and the electric chair, as well as such common objects as the dollar bill and soup cans, Warhol abstracted and multiplied them, re-presenting them in a colorful and aestheticized way. Culling objects from the stream of daily life, Warhol interrupted discourse and confronted the audience. In this way he was an analyst of the culture of his time.

Repetition is essential to the theories of many crucial thinkers: Freud, Marx and Lacan, as well as Søren Kierkegaard (1813–1855), Friedrich Nietzsche (1844–1900), Albert Camus (1913–1960) and Gilles Deleuze (1925–1995), among others. For Lacan, repetition was one of *The Four Fundamental Concepts of Psycho-analysis*, while Deleuze elaborated his theories in the book *Difference and Repetition*. As Alenka Zupančič (b. 1966) delineates in *The Odd One In: On Comedy* (2008), although there

are a variety of differences across these theories, there are also some commonalities. She posits that for Freud, Lacan and Deleuze in particular, the view is shared that repetition is fundamentally different from the logic of representation, concluding that in psychoanalysis it has come to be understood that there comes a limit, both in theory and in practice – sometimes, the act is necessary:

> Freud soon discovered that there is a limit to what remembering and interpretation (which he first posited as the principle tools of psychoanalysis) can accomplish in analysis. They can work most of the time, yet there are certain points that can be approached, and worked through, only via repetition.
> (Zupančič, 2008, p. 150)

Not only did Munch lean toward repetition in his methods of production, but he also tended to return to the same motifs, imagery and themes with regard to the content of his artwork. Munch revolutionized painting by abstracting figures, depicting what he described as that which remained in his mind following an experience with a person, scene or situation, proclaiming: "I don't paint what I see, but what I saw" (Falck, 2018, p. 7). Munch turned inwards toward the realm of dreams, emotions, the unconscious and symbols, bringing his internal experience out onto the canvas. In this way, he can be seen as contributing to the development of expressionism and symbolism, moving away from the then current predominant artistic movements of realism and impressionism, both of which were concerned with recording the world around them, whether it be in a realistic or impressionistic manner, respectively. Munch's work can also be seen as a precursor to surrealism, as he worked to unleash the contents of his unconscious.

Similarly, French artist Paul Gauguin (1848–1903) was known to say that he "closed his eyes in order to see" (Falck, 2018, p. 7). Working during a similar time period as Munch, Gauguin left a successful career as a businessman to pursue the arts later in life. Tired of systems and the social posturing of bourgeois Paris, he set off to the remote islands of the South Pacific in pursuit of something else. There, Gauguin began to paint the natural world around him and the indigenous peoples of these lands. He named his style *synthetism,* espousing the notion that the artist paint from

memory, thereby creating a synthesis of outer reality and internal experience. Lesser known is that Gauguin also worked with etchings, woodcuts and lithographs.

Both Gauguin and Munch created portraits of poet Stéphane Mallarmé (1842–1898), one of the most prominent intellectuals in Paris at the time. From the mid-1880s until his death, Mallarmé held a salon at his apartment on Tuesday nights to discuss poetry, art and philosophy. Both Gauguin and Munch attended these salons at various points in their careers. In the etching Gauguin created of Mallarmé (1891), the subject is positioned in the lower left-hand corner of the page, seemingly dislocated, as if he is about to move out of the frame. A raven is perched upon his shoulder – much as a pirate would have a parrot – an apparent allusion to *The Raven* by Edgar Allen Poe (1809–1849), which Mallarmé had translated into French. Munch created two portraits of Mallarmé, one etching and one lithograph. Both of these images are striking, stark portraits set against deep, dark backgrounds. The impact of these works impart the significance of the subject to these artists. In a letter, Mallarmé thanks Munch for "a gripping portrait, which gives me an intimate sense of myself" (Falck, 2018, p. 18).

Stéphane Mallarmé, Paul Verlaine (1844–1896), Arthur Rimbaud (1854–1891) and their contemporaries exquisitely developed the symbolist aesthetic in literature throughout the latter portion of the 19th century: abandoning traditional forms of poetry, advocating for exploration and expression of inner life through the written word "by elevating intuition, chance, and the 'suggestive magic' of words to the highest position" (Tomkins, 1996, p. 11). The symbolist literary movement had begun years earlier, with the release of the (in)famous *Les Fleurs du Mal* (1857) by Charles Baudelaire (1821–1867). This work is considered to be instrumental to both symbolism and modernism, and was released to much controversy, leading Baudelaire to yet another day in court, his poetry deemed to be salacious and obscene:[6]

> Baudelaire had invoked the essential modernist creed when he described "pure art" as "containing at once the object and the subject, the world external to the artist and the artist himself." Only by giving free rein to subjective fantasies of the most extreme sort, he believed, could art convey the essential quality of modern life.
> (Tomkins, 1996, p. 11)

Baudelaire was enamored with and heavily influenced by the writing of Edgar Allen Poe, often incorporating Poe's imagery into his own work. Having discovered Poe as a young man, Baudelaire remained influenced by him throughout his life; in fact, Poe's work has been cited as a catalyst for a plethora of artists, writers and poets from Baudelaire and Mallarmé to the surrealists (Foye, 1980, p. 75).

Dutch painter Vincent van Gogh (1853–1890) was one of the seminal figures in the development of modern art, considered to be a pioneer of the post-impressionist and expressionist movements. Van Gogh dedicated himself to painting at the age of 28, and proceeded to work at such an intense pace that he created nearly 900 paintings before his death less than a decade later.[7] Van Gogh worked for a relatively short period of time, documenting his work and process in his writings, often in the form of letters[8] to his brother Theo, which he wrote almost daily at times, as well as to friends and fellow artists, including Gauguin.

It is a gift to receive the inner thoughts of a man who was fighting for his sanity and survival through the medium of his art. Van Gogh embodied a prime example of the way in which the creation of art functions; as opposed to modern-day conceptual art, which is more of a thought-experiment emanating from the ego or conscious mind of the artist, Van Gogh's work exemplifies a compulsive working-through of unconscious material.

Van Gogh's brushstrokes and use of color revolutionized painting as it had been known until that time. The short, deliberate strokes and thick application of paint were unlike any seen before him or since, and may be viewed as cuts in themselves. "Let us not forget that the painter's brushstroke is something in which a movement is terminated" (Lacan, 1978, p. 114). Fragments of paint, color and texture come together, reflecting the light; although seemingly disjointed, they form a unique view of the scene at hand. Mixing impressions from the surrounding environment with internal expressions, emotions and impulses, Van Gogh's work may be seen as a prime example of the merging inner and outer worlds. When standing before his artworks, one can almost feel the emotion and anxiety emanating from his pieces.

Van Gogh's use of color reflects a sensitivity to the play of light in the natural world, both in the close-up viewing of the intimate inner workings and nuances of the seeds and pistils of flowers, as well as in more remote scenes – the movement of the waves of rays of sunlight

as they pass across fields of wheat, rolling hills and distant towns. The thick application of paint used by Van Gogh, rather than obscuring his vision, illuminated it. By breaking apart the world he saw around him into small cuts – blotches of dense color – he was able to create a vision true and unique to himself. It is clear from his letters that Van Gogh felt a compulsion to paint as a means of expressing himself, and experienced a burning desire to impart the unique way he viewed the world to others via his artwork; he also expressed concern about how he would be perceived and received by others, desperately hoping to one day be recognized.

The desire to impart personal experience and expression that pervades Van Gogh's work is reflective of Freud's statement:

> What grips us so powerfully can only be the artist's *intention,* in so far as he has succeeded in expressing it in his work and in getting us to understand it. I realize that this cannot be merely a matter of *intellectual* comprehension; what he aims at is to awaken in us the same emotional attitude, the same mental constellation as that which in him produced the impetus to create.
>
> (Freud, 1914b, p. 212)

Another artist who experimented with line and color as a mode of imparting his own internal experiences and emotions was Austrian painter and draftsman Egon Schiele (1890–1918). Schiele broke boundaries by altering the framing of his subjects. Instead of keeping the figures neatly boxed within the boundaries of the canvas, he allowed his subject matter to stretch past the usual borders, often truncating limbs and even heads in the process. This was not something seen as acceptable or desirable in the art world at that time, at least not to do to the primary subject of a work. This decision often elicited a feeling of discomfort in the viewer, as Schiele seemed to disregard the viewer by refusing to present what was considered to be appropriate subjects in an appropriate manner. Furthermore, Schiele often used himself as his own subject, sometimes masturbating or in uncomfortable poses, face grimacing with limbs truncated. Schiele pushed boundaries, painting sex workers, again masturbating, legs spread wide. He often placed his figures upon a monochrome background – unfixed and ungrounded – seemingly in a refusal to situate them in time, place or specific situation.

> Particularly when Schiele crops or, as it were, mutilates the body to a mere torso, we see how little his scrutiny and self-portrayal has to do with external, superficial appearances. His use of colour [...] the arresting highlights and the brusquely juxtaposed brushstrokes indicate vital energy.
>
> (Steiner, 2017, p. 14)

These disruptions in color, frame, image, viewpoint and methodology are cuts: moments when the artist deviates from the norm, refusing to stay within the bounds of narratives that have been accepted as "tradition" up until this point. These deviations in turn affect others – the audience, viewers, critics, colleagues, peers – becoming instigators of potential change, which may be experienced as unsettling or uncomfortable at times. This discomfort may lead to defensiveness on the side of the recipient, or even aggressiveness and retaliation aimed at the artist. Many of the artists considered in this study were initially shunned, put on trial or exiled from their respective communities. Schiele, for example, was charged and jailed for producing "obscene" and "pornographic" artwork. Even if not actively persecuted, artists who push boundaries are often ostracized, ignored or at the very least unappreciated, written off as "mad" or "deviant." Neither Gauguin nor Van Gogh were successful during their lifetimes. Over time, however, once the initial defensiveness subsides, boundaries that were once pushed and broken eventually become the new norm, and the cycle of artists pushing the limits of self-expression and discovery continues.

In 1906, at the age of 16, Schiele entered his formal artistic education at the Vienna Academy.[9] While receiving classical training, Schiele's propensity toward the work of Gustav Klimt (1862–1918) and the Vienna Secession movement was soon obvious. Klimt's paintings are immediately recognizable, with their flattened surfaces, stark line work, incredible detail and use of space. Schiele's admiration for Klimt inspired him to move away from the traditional academic theory of art and toward increasingly modern, revolutionary gestures. While the influence of Klimt on Schiele is clear, Schiele's line work takes on more intensive, expressive qualities, while Klimt's remains largely abstracted, his stylized figures retaining more aesthetic, harmonious forms.

Both Klimt and Schiele were active during the period leading up to the First World War, which is arguably one of the most innovative times in the history of art. Artists began to organize their own shows outside

of the institutions. The impressionists had been one of the first groups to implement this strategy, with the trend continuing through the end of the 19th century and into the next. These breakaway groups became known as secessions, collectives of artists working independently, facilitating their own organizations and exhibitions, which they often called salons.[10] Klimt was an instigator of the Viennese Secessionists, which formed in 1897, when he and his contemporaries officially resigned from the Association of Austrian Artists to set out on their own. Secessionists were concerned with freeing the arts from the constraints of institutions, as captured in the slogan, "May the times have their art, and may art have its freedom" (Steiner, 2017, p. 23). Proclaimed by art critic Ludwig Hevesi (1843–1910), this sentiment served to challenge rigid academic conventions of historicism while espousing the belief that art and life should be more integrated.

In 1905, fauvism burst onto the scene at the Salon d'automne in Paris. Led by Henri Matisse (1869–1954) and André Derain (1880–1954), these artists explored the use of bright, intense colors. Rather than relegating color to its usual place in a more descriptive or realistic role, these artists allowed color to become an element of its own in their paintings: vivid hues taking on a more expressive, provocative and emotional power. The group became known as *les fauves,* or "the wild beasts," a term coined by art critic Louis Vauxcelles (1870–1943) upon first seeing the work.[11]

When Matisse chose to pursue a career as an artist, his family of origin was disappointed to say the least. As the eldest son of a wealthy merchant, Matisse was expected to follow in his father's footsteps:

> Matisse's decision to be an artist did not just reflect on him but was also a source of intense shame for his family, especially his father.
> (Hagman, 2010, p. 61)

This decision led to years of conflict and estrangement from his family and greater community. It may be difficult for us to imagine that an artist as prolific and universally renowned as Matisse was once outcast by his family of origin and the people of his province, but this goes to show the effect of disruption. When we go against what is expected of us, there is often pushback or a pushing away from others – even, and sometimes most especially, from those closest to us. Fortunately, Matisse's mother remained supportive of his work and his decision to pursue his passion and talent.

Toward the end of his career, Matisse went on to work almost exclusively with what came to be called *cut-outs*.[12] These pieces began as a way to play with form during the development of other creative projects; for example, Matisse's *Two Dancers* (1937), which consists of cut-out forms, was created as he was designing a ballet performance. Although the cut-outs began as a means to an end in the creation of other more formal works, they soon took center stage in Matisse's artistic practice. Throughout World War II, Matisse continued to work ever more creatively with the cut-out process, until eventually cut-outs became almost exclusively his primary medium. He was living in occupied France at the time and, to compound the situation, was physically ill. As the years progressed, he continued cutting out abstract forms of all kinds from painted sheets of paper and rearranging them in varying ways to create striking compositions:

> He said he was drawing with scissors, cutting directly into colour, abolishing the conflicts – between colour and line, emotion and execution – that had slowed him down all his life.[13]

Eventually, the cut-outs ventured out, as Matisse began to pin the cut-out pieces directly to the walls of his studio, surrounding himself with them. This eventually led to large-scale pieces and murals. Over time, Matisse transitioned to working exclusively with cut-outs, and continued to work with them until the end of his life:

> A brilliant final chapter in Matisse's long career, the cut-outs reflect both a renewed commitment to form and color and an inventiveness directed to the status of the work of art, whether as a unique object, environment, ornament, or a hybrid of all of these.[14]

An artist that had long been neglected but who is now finally getting her due, is Swedish artist Hilma af Klint (1862–1944). Af Klint studied formally at the Royal Swedish Academy of Fine Arts in Stockholm from 1882–1887, as part of the first generation of women to study alongside male peers.[15] Around the turn of the 20th century, sweeping scientific discoveries forever changed the common understanding of matter and space, and like many of her contemporaries, af Klint was interested in the invisible layers and dynamics running beneath the surface of the manifest content

of the everyday reality we see. She studied plants, planets, atoms, particles and world religions extensively, keeping detailed notebooks. Although af Klint chose not to share her paintings with the art world at the time,

> she was an active member of a group that included poets, inventors, journalists, doctors, scientists, and a proportionally high number of women.
>
> (Burgin, 2018, pp. 7–8)

af Klint created a total of 193 paintings between the years 1906 and 1915, 111 of which were completed between 1906 and 1908.[16] She described these as the "paintings for the Temple." Upon her death, she left 126 notebooks, a dictionary to accompany her work, and over 20,000 pages detailing her process, experiments and explorations. She created a body of work that left visible and predictable reality behind, exploring the radical possibilities of abstraction, and comprising a body of work that in scale, scope and imagery was like no other. In her notes, af Klint maintained that the creation of these works facilitated her own inner evolution, in addition to feeling they were her contribution to the evolution of mankind. Concerned that the masses were not yet ready for her work, she requested that her family not reveal her artwork until 20 years after her death. After such a time had passed, her family attempted to gift this large body of work to the Moderna Museet in Stockholm. However, as af Klint was an unrecognized artist at the time, the museum rejected the donation.[17] Nowadays, however, af Klint's legacy is exploding, with exhibitions popping up across the world. In fact, it was recently announced that the show *Hilma af Klint: Paintings for the Future*, at the Guggenheim in New York, was the most-attended exhibition in the museum's history.[18]

However, just a few years before the success at the Guggenheim, it was a different story. In 2012, the Museum of Modern Art in New York held a major retrospective entitled *Inventing Abstraction: 1910–1925*. It has been reported that even though the curator was aware of af Klint's substantial body of work, the decision was made to not include her, "reflex alarm at the occult"[19] seeming to be the explanation: in other words, discrimination based on the spiritual nature of her beliefs and work. When later confronted about the intentional exclusion of a clear pioneer of abstract painting, the curator exclaimed that af Klint "disqualifies herself by not having defined her paintings as art."[20] Both of these implications are disturbing, as the first

shows a prejudice toward and exclusion of an artist based on her worldview, while the latter implies that the artist somehow precluded herself by not defining her work within the boundaries of the conventional canon.

Another issue to consider is resistance on the part of the art world and market – including critics, dealers and historians – to adding artists to the canon, especially when this addition may potentially disrupt the narrative of art history that has been curated up until that point. Indeed, this seems to have been the case regarding the work of af Klint, as her abstract artworks preceded the work of the until-now supposed forerunners of abstract art, including Wassily Kandinsky (1866–1944), Piet Mondrian (1872–1944) and Kazimir Malevich (1879–1935).[21] It is revealing to see how resistant the art world has been to accepting an artist who did not fit seamlessly into the already delineated history of art, as if this history is immutable or hadn't been written by historians and couldn't be augmented or rewritten.

As has been discussed in the film *Who the #$&% Is Jackson Pollock?* (2006), the art market has even been resistant to acknowledging previously unrecognized or unaccounted for works of canonized artists, exemplifying how conservative scholars of the radical and avant-garde can be. Of course, there have been arguments made that there is a financial component involved in the resistance to these works, as the addition of a previously unaccounted-for work of Jackson Pollock (1912–1956), for example, to the market could potentially devalue the pieces already in the hands of collectors. Then we also must contend with the utter shock and disbelief that such a valuable work of art could be found in a thrift store among everyday artifacts and the work of less revered "folk" or "outsider" artists, but that is a discussion outside of the realm of this study. Here, the focus is on humanity's resistance to altering narratives, even though we are the ones who have written these narratives. Whether on an individual level, within our own psyche, interpersonal relationships, family dynamics or society at large, there is a resistance to changing course; but of course, we must – and do – all the time. We rewrite history every time a new scientific discovery is made. People seem to forget that science is created from theories: theories the human mind invents via creative speculation. These theories become hypotheses, which are tested to see if they stand fast in the face of rigorous repetition. But as we continue to see over and over again throughout this study, the initial reaction to innovation, progress or alteration of a current theory, method, model or worldview is almost always resistance. The knee-jerk reaction is pushback – internally,

from individuals, as well as from the horde – in an attempt to keep things as they are and maintain the status quo, although in reality things are actually changing all the time.

We see this quite often today as the histories of many fields, and perhaps even history itself – at least in the West – is being viewed with more perspectives: rewritten, in a sense. Historically, one dominant point of view has attempted to control the narrative by sheer force and violence, presenting itself as *the* worldview and forcing the rest of us to accept this as truth, when in fact this is not the truth at all; this narrative has been written by a relative few. With the tools and technology we have at our fingertips today, individuals and groups who have historically been silenced – with perspectives that have historically been "othered" – have come together and come to the fore.

Notes

1 Zaczek, I. (2018) *A Chronology of Art: A timeline of Western culture from prehistory to the present.* London: Thames & Hudson. pp. 184–185.
2 Taggart, E. (2018) "Meet William Morris: The Most Celebrated Designer of the Arts and Crafts Movement" [Online]. My Modern Met. Available at https://mymodernmet.com/arts-and-crafts-movement-william-morris/ (Accessed: November 16, 2019).
3 Victoria and Albert Museum. (2018) "William Morris and wallpaper design" [Online]. Victoria and Albert Museum. Available at: www.vam.ac.uk/articles/william-morris-and-wallpaper-design (Accessed: November 17, 2019).
4 Munch Museet. (no date) "Experience the art of Edvard Munch" [Online]. Munch Museet, Oslo, Norway. Available at: https://munchmuseet.no (Accessed: August 18, 2019).
5 Freud, S. (1914) "Remembering, repeating and working-through (further recommendations on the technique of psycho-analysis II)." *SE* XII. London: Hogarth Press. p. 150.
6 The Poetry Foundation. (2007) "Charles Baudelaire" [Online]. The Poetry Foundation. Available at: www.poetryfoundation.org/poets/charles-baudelaire (Accessed: August 17, 2019).
7 Van Gogh Gallery. (2008) "Vincent van Gogh Paintings" [Online]. Van Gogh Gallery. Available at: www.vangoghgallery.com/painting/ (Accessed: November 20, 2019).
8 Van Gogh Museum. (2009) "Vincent van Gogh: The Letters" [Online]. Van Gogh Museum. Available at: http://vangoghletters.org/vg/letters.html (Accessed: November 18, 2019).

9 Biographical information comes from Steiner, R. (2017) *Egon Schiele (1890–1918): The midnight soul of the artist.* Cologne: Taschen. pp. 22–25.
10 Zaczek, I. (2018) *A Chronology of Art: A timeline of Western culture from prehistory to the present.* London: Thames & Hudson. p. 218.
11 Tate. (2014) "Fauvism – Art Term" [Online]. Tate. Available at: www.tate.org.uk/art/art-terms/f/fauvism (Accessed: February 4, 2020).
12 MoMA. (2014) "Henri Matisse: The Cut-Outs" [Online]. The Museum of Modern Art. Available at: www.moma.org/calendar/exhibitions/1429 (Accessed: November 24, 2019).
13 Spurling, H. (2014) "Henri Matisse: drawing with scissors" [Online]. The Guardian. Available at: www.theguardian.com/artanddesign/2014/mar/29/henri-matisse-cutouts-tate-modern-drawing-scissors (Accessed: November 24, 2019).
14 MoMA. (2014) "Henri Matisse: The Cut-Outs" [Online]. The Museum of Modern Art. Available at: www.moma.org/calendar/exhibitions/1429 (Accessed: November 24, 2019).
15 Biographical information from "Introduction" to Burgin, C. (2018). *Hilma af Klint: Notes and Methods.* Chicago: The University of Chicago Press. pp. 7–8.
16 Fiore, J. (2018) "How the Swedish Mystic Hilma af Klint Invented Abstract Art" [Online]. Artsy. Available at: www.artsy.net/article/artsy-editorial-swedish-mystic-hilma-af-klint-invented-abstract-art (Accessed: August 19, 2019).
17 Ferren, A. (2019) "In Search of Hilma af Klint, Who Upended Art History, But Left Few Traces" [Online]. The New York Times. Available at: www.nytimes.com/2019/10/21/travel/stockholm-hilma-af-klint.html (Accessed: November 25, 2019).
18 Armstrong, A. (2019) "Guggenheim's Hilma af Klint Survey Is Most Popular Show in Its History" [Online]. ArtNews. Available at: www.artnews.com/2019/04/18/guggenheims-hilma-af-klint-survey-is-most-popular-show-in-its-history/ (Accessed: August 19, 2019).
19 Kellaway, K. (2016) "Hilma af Klint, a painter possessed" [Online]. The Guardian. Available at: www.theguardian.com/artanddesign/2016/feb/21/hilma-af-klint-occult-spiritualism-abstract-serpentine-gallery (Accessed: August 19, 2019).
20 Kellaway, K. (2016) "Hilma af Klint, a painter possessed" [Online]. The Guardian. Available at: www.theguardian.com/artanddesign/2016/feb/21/hilma-af-klint-occult-spiritualism-abstract-serpentine-gallery (Accessed: August 19, 2019).
21 Fiore, J. (2018) "How the Swedish Mystic Hilma af Klint Invented Abstract Art" [Online]. Artsy. Available at: www.artsy.net/article/artsy-editorial-swedish-mystic-hilma-af-klint-invented-abstract-art (Accessed: August 19, 2019).

Bibliography

Baudelaire, C. (1969) *Intimate Journals.* Translated by C. Isherwood. London: Panther Books.
Benjamin, W. (1997) *Charles Baudelaire: A lyric poet in the era of high capitalism.* London: Verso.
Benjamin, W. (2006) *The Writer of Modern Life: Essays on Charles Baudelaire.* Cambridge: Belknap Press of Harvard University Press.
Birnbaum, D. & Noring, A. (eds.) (2013) *The Legacy of Hilma af Klint: Nine contemporary responses.* London: Koenig Books.
Burgin, C. (2018) *Hilma af Klint: Notes and methods.* Chicago: The University of Chicago Press.
Deleuze, G. (1994) *Difference and Repetition.* Translated by P. Patton. New York: Columbia University Press.
Falck, U. (2018) *With Eyes Closed: Gauguin and Munch.* Oslo: Munch Museum.
Fombeure, M. (1956) *Les Fleurs du Mal du Charles Baudelaire.* Paris: Le livre club du libraire.
Foye, R. (ed.) (1980) *The Unknown Poe: An anthology of fugitive writings by Edgar Allan Poe, with appreciations by Charles Baudelaire, Stéphane Mallarmé, Paul Valéry, J.K. Huysmans and André Breton.* San Francisco: City Lights Books.
Freud, S. (1914a) "Remembering, repeating and working-through (further recommendations on the technique of psycho-analysis II)." *The Complete Standard Edition of the Psychological Works of Sigmund Freud (SE)* XII. London: Hogarth Press. pp. 145–156.
Freud, S. (1914b) "The Moses of Michelangelo." *SE* XIII. London: Hogarth Press. pp. 211–236.
Freud, S. (1919) *The Uncanny. SE* XVII. London: Hogarth Press. pp. 217–258.
Freud, S. (1920) "Beyond the pleasure principle." *SE* XVIII. London: Hogarth Press. pp. 1–64.
Freud, S. (1926) *Inhibitions, Symptoms and Anxiety. SE* XX. London: Hogarth Press. pp. 75–176.
Friedman, S. (2014) *Henri Matisse: The cut-outs.* New York: Museum of Modern Art.
Gaillemin, J-L. (2006) *Egon Schiele: The egoist.* Translated by L. Nash. London: Thames & Hudson.
Hagman, G. (2010) *The Artist's Mind: A psychoanalytic perspective on creativity, modern art and modern artists.* London: Routledge.
Janson, L., Luijten, H. & Bakker, N. (eds.) (2009) *Vincent van Gogh: The letters. The complete illustrated and annotated edition.* London: Thames & Hudson.
Kierkegaard, S. (2009) *Repetition* and *Philosophical Crumbs.* Oxford: Oxford University Press.

Lacan, J. (1978) *The Four Fundamental Concepts of Psycho-analysis*. Translated by A. Sheridan. New York: W.W. Norton & Co.

Laplanche, J. & Pontalis, J-B. (1973) *The Language of Psycho-analysis*. Translated by D. Nicholson-Smith. New York: W.W. Norton & Co.

Lindén, G. (1998) *I Describe the Way and Meanwhile I am Proceeding Along It: A short introduction on method and intention in Hilma af Klint's work from an esoteric perspective*. Stockholm: Rosengårdens Förlag.

Marx, K. & Engels, F. (1848/2015) *The Communist Manifesto*. London: Penguin Classics.

Néret, G. (2006) *Henri Matisse*. Cologne: Taschen.

Nietzsche, F. (1974) *The Gay Science*. New York: Random House.

Nietzsche, F. (1978) *Thus Spoke Zarathustra*. London: Penguin Classics.

Poe, E.A. (1970) *Tales, Poems, Essays*. London: Collins.

Poe, E.A. (1997) *Spirits of the Dead: Tales and poems*. London: Penguin Books.

Rimbaud, A. (2008) *Complete Works*. Translated by P. Schmidt. New York: HarperCollins Publishers.

Rimbaud, A. (2011) *A Season in Hell*. New York: New Directions.

Silverman, K. (1992) *Edgar A. Poe: Mournful and never-ending remembrance*. London: Weidenfeld & Nicolson.

Sinclair, V.R. & Lambrecht, I. (2016) "Ritual and psychoanalytic spaces as transitional, featuring Sangoma trance states." In Abrahamsson, C. (ed.) *The Fenris Wolf*, vol. 8. Stockholm: Trapart Books. pp. 281–289.

Steiner, R. (2017) *Egon Schiele (1890–1918): The midnight soul of the artist*. Cologne: Taschen.

Tomkins, C. (1996) *Duchamp: A biography*. New York: Henry Holt & Co.

Zaczek, I. (2018) *A Chronology of Art: A timeline of Western culture from prehistory to the present*. London: Thames & Hudson.

Zupančič, A. (2008) *The Odd One In: On comedy*. Cambridge: The MIT Press.

Filmography

Who the #$&% Is Jackson Pollock? (2006) Harry Moses (dir.). USA: Hewitt Group & New Line Cinema.

Part II

Unleashing the unconscious

Part II

Unleashing the Unconscious

Chapter 3

The art of noise

In the early 20th century, cubism was all the rage. This revolutionary new style was developed in Paris by Georges Braque (1882–1963) and Pablo Picasso (1881–1973) in the years preceding the First World War. Undermining the use of perspective, subjects were fragmented, broken down into various forms, with differing sides being portrayed simultaneously. Cubism rejected the need for a single, fixed viewpoint, which had been a lynchpin of Western art since the Renaissance (Zaczek, 2018, p. 219).

Futurism built upon this perspective by adding the dimension of movement, using fractured forms to convey a sense of speed, elaborating the power and dynamism of the modern technological era, often focusing on modern technological marvels such as the automobile and even automated weaponry. Fascinated by the experiments of early photographic pioneers like Eadweard Muybridge and Étienne-Jules Marey (1830–1904), whose work showed the breakdown of movement into slices of time, futurists formulated a way to convey speed and movement in their paintings (Zaczek, 2018, p. 199). Italian futurist painter Umberto Boccioni (1882–1916) described the modern artist as capable of painting not only the visible but that which until now was held to be invisible (Chessa, 2012, p. 31).

Though similar in aesthetic and style, the futurist movement couldn't be further from the cubists philosophically. While the cubists tended to be concerned with exploration of the world around them via contemplation of their interior selves, the futurists were proud, loud and brash, celebrating violence, technology and even war. Futurism was a movement animated by contradictory ideas, constantly oscillating between science and art, the rational and irrational, past and future, mechanical and spiritual. It

may have been these very tendencies and frictions that gave futurism its dynamic force.[1]

At the heart of the Italian futurist movement were the manifestos of protagonist Filippo Marinetti (1876–1944). Rather than resisting the deterioration of civilization at a time ripe with strife, war, conflict and chaos, Marinetti seemed to lean into it, diving into the irrational, lauding the inherent fragmentation and destruction, *body-madness*, as he called it:

> Futurism wants to transform the Variety Theater into a theater of amazement, record-setting, and body-madness. One must completely destroy all logic in Variety Theater performances, exaggerate their luxuriousness in strange ways, multiply contrasts, and make the absurd and the unlifelike complete masters of the stage.
>
> (Flint, 1972, p. 120)

This passage, written in 1913, pre-dates the Dadaists and is clearly a precursor, setting the stage for the kind of riotous variety theater for which the Dadaists became known. The automatic writing style, manifestos and declarations of the futurists were adopted by the Dadaists and later by the surrealists. In his *Manifesto of Futurist Musicians* (1910), Francesco Balilla Pratella (1880–1955) declared:

> Futurism, the rebellion of the life of intuition and feeling, quivering and impetuous spring, declares inexorable war on doctrines, individuals and works that repeat, prolong or exalt the past at the expense of the future.
>
> (Black, 2012, p. 28)

Around the same time that the futurists decreed their manifestos, psychoanalysis was taking root. In 1902, Sigmund Freud began his weekly meetings of what would be the precursor to his psychoanalytic society. Meetings of the Wednesday Psychological Society were held at Freud's home office in Vienna with a handful of colleagues who were interested in the burgeoning field of psychoanalysis. By 1908, the first formal psychoanalytic organization had solidified, and the Vienna Psychoanalytic Society was founded.

The relationship between Freud and Swiss physician Carl Gustav Jung (1875–1961) initially began in 1906 when Jung sent Freud his book

Diagnostic Association Studies, in which he frequently cited Freud's theories. Jung worked with Eugen Bleuler (1857–1939) at the Sanatorium Burghölzli in Zürich, which had a reputation for being quite progressive. Jung read Freud's *The Interpretation of Dreams* (1900) the same year he arrived at the Burghölzli. From that point forward, Jung attempted to integrate Freud's concepts into his own work, and also presented these teachings to Bleuler. Jung praised Freud's work highly, citing *Fragment of an Analysis of a Case of Hysteria* (1905) in his *Psychoanalysis and Association Experiments* (1906), and noting his admiration for Freud and his theories in the foreword of *The Psychology of Dementia Praecox* (1906). Reciprocally, Freud "unreservedly acknowledged the services rendered to the spread of psychoanalysis by the Zürich School, 'particularly by Bleuler and Jung'" (McGuire, 1974, pp. xvi-xvii).

Soon after, members of the Zürich Burghölzli began to regularly visit the Wednesday Psychological Society in Vienna, resulting in a fruitful exchange of ideas. It is said that when Freud and Jung first met in person they talked uninterruptedly for 13 hours.[2] Freud and Jung engaged in a passionate and productive collaboration; their correspondence continued for over seven years, as they wrote to each other every few days with only occasional gaps due to illness or holidays. In 1909, the pair traveled to the United States with Hungarian psychoanalyst Sandor Ferenczi (1873–1933) to speak at Clark University on invitation from G. Stanley Hall (1844–1924); this event marked Freud's first and only venture to the Americas.

During this period, psychoanalysis rapidly spread across Europe and North America, with societies forming in Berlin and Zürich (1910), New York and Munich (1911), and London and Budapest (1913). The International Psychoanalytical Association (IPA) was established in 1910, with Freud appointing Jung as the first president. Eventually, Freud and Jung's impassioned relationship ran its course, and Jung resigned from his position as president of the IPA in 1914, their relationship ending just as the Great War was beginning. Yet even following his split with Jung, Freud continued to recognize the important contribution his colleagues in Zürich made to the field of psychoanalysis, as Zürich was the first place outside of Vienna where Freud's theories really began to take hold.

During this same time period, Italian futurist Luigi Russolo (1885–1947) was developing his own manifesto, *The Art of Noises* (1913), which musicologist Luciano Chessa (b. 1971) explores in depth in his

book *Luigi Russolo, Futurist: Noise, Visual Arts, and the Occult* (2012). As the son of watchmaker and organist Domenico Russolo (1847–1907), Luigi continued in his father's footsteps. The professions of watch- and clockmaking, combined with the skills of building and tuning pianos and organs, left Russolo with a passion for sophisticated mechanisms, levers and cogwheels, as well as with knowledge of the mechanical principles of keyboards and instruments. All of this provided fertile seed for Russolo's development, and combined to have significant influence on his artistic and musical endeavors as part of the futurist movement. Russolo's ideas have marked a crucial moment in the evolution of 20th-century musical aesthetics. He is generally considered to be the father of the first systematic poetics of noise and, by some, as the inventor of the synthesizer.

The same year Russolo published *The Art of Noises* (1913), he developed and realized his theories via the construction of his *intonarumori* or "noise intoners." Compositions written for the *intonarumori* were called *reti di rumori* or "networks of noises" and later *spirali di rumori* or "spirals of noises," among them *Risveglio di una città*, "Awakening of a City" (Chessa, 2012, p. 137). The first public concert of the *intonarumori* took place on April 21, 1914, at the Teatro Dal Verme. A negative review questioning the artistic merit of Russolo's instrument was among the press coverage, the critic claiming that the imitation of natural noise was simply a regression and not an artistic endeavor. Russolo rejected this sentiment, proclaiming his *intonarumori* the result of long, laborious and fruitful studies into the substance of sound based on scientific and mathematical principles. Russolo was so incensed that he slapped the critic, who was also a Catholic deputy, in public and was subsequently charged with assault, having to go to trial. Russolo declared that he felt his artistic reputation was at stake, and was intent on defending both his personal and professional character (Chessa, 2012, p. 133).

As mentioned, each change of course, challenge to the dominant narrative, disruption or scansion is initially met with defense. Psychic defenses hold their ground, individuals strike back, crowds become unruly. In psychoanalytic terms, this initial defense is known as *resistance* – resistance to treatment, resistance to change. This initial reaction to disruption is understandable: as the status quo is being challenged, defenses push back. By interrupting the social discourse or internal dialogue we have been wedded to up until this point, scansion interrupts and lays bare the narrative we have been relating to ourselves and those around us. The narrative

society had agreed upon has suddenly been put into question; even though it may be dissonant, one has struck a chord. In this way, these artists fulfill a function in society: challenging the status quo, holding up a mirror, and disrupting the rhythm of the day-to-day.

When World War I erupted, many of the futurists were enlisted. Marinetti noted that when they were all at the front lines of the war, while soldiers were busy preparing dinners, lighting fires or taking turns drawing water, "Russolo was studying the noises of the war and drawing from them improvements for his *intonarumori*" (Chessa, 2012, p. 114). While in the field, Russolo suffered a blow to the head due to the explosion of a grenade. His friend and fellow futurist, Paolo Buzzi (1874–1956), wrote of Russolo:

> Wherever he passed [...] there was a burst of sparks which resembled a halo [...] his brain added to it the aureole of ingenious scintillations [...] the thin, electric Russolo living in our plane, who painted blue concentric atmospheres of music using elusive flashes of the paintbrush and conducted orchestras of intonarumori in theaters worldwide.[3]

Unfortunately, none of the *intonarumori* escaped the bombs of the war and a fragment of seven bars is all that remains of Russolo's original scores. However, Russolo did outline his theories and ideas regarding the development of his noise organs and music in his manifesto *The Art of Noises* (1913). His work has influenced countless experimental and avant-garde musicians over the past century, including Edgard Varèse (1883–1965), Pierre Schaeffer (1910–1995) and John Cage (1912–1992). Modern art also had its musical counterpart in the dissolution of conventional harmonic structures in the revolutionary work of composers such as Claude Debussy (1862–1918), Igor Stravinsky (1882–1971) and Jean Dubuffet (1901–1985).

Another essential and distinct scansion within the Western musical mind frame was the emergence of *jazz*. Following the American Civil War (1861–1865), a slow process of integration began. Out of slavery and into citizenship emerged new communities of African Americans in which distinct cultural identities and innovations became paramount to progress and liberation. Music had been instrumental for the survival of the African spirit throughout many harrowing generations of enslavement, and now this spirit could move more freely in (relatively) unrestricted ways. This

movement was reflected and embodied in a new musical expression: jazz. Jumping off from standard Western instrumentation and arrangements, ragtime and blues, jazz quickly made a cut that allowed for the emergence of something new. Jazz music stressed not only the beats of the rhythm but to an equal degree the pauses and disruptions, thus stressing syncopations and encouraging the audience to dance and move the body. Despite initially being met with resistance – receiving typical, racist criticisms describing it as a "lower" art form that was "primitive" and too "sexual" – with the help of radio, jazz music soon spread like wildfire over the Western world, and has since cross-pollinated with many other forms of music, including itself.

Jazz has also had its fair share of internal scansions as the art form has evolved. Encompassing everything from dance-oriented, big band-based, vocal manifestations to highly personalized expressions and aesthetic interpretations of rhythm and harmony – as in *bebop* – the evolution of jazz music and its impact on the broader cultural landscape reflects a huge sociocultural shift and played an important part in shaking up the stagnant and repressive American mind frame of the mid-20th century, together with other radical manifestations like the civil rights movement, women's liberation, peace protests, beatniks, hippies and psychedelic drugs, as well as other similar reactions to oppression and inertia. Often stressing that bebop, for instance, made "no sense," critics argued that it was an "anti-music," against beauty and harmony, in much the same way the German Nazis ridiculed and demonized modern artworks – as well as Freudian psychoanalysis – as being *entartete* ("derailed" or "degenerate").

A discussion of the deconstruction of the musical, especially with regards to the cut and the space it provides for creation and a new sense of perception, would not be complete without mention of John Cage's *4'33"* (1952).[4] In this performance piece, Cage took the stage and refrained from playing for 4 minutes and 33 seconds. The stated intention of this piece is not that it is composed of 4 minutes and 33 seconds of silence, but rather that the audience is meant to listen to the sounds present in the room for the allotted duration of time. This shift in perspective brings a new awareness to the sounds of the everyday, as we turn our attention to the sounds of our environment: that which we typically fail to lend our attention, or otherwise neglect, block out or ignore as we go about our daily routines.

In the mid-1970s, British avant-garde, experimental music group Throbbing Gristle came onto the scene. Originally meant as a complement

or side project to the work of the performance art collective COUM Transmissions, the group performed as part of the opening party for COUM's exhibition *Prostitution* (1976) at the Institute of Contemporary Arts (ICA), London. Though they had not been trained as musicians, the artists took up instruments and performed their rendition of noise. When introducing the group's first musical performance, ringleader Genesis P-Orridge (1950–2020) announced:

> Tonight we're going to do a one hour set called *Music from the Death Factory*. It's basically about the post-breakdown of civilisation. You know, you walk down the street and there's a lot of ruined factories and bits of old newspaper with stories about pornography and page three pin-ups, blowing down the street, and you turn a corner past the dead dog and you see old dustbins. And then over the ruined factory there's a funny noise.
>
> (Ford, 1999, p. 6.28)

Throbbing Gristle was that "funny noise," capturing the essence of just such a scene, and in so doing reflecting an era. The tongue-in-cheek moniker soon became the driving force for this group of performance artists, who in time would become known as pioneers of *industrial* music. Consisting of P-Orridge, Peter Christopherson (1955–2010), Cosey Fanni Tutti (b. 1951) and Chris Carter (b. 1953), the group was one of the first to utilize sampling techniques and tape delays, cutting, repeating and distorting sound in previously unheard-of ways. Inspired by the cut-up method and tape experiments of Brion Gysin (1916–1986) and William S. Burroughs (1914–1997) – to be discussed in depth further on in this study – the members of Throbbing Gristle experimented with a range of sounds, always in an unconventional manner. Perhaps because this "band" formed out of a performance art collective, the medium of sound was approached with artistic experimentation in mind rather than with a traditional musical sensibility.

Although it ran for just eight days, their *Prostitution* exhibition caused such a stir in British popular media that the group was (in)famously declared "The Wreckers of Civilisation,"[5] causing P-Orridge to instantly become a household name. The intense and immediate notoriety of the group fanned the flame of an already burgeoning experimental music scene sweeping across the United Kingdom.

The late 1970s and early 1980s were rife with avant-garde experimentation. Upon the dissolution of Throbbing Gristle in 1981, Christopherson and P-Orridge went on to found the group Psychick Television (Psychic TV/PTV) focusing on experimentations in the new and burgeoning field of videotape, while continuing to work with audiotape manipulation and effects. In *Thee Splinter Test* (2010), P-Orridge describes the use of sampling in music in much the same way we think of the signifier, describing how this sample – this slice of information, a moment cut from sound – carries with it all of the associations, encyclopedic information, memory and previous experiences that have ever encountered it. In this way, P-Orridge posits that when the artist chooses a sample of music to integrate into their own productions – whether the chosen sample is picked with carefully thought-out intention or by chance – the audio sample, or slice of musical time, contains within it a plethora of information that is then imparted, consciously or unconsciously, to the listening audience. In other words, the encounter the audience then has with the sample will have an effect; this effect could be the triggering of a series of unconscious or conscious associations in the listener, bringing up memories, fragments of dreams or other unconscious material. Taking this a step further, P-Orridge encourages musicians to consider what type of information they are sampling – and thereby putting into their work and sending out into the world – and with this in mind, pause to think about what kind of effect they would like to have on society.

Following his work with Throbbing Gristle and Psychick Television, Peter Christopherson went on to form experimental industrial outfit Coil with fellow PTV member Jhonn Balance (b. Geoffrey Rushton, 1962–2004). As Coil, Christopherson and Balance continued on in this vein of experimentation and exploration, often working in an automatic, associative fashion, incorporating found sounds, chance occurrences, musical accidents and unintended alterations, encouraging the integration of synchronous or happenstance events, and often creating their musical compositions in a ritualistic manner.

In 1978, British artist Stephen Stapleton (b. 1957) formed the group Nurse With Wound (NWW). Experimenting with layering, tape loops, found sounds, field recordings, distortions and sampling, the debut album was called *Chance Meeting on a Dissecting Table of a Sewing Machine and an Umbrella* (1979). Bearing the dedication, "This album is dedicated to Luigi Russolo," Stapleton pulled the idiosyncratic title from a novel

lauded by the surrealists, the long-form prose poem *The Songs of Maldoror* by Isidore Ducasse (1846–1870), written under his pen name Comte de Lautréamont. Stapleton has described NWW as surrealist music, growing "increasingly abstract, displacing 'ordinary' sounds – radio play snippets, detourned lounge music, the klang of metal on metal – into extraordinary situations" (Keenan, 2016, p. 68). These groups of underground artists working in the UK from the late 1970s through the 1990s became known as "England's Hidden Reverse,"[6] and have had a lasting impact on recent generations of artists and musicians.

Noise music has become a genre of its own, with countless iterations and just as many interpretations.

> When I talk about the crowded spaces of info-modernity – I'm talking about a world filled with noise, and if there's one thing we learned from the twentieth century, it's this: noise is just another form of information.
>
> (Miller, 2008, p. 6)

Experimentation and an "anything goes" attitude seem to be at the heart of the scene. Some encourage harsh effects for their own sake, but the elements that concern this current study are those that incorporate chance, association, improvisation, interruption, disruption and discordance: that which pulls the listener out of the routine of linear narrative, and momentarily into a state of suspension, before being dropped back into the rhythm of the flow.

A musical outfit exemplifying this technique is British artist Richard D. James (b. 1971), also known as Aphex Twin. The music of Aphex Twin became prominent in the 1990s during the flood of electronic music that poured onto the scene at that time, as once again technology developed – making computers, synthesizers and other electronic devices and software more affordable, portable and user-friendly. James's style and sound is immediately recognizable, incorporating disturbing and disjointed elements into the more conventional, percussion-driven style of electronic dance music, bringing the listener or dancer to a screeching halt as the rhythm is disrupted, throwing the audience off-course, and out of the expected. This signature sound also developed into its own genre, becoming known as *intelligent dance music* or IDM.[7]

Contemporary American composer John Zorn (b. 1953) has also been breaking the boundaries of music for decades. With influences ranging

from classical, jazz and pop to experimental, improv and hardcore, Zorn's work is as varied as can be, even making a point to break barriers of the expected with regard to time, place, setting and situation. In 2013, Zorn celebrated his 60th birthday by organizing a host of performances across not only New York City[8] but the world,[9] choosing venues as diverse as his compositions. As part of this extravaganza, Zorn took over the Metropolitan Museum of Art for a day in an unprecedented event: every hour on the hour a musical artist or group performed one of Zorn's compositions in different gallery of the museum. Events began with the *Opening Antiphonal Fanfare for Six Trumpets* in the Great Hall in the morning and ended with Zorn performing his *Hermetic Organ* on Thomas Appleton's (1785–1872) pipe organ at closing time. As part of the event, American vocalist Mike Patton (b. 1968) executed a solo piece from *Six Litanies for Heliogabalus* at the Temple of Dendur; Erik Friedlander (b. 1960) performed works from *Masada: Book of Angels* on cello in the gallery for Assyrian Art; female vocalists extolled *The Holy Visions* in the Medieval Sculpture Hall; and an improvisational duet between Zorn on alto saxophone and Milford Graves (b. 1941) on drums took place in the abstract expressionism gallery, appropriately perched in front of Jackson Pollock's *Autumn Rhythm (No. 30)*. The setting alone for these events was a disruption from the usual that placed the audience in a different relation to the music being performed. Rather than the typical performer-audience agreement entered into upon choosing to attend a concert, many visitors to the Met that day had no previous knowledge of Zorn or his works and walked into a chance encounter with arguably some of the most avant-garde and potentially disorienting music of our times.

The solo piece Patton performed relied completely on sounds created by his own body and voice; void of intelligible words or language, no instruments or effects of any kind were utilized. Sounds of vomiting, spitting, coughing, singing, screaming, screeching and sneezing rang out throughout the halls of the museum galleries. Though at first this piece may seem to be an improvisation on the part of the vocalist, in actual fact, it is stringently composed. On closer view, one can see Patton reading from sheet music, turning each page as he startles, screams and gags his way through the performance.

As Russolo set out to capture the noises of the city a century earlier, Zorn and Patton also harness sounds one does not usually associate with music – those that may typically be experienced as harsh, grotesque or

otherwise unappealing – and incorporate them into their own type of music. In this way, this work may be seen as a quite direct extension of Russolo's original noise productions and a further iteration of his goals.

Another in the series of events, Zorn unleashed a cacophony of sound in *The Complete String Quartets* at Lincoln Center. Highlighting the disruption of sharp aural movement, these pieces dislocate the senses, as they disturb the usual flow of harmony and rhythm, short-circuiting the typical in exchange for a heightened awareness of environment and expectations, thereby forcing the audience to remain attentive to each note and every movement, as supposition is disrupted and one is not comforted with the ability to predict what comes next.

Pauline Oliveros (1932–2016), American composer and pioneer of postwar experimental electronic music, once wrote:

> The creativity that emerges through improvisation carries new combinations and possibilities that are now expanding and extending throughout the world […] opening new doors for masses of people.
> (Oliveros, 2008, p. 293)

Oliveros felt that the genre of *world music* is ever evolving, as diverse cultures come together in a multitude of ways. She described the current era as an exciting time for music, as artists have the ability to travel more easily and readily than ever before, further facilitating possible collaborations with one another, as well as the potential to encounter a variety of cultures, traditions and worldviews, all of which can be sources of inspiration. Nowadays, it is not even necessary to physically travel, as musicians have the ability to work together online with colleagues on the other side of the globe; this provides even more opportunity for collaboration with many more potential creative partners than ever before:

> There is no need for musicians to speak the same language. They only need listen to one another giving and receiving sound. Their encounter with different tunings and styles can be negotiations for reconciliations of differences.
> (Oliveros, 2008, p. 294)

Today's technology takes this notion yet another step further, as creative collaborations may take place across the globe *in real time*. In 2010, for

example, the United Nations hosted an event entitled *ResoNations: An International Telematic Music Concert for Peace*[10] in which world-renowned musicians from across the globe – located in New York, Beijing and Seoul – performed live together in real time using the internet and innovations in music technology.

There is an entire field devoted to the art of sampling, remixing and editing together found sounds and clips cut from other pieces of music, fittingly called *remix*. The history of sampling, remixing and mashing-up, especially in hip-hop and DJ culture, is fascinating and contains a world of philosophies and ethics all its own. Remix puts us on a path to a host of other questions, possibilities and potential avenues of exploration – too much to begin to dive into here, especially as the history, breadth and depth of remix has been explored extensively and laid out beautifully in the seminal work *Sound Unbound: Sampling in Digital Music and Culture* (2008) edited by American composer and multimedia artist Paul D. Miller (b. 1970), also known as DJ Spooky, That Subliminal Kid.

American media professor, author and musician Aram Sinnreich (b. 1972) specifically studies the phenomenon of the mash-up in depth in his book *Mashed Up: Music, Technology and the Rise of Configurable Culture* (2010). He states:

> Postmodernism has not only successfully exposed and disrupted the hidden power dynamics of the master narrative, but produced a cultural environment in which an endless parade of symbols float unmoored in a sea of chaos and contradiction. The role of the mashup is to restore some semblance of order to this maelstrom, by stitching together the disparate symbols with a genealogical thread. Every sample in a mashup means something, and brings its entire cultural history trailing behind it. Thus, while the *cut*-up is named for its ability to sever signifier from signified, the *mash*up is named for its power to suture them back together (albeit in different combinations and permutations).[11]

Further resources are David Gunkel's (b. 1963) *Of Remixology: Ethics and Aesthetics after Remix* (2016), Eduardo Navas's (b. 1969) *Remix Theory: The Aesthetics of Sampling* (2012) and Mark Amerika's (b. 1960) *Remixthebook* (2011). Amerika proclaims:

The digital moment in which we live is continuously shifting. Digital technology has transformed contemporary culture. We need to explore the mashup as defining cultural activity in the digital age. The remix: an art form and literary intervention.[12]

Remix opens wide the door to exploration of philosophy and ethics in our digital age, as we have cut up, mashed and re-hashed our culture in so many ways and forms that nowadays it is oftentimes hardly even possible (or some would argue, necessary) to discern what has been remixed from what (if anything) has not. This brings questions of authorship, ownership and authority to the fore, reminiscent of the cut-ups of the Beats, which we will go into more in depth a bit later. In *The Third Mind,* William S. Burroughs stated:

> People say to me, "Oh, this is all very good, but you got it by cutting it up." I say that has nothing to do with it, how I got it. What is any writing but a cut-up?
>
> (Burroughs & Gysin, 1978, p. 8)

Remix takes this notion and expands it even further, sprawling out from the literary realm, poetry and language to cover all aspects of media and digital culture:

> After all, it's all just data. Map one metaphor onto the other, remix and press play. The sampling machine can handle any sound, any expression. You just have to find the right edit.
>
> (Miller, 2008, p. 6)

Notes

1 Much of the information regarding the Italian futurist movement in general and the work of Luigi Russolo in particular is from Chessa, L. (2012) *Luigi Russolo, Futurist: Noise, visual arts, and the occult.* University of California Press.
2 McGuire, W. (1974) *The Freud/Jung Letters: The correspondence between Sigmund Freud and C.G. Jung.* Abridged edition. Princeton: Princeton University Press.
3 Chessa, L. (2012) *Luigi Russolo, Futurist: Noise, visual arts, and the occult.* University of California Press. p. 210.

4 John Cage Trust (no date) "John Cage Complete Works: 4′33″" [Online]. John Cage Trust. Available at www.johncage.org/pp/John-Cage-Work-Detail.cfm?work_ID=17 (Accessed: December 1, 2019).
5 Ford, S. (1999) *Wreckers of Civilisation: The story of COUM Transmissions and Throbbing Gristle*. London: Black Dog Publishing.
6 Keenan, D. (2003/2016) *England's Hidden Reverse: A secret history of the esoteric underground – Coil, Current 93, Nurse with Wound*. London: Strange Attractor Press.
7 Cardew, B. (2017) "Machines of loving grace: how *Artificial Intelligence* helped techno grow up" [Online]. The Guardian. Available at www.theguardian.com/music/2017/jul/03/artificial-intelligence-compilation-album-warp-records-idm-intelligent-dance-music (Accessed: November 30, 2019).
8 BWW News Desk. (2013) "Zorn@60 Kicks Off John Zorn's 60th Birthday Celebrations in NYC Today" [Online]. Broadway World. Available at www.broadwayworld.com/article/Zorn60-to-Kick-Off-John-Zorns-60th-Birthday-Celebrations-in-NYC-Today-20130607 (Accessed: November 30, 2019).
9 The Wire. (2013) "John Zorn's 60th birthday celebrations continue in London, with Mike Patton, Marc Ribot, Trevor Dunn in tow" [Online]. The Wire. Available at www.thewire.co.uk/news/23981/john-zorn_s-60th-celebrations-continue-in-london (Accessed: December 1, 2019).
10 United Nations. (2010) "ResoNations" [Online]. United Nations WebTV. Available at http://webtv.un.org/en/ga/watch/resonations-2010-an-international-telematic-music-concert-for-peace/5240597314001/ (Accessed: August 19, 2019).
11 Sinnreich, A. (2011) "Remixing Girl Talk: The Poetics and Aesthetics of Mashups" [Online]. Sounding Out! Available at https://soundstudiesblog.com/2011/05/02/remixing-girl-talk-the-poetics-and-aesthetics-of-mashups/ (Accessed: February 26, 2020).
12 Amerika, M. (2012) Remixthebook. Available at www.remixthebook.com (Accessed: February 4, 2020).

Bibliography

Amerika, M. (2011) *Remixthebook*. Minneapolis: University of Minnesota Press.
Bailey, T. (2009) *Micro-Bionic: Radical electronic music and sound art in the 21st century*. Creation Books.
Black, C. (ed.) (2012) *The Art of Noise: Destruction of music by futurist machines*. London: Sun Vision Press.
Breyer P-Orridge, G. (2010) "Thee Splinter Test." In Zorn, J. (ed.) *Arcana V: Music, magic and mysticism*. New York: Hips Road. pp. 297–313.

Burroughs, W.S. & Gysin, B. (1978) *The Third Mind*. New York: Viking Press.

Chessa, L. (2012) *Luigi Russolo, Futurist: Noise, visual arts, and the occult*. University of California Press.

Flint, R.W. (ed.) (1972) *Marinetti: Selected writings*. London: Martin Secker & Warburg.

Ford, S. (1999) *Wreckers of Civilisation: The story of COUM Transmissions and Throbbing Gristle*. London: Black Dog Publishing.

Gunkel, D. (2016) *Of Remixology: Ethics and aesthetics after remix*. Cambridge: MIT Press.

Hegarty, P. (2007) *Noise/Music: A history*. London: Continuum International Publishing Group.

Keenan, D. (2016) *England's Hidden Reverse: A secret history of the esoteric underground – Coil, Current 93, Nurse with Wound*. London: Strange Attractor Press.

Laradji, X., Laufenburg, C. & Thighpaulsandra (eds.) (2014) *Peter Christopherson: Photography*. Toulouse: Timeless.

Loewenberg, P. & Thompson, N. (eds.) (2011) *100 Years of the IPA. The Centenary History of the International Psychoanalytical Association 1910–2010: Evolution and change*. London: Karnac.

McGuire, W. (1974) *The Freud/Jung Letters: The correspondence between Sigmund Freud and C.G. Jung*. Abridged edition. Princeton: Princeton University Press.

Miller, P.D. (2008) *Sound Unbound: Sampling in digital music and culture*. Cambridge: MIT Press.

Navas, E. (2012) *Remix Theory: The aesthetics of sampling*. Vienna: Springer.

Neal, C. (1987) *Tape Delay*. London: SAF Publishing.

Oliveros, P. (2008) "The collective intelligence of improvisation." In Zorn, J. (ed.) *Arcana V: Music, magic and mysticism*. New York: Hips Road. pp. 292–296.

Sinnreich, A. (2010) *Mashed Up: Music, technology and the rise of configurable culture*. Amherst: University of Massachusetts Press.

Taylor, J. (1962) *Futurism*. New York: The Museum of Modern Art.

Thomas, L. & Thighpaulsandra. (2014) *Bright Lights and Cats with No Mouths: The art of John Balance collected*. Toulouse: Timeless Editions.

Tomkins, C. (1996) *Duchamp: A biography*. New York: Henry Holt & Co.

Zaczek, I. (2018) *A Chronology of Art: A timeline of Western culture from prehistory to the present*. London: Thames & Hudson.

Zorn, J. (ed.) (2010) *Arcana V: Music, magic and mysticism*. New York: Hips Road.

Chapter 4

Psychoanalysis and Dada

In the years leading up to the First World War, many individuals fled their homelands in search of safety; Switzerland received a large influx of these people, as it provided a neutral center amidst the Central powers of Germany and Austria-Hungary and the Entente powers of France and Italy. Surrounded by violence and bloodshed, the Swiss found themselves in a tense, albeit unique, position. Soon after the outbreak of the war, German poets Hugo Ball (1886–1927) and Emmy Hennings (1885–1948) fled to Zürich. While the seeds of the Dada movement had been planted in the years before the war – shaped by the futurists as well as independent artists – the opening of the Cabaret Voltaire in February 1916 is considered the official beginning of the Dada movement. This event was monumental in bringing together a variety of artists and intellectuals from varying backgrounds, countries, media, orientations and worldviews. The result was a group of players coalescing into a more or less coherent, integrated movement, while still maintaining the integrity and diversity of the individuals involved.

The Cabaret Voltaire was founded when Ball placed a call to artists in the local paper. Remarking on this event, Ball stated:

> I was sure that there must be a few young people who like me were interested not only in enjoying their independence but giving proof of it. Cabaret Voltaire has as its sole purpose to draw attention, across the barriers of the war and nationalism, to the few independent spirits who live for other ideals.
>
> (Aspley, 2010, p. 95)

The artists who responded to the call staged their first soirée just days after the original announcement and were initially known as the Voltaire Artists' Society.

Ball and Hennings first established the Cabaret Voltaire as a literary cabaret; Ball often accompanying Hennings on the piano while she performed songs and poetry readings. The charisma of the pair attracted other artists and performers, and they were soon joined by local Sophie Taeuber (1889–1943), German artists Richard Hülsenbeck (1892–1974) and Hans (later Jean) Arp (1886–1966), and Marcel Janco (1895–1984) and Tristan Tzara (1896–1963) from Romania, among others. The synergy of the group, their revolutionary spirit, poems, productions and manifestos, sparked an element of vivacious upheaval and produced rambunctious happenings.

As is the case for many women throughout history, when the story is told, Hennings is usually portrayed as an *accoutrement* to Ball, rather than an artist and pioneer in her own right. As outlined in Ruth Hemus's (b. 1971) groundbreaking study *Dada's Women* (2009), Hennings herself was actually quite well known at the time the Cabaret Voltaire was founded. Involved with the German expressionist movement before she became the "face of Dada," Hennings brought with her a network of connections. In her work, Hemus researches the lives and contributions of five central female figures of the Dada movement in depth: Emmy Hennings, Sophie Taeuber, Hannah Höch (1889–1978), Suzanne Duchamp (1889–1963) and Céline Arnauld (1885–1952), all of whom will be discussed in this study as well.

The Dadaists utilized the performative aspect of cabaret to showcase their experiments and artistic endeavors, incorporating popular songs, ballads and entertainment alongside readings of classic and experimental literary texts. One of the most popular performances was Hennings's rendition of Ball's anti-war poem *Totentanz* or "Dance of Death," which she sang to the tune of what was a well known jingle at the time, "This is How we Live":

This is how we die, this is how we die.
We die every day
Because they make it so comfortable to die.[1]

Hennings was provocative, as she sang these words accompanied by music and a melody typically used to invoke patriotism; this juxtaposition was intended to shake the viewer out of the usual, out of the expected. This type of act – combining discordant words, form and content – was typical

of Dada performances and experiments, as the artists set out to create an unsettling effect in the audience:

> At the heart of Dada lay the "gratuitous act," the paradoxical, spontaneous gesture aimed at revealing the inconsistency and inanity of conventional beliefs.
>
> (Rubin, 1967, p. 12)

Both the Dada and psychoanalytic movements were inescapably influenced by the atrocities of World War I. Hülsenbeck, in his *En avant Dada* (1920), reported that the Dadaists agreed the reasons for the war were materialistic and contrived. The group concurred that politicians are the same everywhere – flatheaded and vile – and described this brutality of war as the moral enemy of every intellectual impulse. Hans Arp wrote of this time:

> At Zürich in 1915, disinterested as we were in the slaughter-houses of the world war, we gave ourselves to the fine arts. While the canon rumbled in the distance, we pasted, recited, versified, we sang with all our soul. We sought an elementary art, which, we thought, would save men from the curious madness of these times. We aspired to a new order which might restore the balance between heaven and hell.[2]

For many, the war produced a collapse of confidence in the rhetoric and principles of the culture of logic and rationality that had prevailed across Europe until this point. The birth of mechanized warfare with its massive death tolls, coupled with the totalitarian politics of the time produced a sense of the fragility of civilization. In his essay *Thoughts for the Times on War and Death* (1915), Freud described the disorientation of modern man so divided from his nature, expressing disillusionment with the civilized world – in particular the state – and acknowledging the altered attitude toward death that this and every war forces upon its people:

> The individual who is not himself a combatant – and so is a cog in the gigantic machine of war – feels bewildered in his orientation, and inhibited in his powers and activities.
>
> (Freud, 1915, p. 275)

Dada was born in this crisis of disillusionment; its collaborators' wartime experiences greatly influencing their collective body of work. The First World War shifted the terms of battle as it was the first war of the industrialized age. With vast numbers of technological innovations, it was the first global war of its kind and bore moral and intellectual crises. As the experience of the shattered bodies of veterans returning home from war became more and more commonplace, it became reflected in the art of the time. The Dadaists often depicted the casualties of war in their artworks – wounded soldiers and amputees with prosthetic limbs – eventually even positing the conception of a race of half-mechanical men.

An artist who often worked with these themes is Suzanne Duchamp.[3] Clearly coming from a creative household, with the mother and all four children being artists, Suzanne Duchamp trained at the École des Beaux-Arts in Rouen, France, beginning at the age of 16, and later moved to Paris to join the artist community in Montparnasse. Following the outbreak of the war, she served as a nurse's aid, and at this time either she took a hiatus from her art, or her artwork from this time period did not survive.

> It was over the next six years, from 1916 onwards, that she created a number of works using innovative techniques that place her firmly at the heart of avant-garde preoccupations.
> (Hemus, 2009, p. 133)

Suzanne Duchamp's work often focused on the interplay between machinery and the body. The futurists of Italy had paved the way with their idealization and exaltation of the machine as the ultimate symbol of power and progress in the modern age. Affected by the rapid changes taking place in technology and society, artists of the era seemed to process these shifts via exploration of the machine and its intersection with the human body and life. As Dada artists worked with these themes, they expressed more ambivalence regarding this so-called progress than the futurists had:

> Whether perceived and portrayed as a boon or a threat, the importance of the machine to avant-garde artists lay in its references to and evocations of modernity.
> (Hemus, 2009, p. 134)

Other artists who played with the line between human and machine included Marcel Duchamp (1887–1968), Francis Picabia (1879–1953), Jean Crotti (1878–1958) and Man Ray (1890–1976), most of whom were based in New York at this time, seeking refuge from the war.

Francis Picabia began his movement into modern art with his first abstract painting *Caoutchouc,* completed in 1909. That same year he married French avant-garde musician and art critic Gabrièle Buffet (1881–1985). Soon after, Picabia visited New York to present four of his works for the 1913 Armory show – the first International Exhibition of Modern Art in the United States. Influenced by the machine of New York City, Picabia began to incorporate more industrial elements into his work. In a *New York Tribune* article from 1915, he stated:

> The machine has become more than just a mere adjunct of life, it's really part of human life, perhaps the very soul. In seeking forms through which to interpret ideas or by which to expose human characteristics, I have come at length upon the form which appears most brilliantly plastic and fraught with symbolism. I have enlisted the machinery of the modern world, and introduced it into my studio, I mean to simply work on and on until I attain the pinnacle of mechanical symbolism.[4]

Sophie Taeuber-Arp[5] is perhaps best-known for her sculpted wooden heads and the self-portraits in which she peeks out from behind them. She also created marionettes, puppets and textiles, working with a variety of materials, including metal, paint, watercolor, yarn, wool, fabrics, feathers, pearls and other found items. Her *Military Guards* (1918) were crafted out of wood, then painted silver to resemble metal, recalling the machine. One piece in particular has a cylindrical torso and five legs with just as many arms, all brandishing swords, calling to mind the collective nature and potential groupthink of the horde. Reflective of the earlier work of the futurists, who took technology as their focus and played with the boundaries between human, robot and machine, Taeuber-Arp's work:

> [...] also anticipates the workshops and performances of the Bauhaus group in the 1920s, into which Oskar Schlemmer [1888–1943] introduced puppets as a means of exploring the relationship between man and machine.
>
> (Hemus, 2009, p. 60)

As Hemus notes, Taeuber-Arp was also a choreographer and dancer, hosting soirées characterized by improvisation and chance, highlighting the ephemeral aspect of performance. While engaging in these avant-garde performance art collectives, Taeuber-Arp concurrently maintained a position as a teacher at the Applied Arts and Crafts School in Zürich where she taught textiles, embroidery and weaving from 1916 to 1929. She engaged in interior design and architecture for hotels, bars and other public spaces, as well as for the home she shared with her husband Hans Arp. In this way, Taeuber-Arp was pioneering in her breakdown of the barriers between applied and fine art. She collaborated not only with Dadaists but also with constructivist and concrete artists; her work had an impact on the development of minimalism and serial art as well. Later on, Taeuber-Arp founded and ran her own journal *Plastique*, of which five issues were published between 1937 and 1939. *Plastique* contained experimental literature, critical texts from European and American artists, as well as reproductions of paintings and sculptures.

Sophie Taeuber-Arp and Hans Arp maintained an ongoing, collaborative creative process throughout their lives and relationship. The two often engaged in what they called *duo drawings*. Arp even continued their collaboration after Taeuber-Arp's death:

> tearing up some of their duo-collages and reassembling them, tracing in ink on paper her geometric wood reliefs, and commissioning woven work based on her patterns.
> (Hemus, 2009, p. 85)

During World War I, many physicians fled to psychoanalysis in an attempt to understand the effects of such trauma on the mind. The war left soldiers with psychological as well as physical wounds, which in turn also became a motif of certain Dada works. For the first time, the military began to recognize psychological trauma as valid, almost on par with physical injury. A large number of those discharged from the service were diagnosed with war neurosis or *shell shock*. Grafton Elliot Smith (1871–1937) was one of the first to describe its pathology and symptomatology, cautioning that for those suffering, reason was not lost but rather was "functioning with painful efficiency" (Grogan, 2014, p. 29).

The period of the First World War, with its pervasive destruction, fragmentation and subsequent reconstruction of both the physical world and

of the psyche, is reflected in the Dada methodology of the *cut-up*. While there are various ways in which to apply the concept of the cut-up, Tzara introduced one process in his manifesto *To Make a Dadaist Poem* (1920), instructing us to:

> Take a newspaper.
> Take some scissors.
> Choose from this paper an article the length you want to make your poem.
> Cut out the article.
> Next carefully cut out each of the words that make up this article and put them all in a bag.
> Shake gently.
> Next take out each cutting one after the other.
> Copy conscientiously in the order in which they left the bag.
> The poem will resemble you,
> And there you are – an infinitely original author of charming sensibility, even though unappreciated by the vulgar hand.[6]

Dada questioned society's accepted values and consensus worldview, challenging the status quo while embracing new ways of thinking, utilizing new materials and methods. Dada quickly shattered certain conceptions about the nature of art, including the appropriate method and mode of creating, as well as viewing and experiencing artwork. Valuing cacophony, dreams and the violation of syntax as techniques for freeing the unconscious from the domination of reason and tradition, the Dadaists felt that up to this point art had served civilization: their anti-art would challenge it. This radical rethinking of the creation of art is one of Dada's fundamental achievements. Historically, Dada has not been readily understood as a movement in the traditional sense – as a small alliance of artists working and showing together, committed to a common aesthetic, credo and style – and has often been portrayed as simply a precursor to surrealism. However, the individual participants of the Dada movement varied widely in their concepts and techniques, in contrast to surrealism, which, as we will see, remained largely centralized in terms of leadership and geography. The Dada movement was notably diffuse with several active city centers, creating a network of itinerant,

politically displaced artists of diverse nationalities; previously there had been no artistic movement so self-conscientiously international. Part of Dada's radical achievement lay in its ability to create a global network of artists and intellectuals, especially during such a tumultuous time in world history. In fact, this is an under-recognized and invaluable accomplishment of both the Dada and psychoanalytic movements.

The Dadaists championed methods reflective of the workings of the unconscious, including automatic writing, which was later incorporated into the surrealist literary movement. Similar to the process of free association, automatic writing allows the creator a glimpse into their own unconscious processes by attempting to bypass inhibition and interference from the psychic censor as much as possible, unveiling latent connections and illustrating Freud's notion that there is nothing left to chance. Everything, even if seemingly unrelated, is intricately intertwined, interconnected and overdetermined. In the unconscious, central concepts are concentrated into nodes with multiple pathways leading to and from each of these kernels. No matter at what point one begins, certain themes and patterns will inevitably arise. In *The Psychopathology of Everyday Life*, Freud stated, "I believe in external (real) chance, it is true, but not in internal (psychical) accidental events" (1901, p. 257).

Lacan described the unconscious as structured like language: an infinite web of signifiers, the sliding of metonymy, an endless knot. Each piece of information is interconnected to every other piece of information in an unfathomable web. Ever since the development of semiotics by Swiss linguist Ferdinand de Saussure (1857–1913), the terms *sign, signifier, signified* and *signification* have become part of discourse, and part of our culture, taken up not only by modern linguistics, but in the fields of philosophy, psychoanalysis and the humanities as well. For Saussure, the sign is the basic unit of language. The sign is comprised of the signified (the concept) and the signifier (the phonetic element), the two elements linked by "an arbitrary but unbreakable bond." Lacan, however, argued that this bond is actually quite precarious and unstable:

> [H]e sees the BAR [the line separating the signifier from the signified] between them [...] as representing not a bond but a rupture, a "resistance" to signification.
>
> (Evans, 1996, p. 185)

Lacan further upended Saussure's concept by insisting that the concept or signified does not in fact come before the signifier, but rather that signifiers are fundamentally present and constantly at play, and are only then attached to ideas. Lacan called the moment signifier and signified knot a *point de caption* or "quilting point," similar to Freud's "nodes."

The proposition that we are swimming in a sea of signifiers, or phonetic elements, becomes evident when we encounter psychosis. Such phenomena as *word salad* and *clang associations* make sense when one considers the play of sound elements in language. One can also see these mechanisms at work in puns, jokes and other forms of wordplay. Through their games of chance, the Dadas attempted to bypass the psychic censor in order to minimize conscious interference with unconscious elements as much as possible in a desire to access these foundational, phonetic building blocks, immersing themselves in the endless interplay of metonymy and metaphor, condensation and displacement.

With the end of the war, Dada spread out into various city centers, as many of its proponents returned to their homelands or nearby regions. The Dadaists made use of new media that allowed for contact between persons across long distances; connections were forged between artists and writers in different cities across the globe. As these interactions were documented through various forms of media, including letters, postcards and journals, this movement of ideas was traced as it transformed art and intellectual thought as it had been known. Letters, postcards, books, journals and magazines not only provided important means of sharing ideas and images, but were also incorporated into new forms of artwork; their work being influenced by the medium in which it was transmitted.

The aims of Dada were often supranational. Emerging amidst the racially tinged nationalistic discourse of WWI, a central tenet of Dada was anti-nationalism. Fashioning itself as a network with centers in Zürich, Vienna, Berlin, Hannover, Cologne, Munich, New York and Paris, Dada formed a web of connections between its various contributors, serving as a conduit for creative thought. Even though Europe and North America contained the city centers, Dada promoted a global identity and was as far-reaching as Japan. Gabrièle Buffet-Picabia stated that the atmosphere was heavily charged as a result of the unusual gathering together of individuals of all nationalities, each with unique talents to offer:

> It also turned out to be an exceptionally favorable climate for the development of a certain revolutionary spirit in the domain of the arts

and letters which, later on, became crystallized in Europe under the name of Dada.

(Buffet-Picabia, 1938, p. 13)

Arguably, the center of Dada migrated to Paris with Tristan Tzara, who joined Francis Picabia there in January of 1920; artists such as Man Ray and Max Ernst (1891–1976) also gathered in Paris after the war, bringing with them ideas from other European centers as well as from New York. The group held an exhibition at the Salon des indépendants, which newly reopened, and on February 5 of that year, there was a reading of the *23 Dada Manifestos* by 38 readers. Tzara's periodical *Bulletin Dada* was distributed to those in attendance. Literary Dada flourished in Paris, as pamphlets and journals thrived in the early 1920s; poetry, prose and short dramatic pieces featured in these Dada journals.

Perhaps the largest-scale project that was never able to be realized was *DadaGlobe*. When Tzara went to Paris, he immediately moved in with Picabia, and the pair soon took the city by storm. As they organized the journal *Dada* (1920–1921), Tzara conceived of *DadaGlobe* and sent out invitations to potential contributors, requesting they submit portraits of themselves as well as photographs of their artwork. The plan was for the submissions to be collected together in an anthology and printed in a run of 10,000 copies, allowing for *DadaGlobe* to be distributed worldwide with the help of international collaborators and local groups.

Although officially announced in Marcel Duchamp and Man Ray's journal *New York Dada* (April 1921), *DadaGlobe* never came to fruition. If it had, it would have collected together the works of an extraordinary range of Dada artists from all over the world at the peak of the movement, as curators and art historians have realized retrospectively that many of the most iconic images associated with the Dada movement were in fact produced for *DadaGlobe*. Recently, however, the works that remain have been collected together into the exhibition and publication *DadaGlobe Reconstructed* (2016), so now one is finally able to "Read *DadaGlobe* if you have troubles!"[7]

The poet Céline Arnauld[8] was a woman at the heart of Paris Dada, whose work has historically been overlooked. Photographed with the most prominent members of the Dada movement, her experimental texts appeared in their avant-garde journals, and she published almost a dozen books during her lifetime. Yet despite this, her work is long out of print, examples of her poetry in anthologies are scarce, and English translations are few and far

between. Again, thanks to the perseverance of Ruth Hemus, who has written a forthcoming manuscript focused entirely on Arnauld, *The Poetry of Céline Arnauld: from Dada to Ultra-Modern* (2020),[9] her work is finally beginning to gain more widespread recognition and hopefully will increasingly be translated.

Arnauld produced a long line of individual publications – eleven volumes of poetry, one novel and an anthology – between the years 1914 and 1948. Her output was especially concentrated in the 1920s during the height of Dada activity in Paris, as she contributed to a variety of avant-garde journals and publications. In addition to her written work, Arnauld participated in major performance events: as the pregnant woman in the first Parisian performance of Tzara's *The First Heavenly Adventure of Mr. Antipyrine* (1920) at the Manifestation Dada de la Maison d'Oeuvre, and also as performer and author of *Chessboard* (1920), one of the pieces featured in the Festival Dada at the Salle Gaveau. Even after the end of Dada as a coherent movement in Paris,

> Arnauld managed to be consistently published as a poet in her lifetime, with recognition from many of her contemporaries, but always in small print runs with the avant-garde publishers of the time.
> (Hemus, 2009, p. 168)

Her work exhibits characteristics typical of Dada, with innovations in language – playing with the word, both written and spoken – as well as features of surrealism, which was being birthed at the time. Arnauld herself came to describe her work as *ultra-modern*.[10]

As Hemus points out in the introduction to *Dada's Women*, there is a reason we rarely hear of great women Dadaists. In a letter to Tzara dated October 24, 1924, Arnauld wrote:

> My dear friend, I am very surprised that in your history of the Dada Movement – where you show yourself to be fairly generous even towards your current enemies – you forget my efforts both in lyricism and in action.
> (Hemus, 2009, p. 1)

This letter can be seen as paradigmatic for the fortunes of not only a number of women Dadaists but of pioneering women in all fields, whose names

and works have been omitted from accounts of movements by historians, as well as by their male counterparts who often viewed women as support figures – lovers, models, muses and inspiration – rather than artists and innovators in their own right, "and whose stories remain partially or even wholly unwritten" (Hemus, 2009, p. 1).

Notes

1 Hemus, R. (2009) *Dada's Women*. New Haven: Yale University Press. p. 32.
2 Buffet-Picabia, G. (1949) "Some memories of pre-Dada: Picabia and Duchamp." Reprinted in Motherwell, R. (ed.) (1951) *The Dada Painters and Poets: An anthology*. 2nd edition. Cambridge: The Belknap Press of Harvard University Press. p. 264.
3 Suzanne Duchamp's biographical information drawn from Hemus, R. (2009). *Dada's Women*. New Haven: Yale University Press. pp. 129–164.
4 Hemus, R. (2009). *Dada's Women*. New Haven: Yale University Press. p. 134.
5 Sophie Taeuber-Arp's biographical information drawn from Hemus, R. (2009). *Dada's Women*. New Haven: Yale University Press. pp. 53–90.
6 Tzara, T. (2013). *Seven Dada Manifestos and Lampisteries*. London: Alma Classics. p. 39.
7 MoMA. (2016) "Dadaglobe Reconstructed" [Online]. Museum of Modern Art. Available at www.tonyleejr.com/dadaglobe-reconstructed.html (Accessed: December 1, 2019).
8 Céline Arnauld's biographical information drawn from Hemus, R. (2009). *Dada's Women*. New Haven: Yale University Press. pp. 165–194.
9 Hemus, R. (2018) "The Poetry of Céline Arnauld: From Dada to Ultra-Modern" [Online]. Modern Humanities Research Association. Available at www.mhra.org.uk/publications/Poetry-Céline-Arnauld (Accessed: August 20, 2019).
10 Hemus, R. (2018) "The Poetry of Céline Arnauld: From Dada to Ultra-Modern" [Online]. Modern Humanities Research Association. Available at www.mhra.org.uk/publications/Poetry-Céline-Arnauld (Accessed: August 20, 2019).

Bibliography

Ades, D. (1976) *Photomontage*. London: Thames and Hudson.
Ades, D. (2006) *The Dada Reader: A critical anthology*. The University of Chicago Press.
Aspley, K. (2010) *Historical Dictionary of Surrealism*. Maryland: Scarecrow Press.

Buffet-Picabia, G. (1938) "Arthur Cravan and American Dada." Reprinted in Motherwell, R. (ed.) (1951 2nd edition) *The Dada Painters and Poets: An anthology*. Cambridge: The Belknap Press of Harvard University Press. pp. 13–17.

Buffet-Picabia, G. (1949) "Some memories of pre-Dada: Picabia and Duchamp." Reprinted in Motherwell, R. (ed.) (1951 2nd edition) *The Dada Painters and Poets: An anthology*. Cambridge: The Belknap Press of Harvard University Press. pp. 255–267.

Dickerman, L. (2005) *DADA*. Washington DC: National Gallery of Art.

Evans, D. (1996) *An Introductory Dictionary of Lacanian Psychoanalysis*. London: Routledge.

Freud, S. (1901) *The Psychopathology of Everyday Life*. In *The Complete Standard Edition of the Psychological Works of Sigmund Freud (SE)* VI. London: Hogarth Press. pp. 1–279.

Freud, S. (1915) "Thoughts for the times on war and death." *SE* XIV. London: Hogarth Press. pp. 273–300.

Grogan, S. (2014) *Shell Shocked Britain: The First World War's legacy for British mental health care*. Barnsley: Pen & Sword History.

Hemus, R. (2009) *Dada's Women*. New Haven: Yale University Press.

Hülsenbeck, R. (1920) *En avant Dada: A history of Dadaism*. Hannover: Paul Steegemann Verlag.

Hülsenbeck, R. (1974) *Memoirs of a Dada Drummer*. New York: Viking Press.

Kostelanetz, R. (2001) *A Dictionary of the Avant-gardes*. 2nd edition. New York: Routledge.

Motherwell, R. (1951) *The Dada Painters and Poets: An anthology*. 2nd edition. Cambridge: The Belknap Press of Harvard University Press.

Naumann, F. & Venn, B. (eds.) (1996) *Making Mischief: Dada invades New York*. New York: Whitney Museum of Art.

Richter, H. (1964) *Dada: Art and anti-art*. New York: Thames & Hudson.

Rubin, W. (1967) *Dada, Surrealism, and Their Heritage*. New York: The Museum of Modern Art.

Sinclair, V.R. (2014) "The zeitgeist creating psychoanalysis and Dada." In Abrahamsson, C. (ed.) *The Fenris Wolf*, vol 7. Stockholm: Edda Books. pp. 38–45.

Sudhalter, A. (ed.) (2016) *DadaGlobe Reconstructed*. Zürich: Scheidegger & Spiess.

Tzara, T. (2013) *Seven Dada Manifestos and Lampisteries*. London: Alma Classics.

Umland, A. & Hug, C. (2016) *Francis Picabia: Our heads are round so our thoughts can change direction*. New York: Museum of Modern Art.

Filmography

Dada and Surrealism: Europe after the rain. (1978) Mick Gold (dir.). England: Arts Council of Great Britain.

Chapter 5

Collage, photomontage and assemblage

In 1912, the cubists began to collage bits of paper, cloth and other fragments onto the surfaces of their paintings as they entered their "synthetic" phase (Tomkins, 1996, p. 65). The technique of photomontage took this a step further, not only introducing new elements alongside paint but rather, "making use exclusively of ready-made photographic images as its material" (Hemus, 2009, p. 96). Photomontage took the experimentation of avant-garde artists with new materials to a new level, replacing paint altogether and substituting it with its new rival, the photograph. The technique of photomontage was revolutionary, an exciting innovation at the heart of Dada endeavors that proved to have a lasting impact on modern art. Often cut from popular printed publications, such as newspapers and magazines, many of the images used in collage and photomontage would have been familiar to the viewer. In this way, the known is turned on its head as images are re-presented, providing an uncanny dimension:

> Indeed, it was the familiarity, the "already seen" aspect of the newspaper and magazine images that provided their impact when subverted. Language is similarly subverted, with headlines broken up and re-formulated.
>
> (Hemus, 2009, p. 104)

Hannah Höch (1889–1978)[1] and Raoul Hausmann (1886–1971) claim invention of photomontage when they were on holiday in the summer of 1918 on the Baltic coast. At that time, almost every home had a framed colored lithograph of an image of a soldier set against a background of the barracks; this military memento was made more personal when a family exchanged a photographic portrait of a particular solider with

the head of the generic soldier. After repeatedly coming across these tokens, the couple began to work with such imagery, experimenting with and elaborating the possibilities, as they exchanged various pictures for the head and placed the soldier in different situations on a range of backgrounds.

Höch continued to work with collage and photomontage throughout her lifetime, incorporating an array of subject matter, including advertisements and photographs of politicians, machinery, technology, architecture, people, places, situations and crowds. She often juxtaposed objects and texts with images of women – ranging from housewives to ballet dancers and athletes. Höch called this fodder *photomatter*; these clippings would have been considered superficial and inappropriate for use as artistic material, as even photography itself was not yet considered an appropriate art form at the time (Hemus, 2009, p. 97).

Haussmann has stated:

> The idea of photomontage was just as revolutionary as its content. Its form as subversive as the application of the photograph and printed texts which together are transformed into a static form. Having invented the purely phonetic poem, the Dadaists applied the same principles to pictorial representations. They were the first to use photography as material to create, with the aid of structures that were very different, often anomalous and with antagonistic significance, a new entity which tore from the chaos of war and revolution an entirely new image; and they were aware that their method possessed a propaganda power which their contemporaries had not the courage to exploit.
>
> (Ades, 1976, p. 10)

Over her lifetime, Höch collected together an extensive archive comprised of thousands of items: poems, memoirs, journals, letters, postcards, manifestos, exhibition posters and catalogs, newspapers, magazines, books and works of art; not only her own artwork, but also that of her contemporaries, including Raoul Hausmann, Hans Arp and Kurt Schwitters (1887–1948). Höch concealed this collection by hiding it behind a fireplace chimneystack of her retreat house on the outskirts of Berlin, as well as by enclosing it in chests, which were buried in her garden, thus allowing the collection to survive World War II.

The surviving archive offers vivid insights not only into her personal and professional relationships but also into discussions, stimuli and new concepts that contributed to Dada's development in Berlin.

(Hemus, 2009, p. 91)

Höch recognized the impact advances in technology and media have on the traditional arts and incorporated those elements into her work. Developments in photography and film were widespread and arguably more economic and efficient in many contexts, especially in reporting and journalism as well as popular and commercial media. Where some artists avoided confrontation with these new developments and the questions they raised, avant-garde movements such as cubism, futurism and Dada had the impetus to confront them head-on, finding new means of expression. Höch noted:

The Dada photomonteur set out to give something entirely unreal to all the appearance of something real that had actually been photographed.

(Lippard, 2007, p. 73)

These techniques highlighted the constructed nature of much of our reality by recontextualizing familiar images and objects, thereby repurposing the everyday. Furthermore, the titles Höch chose for her pieces often reflect the process inherent in the work itself; for example, *Cut with the Kitchen Knife Through the Last Weimar Beer-Belly Cultural Epoch in Germany* (1919–1920) mirrors the cut up words, deconstructed images and fragmented bodies present in her work, as well as the shifting cultural and political landscape, and her own place within all of this.

Reflections of these sentiments may be found in the work of pioneering psychoanalyst Sabina Spielrein (1885–1942).

Psychoanalysis is a profession in which women gained early recognition, institutional equality, and governance roles well before achieving comparable status in other sciences...

(Hanly, 2011, p. xxix)

with several early women psychoanalysts – including Lou Andreas-Salomé (1861–1937), Marie Bonaparte (1882–1962), Melanie Klein (1882–1960), Anna Freud (1895–1982) and Helene Deutsch (1884–1982) – being key

figures. However, Spielrein was all but forgotten for decades. Having worked closely with both Freud and Jung during the early formative years of psychoanalysis, Spielrein is now often credited as the theoretician behind the *death drive*.[2] Furthermore, she was one of the very few who maintained close relationships with both Freud and Jung even after their split.

In 1923, with Freud's support, Spielrein decided to return to her native Russia to foster the growth of psychoanalysis there. Nearly 60 years later, a cache of her personal and professional writings were unearthed in the basement of the Rousseau Institute, a clinical, training and research center for child development in Geneva, Switzerland, where Spielrein had worked for several years prior to her return to Russia. During her time there, Spielrein analyzed pioneering Swiss psychologist Jean Piaget (1896–1980), who spoke highly of her. Having originally planned to return to Geneva, Spielrein left many of her writings, journals and other documents at the Rousseau Institute for safekeeping. Upon their discovery, the papers were organized, and selections of her writing published by Italian psychoanalyst Aldo Carotenuto (1933–2005) in the book *A Secret Symmetry: Sabina Spielrein between Jung and Freud* (1982). Her story was later popularized in *A Most Dangerous Method: The Story of Jung, Freud and Sabina Spielrein* (1993) by American author John Kerr (1950–2016), which was subsequently adapted into the film *A Dangerous Method* (2011) directed by David Cronenberg (b. 1943).

Spielrein's most known and referenced work is "Destruction as the cause for coming into being" (1912). Written at a time when psychoanalysis was attempting to root itself in biology, Spielrein's arguments focused on sexed reproduction, as well as mythical and religious themes, outlining the inherently destructive side of sexuality in the drive to reproduce. Throughout the development of the discipline of psychoanalysis, varying schools of thought have held differing views on the fundamental *instincts* or *drives* of human beings. Some schools have maintained that sexuality and aggression are separate drives: opposites in competition with one another. Spielrein, however, described "opposed yet complimentary passions building vertiginously in a kind of *drive-dialectic*" (Reisner, 2019, p. 23) – a compelling argument. It may be useful to think of the sexual and aggressive drives as part and parcel of the same force, the libido. There is a destructive component to sexuality, and what both aggression and sexuality oppose is stagnation or inertia, which I would consider to be the true death drive.

We see this fight for survival and push of inventiveness, as well as the destructive element in the creative, in the methodology of the cut-up, collage and photomontage – the cutting up and out, displacement and rearrangement of forms, word, image and content inherent in such techniques.

At about the same time that Hannah Höch and Raoul Hausmann were experimenting, George Grosz (1893–1959) and John Heartfield (1891–1968) also claim the invention of the photomontage. Their story is as follows: in 1916, at five o'clock, early one morning in May,

> On a piece of cardboard we pasted a mishmash of advertisements for hernia belts, student song books and dog food, labels from schnapps and wine bottles, and photographs from picture papers cut up at will in such a way as to say, in pictures, what would have been banned by the censors had it been said in words.
>
> (Ades, 1976, p. 10)

With this concept in mind, the pair began creating and sending out postcards as if they had been sent out from the front lines, sending messages in images that could not be said in words.

The Berlin Dada Club, as it became known, was quite political, producing a plethora of periodicals, newssheets and pamphlets from 1918 to 1919; they were especially active after the November Revolution. Only Heartfield and his brother, Wieland Herzfelde (1896–1988), were technically founding members of the German Communist Party in 1918, but the group as a whole sided with the radical left wing against the middle-class Republic. The techniques of collage and photomontage were extensively used by Heartfield, first against the Weimar Republic and then to chart the terrible rise of fascism and Adolf Hitler (1889–1945). In his work, Heartfield cut out and reassembled photographs and images of contemporary objects and events to create new and surrealistic scenes. For example, he blended the book-burning in Berlin with the fire at the Reichstag into the piece *Through Light to Night* (1933) with the caption, "Thus spake Dr Goebbels: 'Let us start new fires so that those who are blinded shall not wake up.'" In another piece he remarked, *Adolf the Superman* (1933) "swallows gold and spouts junk." And in *Millions Stand Behind Me: The Meaning of Hitler's Salute* (1932), Heartfield turns the Nazi salute around into a receiving hand, showing the hand receiving money, with the

statement "small man asks for big donations," highlighting the corruption of the administration. The effect of these works are all the more potent as they are constructed from depictions of real objects and events (Ades, 1976, pp. 13–14).

Richard Hülsenbeck wrote the first Dada manifesto of the Berlin group in 1918, calling for an art,

> which in its conscious content presents the thousandfold problems of the day, an art which has been visibly shattered by the explosions of last week, which is forever trying to collect its limbs after yesterday's crash. The best and most extraordinary artists will be those who every hour snatch the tatters of their bodies out of the frenzied cataract of life, who with bleeding hearts and hands hold fast to the intelligence of their time.
>
> (Ades, 1976, p. 11)

Photomontage perhaps comes closest to fulfilling Hülsenbeck's ideal. In using the very stuff of today's and yesterday's news, Dada was beginning to subvert the voice of society itself. Haussmann has stated:

> The field of photomontage is so vast that it has as many possibilities as there are different milieux, and in its social structure and the resulting psychological superstructure the milieu changes every day. The possibilities of photomontage are limited only by the discipline of its formal means.
>
> (Ades, 1976, p. 23)

Emphasizing the links between photomontage, revolutionary politics, industrialism and technology, Latvian artist Gustav Klutsis (1895–1938) described:

> Photomontage as a new kind of art of agitation [...] closely linked to the development of industrial culture and of forms of mass cultural media [...] [T]here arises a need for an art whose force would be a technique armed with apparatus and chemistry meeting the standards of socialist industry. Photomontage has turned out to be such an art.
>
> (Ades, 1976, p. 15)

Klutsis also claimed priority in the field of political photomontage, gathering momentum with *Left* (Journal of the Left Front of the Arts, 1923–1925).

In 1919, Max Ernst founded the Cologne Dada group, joined by Hans Arp. At that time, Ernst had begun working with collage, opening up new areas. This work soon evolved as Ernst began combining photograph, image and word, at times adding line work or drawings of his own, frequently intensifying their potency by adding long poetic inscriptions or titles. Collage for Ernst was a conquest of the irrational. Ernst viewed his collage work as akin to automatic writing or drawing, as he often worked in an automatic fashion. He felt his works provoked unconscious images in the viewer and described the photomontages and works of other surrealists similarly, as expressing the hallucinatory qualities of dreams:

> Contradictory images, double, triple and multiple images, piling up on each other with the persistence and rapidity which are peculiar to love memories and visions of half sleep.
>
> (Ades, 1976, p. 20)

Ernst even created entire collage novels, including *The Hundred Headless Woman* (1929), *A Little Girl Dreams of Taking the Veil* (1930), and *A Week of Kindness* (1934).[3]

Ernst's work is multifaceted. On the surface, there is the ongoing mastery of formal experimentation – the restless creative mind seeking expression. But underneath the surface of Ernst's dreamlike images, there are clues to the ideas and concepts that were percolating inside the mind of the artist, as well as in the minds of other surrealists. The cutting out of Ernst's source material, to be reassembled in new ways, seems to have been parallel to his own interests in psychoanalysis and alchemy. There is a malleability and fluidity of personal traits as well as gender expressions and affiliations, most of which have been interpreted as having alchemical sources for Ernst. For instance, in analyzing *The Hundred Headless Woman,* American professor of European modern art M.E. Warlick (b. 1946) notes:

> One of these collages alludes to a central theme of the novel, the fluctuating genders of the principal characters between Loplop, the male bird, and La Femme, the hundred-headless woman. The caption to the collage *The Demi-fecund Ram Dilates Its Abdomen at Will and*

Becomes a Ewe indicates this animal's magical ability to change from male to female. This transmutation is enacted in other ways throughout the novel, particularly in the sequential substitutions of male and female figures in similar poses.

(Warlick, 2001, p. 111)

The First International Dada Fair, held in Berlin in 1920, included works by members of both the Berlin and Cologne groups, as well as Francis Picabia and Otto Dix (1891–1969), among others. The stated theme of the exhibition was "Art is dead! Long live the machine art of Tatlin!" The highlight of the fair – which also led to prosecution – was a stuffed dummy dressed in a German officer's uniform with the head of a pig. Haussmann stated with this work he was "interested in showing the image of a man who only had machines in his head" (Ades, 1976, p. 12).

Bauhaus school-associated, Hungarian artist László Moholy-Nagy (1895–1946), made efforts to theorize modern man confronted with the age of technology. He posited that in order to become part of this modern age – to synthesize and work with ever-evolving technologies and demands, rather than sink back into a retrogressive symbolism or expressionism – the camera was the ideal tool. With its capacity to complement or supplement our own optical instrument – the eye – the camera aids us in disengaging ourselves from our routine and traditional habits of perception. Moholy-Nagy termed this our *Neues Sehen* or "New Vision." Furthermore, he developed what were called *photograms* on light-sensitive paper. Working with the interplay of light and shadow, he attempted to use light effects themselves as lenses, like light refracted through liquid or crystals. He also developed what he termed *photoplastics,* which combined photography and drawing; "fully aware of the vast range of possibilities in the field," Moholy-Nagy noted they can tell a story more versatile "than life itself" (Ades, 1976, p. 22).

Similar thoughts and expressions were also growing in the Soviet Union. Constructivist painting had been an artistic force parallel to the development of the overall Soviet modernist aesthetic. Although individual artistic expressions without communist pathos were often looked upon as suspicious or decadent, the *form* of the avant-garde seeped into the Soviet aesthetics of the 1920s and 1930s. Photography and photomontage were undoubtedly as important there as in the West. Polymath artist Alexander Rodchenko (1891–1956) was a central generator of versatility

and playfulness. As Vladimir Mayakovsky (1893–1930) became the poet laureate of pre-Stalin Soviet Russia, so his friend Rodchenko jumped headfirst into basically any art form he could find that appealed not only to his creative sensibilities but also to the necessities of the new communist republic. Photography was quintessential as a tool for him:

> In order to teach man to see from new viewpoints, it is necessary to photograph ordinary, well-known objects from completely unexpected viewpoints and in unexpected positions, and photograph new objects from various viewpoints, thereby giving a full impression of the object.
>
> (Rodchenko, 2005, p. 211)

The kinship between similar/parallel expressions like Moholy-Nagy's and Rodchenko's seems to be based in form rather than theoretical or political justification. The capturing of, say, a modern architectural structure is first and foremost *formally* interesting. But if the image is strong it may of course be contextualized in many different ways. What unites these different and seemingly independent expressions and approaches is the desire to look at the familiar in unfamiliar ways. Where Charcot had used photographs of his patients in what could be termed a platform for further "meta-analysis," the new avant-garde attempted to cut the ties to the *personal* analysis, thereby abstracting the visual from the distinctly human perspective, or conversely turning the human being into an abstracted unit within a collective. Although psychoanalysis had once been accepted as a viable technique of self-knowledge and insight, the new formal experiments could in some ways be seen as a refusal or retraction – a reaction against the proto-personal, irrational and emotional aspects essential not only to psychoanalysis but to the artist as an individual with a creative trajectory.

German painter Christian Schad (1894–1982) also experimented with photograms. He developed a form of automated collage, in which he laid scraps he'd collected, such as torn tickets, receipts and swatches of cloth, on light-sensitive paper to create abstract photograms. These images made without cameras came to symbolize the creation of the new from the damaged or discarded. Objects were laid out at random, thereby allowing for the unconscious to work with as little censorship and interference from the conscious mind as possible. Later, Tristan Tzara carried a group of these

tiny photographic compositions to Paris, where Man Ray experimented with the technique, naming them *rayograms*.

Another of the Bauhaus greats, Josef Albers (1888–1976) emigrated to the United States after the closing of the Bauhaus school under Nazi pressure in 1933. Albers was offered a position as head of the painting program at Black Mountain College in North Carolina, which at the time was a new art school. He remained there until 1950, when he relocated to Connecticut to teach and head the department of design at Yale University. Best known for his *Homage to the Square* series (1950–1975) – an expansive suite of paintings and prints that explore the nuances of color, tonal relationships and the relative nature of perception – prior to this, Albers was already an acclaimed artist and professor. In addition to painting and design, he created hundreds if not thousands of photos with his Leica camera and constructed collages from these photographs, which tended to consist of a mixture of portraits, mannequins, nature and architecture; however, these works were not widely known or recognized until after his death (Meister, 2016, p. 11).

In the 1950s and 1960s there was a resurgence of the Dada sensibility with a group in New York, who came to be known as the neo-Dadaists, headed by Robert Rauschenberg (1925–2008) and Jasper Johns (b. 1930). They embraced a variety of artistic mediums, materials and methods, espousing the techniques of assemblage, photomontage and collage of the original Dada movement itself. As this generation of artists sought to escape what they felt had become:

> the stifling conventions of abstract painting, younger artists were empowered by their newfound knowledge of the methods and manifestations of the Dada movement.
>
> (Hapgood, 1994, p. 11)

Neo-Dadaists rebelled against formal conventions by reintroducing everyday materials into painting and sculpture. Like their predecessors, the neo-Dadaists used chance as a compositional method and were interested in performance and other ephemeral manifestations of art. They challenged not only conventional notions of what art should be, how it should be created and presented, but also of the distribution, commodification and consumption of works of art. During this time period, attitudes toward art – including acceptable ways to create, present and engage with

artwork – were once again challenged and began to shift on the most fundamental levels.

Contemporary American artist Peter Beard (1938–2020) worked actively with collage, photomontage and assemblage techniques for decades. Beard studied art with Josef Albers at Yale University. Using found objects, drawings, photographs and magazines, Beard created scrapbooks full of collages, drawings, ink stains, paintings and fingerprints in his own blood. Inspired by Karen Blixen's *Out Of Africa* (1937), Beard traveled to Kenya for the first time in 1955, and also to Denmark in 1961, where he met with the then dying Blixen in person. He bought land next to her former estate just outside Nairobi, where he built his own sanctuary of houses and tents, which he called "Hog Ranch."[4]

Beard spent the bulk of his time in Africa documenting a critical phase of history during which many species were almost made extinct, while at the same time wildlife conservation efforts were underway. Concurrently, Beard was a jet-setter, hanging out internationally with artists and members of high society, including Salvador Dalí, Andy Warhol and Francis Bacon (1909–1992). In a poignant and unique way, Beard preserved the memories of these people, places and situations through his photographs, paintings, collages, photomontages and memory books. He documented his life – and indirectly the lives of many others – in the form of these diaries that are really rather ever-swelling three-dimensional works of art, and in so doing has created a new kind of aesthetic. His work is raw, unedited, chaotic and irregular, and at times violent, passionate and transcendent. In this way, Beard's work seems reminiscent of the many aspects and layers of life itself – cut out, entwined and reconstructed into compelling new forms. Oftentimes, his scrapbooks are displayed whole as art objects in and of themselves when on view in galleries and museums.

Beard not only photographed the people and objects in his life, he also photographed his own works. He then, in turn, used these photographs of his own works of art as images in the creation of upcoming projects and collages; these works were then photographed and utilized in future works, and so on and so forth. This is Beard's cycle – an eternal creative feedback loop where anything and everything can and will be recycled.

Late into his life, Beard continued to create these enormous collage and photo-based works, which he often enhanced with quotes from his favorite books or authors, handwritten in his own script. His work illustrates the manic will of an artist assembling loose fragments to create a new kind of

order and beauty, all the while documenting life and current events as they pass before the artist's eyes and camera:

> My diaries were and are all about getting out into life [...] They're meant to be unartistic. People think they're artistic because they're expressionistic [...] I'm just collecting things that are fun. I'm an escapist. I'm just looking for subject matter and life enhancement.[5]

Another artist who works in this vein is contemporary Japanese artist Shinro Ohtake (b. 1955). Creating multilayered works in painting, sculpture and bookmaking, one of the most prominent and persistent facets of his practice is his ongoing series of scrapbooks, which, since its inception in 1977, has grown to a collection of more than 60 individual books, some bulging with over 700 pages (Gioni & Bell, 2016, p. 202). These books hold collections of found materials, pictures from magazines, ticket stubs, photographs, matchbooks, and many other odds and ends the artist has collected in his day-to-day life. Ohtake collages and paints these miscellaneous materials to create compositions, turning a book of memories into a sculptural object.

American author-artist William S. Burroughs also kept extensive scrapbooks, documenting his various experiments. Collecting evidence to support his theories about the cut-up method and its creative potential, Burroughs maintained his focus on moments that seemed particularly significant, including synchronicity, signification, dreams and chance:

> I don't know where fiction ordinarily directs itself, but I am quite deliberately addressing myself to the whole area of what we call dreams. Precisely what is a dream? A certain juxtaposition of word and image. I've recently done a lot of experiments with scrapbooks. I'll read in the newspaper something that reminds me of or has a relation to something I've written. I'll cut out the picture or article and paste it in a scrapbook beside the words from my book. Or I'll be walking down the street and I'll suddenly see a scene from my book and I'll photograph it and put it in a scrapbook. I've found that when I'm preparing a page, I'll almost invariably dream that night something relating to this juxtaposition of word and image. In other words, I've been interested in precisely how word and image get around on very, very complex association lines.
>
> (Burroughs & Gysin, 1978, p. 1)

Notes

1 Much of the biographical information about Hannah Höch and her process culled from Hemus, R. (2009). *Dada's Women*. New Haven: Yale University Press. pp. 90–127.
2 Spidahl, A.M. (2018) "'Life-as-it-is must die': Sabina Spielrein and the Death Instinct of Our Time" [Online]. Still Point Magazine. Available at https://stillpointmag.org/articles/life-as-it-is-must-die-sabina-spielrein/ (Accessed: December 21, 2019).
3 Dery, M. (2018) "Max Ernst's Collage Novels Are Part Séance, Part Victorian Underworld, and All Uncanny" [Online]. Hyperallergic. Available at https://hyperallergic.com/424432/max-ernsts-collage-novels-are-part-seance-part-victorian-underworld-and-all-uncanny/ (Accessed: December 7, 2019).
4 Biographical information for Peter Beard from Abrahamsson, C. (2007). *Olika Människor*. Umeå, Sweden: Bokförlaget h:ström. pp. 160–169.
5 Abrahamsson, C. (2007). *Olika Människor*. Umeå, Sweden: Bokförlaget h:ström. p. 169.

Bibliography

Abrahamsson, C. (2007) *Olika Människor*. Umeå, Sweden: Bokförlaget h:ström.
Ades, D. (1976) *Photomontage*. London: Thames and Hudson.
Ades, D. (2006) *The Dada Reader: A critical anthology*. The University of Chicago Press.
Albers, J. (2013) *Interaction of Color*. New Haven: Yale University Press.
Arbus, D. (1995) *Untitled*. New York: Aperture.
Beard, P. (1988) *The End of the Game*. San Francisco: Chronicle Books.
Beard, P. (1998) *Beyond the Edge of the World*. New York: Universe Publishing.
Beard, P. (1999) *Peter Beard: Fifty years of portraits*. Santa Fe: Arena Editions.
Beard, P. (2004) *Zara's Tales from Hog Ranch: Perilous escapades in equatorial Africa*. New York: Alfred A. Knopf.
Blixen, K. (1937/1989) *The Illustrated Out of Africa*. London: Cresset Press.
Blythe, S. & Powers, E. (2006) *Looking at Dada*. New York: The Museum of Modern Art.
Bonn, G. (2006) *Peter Beard: Scrapbooks from Africa and beyond*. New York: Empire Editions.
Buffet-Picabia, G. (1938) "Arthur Cravan and American Dada." Reprinted in Motherwell, R. (ed.) (1951) *The Dada Painters and Poets: An anthology* (2nd edition). Cambridge: The Belknap Press of Harvard University Press. pp. 13–17.
Burroughs, W.S. & Gysin, B. (1978) *The Third Mind*. New York: Viking Press.

Carotenuto, A. (ed.) (1982) *A Secret Symmetry: Sabina Spielrein between Jung and Freud*. New York: Pantheon Books.

Droste, M. (2019) *The Bauhaus (1919–1933): Reform and avant-garde*. Cologne: Taschen.

Ernst, M. (1929/2017) *The Hundred Headless Woman*. New York: Dover Publications.

Ernst, M. (1930/2017) *A Little Girl Dreams of Taking the Veil*. New York: Dover Publications.

Ernst, M. (1934/ 2017) *A Week of Kindness*. New York: Dover Publications.

Gioni, M. & Bell, N. (eds.) (2016) *The Keeper*. New York: The New Museum.

Hanly, C. (2011) "Foreword." In Loewenberg, P. & Thompson, N.L. (eds.) (2011) *100 Years of the IPA. The Centenary History of the International Psychoanalytical Association 1910–2010: Evolution and change*. London: Karnac.

Hapgood, S. (1994) *Neo-Dada: Redefining art (1958–1962)*. New York: The American Federation of the Arts in association with Universe Publishing.

Hemus, R. (2009) *Dada's Women*. New Haven: Yale University Press.

Hinkson, L. (2017) *Josef Albers in Mexico: Peggy Guggenheim Collection*. New York: Thames & Hudson.

Höch, H. (2016) *Life Portrait: A collaged autobiography*. Berlin: The Green Box.

Huelsenbeck, R. (1920) *En Avant Dada: A history of Dadaism*. Hannover: Paul Steegemann Verlag.

Kerr, J. (1993) *A Most Dangerous Method: The story of Jung, Freud and Sabina Spielrein*. New York: Vintage Books.

Kostelanetz, R. (2001) *A Dictionary of the Avant-Gardes* (2nd edition). New York: Routledge.

Lavin, M. (1993) *Cut with the Kitchen Knife*. New Haven: Yale University Press.

Lippard, L. (2007) *Dadas on Art: Tzara, Arp, Duchamp and others*. New York: Dover Publications.

Meister, S. (2016) *One and One is Four: the Bauhaus Photocollages of Josef Albers*. New York: The Museum of Modern Art.

Motherwell, R. (1951) *The Dada Painters and Poets: An Anthology*. (2nd edition). Cambridge: The Belknap Press of Harvard University Press.

Reisner, G. (2019) "The absent feminine: overlooking the fusion of love and death in Sabina Spielrein's 'Destruction as the cause of coming into being.'" In Sinclair, V.R. (ed.) (2019) *Rendering Unconscious: Psychoanalytic perspectives, politics and poetry*. Stockholm: Trapart Books.

Rodchenko, A. (2005) *Experiments for the Future*. New York: MOMA.

Rubin, W. (1967) *Dada, Surrealism, and Their Heritage*. New York: The Museum of Modern Art.

Simac, C. (1992) *Dime-Store Alchemy: The art of Joseph Cornell*. New York: New York Review of Books.

Sinclair, V.R. (2014) "The zeitgeist creating psychoanalysis and Dada." In Abrahamsson, C. (ed.) *The Fenris Wolf,* vol 7. Stockholm: Edda Books. pp. 38–45.
Tomkins, C. (1996) *Duchamp: A biography.* New York: Henry Holt & Co.
Warlick, M.E. (2001) *Max Ernst and Alchemy.* Austin: University of Texas Press.
Wescher, H. (1971) *Collage.* New York: Harry N. Abrams.

Filmography

A Dangerous Method. (2011) David Cronenberg (dir.). Canada/USA: Recorded Picture Company, Lago Film, Prospero Pictures & Talking Cure Productions.
Dada and Surrealism: Europe after the rain. (1978) Mick Gold (dir.). England: Arts Council of Great Britain.
Peter Beard: Scrapbooks from Africa and beyond. (1998) Jean-Claude Luyat & Guillaume Bonn (dirs.). France: Canal Plus Ecriture & Program 33

Chapter 6

Disrupting the expected
Marcel Duchamp

When American author and art critic Calvin Tomkins (b. 1925) first met Marcel Duchamp in 1959, he asked him what he was currently working on, now that he'd left the art world. "Oh I'm a breather," Duchamp replied, "I'm a *respirateur*, isn't that enough?" he asked, "Why do people have to work? Why do people *think* they have to work?" (Tomkins, 2013, p. 3).

Constantly subverting the norms of what was being asked of him, Duchamp's whole career could be considered a disruption of the expected and "a cut above the rest." When a readymade was stolen from a gallery, he signed a duplicate object of the same model and handed it into the gallery as a replacement piece. When critics complained that his work was not commercially viable, he enrolled American artist Joseph Cornell (1903–1972) to aid him in creating portable cases containing miniature reproductions of several of Duchamp's key artworks. Duchamp's ability to surprise and disrupt expectation seemed to have no end:

> The sensibilities of Marcel Duchamp went beyond the superficial level of established social customs and cultural norms; they concerned the classification and interpretation of objects and phenomena, and, consequently, the role played by art and by the artist in all this.
>
> (Moure, 1988, p. 7)

Tired of the art world and market, he supposedly quit his artistic career to pursue chess, only to reveal toward the end of his life that he had been working on his final masterpiece *Étant donnés* for nearly two decades. Disrupt he did, and disrupt till the end.

Peggy Guggenheim (1898–1979) has credited Duchamp with being a huge influence:

> At that time I couldn't distinguish one thing in art from another. Marcel tried to educate me. I don't know what I would have done without him. To begin with, he taught me the difference between Abstract and Surrealist art. Then he introduced me to all the artists. They all adored him, and I was well received wherever I went. He planned shows for me and gave me lots of advice. I have him to thank for my introduction to the modern art world.
> (Guggenheim, 2005, pp. 161–162)

As mentioned, Duchamp was from a family of artists,[1] with his mother and four of the six children being artists as well. Though his brothers initially enjoyed more commercial success at the beginning of their careers, Marcel is undoubtedly the most well known of the family. Historically, his sister, Suzanne Duchamp, has tended to receive mention only in relation to her brothers or husband; however, as previously noted, she is finally beginning to gain recognition as an artist in her own right. Their brother, Raymond Duchamp-Villon (1876–1918), quit his last year of medical school in 1900 to become a sculptor and remained the most well known of the siblings in France for most of their lives. Their older brother, Jacques Villon (1875–1963), was a fine and commercial artist, who exhibited in the annual Salon des indépendants, never wavering in his ambitions to be recognized as a serious painter. Marcel, however, reported that he realized very early on:

> how different I was even from my brother (Villon). He aimed at fame. I had no aim. I just wanted to be left alone to do what I liked.
> (Tomkins, 1996, p. 32)

In 1905, Duchamp visited the exhibition at the Salon d'automne in which the works by Henri Matisse, André Derain and others were displayed that led critics to call them *les fauves* or "the wild beasts." Duchamp was taken aback by this show, later recounting that this was the moment "that I decided I could paint" (Tomkins, 1996, p. 38). Duchamp enrolled in the art academy just as the French government had passed a law requiring all healthy young French men to enlist in the military for two years, which could be reduced to one for individuals in certain essential professions, of which *ouvriers d'art* or "art-workers" was one. So Duchamp cut short his classes at the Académie Julian in Paris to apprentice at a well-regarded print shop in Rouen, where his parents lived. There, he learned the techniques of engraving, etching and typesetting, and became a master craftsman.

Duchamp's year in the army gave his recovered freedom a delicious savor. Instead of reentering the Académie Julian, he slipped easily into the role of a *flâneur* – a detached observer of the passing scene, whose artistic leanings required no undue expenditure of effort.

(Tomkins, 1996, p. 34)

In the spring of 1907, Duchamp had five of his drawings accepted for the first Salon des artistes humoristes exhibition, and again showed in the second one the following year. He also exhibited work at the 1908 Salon d'automne. That same year, Matisse rejected the paintings submitted by Georges Braque, describing them as being made of "little cubes." "Cubism had been born but for the moment few people noticed" (Tomkins, 1996, p. 39).

While Georges Braque and Pablo Picasso were developing cubism, Duchamp remained occupied with fauvist-inspired pieces for the next couple of years. He focused on nude forms created with heavy bold outlines and an assortment of colors. Meanwhile, Picasso and Braque worked in isolation without recourse to theories, manifestos or verbal explanations of any sort; seeing each other's work every day was their main stimulus. Braque later reflected that during the years of their most intensive collaboration (1908–1914), they felt "like two mountaineers roped together" (Tomkins, 1996, p. 49).

In 1911, cubism was suddenly catapulted into the public domain. The newly formed cubist group "felt the need to discuss and analyze the radical innovations of Picasso and Braque" (Tomkins, 1996, p. 49) without the participation of its founders. Braque and Picasso remained completely aloof from this budding cubist group, whose theoretical discussions and idealist goals held no interest for them at all. Duchamp, however, was intrigued by this development, later reflecting that this intellectual approach to cubism was attractive to him; however, he "wanted to invent or find my own way instead of being a plain interpreter of a theory" (Tomkins, 1996, p. 48).

In this, cubism's "analytical" phase, Picasso and Braque had come very close to an art of complete abstraction. They eventually drew back from it, unwilling to abandon all contact with the natural world, but for a number of other artists further abstraction became the inevitable next step. Between 1906 and 1916, Swedish artist Hilma af Klint, Russian artists Wassily Kandinsky and Kazimir Malevich, Dutch painter Piet Mondrian, Czech artist František Kupka (1871–1957) and French painter Robert Delaunay (1885–1941), each working independently, took art into the realm of pure,

non-representational form and order, while Braque and Picasso moved toward the collaging of pieces of the "real world" onto the canvases of their paintings (Tomkins, 1996, p. 65).

In 1912, the Société des artistes indépendants held their 28th exhibition. Duchamp submitted *Nude Descending a Staircase (No. 2)*, to be hung with the cubist work. Although the cubists were the most innovative, radical movement of their time, they inevitably developed a strict set of rules for themselves. Cubist images were to be static and fixed, and while *Nude Descending a Staircase (No. 2)* contained the fragmentation, synthesis and muted colors associated with cubism, the suggested movement found in the piece was deemed to be of futurist influence. Duchamp, however, stated that he was not aware of the futurist movement at that time. Even the title was under attack, being deemed "too literary." Duchamp recollected, "I always gave an important role to the title, which I added and treated like an invisible color" (Tomkins, 1996, p. 51). When his brothers Villon and Duchamp-Villon broke the news to Duchamp that his piece had been rejected from the exhibition, Duchamp quickly proceeded to pack up his painting and take it home in a cab.

The following year, this same work became the most talked-about piece of the first International Exhibition of Modern Art in New York, also known as the Armory Show. Organized by the Association of American Painters and Sculptors and held in New York's 69th Regiment Armory in 1913, the Armory Show was the first large-scale exhibition of modern art in America. Images we find iconic today shocked and appalled audiences at the time. Teddy Roosevelt (1858–1919) famously declared, "This is not art!" (1913, p. 719), while the media likened the works to cartoons and child's play. Duchamp's *Nude Descending a Staircase (No. 2)* was quickly satirized as "The Rude Descending a Staircase (Rush Hour in the Subway)" by J. F. Griswold (1881–1931) of the *New York Evening Sun* (Blythe & Powers, 2006, p. 41) and an "explosion in a shingle factory" by journalist Julian Street (1879–1947).[2] Viewers were outraged, as they had never seen art of this kind and did not understand how to relate to it. It was called "un-American" – an attack on cultural mores and religious values. And although the Armory Show included many pieces by well-established and more traditional artists – including American painters and printmakers Mary Cassatt (1844–1926), Edward Hopper (1882–1967) and James Whistler (1834–1903) – the shock and outrage that ensued from works such as Duchamp's *Nude* and Matisse's *Luxury* has forever linked the

signifier Armory with the European avant-garde, pushing and questioning the boundaries of art as espoused by institutions. Gabrièle Buffet-Picabia wrote of this time:

> All of us, young intellectuals of that period, were filled with a violent disgust at the old, narrow security; we were all conscious of the progressive decline of reason and its experience, and alert to the call of another reason, another logic which demanded a different experience and different symbols.
>
> (Buffet-Picabia, 1949, p. 255)

Sometime in 1913, Duchamp fashioned the first "readymade." Claiming the idea came to him completely by chance, Duchamp designed *Bicycle Wheel* purely for his own gratification and not as a conscious art object. He fixed a bicycle wheel to the seat of an ordinary kitchen stool, as he enjoyed gazing at the spinning wheel as a form of pleasure and relaxation, the way one might sit in front of a fireplace and stare into the flames. "It was not intended to be shown. It was just for my own use" (Tomkins, 1996, p. 135). *Bicycle Wheel* is considered to be the first readymade, as well as the first kinetic sculpture, foreshadowing Duchamp's *rotoreliefs*.

In 1914, Duchamp picked up a bottle-drying rack, which was a fairly common item in those days (French families typically reused their wine bottles, taking used ones in to be refilled directly from the barrel). In a letter to his sister Suzanne, he explained, "I had purchased this as a sculpture already made." It occurred to him at the time to write something on it, a phrase that would be "without normal meaning," but it seems he never got around to doing so (Tomkins, 1996, p. 136). Duchamp soon moved to New York, and the bottle rack gathered dust in a corner.

Once situated in New York, Duchamp soon founded the Society of Independent Artists, along with Man Ray, Walter Arensberg (1878–1954), Katherine Dreier (1877–1952) and Joseph Stella (1877–1946). Modeled after the Société des artistes indépendants, the group was founded with the intention of providing a platform for individual artists – whether new, experienced, experimental or avant-garde – to showcase their work, and was dedicated to advancing the ideas of independent artists, free of juries, prizes or ranking of any kind. In 1917, the Society of Independent Artists held its first annual exhibition in New York City, which included over 2,000 works of art. The idea was that as long as one paid the entry fee

of six dollars, one's work would be shown. Even the catalog and exhibition were arranged in alphabetical order by the artists' surnames to ensure equal treatment. Duchamp submitted a readymade urinal to this exhibition under the pseudonym, "R. Mutt." Yet, shortly before the opening, the society decidedly refused to show Duchamp's *Fountain*, revealing that the Society of Independent Artists was apparently not as open to new ideas and forms of artwork as they would have others believe. Once this became clear, Duchamp soon resigned from his position as a director.

In 1919, Suzanne Duchamp married Swiss artist Jean Crotti, who had shared a studio with Marcel in New York City. Marcel sent the couple a geometry book as their wedding gift, with the instructions that it should be hung outdoors by a string from the balcony. "It needs to be blown around by the wind, choose its own problem, turn and tear the pages" (Hemus, 2009, p. 131). As Marcel was not the only member of the family to have a sense of humor, Suzanne then took a photograph of the readymade – now weather-beaten and blown apart – and sent it to her brother, stating, "That's all that's left because the wind destroyed it," to which Marcel replied, "I really like the photo of the ready-made getting bored on the balcony. If it's completely torn to shreds, you can replace it" (Hemus, 2009, p. 131). This banter continued back and forth between the siblings, with Suzanne taking the prank even further still by creating yet another portrait of the book, this time an oil painting entitled *Marcel's Unhappy Ready-made* (1920).

Throughout his career, Marcel Duchamp created a series of boxes to house or accompany his work. The first was his *Box of 1914* (1913–1914), which consisted mostly of a collection of notes, reflections and calculations created in preparation for his work *The Large Glass* (1915–1923); then there was *The Green Box – Artwork Created for 'The Bride Stripped Bare by her Bachelors, Even'* (1934), which he assembled after the execution of *The Large Glass* and which was also meant to accompany the piece (Judovitz, 1998, p. 58). Duchamp then decided to gather miniature reproductions of his work together into a package, resulting in *Box-in-a-Suitcase* (1935–1941). Rather than creating a more traditional album or book of his work, in essence Duchamp created a miniature, portable Duchamp-museum-in-a-box. For this project, he commissioned New York artist Joseph Cornell to aid him in the construction of these works. Among them were miniature three-dimensional replicas of three readymades – *Fountain* (1917), *Traveler's Folding Item* (1917) and *Paris Air* (1919) – along with photographs of other readymades, a miniature of *The Large*

Glass, as well as tiny reproductions of paintings, drawings, rotoreliefs, magazine cover designs, and 25 of his puns and wordplays. Duchamp designed a deluxe edition of 20 boxes, each in a brown leather carrying case with slight variations in design and content. A later edition consisting of six different series was created during the 1950s and 1960s. These eliminated the suitcase, used different colored fabrics for the cover and altered the number of items inside. Each box unfolded to reveal standing frames designed to pull out to display miniature reproductions of *Nude Descending a Staircase (No. 2)* (1912) and other works, as well as small-scale readymades and loose prints mounted on paper. Duchamp included in each deluxe box one original work of art.

Joseph Cornell is often considered a surrealist in his own right, as he collected together and juxtaposed items that he found across the city, combining them into intricate display boxes of his own design. Cornell was not the first artist to use collage and assemblage, but he was a pioneer in the field, maintaining the assembly of found objects as the focus of his work throughout his lifetime. Cornell's work was included in the exhibition *Fantastic Art, Dada, Surrealism* at the Museum of Modern Art (December 1936-January 1937), which launched his career as this exhibition was one that "marked the moment that Surrealism became a popular sensation in New York" (Hartigan, 2015, p. 23). Despite appreciating surrealism's ethos and style, Cornell maintained a desire to define himself independently.

In a note dated from 1913 that was included in *The Green Box* (1934), Duchamp asked himself "Can one make works which are not works of 'art'?" (Tomkins, 1996, p. 131). This question captures something integral about the nature of his work. Duchamp had a way of showing that life and art can be one and the same. Our act of living is itself a form of art, and conversely, art, in the typical way of which it is thought, is a representation of life: a capturing of the process of creation in a moment or object. Rather than separating the creative process from the actions that make up our day-to-day lives, we may choose to integrate artistic endeavors into our lives, or even conceptualize our lives themselves as works of art we are creating. Rather than deeming works of art as separate, we may reframe our thinking and choose to aestheticize our lives more intentionally, taking care to pay more attention to our immediate surroundings as we create our living spaces, workplaces and general environment in a way that is more conscientious, careful and deliberate, rather than living our lives caught up in the cycles of the daily grind. Duchamp explored life and art by deconstructing

and dissecting them, asking how they worked and why, and if they could be construed in different ways. "He reserved for the artist an essentially intuitive role" (Moure, 1988, p. 7), espousing that it is not possible nor even desirable for the artist to be fully aware of the implications or ramifications of their work. Highlighting the collaborative nature of art/life:

> One of his pet theories was that the artist performed only one part of the creative process and it was up to the viewer to complete that process.
> (Tomkins, 1996, p. 11)

In the 1960s, Duchamp's artwork received a resurgence; a new generation of artists discovered his work, which led to a series of retrospective exhibitions internationally. He was described as "the most radical thinker of Modern Art, with an influence that is rivaled only by Picasso's."[3] Many pieces of Duchamp's artwork, however, had been lost or broken over the years, so this concurrently led to the reconstruction of several of his key works, such as *The Bride Stripped Bare by her Bachelors, Even,* also known as *The Large Glass* (1915–1923), as well as popular readymades.

Perhaps Duchamp's most essential creation was the development of his femme self: Rrose Sélavy. Responsible for many of Duchamp's most well-known puns, Sélavy was the author and copyright owner of many of the readymades. Her name appeared definitively when Duchamp wrote the punning phrase "Pi qu'habilla Rose" on Francis Picabia's *L'OEil cacodylate* (1920). Her name is associated with two phrases that emerge: "aRrose Sélavy" meaning "art is life" and "Rrose Sélavy," "Eros is life" (Moure, 1988, p. 16).

With the assumption of his femme identity, Sélavy, Duchamp explored self, gender, sexuality and identity as performative, as did many of the revolutionary artists that will be discussed throughout this study. As is now finally being more widely recognized and understood, gender and sexuality are not simply determined by biology. Judith Butler (b. 1956) revolutionized the academic discourse surrounding gender and gender identity in 1990 with her book *Gender Trouble*, in which she introduced the idea of gender as performance, utilizing drag kings and queens as overt examples. Taking this a step further, not only is gender performative, but our entire identity may be viewed in this way. So if gender and overall identity may be seen as a performance, or at least as having a heavy performative

aspect, they may also be understood as being essentially malleable. In other words, not only are there an infinite array of variations through which gender, identity and sexuality may find expression from person to person, but these aspects of identity may evolve over a person's lifespan, or vary from situation to situation depending on interpersonal dynamics; we may find ourselves relating differently as we engage in various relationships throughout our lives.

The key to Duchamp's genius, which runs throughout his body of work, is his ability to coerce the audience into shifting our perspective. Consider the position in which he places the viewer: his rotoreliefs catch the eye with their movement; the readymades draw one's attention in a way that is unnerving as the viewer isn't quite sure what to make of the artworks, if one may call them artworks at all. With *The Large Glass*, Duchamp leads the audience to peer through the artwork in an attempt to make sense of it; in doing so, the viewer may catch the eye of another peering through from the other side of the glass. With *Étant donnés* (1946–1966), Duchamp coerces the audience into peering through a peep hole in order to bear witness to what many viewers have found to be quite disturbing. To view the work (housed at the Philadelphia Museum of Art), patrons must make their way through the museum to locate the installation, as *Étant donnés* is housed in a room off a room, off a room, off a room. Once the viewer-participants finally arrive, they are confronted with the room itself. At times it is empty, harboring a forbidden air; on other occasions there is a long line, as people wait their turn to witness the distressed body of a woman; splayed, spread and laid bare, she seems to have been tossed into a field, yet she holds a lantern whose light twinkles while a waterfall and stream sparkle in the distance.

> We see the erotic object *through* the obstacle, be it door or glass, and this is voyeurism; the Bride sees herself naked in our gaze, and this is exhibitionism.
>
> (Paz, 1990, p. 117)

This positioning that Duchamp plays with is akin to what occurs in a sexual relation. There is always an element of dominance and submission in the sexual relation, no matter if the participants are aware of it or not. One is always on top, while another assumes the bottom; one takes control, while the other cedes control. The relationship need not be overtly

sadomasochistic for the power dynamic to be present: it is inherent. Freud discussed this positioning in "'A Child is Being Beaten': A Contribution to the Study of the Origin of Sexual Perversions" (1919). In this, Freud explored the fantasy mapping this relation when several of his analysands (one later learned to be his own daughter Anna, who was in analysis with him at the time the paper was written[4]) fantasized of being beaten by an authority or father figure. In one scene the protagonist witnesses an/other being beaten by the father: *My father is beating the child whom I hate*; in another scenario the child observes many other children being beaten by one or more authority figures. In this situation, the analysand has become the observer, outside of the situation but nevertheless the witness, "I am probably looking on." The children have become nameless and are being beaten, not by the father, but by equally undifferentiated authority figures. A third scene is inferred from these two: a scene where *I am being beaten by my father*. This scene:

> is most important and the most momentous of all. But we may say of it in a certain sense that it has never had a real existence. It is never remembered, it has never succeeded in being conscious. It is a construction of an analysis, but it is not less a necessity on that account.
> (Freud, 1919, pp. 185–186)

The shifts in positioning that take place from one scene to the next in these fantasies exemplify the power dynamics inherent in the relationship between the mother-father-child or first-second-third, as well as those that come into play in the sexual relation. Even in masturbation, in the sexual relationship with oneself, there is an element of dominance and submission. One may be performing the act on oneself, by oneself, but in the realm of fantasy, one is performing for someone or in some scenario.

This triangulation allows for movement or metonymy between positions, as no matter in which position one might begin, we may concurrently take the stance of the other(s) as well and, therefore, in turn occupy both (and all) positions. We are voyeur and exhibitionist: we are being seen while enacting and observing the scene, exposing ourselves as we bear witness to the exposure. Duchamp played with this positioning, luring his audience into scenarios that were often unsure and unsettling. He designed not objects but rather situations. It's as if he wondered what would happen next, as he placed others in unexpected circumstances of his own design; seducing

the viewer into looking again and looking closer. Perhaps his intention may have been to assess the reaction of the audience members, as he often seemed to be playing with inducing feelings of excitement, arousal, curiosity or even disgust, invoked in the witness by the works of "art" he created. By placing the viewer in a particular position in relation to the art object he has created, Duchamp therefore places that person in relation to himself also, as the artist who created the object. In this way, Duchamp is playing the game of power dynamics that we see at work in the sexual relation: he is a participant in the game by the proxy of his art object; he positions the viewer in relation to himself by way of said object, while also assuming the position of the witness who is observing the scene he himself crafted.

To add another level to this, throughout his life and career Duchamp maintained an air of nonchalance, seeming to disregard the ways of the world – the art world and otherwise. However, this added level of feigned indifference only further captures the essence of the game Duchamp played, as if to say, "Who, me?" as he throws his hands up in the air and walks away, leaving the audience with a sense of unease and bewilderment, wondering and wanting more.

Toward the end of his life Duchamp stated, "I believe that art is the only form of activity in which man shows himself to be a true individual" (Tomkins, 1996, p. 12). He espoused the necessity of the creative process, adamantly believing that:

> the possibility of creative activity had to be available to every individual, and an individual was what Duchamp himself simply tried to be.
> (Moure, 1988, p. 8)

> What he was interested in above all was freedom – complete personal and intellectual and artistic freedom – and the manner in which he achieved all three was, in the opinion of his close friends, his most impressive and enduring work of art.
> (Tomkins, 1996, p. 13)

Notes

1 Biographical information taken from Tomkins, C. (1996) *Duchamp: A Biography*. New York: Henry Holt & Co.
2 Tomkins, C. (1996) *Duchamp: A Biography*. New York: Henry Holt & Co. p. 116.
3 *Dada and Surrealism: Europe after the rain*. (1978) Mick Gold (dir.). England: Arts Council of Great Britain.

4 Young-Bruehl, E. (1988) *Anna Freud: A Biography.* New York: Summit.

Bibliography

Ades, D. & Brotchie, A. (2013) *Three New York Dadas and the Blind Man.* London: Atlas Press.

Ades, D. & Jeffett, W. (eds.) (2018) *Dalí/Duchamp.* London: Royal Academy of Arts.

Blythe, S. & Powers, E. (2006) *Looking at Dada.* New York: The Museum of Modern Art.

Buffet-Picabia, G. (1949) "Some memories of pre-Dada: Picabia and Duchamp." Reprinted in Robert Motherwell (ed.) (1951) *The Dada Painters and Poets: an Anthology.* (2nd edition). Cambridge: The Belknap Press of Harvard University Press. pp. 255–267.

Butler, J. (1990) *Gender Trouble: Feminism and the Subversion of Identity.* London: Routledge

Cabanne, P. (1987) *Dialogues with Marcel Duchamp.* New York: Da Capo Press.

Demos, T.J. (2007) *The Exiles of Marcel Duchamp.* Cambridge: MIT Press.

Freud, S. (1919) "'A child is being beaten': a contribution to the study of the origin of sexual perversions." *The Complete Standard Edition of the Psychological Works of Sigmund Freud (SE)* XVII. London: Hogarth Press. pp. 175–204.

Guggenheim, P. (2005) *Out of This Century – Confessions of an art addict: The autobiography of Peggy Guggenheim.* London: Andre Deutsch Ltd.

Hagman, G. (2010) *The Artist's Mind: a psychoanalytic perspective on creativity, modern art and modern artists.* London: Routledge.

Hartigan, L. et al. (2015) *Joseph Cornell: Wanderlust.* London: Royal Academy Publications.

Hemus, R. (2009) *Dada's Women.* New Haven: Yale University Press.

Henderson, L. (1998) *Duchamp in Context.* Princeton, NJ: Princeton University Press.

Judovitz, D. (1998) *Unpacking Duchamp: Art in transit.* University of California Press.

Lacan, (2006) *Écrits: The first complete edition in English.* Translated by B. Fink. New York: W.W. Norton & Co.

Laplanche, J. (2011) *Freud and the Sexual: Essays 2000–2006.* Translated by J. House, J. Fletcher & N. Ray. New York: IP Books.

Leader, D. (2000) "Beating fantasies and sexuality." In Salecl, R. (ed.) *Sexuation.* Durham: Duke University Press.

Mink, J. (2000) *Marcel Duchamp (1887–1968): Art as anti-art.* Cologne: Taschen.

Motherwell, R. (1951, 2nd edition) *The Dada Painters and Poets: An anthology.* Cambridge: The Belknap Press of Harvard University Press.

Moure, G. (1988) *Marcel Duchamp*. London: Thames & Hudson.
Mundy, J. (ed.) (2008) *Duchamp, Man Ray, Picabia*. London: Tate Publishing.
Naumann, F. & Obalk, H. (2000) *Affect/Marcel: The selected correspondence of Marcel Duchamp*. London: Thames & Hudson.
Naumann, F. & Venn, B. (eds.) (1996) *Making Mischief: Dada invades New York*. New York: Whitney Museum of Art.
Paz, O. (1990) *Marcel Duchamp: Appearance stripped bare*. New York: Arcade Publishing.
Richter, H. (1964) *Dada: Art and anti-art*. New York: Thames & Hudson.
Roosevelt, T. (1913) "A layman's views of an art exhibition," *Outlook*, 103, Reprinted in Nash, R. (ed.) (1970) *The Call of the Wild* (1900–1916). New York: George Braziller. pp. 718–720.
Rubin, W. (1967) *Dada, Surrealism, and Their Heritage*. New York: The Museum of Modern Art.
Sanouillet, M. & Peterson, E. (eds.) (1973) *The Writings of Marcel Duchamp*. New York: Da Capo Press.
Simac, C. (1992) *Dime-Store Alchemy: The art of Joseph Cornell*. New York: The New York Review of Books.
Sinclair, V.R. (2014) "The zeitgeist creating psychoanalysis and Dada." In Abrahamsson, C. (ed.) *The Fenris Wolf*, vol 7. Stockholm: Edda Books. pp. 38–45.
Sinclair, V.R. (2019) "*Das Unbehagen* of Duchamp, Dada and psychoanalysis." In Sinclair, V.R. (ed.) *Rendering Unconscious: Psychoanalytic perspectives, politics and poetry*. Stockholm: Trapart Books. pp. 210–214.
Tomkins, C. (1996) *Duchamp: A biography*. New York: Henry Holt & Co.
Tomkins, C. (2013) *Marcel Duchamp: The afternoon interviews*. Brooklyn: Badlands Unlimited.
Young-Bruehl, E. (1988) *Anna Freud: A biography*. New York: Summit.

Filmography

Dada and Surrealism: Europe after the rain. (1978) Mick Gold (dir.). England: Arts Council of Great Britain.
Marcel Duchamp: Art of the possible. (2018) Matthew Taylor (dir.). United States: Electrolift Creative & ZDF/Arte.

Part III

Revolution of mind

Part III
Revolution of mind

Chapter 7

Surrealism/Acéphale

Historically, surrealism has been the artistic movement most often associated with psychoanalysis, as the surrealists actively promoted Freud's ideas, studied his writings, and explored various methods for uncovering and working with unconscious material. The surrealists espoused the technique of free association, paying close attention to dreams, slips, synchronicity and chance. They tended to work in any fashion they found could minimize conscious interference of the ego and the psychic censor, thereby allowing the unconscious to come through, practicing automatic poetry, writing and drawing. There has been so much written on surrealism that I will just mention a few points of interest here.

Both the surrealist and psychoanalytic movements were heavily affected by World War II, as artists and intellectuals once again were forced to scatter. Many left their homelands in search of safety from persecution as both psychoanalysis and artistic avant-garde practices were proclaimed to be "degenerate." Two artists whose lives were inextricably affected were Leonora Carrington (1917–2011) and Max Ernst. The pair first met in 1937, at a London dinner party held in honor of the opening of a major exhibition of Ernst's work[1] and quickly fell in love. The couple stayed in Cornwall for a period of time with American photographer Lee Miller (1907–1977) and her husband, British artist Roland Penrose (1900–1984), who had organized the exhibition in London. Carrington was introduced "to a community that shared her passion for art and literature and her appreciation of black humour" (Chadwick, 2017, p. 61).

Carrington and Ernst soon relocated to Paris. During this time, Carrington created a painting for which she has since become known, *The Inn of the Dawn Horse (Self-Portrait)* (1937–1938), already revealing her surrealist style. In her work, Carrington seamlessly mixed dream and

reality, the magical and mundane, human and animal, natural and manmade. Not long after, the couple bought a house in the French countryside where they spent their days writing, drawing, painting and cooking. Ernst created collages to accompany Carrington's short stories, and the couple designed sculptures of humans with the heads of animals, and animals with the heads of humans, which they installed as guardians and gatekeepers around their home, as well as throughout their garden.

Drawing on imagery that fascinated each of them before their joint collaboration began, the artists often returned to themes of mythical and hybrid creatures, seemingly symbols of transformation:

> Horses and birds, both of which had emerged prior to the couple's meeting, soon became talismans and transitional beings that challenged oppositional terms like male/female, animal/human, mythic/real. They were readily incorporated into both artists' mythologies of hybridity, androgyny and the surrealist couple; of individual freedom and psychic and physical transformation.
>
> (Chadwick, 2017, pp. 66–67)

Upon moving to France, Carrington also became acquainted with Leonor Fini (1907–1996), who was a friend and former lover of Ernst's. Born in Buenos Aires, Argentina, and raised in her mother's native Trieste, Italy, Fini met the surrealists in Paris in 1935. She maintained close friendships with several surrealists including German artists Meret Oppenheim (1913–1985) and Hans Bellmer (1902–1975). However, despite participating in several surrealist exhibitions, Fini refused to ever officially join the group, rejecting the necessary submission to an authority figure or leader. Fini was to become a close friend and support for Carrington during the turmoil that was to come.

In 1939, Ernst was arrested as a German citizen in France. Hans Bellmer was also interned in the same prison at the same time:

> In Berlin before the War, German critics saw his work as "degenerate" and pornographic – lacking the idealism of the Aryan creed. When Bellmer came to Paris in 1938, his problems with censorship followed as the Nazis came to occupy France.
>
> (Morgan, 2013, p. 286)

Carrington spent months writing Ernst letters, bringing him gifts and meals. The prison guards relentlessly searched through what she brought for him, refusing to allow Ernst to eat the meals Carrington prepared. Though few and far between, Ernst continued to produce artwork while incarcerated – mostly collages and *frottages* ("rubbings") that were small enough to be smuggled out, hidden under a jacket or in the palm of one's hand.

Through the intervention of friend, fellow artist and, perhaps most importantly, French citizen, Paul Éluard (1895–1952), Ernst was eventually released and allowed to return home with Carrington. For a time, the couple had the opportunity to return to their life of writing, painting, cooking and gardening. Carrington's *Portrait of Max Ernst* (1939) dates from this period. However, Ernst was soon arrested again and imprisoned. This time friends insisted Carrington leave France and arranged for her to flee to Spain, where Fini and others had already relocated. However, upon arriving in Madrid, Carrington was abducted and raped by a group of Spanish soldiers; in distress she fled to the British Consulate where instead of receiving the help she sought, she was declared "mad."[2] Detained in a psychiatric hospital, Carrington suffered the mental decomposition outlined in her book, *Down Below* (1944/2017).

During the Second World War, psychoanalysts were being persecuted by both the Nazi and Soviet regimes. Psychoanalysis was deemed to be a "degenerate" profession and therefore outlawed. Many psychoanalysts were Jewish, and Freud's books were some of the first to be burned. Nevertheless, they persisted. Many psychoanalysts continued to meet in secret to study with one another and treat their patients. Freud remained in Vienna as long as he possibly could before finally fleeing to England on the insistence of his daughter Anna, with the aid of British psychoanalyst Ernest Jones (1879–1978) and French aristocrat and psychoanalyst Marie Bonaparte. Sabina Spielrein had returned to her native Russia in 1923, working there to facilitate psychoanalytic study and training at the newly formed Moscow Psychoanalytic Institute. By 1936,

> Stalin had turned violently against psychoanalysis […] forcing Spielrein to work in altruistic obscurity. When the war began, she refused to believe the civilized German citizens were capable of the atrocities that had been attributed to them.
>
> (Reisner, 2019, p. 14)

Spielrein and her daughters were murdered in 1942 by the SS Einsatzgruppe during the massacre of Zmievskaya Balka, Rostov-on-Don, considered to be the largest mass murder of Jewish persons on Russian territory, with approximately 27,000 Jewish and Soviet civilians massacred.[3]

In the summer of 1940, Max Ernst was once again released from prison, this time due to the influence of Peggy Guggenheim. He returned to the home he had shared with Carrington, but by this time the house was deserted. Ernst and Guggenheim rescued a few paintings that remained there and traveled to New York, where he and Guggenheim married. By this time, Carrington was also able to make arrangements to flee Europe for Mexico via her marriage to Mexican ambassador, poet and journalist Renato Leduc (1897–1986). In a surreal moment indeed, as Carrington prepared to leave Europe via Portugal, she ran into Ernst by chance:

> There, in May 1941, while browsing through a Lisbon market piled with vegetables and fruits, Leonora suddenly found herself face-to-face with Max. The shock was mutual and its implications quick to surface, as the former lovers realized that both were now dependent on others for their survival.
>
> (Chadwick, 2017, p. 101)

Once in New York, Ernst connected with many fellow artists in exile, including Marcel Duchamp, Salvador Dalí, André Breton (1896–1966), André Masson (1896–1987) and Yves Tanguy (1900–1955).[4] Similarly, many psychoanalysts emigrated to New York at this time to avoid persecution, including Wilhelm Reich (1897–1957), Erich Fromm (1900–1980), Frieda Fromm-Reichmann (1889–1957) and Edith Jacobson (1897–1978), profoundly influencing the psychoanalytic and broader cultural landscape in the United States.

André Breton found in Max Ernst's works an entirely original and exhilarating form of expression that corresponded with a quality he reported he had been seeking in art and poetry. He felt that photography had rendered traditional kinds of painting obsolete, dealing a mortal blow to the old modes of expression, while describing automatic writing in poetry to be "a true photography of thought" (Ades, 1976, p. 20). Breton himself had discovered automatic writing in 1919, quickly taking to it. He has described using automatic writing exclusively to write his poetry, attempting to paint

pictures with words, creating a succession of images and swift passage of ideas, much like a dream or flowing current of free associations (Aspley, 2010, p. 8). Breton wrote the *Surrealist Manifesto* in 1924, and with that announced himself as the leader of the surrealist group.

Jacques Lacan came of age in the same cultural and intellectual environment as surrealism at its peak in Paris.[5] As a teenager, the young Lacan frequented the now famous bookshop of Adrienne Monnier (1892–1955), La Maison des Amis des Livres, at 7 rue de l'Odéon. There he became acquainted with the likes of André Breton, Louis Aragon (1897–1982) and Philippe Soupault (1897–1990), among others. Monnier offered advice and encouragement to Sylvia Beach (1887–1962) when she founded an English language bookstore called Shakespeare and Company across the street from Monnier's in 1919. Here, a young Lacan listened spellbound to the first readings of *Ulysses* by James Joyce (1882–1941) (Roudinesco, 1997, p. 13). Lacan was already interested in Dadaism and soon immersed himself in the new perspectives and early manifestations of surrealism as well.

> Automatic writing, exquisite corpses, dream exploration (under Freud's patronage), praise of hysteria (whose "centenary" was celebrated by Aragon and Breton in 1928), in short, the bold free plunge into depths written off as lunacy by psychiatrists, and reasons to live sought out in unreason itself: here was fascination enough.
> (Grosrichard, 1987, p. 159)

Lacan embarked on his medical career at a time when interest in Freud was widespread. France's first psychoanalytic society was founded in Paris in 1926, at the same time the literary, artistic and intellectual avant-garde were embracing Freud's ideas. According to Lacan's biographer, French historian and psychoanalyst Élisabeth Roudinesco (b. 1944):

> Whereas the physicians were chauvinistic and took a strictly therapeutic view of psychoanalysis, the writers accepted the idea of a wider sexuality, declined to look on Freudianism as a "Germanic culture," and maintained that psychology did not belong exclusively to doctors.
> (Roudinesco, 1997, p. 16)

This is a familiar divide in the field that continues to this day.

Lacan began to incorporate insights from surrealist experiments with Freudian psychoanalysis and the dominant views held in the field of medical psychiatry at the time. Toward the end of his medical training, Lacan came across an article in the first issue of *Surrealism in Service of the Revolution* (1930) in which Salvador Dalí proclaimed his theories on paranoia. An avid reader of psychoanalytic theory, the first Spanish translation of Freud's *Interpretation of Dreams* in 1922 had made Dalí an almost fanatical Freud enthusiast. According to Roudinesco, this encounter with Dalí's theories spawned in Lacan a new understanding of language as it related to psychosis. The contents of Dalí's article "L'âne pourri" ("The rotten donkey"), combined with Lacan's remarkable knowledge of philosophy, in particular Baruch Spinoza (1632–1677), Friedrich Nietzsche, Edmund Husserl (1859–1938), Henri-Louis Bergson (1859–1941) and Karl Jaspers (1883–1969), contributed to the development of his medical thesis, *Paranoid Psychosis and its Relation to Personality* (1932), which won Lacan early acclaim. Lacan was careful not to note the influence the surrealists had on his thinking, wary of the affect such knowledge would have on his professors' and colleagues' opinions of his work. However, immediately following publication, Dalí praised Lacan's achievement in the first issue of *Minotaure* (1933):

> Because of it we can for the first time arrive at a complete and homogeneous idea of the subject, quite free of the mechanistic mire in which present-day psychiatry is stuck.
>
> (Roudinesco, 1997, p. 60)

Dalí and Lacan remained friends, as Lacan continued to socialize within surrealist circles and himself contributed to surrealist publications such as *Minotaure* (1933–1939).

It is interesting to consider how these artists and intellectuals influenced one another. Dalí and Duchamp were also long-term friends:

> The friendship beginning in Paris in the context of Surrealism, a movement of which Dalí was an enthusiastic member and Duchamp a courted but slightly remote affiliate, and lasted until Duchamp's death.
>
> (Ades & Jeffett, 2017, p. 15)

Though often described as polar opposites, the men admired each other. When Dalí created his *10 Recipes for Immortality* (1973), he declared the work was an homage to Duchamp. Housed in a box – or, one might claim, a suitcase of its own – Dalí designed meticulous instructions of the exercises contained therein. Additionally, sounding very Lacanian indeed, Duchamp once told his biographer:

> There is absolutely no chance for a word ever to express anything [...] As soon as we start putting our thoughts into words and sentences, everything goes wrong.
>
> (Tomkins, 1996, p. 68)

Furthermore, Dalí once had the opportunity to meet Freud. Upon hearing of Freud's flight to London escaping Nazi persecution in 1938, Dalí requested that Arnold Zweig (1887–1968) – writer, friend and analysand of Freud – arrange a meeting between the two. Zweig described Dalí to Freud as "the only painter of genius in our epoch" and "the most faithful and most grateful disciple of your ideas among the artists" (Brown, 2012, p. 295). During the meeting Dalí sketched Freud, and this drawing is now housed in the Freud Museum, London.[6]

Psychoanalyst Ray O'Neill (b. 1971) discusses this meeting, as well as Dalí's exploration of the double and narcissism in his work; incidentally, *The Metamorphosis of Narcissus* (1937) is the piece with which Dalí was preoccupied at the time and wished to discuss with Freud during their meeting. Less well known is that Dalí wrote a poem of the same title to accompany this painting:

> Like mirroring like; language augmenting art; signifiers doubling the image, this was the first work Dalí ascribed as being painted in his paranoid, critical interpretive methodology.
>
> (O'Neill, 2017, p. 199)

Even still less well-known, at birth Dalí was given the same name as an older brother who had died as an infant. Dalí carried this name, and its accompanying weight, with him throughout life – haunted, as mirrors, reflections, doubles and *doppelgängers* became a recurring theme he explored through the medium of his art. In considering all of this, O'Neill

poses the question, "What's in a name?" as he explores our names as signifiers loaded with information, coming to us across time, through ancestry, history and culture:

> But this is not *my* name. It is my parents' name for me [...] Our names are never our own, they come with legacies, desires, significations and ghosts.
>
> (O'Neill, 2017, p. 196)

Over time, Breton became increasingly rigid in his adherence to his ideals. Rather than allowing the artists in the surrealist fold their own freedom of expression, he became dogmatic about what techniques and ways of working allowed for "maximum" illumination of the unconscious, deciding definitively that only artists working in the most automatic and free-associative way possible could be considered Surrealist. By the time he wrote his *Second Manifesto* (1929), Breton:

> had proclaimed the necessity of seeking out a "point of mind" from which man might resolve the contradiction between real life and dream. Experiment in hypnotically induced sleep and automatic writing was a thing of the past; a new field of operations must be found in political action.
>
> (Roudinesco, 1997, p. 31)

As a result, a multitude of artists were catapulted from the fold of the formal surrealist movement on the direction of Breton, including Max Ernst, who was "expelled" in 1954, after accepting an award at the Venice Biennale, and Salvador Dalí, for refusing to adhere to Breton's political standpoint.

The dogmatic conditions facilitated by this self-imposed father figure led to many splits throughout the surrealist movement. Upon his break with Breton, Georges Bataille (1897–1962) felt compelled to create a group of his own, which he called *Acéphale* or "headless," connoting a group without a definitive leader; members had autonomy and agency, and were encouraged to work in whichever ways they felt so inspired. The cover art for the first issue of Bataille's accompanying publication *Acéphale* (1936)[7] was created by André Masson, who drew a rendition of Leonardo da Vinci's *Vitruvian Man* (1492) with no head, seemingly decapitating conventional

reason. The idea of this type of headless community has been a staple of avant-garde movements throughout time. Valiant attempts occur again and again, as revolutionaries challenge structures of power, but inevitably end up falling prey to group dynamics, as authority and hierarchy creep back in, and the revolutionary becomes the next system in place. Bataille did his best subvert this well-worn cycle of the avant-garde becoming the next institution, aiming to avoid recreating the stranglehold he felt Breton had on Surrealism proper.

Similar challenges have also been present in the psychoanalytic community over the decades, as parties have split off from groups and institutions to form their own organizations. The "proper" way to conduct and transmit psychoanalysis, including the "correct" method of training and psychoanalytic formation has been a debate since at least 1926. At that time, the credentials of Theodor Reik (1888–1969), one of Freud's earliest students, were called into question for practicing psychoanalysis as a non-physician. Reik earned a doctorate in psychology from the University of Vienna in 1912, but was not a medical doctor. In response, Freud wrote *The Question of Lay Analysis: Conversations with an Impartial Person* (1926), defending the rights of non-physicians to become psychoanalysts. Decades later, Reik left Europe for the United States, where he founded the National Psychological Association for Psychoanalysis (NPAP) in New York.

In Britain, there were what were called the "controversial discussions" from 1942–1944, which led to an official augmentation of the policies of psychoanalytic training at the British Psychoanalytical Society in 1946. The community had split into camps, dividing those analysts who followed the work of Anna Freud from those who espoused the theories and practices of Melanie Klein. A third group also developed, that was known as the "Middle" or "Independent" group:

> In Britain there was a clear conflict between two opposing doctrines, and the advent of a third school had forced the adversaries to conclude a treaty of peaceful coexistence.
> (Roudinesco, 1997, p. 201)

Some years later in France, it had become evident that Lacan was not obeying the technical rules of psychoanalytic practice put in place in the 1920s and 1930s. According to the rules of the International Psychoanalytical

Association (IPA), an analysis was to last for several years at a frequency of four to five sessions per week, each session lasting exactly 50 minutes. Lacan hadn't yet begun to use what came to be known as "short sessions," but was experimenting with variable-length sessions. After multiple attempts to explain and defend his theories and practice to his contemporaries, Lacan resigned from the Société psychanalytique de Paris (SPP) in 1953 and joined the newly formed Société Française de Psychanalyse (SFP); in so doing, he inadvertently also left the IPA. Over the next decade, the SFP worked to obtain IPA affiliation; however, the main obstacle was Lacan's unorthodox practice. The two organizing bodies finally came to an agreement: the SFP could only be affiliated with the IPA on the condition that Lacan and his teachings were expelled. The IPA not only refused Lacan's teaching but also threatened to ban anyone else who dared to promote Lacan's ideas. In January 1964, Lacan began his first seminar following this excommunication. In his own words:

> For ten years, I held what was called a seminar, addressed to psychoanalysts. As some of you may know, I withdrew from this role (to which I had in fact devoted my life) as a result of events occurring within what is called a psycho-analytic association, and, more specifically, within the association that had conferred this role upon me[.]
>
> My teaching [...] has been the object of censure by a body calling itself the Executive Committee of an organization calling itself the International Psycho-analytical Association. Such censorship is of no ordinary kind, since what it amounts to is no less than a ban on this teaching – which is to be regarded as null and void as far as any qualification to the title of psycho-analyst is concerned. And the acceptance of this ban is to be a condition of the international affiliation for the Psycho-analytical Association to which I belong.
>
> But this is not all. It is expressly spelt out that this affiliation is to be accepted only if a guarantee is given that my teaching may *never again* be sanctioned by the Association as far as the training of analysts is concerned.
>
> So, what it amounts to is something strictly comparable to what is elsewhere called major excommunication [...] The latter exists only in a religious community.
>
> (Lacan, 1978, pp. 1–3)

With this statement, Lacan laid out his case quite eloquently while at the same time putting what he practiced into play: challenging the very structures underlying such proclamations and questioning those who claim authority.

What became known as psychoanalysis in the latter half of the 20th century was hardly recognizable when compared with what Freud had originally had in mind. In the United States, the strain of psychoanalysis that came to become known as *ego-psychology* flourished, as its premise and practice promoted the strengthening of one's ego and defenses, so that the analysand may become "resilient," able to stand fast in times of stress and pressure, when havoc is wreaked from the outside as well as from within. This type of psychoanalysis developed from the theories of Anna Freud, as outlined in *The Ego and the Mechanisms of Defence* (1946). As her famous father analyzed her (and wrote about it, however disguised), from a psychoanalytic point of view, it's no wonder Anna went on to work primarily with children and developed a rigorous theory of psychic defenses.

Lacan called for a "return to Freud" in which he set to return to the study of Sigmund Freud's original texts, rather than continuing the debate of psychoanalytic terms and literature that had continued on since his death:

> Analysts in general have not yet caught up with these concepts [...] in this literature most of the concepts are distorted, debased, fragmented, and that those that are too difficult are quite simply ignored.
> (Lacan, 1978, p. 11)

Lacan posited that the fundamental notions of Freud had been all but forgotten, erased and pushed aside, in a move of repression – whether that be conscious or unconscious – and that Freud himself had in fact predicted that this would occur:

> [T]his dimension of the unconscious that I am invoking *had been forgotten*, as Freud had quite clearly foreseen. The unconscious had closed itself up against his message thanks to those active practitioners of orthopaedics that the analysts of the second and third generation became, busying themselves, by psychologizing analytic theory, in stitching up this gap.
> (Lacan, 1978, p. 23)

At present, a diverse group of psychoanalysts, psychologists, philosophers, graduate students and other intellectuals interested in the study of psychoanalysis have taken up these ideas, coming together across "national lines" to meet under the signifier Das Unbehagen[8] – a reference to Freud's *Das Unbehagen in der Kultur* ("Civilization and its Discontents") (1930). Calling itself "a free association for psychoanalysis," the group spawned from a growing frustration with the constraints of traditional psychoanalytic institutes, specifically those belonging to the American Psychoanalytic Association (APsaA) and extending to the IPA. These clinicians set out to reimagine the idea of psychoanalytic community in a way that would hopefully revitalize the field from the inside out, breaking out of what was felt to be the stagnation that had resulted from rigid hierarchical and authoritarian structures in place regarding the training – or what Lacan preferred to call the *formation* – of psychoanalysts.

> If there is an image which could represent for us the Freudian notion of the unconscious, it is indeed that of the acephalic subject, of a subject who no longer has an *ego*, who doesn't belong to the *ego*. And yet he is the subject who speaks[.]
> (Lacan, 1991, p. 167)

The very first public event held by Das Unbehagen was a meeting with Otto Kernberg (b. 1928) in 2012[9] to discuss his work, best summarized in the article "Thirty methods to destroy the creativity of psychoanalytic candidates," which he describes as "essentially a plea for the fostering of psychoanalytic creativity" (Kernberg, 1996, p. 1031). In this tongue-in-cheek piece, Kernberg refers to many aspects of the slow, cumbersome process of institutional psychoanalytic training:

> If the students acquire a grasp of the methodology of Freud's thinking, which was unavoidably revolutionary, this may lead them to dangerous identifications with his originality and thus defeat the purpose.
> (Kernberg, 1996, p. 1032)

It is noted in the introduction[10] that Kernberg wrote this article just before he was to begin his term as president of the IPA. A decade earlier, in 1986, he had written another important essay, "Institutional problems of psychoanalytic education," where he first addressed what he described as the

paranoid atmosphere cultivated at some institutes, as well as the difficult relationship between the educational process and the therapeutic aspects of training, noting the phenomenon of psychoanalytic candidates undergoing one course of psychoanalytic treatment to meet the requirements of institutional training and then later undertaking a second period of psychoanalytic treatment, "for themselves" (Kernberg, 1986, p. 802).

The three major components in the process of becoming a psychoanalyst are: 1. to undergo one's own analysis; 2. to study psychoanalytic history, theory, ethics and practice; and 3. to be supervised by a psychoanalyst while learning to facilitate psychoanalytic treatment. Institutions gather these components into a formal course of structured psychoanalytic study and practice, while the psychoanalyst-to-be is in "training" or "formation," which culminates in the awarding of a certificate once all of the outlined requirements have been met. This may be useful for those who work well within this type of framework, but it is by no means the only route to becoming a psychoanalyst. The road to becoming a psychoanalyst has been "under construction," so to speak, since the inception of the field.

One of the main focuses of Das Unbehagen is to maintain an ongoing dialogue concerning the process of psychoanalytic formation itself, whether this be via formal psychoanalytic training at an institute, independent study and development, or a combination of resources. Lacan finally came to the conclusion that only the analyst has the authority to authorize oneself, stating:

> What hierarchy could confirm him as an analyst, give him the rubber stamp? A certificate tells me I was born. I repudiate this certificate: I am not a poet but a poem. A poem that is being written, even if it looks like a subject.
>
> (Lacan, 1978, p. viii)

Lacan also brought the question of lay analysis back to the forefront. Freud had supervised and mentored people from all kinds of professional backgrounds; if one displayed the desire to become a psychoanalyst, Freud encouraged and supported formation. Over the decades, the field of psychoanalysis became increasingly regulated, as medical doctors began to take a strong hold, pushing psychologists and other clinicians out of the field for decades in many places. In the United States in the 1980s, for example, psychologists had to fight for the right to be practicing psychoanalysts by

filing lawsuits targeting APsaA and other authorizing bodies (Wallace & Gach, 2008, p. 673). Many psychoanalytic institutes continue to refuse to admit mental health counselors, social workers and other clinicians having masters-level graduate education, or people wishing to become lay analysts, who often hold doctorate degrees in non-clinical fields, such as literature or the humanities, where psychoanalytic theory is actually more readily taught nowadays than in standard psychology graduate programs. In *The Question of Lay Analysis*, after defending his position that non-physicians should have the right to train and practice as psychoanalysts, Freud concluded:

> It is by no means so important what decision you give on the question of lay analysis. It may have a local effect. But the things that really matter – the possibilities in psycho-analysis for internal development – can never be affected by regulations and prohibitions.
> (Freud, 1926, p. 250)

Das Unbehagen encourages rigorous study of psychoanalytic history, theory, ethics and practice, and hosts lectures and conferences with prominent psychoanalysts in the field. Members have formed peer supervision, study, and working groups, contemplating such topics as: creating support structures for those taking on analytic work independently; psychoanalytic formation; case presentation; investigating systemic violence in mental health services in general and in the United States in particular; and bringing psychoanalytic treatment to historically underserved populations.

Das Unbehagen strives to maintain itself as a group of individuals forming a series of lateral relationships, coming together to facilitate events and publications, thereby developing a platform to support independent professionals interested in the study and practice of psychoanalysis, free from authoritarian, legitimizing bodies. Members wish to revitalize the field of psychoanalysis in an ethical manner and bring new impetus to Freud's discoveries. Das Unbehagen continuously considers questions around the event of its own inception, as well as maintenance of the analytic position and what that would mean for a collective of this sort: a group attempting to exist without ordained leaders. Free from formal hierarchical structures and authorizing bodies, the key is to be able maintain this position – a position akin to the analytic position – and not be swept up again in the well-worn cycle of the avant-garde becoming

the next institution. Needless to say, though Das Unbehagen is open to professionals and students of all theoretical orientations, the group has a heavy base of Lacanian scholars and clinicians, as Lacan's own views on psychoanalytic formation lend themselves well to the independent spirit of autonomous psychoanalytic development, outside of the constraints of psychoanalytic institutions.

Freud once called psychoanalysis the knowledge that "disturbed the peace of the world" (1917, p. 285). What happened? Even as early as the time of the surrealists, psychoanalysis was seen by some as yet another method of compartmentalization and categorization. When did free association become co-opted as a means of organization and normalization? When did the focus shift away from the desire to enable the subject to speak with no intention set upon what the outcome should be?

> Lacan sought to bring plague, subversion, and disorder to the moderate Freudianism of his time. It was a Freudianism that, having survived fascism, had adapted itself so well to democracy that it had almost forgotten the violence of its origins.
>
> (Roudinesco, 1997, p. xv)

The Dadaists moved away from formal organization and conventional structure by embracing chance, dreams, free association and automatic writing. Marcel Duchamp remained autonomous while playing a key role in several artistic movements over the course of his development. In this vein, Das Unbehagen has the potential to be a vehicle of support for individuals who desire to forge their own paths, whether completely comprised of independent study or utilizing external resources to supplement formal training. Practitioners are welcome from every theoretical orientation and may remain a part of any institution they wish. What is encouraged is self-direction, the building of bridges, and the fostering of working relationships.

Notes

1 Biographical information tracing the relationship between Leonora Carrington, Max Ernst, Leonor Fini and Peggy Guggenheim culled from Chadwick, W. (2017) *The Militant Muse: Women of surrealism.* London: Thames & Hudson. pp. 60–102.

2 Chadwick, W. (2017). *The Militant Muse: Women of surrealism.* London: Thames & Hudson. p. 100.
3 Jewish Community of Rostov. (2012) "Rostov Holocaust at Zmiyovskaya Balka" [Online]. Jewish Rostov. Available at www.jewishrostov.com/holocaust (Accessed: February 17, 2020).
4 *Dada and Surrealism: Europe after the rain* (1978) Mick Gold (dir.). England: Arts Council of Great Britain.
5 Biographical information of Lacan from Roudinesco, E. (1997) *Jacques Lacan.* New York: Columbia University Press.
6 Freud Museum London. (2018) "Freud, Dalí and *The Metamorphosis of Narcissus*" [Online]. Freud Museum London. Available at www.freud.org.uk/exhibitions/freud-dali-and-the-metamorphosis-of-narcissus/ (Accessed: February 22, 2020).
7 Barok, D. (2017) "Acéphale" [Online]. Monoskop. Available at https://monoskop.org/Acéphale (Accessed: March 8, 2020).
8 Das Unbehagen. (2012) "A free association for psychoanalysis" [Online]. Das Unbehagen. Available at http://dasunbehagen.org/ (Accessed: August 23, 2019).
9 Das Unbehagen. (2012) "Otto Kernberg: The Suicide of Psychoanalytic Institutes" [Online]. Das Unbehagen. Available at http://dasunbehagen.org/event/otto-kernberg-the-suicide-of-psychoanalytic-institutes/ (Accessed: March 3, 2020).
10 Kernberg, O. (1996). "Thirty methods to destroy the creativity of psychoanalytic candidates." Introduction by Paolo Migone. [Online]. PsychoMedia Telematic Review. Available at www.psychomedia.it/pm/modther/probpsiter/kernberg-2.htm (Accessed February 17, 2020).

Bibliography

Ades, D. (1976) *Photomontage.* London: Thames and Hudson.
Ades, D. (2006) *The Dada Reader: A critical anthology.* Chicago: The University of Chicago Press.
Ades, D. & Brotchie, A. (2013) *Three New York Dadas and the Blind Man.* London: Atlas Press.
Ades, D. & Jeffett, W. (eds.) (2017) *Dalí/Duchamp.* London: Royal Academy of Arts.
Aspley, K. (2010) *Historical Dictionary of Surrealism.* Maryland: Scarecrow Press.
Badiou, A. (2000) *Ethics: An essay on the understanding of evil.* New York: Verso.
Bataille, G. (1986) *Erotism: Death and sensuality.* San Francisco: City Lights.
Bataille, G. (1994) *The Absence of Myth: Writings on surrealism.* London: Verso.

Brown, C. (2012) *Hello, Goodbye, Hello: A circle of 101 remarkable meetings.* New York: Simon & Schuster.
Carrington, L. (1944/2017) *Down Below.* New York: New York Review of Books.
Carrington, L. (2017) *The Complete Stories of Leonora Carrington.* St. Louis, MO: Dorothy Project.
Chadwick, W. (2017) *The Militant Muse: Women of surrealism.* London: Thames & Hudson.
Dalí, S. (1942) *The Secret Life of Salvador Dalí.* New York: Dial Press.
Dalí, S. (1973) *Hidden Faces.* London: Peter Owen Ltd.
Finkelstein, H. (ed.) (2017) *The Collected Writings of Salvador Dalí.* St. Petersburg, Florida: The Salvador Dalí Museum.
Freud, A. (1995) *The Ego and the Mechanisms of Defence.* London: Karnac Books.
Freud, S. (1917) "Introductory lectures on psycho-analysis; Lecture XVIII: Fixation to traumas – the unconscious." *The Complete Standard Edition of the Psychological Works of Sigmund Freud (SE)* XVI. London: Hogarth Press. pp. 273–285.
Freud, S. (1926) *The Question of Lay Analysis. SE* XX. London: Hogarth Press. pp. 177–258.
Freud, S. (1930) *Civilization and its Discontents. SE* XXI. London: Hogarth Press. pp. 59–145.
Goerg. C., et al. (1987) *Focus on Minotaure: The animal headed review.* Geneva: Musée d'Art et d'Histoire.
Grosrichard, A. (1987) "Dr. Lacan, 'Minotaure,' Surrealists encounters." In Goerg, C. et al. *Focus on Minotaure: The animal headed review.* Geneva: Musée d'Art et d'Histoire.
Guggenheim, P. (2005) *Out of This Century – Confessions of an art addict: The autobiography of Peggy Guggenheim.* London: Andre Deutsch Ltd.
Hartigan, L., et al. (2015) *Joseph Cornell: Wanderlust.* London: Royal Academy Publications.
Kernberg, O. (1986) "Institutional problems of psychoanalytic education." *Journal of the American Psychoanalytic Association,* 34 (4). pp. 799–834.
Kernberg, O. (1996) "Thirty methods to destroy the creativity of psychoanalytic candidates." *International Journal of Psycho-Analysis,* 77 (5). pp. 1031–1040.
Kostelanetz, R. (2001) *A Dictionary of the Avant-Gardes.* (2nd edition). New York: Routledge.
Lacan, J. (1978) *The Four Fundamental Concepts of Psycho-analysis.* Translated by A. Sheridan. New York: W.W. Norton & Co.
Lacan, J. (1991) *The Seminar of Jacques Lacan, Book II: The Ego in Freud's Theory and in the Technique of Psychoanalysis (1954–1955).* Translated by S. Tomaselli. New York: W.W. Norton & Co.

Laplanche, J. & Pontalis, J-B. (1973) *The Language of Psycho-analysis*. Translated by Donald Nicholson-Smith. New York: W.W. Norton & Co.

Lomas, D. (2011) *Narcissus Reflected: The myth of Narcissus in surrealist and contemporary art*. Edinburgh: The Fruitmarket Gallery.

Morgan, R.C. (2013) "Hans Bellmer – The infestation of Eros." In Abrahamsson, C. (ed.). *The Fenris Wolf*, vol. 6. Stockholm: Edda Publishing. pp. 285–293.

O'Neill, R. (2017) "Double Double, Toil and Trouble; Psychoanalysis Burn and Surrealism Bubble." In Sinclair, V.R. & Abrahamsson, C. (eds.) *The Fenris Wolf*, vol. 9. Stockholm: Trapart Books.

Penrose, A. (2006) *The Home of the Surrealists: Lee Miller, Roland Penrose and Their Circle at Farley Farm*. London: Frances Lincoln.

Reisner, G. (2019) "The Absent Feminine: Overlooking the fusion of love and death in Sabina Spielrein's 'Destruction as the Cause of Coming into Being.'" In Sinclair, V.R. (ed.) *Rendering Unconscious: Psychoanalytic perspectives, politics and poetry*. Stockholm: Trapart Books. pp. 14–25.

Roudinesco, E. (1997) *Jacques Lacan*. New York: Columbia University Press.

Rubin, W. (1967) *Dada, Surrealism, and Their Heritage*. New York: The Museum of Modern Art.

Sinclair, V.R. (2019) *"Das Unbehagen* of Duchamp, Dada and psychoanalysis." In Sinclair, V.R. (ed.) *Rendering Unconscious: Psychoanalytic perspectives, politics and poetry*. Stockholm: Trapart Books. pp. 210–214.

Tomkins, C. (1996) *Duchamp: A biography*. New York: Henry Holt & Co.

Wallace, E. & Gach, J. (2008) *History of Psychiatry and Medical Psychology: with an epilogue on psychiatry and the mind-body relation*. New York: Springer.

Young-Bruehl, E. (1988) *Anna Freud: A biography*. New York: Summit.

Filmography

Dada and Surrealism: Europe after the rain. (1978) Mick Gold (dir.). England: Arts Council of Great Britain.

Chapter 8

Double-bind
Cutting the bonds of gender

The final surrealist exhibition before the outbreak of World War II was the Exposition Internationale du Surréalisme (1938) in Paris, organized by André Breton with Paul Éluard, Marcel Duchamp, Salvador Dalí, Max Ernst and Man Ray, among others. Besides this being the quintessential last hurrah of the surrealist group, the prominent use of mannequins and Man Ray's haunting images[1] of these anthropomorphic figures as doubles is noteworthy.

In *The Uncanny* (1919), Freud described the work of Austrian psychoanalyst and close companion Otto Rank (1884–1939) and his exploration of the double:

> He has gone into the connections the "double" has with reflections in mirrors, with shadows, guardian spirits, with the belief in the soul and with the fear of death [...] For the "double" was originally an insurance against destruction to the ego, "an energetic denial of the power of death," as Rank says; and probably the "immortal" soul was the first "double" of the body.
>
> (Freud, 1919, pp. 234–235)

Work with the double in art may be seen as engagement with this place of the other, enactment with a figure or screen onto which we may project our desires. The m/Other or primary caregiver usually holds the place of this first "other" onto whom we project and by whom we are concurrently mirrored. However, we may also view this work with the double as representative and reflective of the fundamental split inherent in our very selves that both constitutes and harbors subjectivity.

To illustrate this, let us begin with the development of the individual and the individual's sense of self. Some schools of psychoanalysis posit that

we gain our sense of identity through the introjection of an identification with the m/Other that we then continue to modify via a series of identifications with other figures with whom we come into contact throughout our lives. In this way, we may be seen as constantly adding to and reworking our identity/ego throughout our lifespan. This is one way to view identity formation.

Lacan, however, explored the notion of identity a little differently with his theory of the *mirror stage*. During this time, approximately ages 6–18 months, the child experiences he/r sense of self and body as fragmented, but when s/he sees he/r self in the mirror, the mirror image appears to be whole. As the child's experience of he/r own body/self is fragmented, there seems to be a disconnect between he/r experience of he/r self and the image in the mirror. This experience of disconnection continues throughout life. Through a similar process of identification, this time identification with he/r own mirror image, the child is able to internalize the cohesive sense of self that s/he imagines the mirror self/image to have, which thus forms the ego/identity. We identify with what we imagine ourselves to perceive. The ego/identity is, therefore, an identification with a fantasy. At the moment the child recognizes he/r self in the mirror image, s/he turns to the m/Other sitting beside he/r, searching for a sign that he/r perception is accurate – that this whole person s/he sees in the mirror is in fact a reflection of he/r self. Once the m/Other provides affirmation of this, the child turns he/r attention back to the mirror image confirming that this perception is indeed he/r self, thereby reifying he/r identity.

However, the position of what would more accurately be considered to be the "true self," what Lacan calls the subject, is not equivalent to the ego/identity but rather is situated in the gap that exists between the self and the mirror image, consciousness and matter, the ego and the real of the body, perception and the unconscious, sexuality and death. Freud states that the ego is first and foremost a body ego. It is the product of our fantasy as we attempt to produce an experience of a cohesive body/self identification.

In *Beyond the Pleasure Principle* (1920), Freud likened the ego to a crust. One may think of it as a callous that is built up through repetition of experience, or a scab that forms when the skin is cut. The ego is our symptom. It is the scaffolding. But we as subjects are situated in the gap – in the space between. If identity can be understood as identification with a fantasy of what we imagine ourselves and/or m/Others to perceive us to be, which is then solidified by the repetition of similar experiences that

validate this fantasy, then why couldn't we choose to adjust that experience and those characteristics and mold our identity in a different way? In a way we choose, rather than being products of the system into which we are born.

We see the fantasy of cohesion break down in psychosis, for example, where the person is plagued by the experience of the fragmented body/self and unable to pull consciousness out of the real of the body and into the realm of the imaginary, which makes the experience of living more tolerable via fantasy. We also gain a glimpse of our real fragmented state in our dream lives, where we often experience a state of anxiety accompanied by pieces of a puzzle that we later string together upon retelling in an attempt to form a cohesive narrative. We actually perform a similar action in our waking lives as well, which is also a series of fragmented events that we string together with fantasy to create an experience of a cohesive narrative that we can then relate to ourselves and others. But as we've been discussing, we are able to take a step back, reflect on our understanding of events in our lives, alter our perception and rewrite our personal narrative in a way.

One of the fundamental theories Freud posited regarding dreamwork was the idea that a trace of our day – day residue – may be found in our dreams of that night: something that occurs during our day resonates with something that occurred in our past, usually in early childhood. This connection is a cut in itself – a cut through time – as each moment connects to every other similar moment, from our very recent past back through our earliest childhood experiences and memories. This is also why it is not important to remember every aspect of a dream; if one is able to grasp a fragment, that tiny sliver connects to many times and places in one's life.

It is also useful to view waking and dream states not as a binary of awake-asleep but rather a continuum of wakefulness-sleep/conscious-unconscious. In this way, we recognize that when we are asleep we oftentimes have "one eye open" and are able to perceive that which is happening in our environment. Often our dreams are a way to encourage ourselves to remain asleep. What we call our *censor* decides not only what will be allowed from the unconscious into the conscious mind – however altered it is in representation to veil its true meaning – but also masks stimuli from the environment, frequently incorporating it into the dreamwork (i.e., when an alarm clock becomes a fire alarm in our dream and we suddenly need to evacuate the building). Similarly, when we are

"wide awake" our unconscious mind is still active and is more or less present in daydreams, fantasies, imagination, etc. This concept of the ratio or continuum in a state of flux can be applied not only to dream-wake states and conscious-unconscious but also to aspects of identity such as homosexuality-heterosexuality and femininity-masculinity.

When reviewing this study of artists who have worked over the past century, it is remarkable how many have explored the concept of the double, utilizing mirrors, mannequins, masks, dolls or puppets in some fashion in their work; from the Dada works of Emmy Hennings, Sophie Taeuber-Arp and Hannah Höch to the surrealists and contemporary artists of our day, many artists explore subjectivity, identity, gender and sexuality through work with the double.

One such artist was French surrealist Pierre Molinier (1900–1976).[2] Born in *belle époque* Bordeaux on Good Friday the 13th, his mother was a seamstress and father a house painter specializing in creating faux finishes, particularly of wood; this is important to note, as Molinier seemed to have acquired such skills from his parents. As a young artist, Molinier first established himself as a more traditional landscape painter, but soon developed his own unique style, moving into photography, collage and photomontage. While the surrealists were Molinier's closest creative companions, he exhibited very rarely during his lifetime. In 1928, the avant-garde hit Bordeaux with the creation of a group in the vein of the Société des artistes indépendants of Paris. Molinier took an active role as a founding member and curator tasked with hanging the exhibitions. He remained active as a curator for the first few years but eventually withdrew from the organizing committee, though he continued to exhibit his work with the group. The only solo exhibition Molinier had during his lifetime was organized by André Breton at l'Étoile scellée in 1957 (Mercié, 2010, p. 309).

Much of Molinier's work consisted of self-portraits; he often photographed himself with the aid of mirrors. His home studio was full of them, containing several full-length mirrors, as well as mirrors propped on top of chests of drawers, another fastened above his bed, placed on the fireplace mantle and hanging on the walls; in addition to this, he often used a handheld cosmetics mirror. Molinier explored the fluidity of sexuality and experimented with the malleability of identity and gender. Using his own body as his central canvas, Molinier took self-portraits wearing lingerie, stockings, wigs and high-heeled shoes, which he usually sewed and fashioned himself. This focus on utilizing oneself as one's primary medium

continues to inspire to this day, as seen in the work of American artists Cindy Sherman (b. 1954) and Ron Athey (b. 1961), Australian performance artist Stelarc (b. 1946), and British artist Val Denham (b. 1957), to name a few.

Performance artists Breyer P-Orridge have become champions of Molinier as not only a radical aesthete but as a pioneer of psychosexual and corporeal fluidity:

> Molinier's multiple combinations of bodies in particular insist we mutate, immerse our SELF in potentia. His maps describe a tumultuous reconstruction of our physical self-image. They propose eroticism over replication and androgeny as a natural, even preferred, state. He implies DNA and experience as spiraling, and also he proposes mutation, deliberately engineered in order to divert behavior patterns that are catastrophic if left unchecked. Our patterns of existence must change at a molecular level; our cultural passion for obliteration must be transformed.
> (Breyer P-Orridge, 2012, p. 116)

Molinier's work has been described as a "suture of photography and painting" (Mercié, 2010, p. 46). He used long exposure times, which resulted in double exposures and other generative chance encounters. Molinier often intervened on the negative itself – as well as on the proof – reworking them as he saw fit, often embellishing the eyes, lips, hair, nails, heels, waists and breasts of his figures. Sometimes he would double the negatives or alter them, enhancing certain areas with graphite while discreetly cutting away or slenderizing others. There was an in-depth process in the manipulation and printing of his photographs.

Soon Molinier began working in a way that allowed him to recycle the various fragments that comprised his images. Instead of pasting down all of the pieces he had cut out and assembled from the photographs he had taken, he began taking photographs of his montages, thus facilitating the reuse, multiplication and re-manipulation of the cut-out pieces used in the creation of his artworks. He then created prints from the photographs of the montages, and presented these prints as the final art object. In order to do this, Molinier placed a foam rubber mat on a piece of glass and then laid out all of the forms, often multiple arms, heads, trunks of the body, and legs intertwined and nestled into complex patterns. Once his

composition was complete, he placed a second sheet of glass on top of the configuration, remaining careful to keep the montage exactly in place. He then tightened pieces of glass together using drawing clips, and photographed the resulting montage through the glass. A print was made, which was often retouched, embellished and then printed again. This final print became the artwork that was presented, and Molinier could then dismantle his assemblages and store the pieces of his puzzles for later reuse (Mercié, 2010, p. 45).

A similar technique was also utilized by Swedish surrealist Tom Benson (1935–1999) who, like Molinier, often worked with photographed images of himself and those who were closest to him. Benson posed and photographed his subjects, then cut them out of their familiar settings and placed them in surreal landscapes and scenes, which he assembled, arranged, photographed, retouched and photographed again, creating worlds of his own.

> Minds like Benson's create art wherever they go, and basically out of anything. A preferred gesture, a reassembling of existing objects and structures, a spatial organisation based on intuitive ideals. Fictive personas, dreams, environments and strange happenings bloomed from out of his imaginary sphere and into a tangible reality. Benson's work seems very much to be a manifested vision, an inner kingdom, a sacred sphere, almost a temple space, in which he could indulge a highly personal, existential playfulness.
>
> (Abrahamsson, 2017, p. 12)

In his work, Molinier also harnessed this "existential playfulness" permeated with a certain severity of sexuality and meticulous morbidity: flesh intermingled with prosthetic limbs; the contrast of the living alongside effigies; dildos veiled as the phallus. The merging of bodies, doubling and multiplying, his own with that of others, as multiple legs, arms, heads and torsos were detached, inverted, reframed and reorganized, producing a sense of unease and harkening to the return of the repressed, the uncanny, the thing. The cut, fragmentation, repetition and multiplicity mirror the interchangeability of object and subject, organic and inorganic; the anthropomorphic – inanimate yet living – not dead but not fully alive.

Just a few short years after his death by suicide (his father also committed suicide), Molinier was honored with a retrospective at the Centre

Georges Pompidou, as well as with the publication of accompanying books. In 2001, his archives were made available, so we now have a plethora of information about his creative process; the inner workings of the mind of the man are laid bare, as he was meticulous about his methods and intentions. Finally, given the nature of his work, it's interesting to note that Molinier knew his body was going to be literally cut into pieces after his death, as he donated it to medical science (Mercié, 2010, p. 68).

> The uncanny is that class of the frightening which leads back to what is known of old and long familiar. How this is possible, in what circumstances the familiar can become uncanny and frightening, I shall show in what follows.
> (Freud, 1919, p. 220)

One of the most renowned couples who worked with the double were German surrealists Hans Bellmer and Unica Zürn (1916–1970). The pair met in the early 1950s and immediately began a romantic relationship. From that point forward, Zürn modeled for Bellmer, her form often bound and cut. Upon meeting Zürn, Bellmer is said to have proclaimed, "Here is the doll."[3] The couple's work explored the dissociation and fragmentation of the body in a similar way to the Dadas' exploration of the shattered world around them through the cutting up of word, sound and image.

Prior to encountering Zürn, Bellmer was at work creating visual and sculptural pieces. His first artworks involving the dismemberment and reassembling of dolls date from 1933; Bellmer described his first creation *Die Puppe* ("The Doll") as "an artificial girl with multiple anatomical possibilities."[4] He documented the various stages of the doll's assembly in a book of the same name which he published the following year. In Bellmer's work, bodies are often presented disfigured, disassembled and reconfigured in uncanny ways, photographed from odd angles, some with prominent breasts and vulvas.

> With Bellmer the question of sexuality was not simply an issue of the imagination [...] Sexuality was not simply an imaginative fancy, but a reality of the mind perpetually in search of the corporeal substance of the body.
> (Morgan, 2013, p. 288)

In one staged photograph,[5] two pairs of legs were laid over a chair, their inner thighs painted pink, suggestive of a vulva. Another doll was created by connecting two pairs of legs directly at the thighs, forming two parallel columns of legs, with no waist, hips nor torso to bridge them. Other photos show dolls embracing each other, while another is of a dismembered doll resting her own head upon her breast.

> Bellmer's erotic imagination absorbed every aspect of his work, including the paintings, drawings, sculptures and photographs. His vision was a ravishing obsession, and his assiduity as an artist was consumed by an unremitting search for the heightened (and obscure) object of desire. In giving the Doll its variety of visually constructed permutations [...] Bellmer explored the outermost limits of sexual conflict and resolution, openly investigating the dark side of consciousness, the discomforting zone between Eros and Thanatos.
> (Morgan, 2013, p. 286)

This play with the parts of the body and dismemberment of the self via the double of the doll is reflective of the true state of being that underlies our unconscious fantasy of seamless self-cohesion and identity. Our underlying experience is one of disturbance, disjunction and fragmentation. Perhaps this is one reason why the masses find artwork that nods to this underlying experience disturbing; it provides viewers a glimpse into their own state of mind, the state of mind-body experience that we have all worked our whole lives to smooth over and cover up.

If you turn some of these mannequins around and view them from the front, Bellmer has left their midsection wide open and included mechanical parts where the internal organs would be. This mix of human and machine is a theme we have seen running throughout the work of the artists examined. Sometimes Bellmer seemed to intentionally invoke feelings of body horror in the viewer. Some dolls have pink spots covering their "skin," reminiscent of disease, sores, chicken pox, measles, or even the plague; other figures have skin that seems to have been burned or somehow disfigured, consisting of an odd texture.

At times the artist places bows on the heads of the dolls, and often the figures are wearing the black patent leather saddle shoes and short white socks one would typically see on the feet of prepubescent girls, adding another disturbing layer to an already unsettling juxtaposition of images.

This appears to have a fetishistic quality. Bellmer's work highlights the importance of sublimation, as we may note what separates the words *pediophilia* (sexual attraction to dolls) from *pedophilia* (sexual attraction to prepubescent children) is merely a single "I."

In one scene, a doll was strewn on a bed with striped sheets, the head having been removed; the decapitated head lies on a wig of hair and seems to be looking off at an undisclosed location and indescribable angle. In another sequence, we see a doll as fully dressed and put together as possible for Bellmer's work; we then see the same doll completely dismembered all the way down to the eyeballs having been removed from the mannequin's head and placed on another spherical part, perhaps a knee or ball and socket joint. Her torso remains intact and now her head peers from her waist, looking away from her own body as if the doll herself is horrified or ashamed of the state of her being and cannot bear to look. Yet another photo of the same doll shows her completely taken apart with her internal mechanisms placed on the table to be photographed as well, so we can see not only her face, breasts and private parts but the inner workings of her form. In this, her hand reaches away from the rest of the pieces, as if she is attempting to grasp on to something... anything.

Sometimes the dolls were photographed in pieces, having been thrown down the stairs and broken into bits. One doll seems to be smelling a rose. At times there is no head at all, and what seems like two dolls are connected at the waist, creating a doll with four legs, two walking and two flailing about above where the head and arms should be. In contemporary popular media and culture, creations such as these seem to have been used as inspiration for creatures in horror films and video games: for example, in the *Silent Hill* series; although the designer denies Bellmer's dolls were used as inspiration, the resemblance is uncanny.[6] "The 'double' reverses its aspect. From having been an assurance of immortality, it becomes the ghastly harbinger of death" (Freud, 1919, p. 235).

Some of Bellmer's dolls were photographed in wooded areas, at times bound, propped up against or hanging from trees. At times they appear to be struggling, while others seem to have relented, exhausted. Sometimes it seems like we can even see a dark shadowed figure lurking in the background, hovering over the dolls, threatening, leering, stalking. Some dolls appear to have been strewn on the ground – seemingly tossed out or discarded – having landed in unnatural and often disturbing, disjointed ways, the way one might imagine coming across a murder victim, such

as Elizabeth Short (1924–1947), the Black Dahlia.[7] Scenes such as these give one pause, considering the only way one would come upon bodies distorted like this in life would be to bear witness to the aftermath of a brutal slaying.

In this sense, Bellmer's work is reminiscent of Marcel Duchamp's *Étant donnés* (1946–1966). When peeking through the hole of the wooden door at the Philadelphia Museum of Art, we see a nude female body with her legs spread, visitors encouraged to peep at what appears to be a sex crime scene. Whether she is alive or dead we don't know, but the associations and speculations immediately begin in the viewer's mind. Many people are disturbed by the installation, and perhaps rightly so. No matter what, there is undoubtedly a strange attraction/repulsion to this piece, and to the double, with its manifestation seen here in this fascination with dolls.

Another artist who utilized the double as a consistent and central theme in her work, is Danish outsider artist Ovartaci (b. Louis Marcussen, 1894–1985).[8] Ovartaci was admitted to an inpatient hospital in 1929 after pointing a rifle at her blind brother, and remained hospitalized for 56 years. She drew, painted and sculpted utilizing a variety of materials, including fabric, metal, plaster, *papier-maché* and wire. Prolific for decades, she used any and all materials available to her – including bed linen, wrapping paper, cardboard and empty tin cans – in the creation of her work, spending virtually all of her inheritance on oil paints, brushes and other art supplies. She created everything from smoking pipes using sardine cans to life-size dolls as companions, even painting the bed in which she slept. All in all, over 800 works are known, with 500 remaining in the hospital's collection, which has been converted into a museum in her honor. Johannes Nielsen (1924–2017), head of the hospital museum and the first to recognize the greatness of her artwork, first met Ovartaci in 1960 and tended to the collection until his passing.

Ovartaci worked with the double and the transitional, exploring the malleability of identity, gender and sexuality. She created figures that appear to be inhabitants of her own world, usually visibly feminine with painted lips, breasts and curving hips. Often her creations seem to vacillate between human, animal, fantasy and fairy-tale beings or even extraterrestrials: combined creatures that seem to harbor aspects of both human and animal forms, often with large almond-shaped eyes. Ovartaci created worlds filled with sprites, faeries, nymphs, panthers, tigers, birds and flying machines. She also often created Janus-headed figures:

[...] where Janus is the name of the Roman god in charge of all beginning. The dual head makes Janus able to see both forward and backward at the same time, or to see an issue from several angles. If the Janus head symbolizes both change and transition from one state to another, and a transition between universes – from one way of seeing to another – then Ovartaci's meaning falls into place.

(Lejsted & Danielsen, 2014, p. 91)

Ovartaci so beautifully captured these transitional places, differing perspectives and multiple modes of being. Her work seems to describe or connote the process of transformation or evolution of the self, as she seemed to express internal, subjective experiences and dreams through her creative work. She also often told imaginative stories that would draw in the listener. Some staff would even bring their children to the ward on Sundays to listen, enraptured, to Ovartaci telling her stories.

Her smoking instruments were called "smoking phantoms" (Lejsted & Danielsen, 2014, p. 91). Built from wire, plaster and metal foil, Ovartaci reused empty tubes of oil paint to construct these and other small sculptures. These methods highlight Ovartaci's resourcefulness, as well as her compulsion to create. She focused on the detailed painting of them. They usually have a smooth, fine finish and simple elongated shape, with small variations in the positioning of the arms, for example. Sometimes the feminine form has an extremely long neck; at times the place for the tobacco is the woman's mouth or a hat placed on the woman's head; sometimes the double heads appear to be smoking themselves.

Ovartaci's larger dolls are predominantly flat, made from fabric, millboard and paper. Ovartaci often mounted them with a device on the top of the head from which to hang. She also developed a gadget comprised of a long stick with a hook at the end so she could move the dolls around the room. Ovartaci's dolls were invariably feminine, and she tended to relate to them as companions. She also often cut a hole where the genitals would be. Similar to what we saw in the work of Molinier, many of her dolls had embellished parts to make them more voluminous; some have been stuffed with material to give them more girth and feminine curves. Often lips, noses, ears, breasts, hips, arms and legs were built out or attached to make the dolls more three-dimensional. In some of Ovartaci's larger sculptures, the heads were used as secret compartments for texts, ingenious technical devices or other little secrets, such as tobacco, sweets, letters, small drawings or diagrams.

The head psychiatrist at the facility allowed Ovartaci a single room, the freedom to refrain from psycho-pharmaceutical treatment, and the ability to create her artwork. At one point, however, years into her hospitalization, she was relocated and the new doctor and staff resisted her creative process, taking her artwork and art supplies from her. This, of course, agitated Ovartaci beyond consolation. She became catatonic and refused to eat. Eventually the staff relented and returned her art supplies and life-size sculptures to her. In 1951, she was granted her request for castration, which she had been pursing for years; the doctors believed it would decrease her sexual urges and fervor. The surgery was performed, but Ovartaci wished to continue further. She eventually attempted to remove her own penis: first unsuccessfully with a razor blade, then successfully with a chisel and hammer from the hospital's carpentry workshop. Finally, in 1957, she was given a full sex change operation via a medical professional, after which it was reported she became visibly calmer and content, more social and less agitated.

All of the aforementioned artists – Pierre Molinier, Tom Benson, Ovartaci, Hans Bellmer and Unica Zürn – exemplify the process involved in the creation of art. It is noteworthy that each of them chose to work with the double – be it through mirrors, mannequins, dolls or anthropomorphic figures of their own creation – as they each worked with themes of identity, place, sense of self, gender and sexuality, not just in a symbolic way but in a transformative manner. In this way each of these artists illustrate the place of art as a space for the act of creation – a liminal, transitional space of play, experimentation and exploration. Just as in psychoanalysis, analysands learn what they have to say through the act of speaking, so artists learn through the creation of their artwork. As we come to understand what was on the minds of the aforementioned artists through their work, so artists may learn about themselves through the creative act itself. Furthermore, artists may learn to make their place in the world through the creation of their work and the implementation of their vision via the act of creation.

Notes

1 Melby, J.L. (2008) "L'Exposition surréaliste de 1938" [Online]. Princeton Graphic Arts. Available at www.princeton.edu/~graphicarts/2008/12/lexposition_surrealiste_de_193.html (Accessed: December 11, 2019).
2 Biographical information drawn from Mercié, J-L. (2010) *Pierre Molinier.* Paris: Les Presses du réel.

3 Indiana, G. (2009) "A Stone for Unica Zürn" [Online]. Art in America. Available at www.artinamericamagazine.com/news-features/magazines/a-stone-for-unica-zurn/ (Accessed: August 23, 2019).
4 MoMA. (2012) "Hans Bellmer – Plate from *La Poupée* (1936)" [Online]. Museum of Modern Art. Available at www.moma.org/collection/works/92611 (Accessed: February 21, 2020).
5 Photographs described are from Iwaya, K. (2011) *The Doll: Hans Bellmer*. Tokyo: Éditions Treville.
6 Various (2019) "Mannequin" [Online]. Silent Hill Wiki. Available at https://silenthill.fandom.com/wiki/Mannequin (Accessed: August 23, 2019).
7 An unsolved murder in Los Angeles in 1947. Newspapers nicknamed the victim the "Black Dahlia" after the film noir *The Blue Dahlia* having been released the previous year. See FBI (2008) "The Black Dahlia" [Online]. Available at www.fbi.gov/history/famous-cases/the-black-dahlia (Accessed: February 5, 2020).
8 Most biographical information for Ovartaci obtained from Lejsted, M. & Danielsen, E. (2014) *Ovartaci: In more dimensions*. Denmark: Museum Ovartaci.

Bibliography

Abrahamsson, C. (ed.) (2017) *Tom Benson: Visionary*. Stockholm: Trapart Books.
Artaud, A. (1958) *The Theater and Its Double*. New York: Grove Press.
Baerwaldt, W., Watson, S. & Gorsen, P. (1997) *Pierre Molinier*. Santa Monica: Smart Art Press.
Bellmer, H. (1969) *Oeuvre Gravé*. Paris: Editions Denoël.
Bellmer, H. (2004) *Little Anatomy of the Physical Unconscious or the Anatomy of the Image*. Waterbury Center, VT: Dominion Publishing.
Breyer P-Orridge, G. (2012) "A Dark Room of Desire – The sensual shrapnel of Pierre Molinier." In Abrahamsson, C. (ed.). *The Fenris Wolf*, vol. 5. Stockholm: Edda Publishing.
Butler, J. (1990) *Gender Trouble: Feminism and the subversion of identity*. London: Routledge
Dean, T. (2000) *Beyond Sexuality*. Chicago: University of Chicago Press.
Freud, S. (1900) *The Interpretation of Dreams*. In *The Complete Standard Edition of the Psychological Works of Sigmund Freud (SE)* IV-V. London: Hogarth Press. pp. 1–627.
Freud, S. (1905) *Three Essays on the Theory of Sexuality*. *SE* VII. London: Hogarth Press. pp. 123–246.
Freud, S. (1910) "The antithetical sense of primal words." *SE* XI. London: Hogarth Press. pp. 153–162.
Freud, S. (1915) "Instincts and their vicissitudes." *SE* XIV. pp. 109–140

Freud, S. (1919) *The Uncanny. SE* XVII. London: Hogarth Press. pp. 217–258.
Freud, S. (1920) "Beyond the pleasure principle." *SE* XVIII. London: Hogarth Press. pp. 1–66.
Fox, C. (1973) *The Doll*. New York: Harry N. Abrams.
Iwaya, K. (2011) *The Doll: Hans Bellmer*. Tokyo: Éditions Treville.
Lacan, J. (2006) "The mirror stage as formative of the *I* function as revealed in psychoanalytic experience." In *Écrits: The first complete edition in English*. Translated by B. Fink. New York: W.W. Norton & Co. pp. 75–81.
Laplanche, J. (2011) *Freud and the Sexual: Essays 2000–2006*. Translated by J. House, J. Fletcher & N. Ray. New York: IP Books.
Lejsted, M. & Danielsen, E. (2014) *Ovartaci: In more dimensions*. Denmark: Museum Ovartaci.
Mercié, J-L. (2010) *Pierre Molinier*. Paris: Les Presses du réel.
Morgan, R.C. (2013) "Hans Bellmer – The infestation of Eros." In Abrahamsson, C. (ed.). *The Fenris Wolf*, vol. 6. Stockholm: Edda Publishing. pp. 285–293.
Nobus, D. & Downing, L. (eds.) (2006) *Perversion: Psychoanalytic perspectives, perspectives on psychoanalysis*. London: Karnac Books.
Salecl, R. (ed.) (2000) *Sexuation*. Durham: Duke University Press.
Verhaeghe, P. (1997) *Does the Woman Exist? From Freud's hysteric to Lacan's feminine*. New York: Other Press.
Winnicott, D.W. (2005) *Playing and Reality*. London: Routledge.

Chapter 9

The cutting edge
Avant-garde and experimental cinema

Maya Deren (1917–1961) was an artist who explored the double through her film work, using mirrors, the splicing of film and effects to create doubles – even tripling and quadrupling herself at times. She also utilized others as doubles of herself, as well as of one another. Playing with positioning, doubling and triangulation, Deren often placed herself in multiple positions at a time in a film.

Born in Kiev, Ukraine, Deren came to New York with her parents in 1922, when she was five years old. She met her first husband Alexander Hammid (1907–2004) in Los Angeles in 1942, while she was on tour with a dance company. Hammid had been a leading figure in experimental film in Czechoslovakia in the 1930s, emigrating to the United States owing to the war. The two soon married and moved to New York.[1] The following year, Deren and Hammid created the film *Meshes of the Afternoon* (1943). Often playing with the concept of the double via the mirror image, Deren adjusted mirrors to double and triple her reflection. As she drifts off to sleep in the film, she then appears on the path visible from the window. She encounters a hooded, veiled figure in her path, whom she follows. Mysterious – suggestive of a widow, witch, saint or even death itself – the hooded figure has a mirror where the face should be. Deren chases this figure, presumably a reflection of herself, down the path until she comes to the stairs that mark the entrance to her house. She then turns and walks up the stairs into the home. She continues to climb the stairs until she encounters herself asleep in a room on the top floor, at which point, she looks out the window and again sees the hooded figure on the path with herself following close behind. This series of scenes continues on a loop throughout the film, slightly altering each time. A knife appears in various places throughout the sequence, foreshadowing, as Deren appears to

struggle with the impulse to cut her own throat – that is, the throat of the sleeping double. In the end, her throat is cut by shards of a broken mirror.

Deren worked with mirrors throughout her career, often peering through windows or glass, veiling her face and working with masks:

> The mask as such has no content, it is more like the pure surface – or, most literally, it is the interface.
> (Zupančič, 2008, p. 25)

Deren described film as an artistic medium that has a way of invoking a particular experience in the audience. Having a background as a dancer, she choreographed her film sequences in a way that was often "stream of consciousness," surreal, like a dream; the silence accompanying her films potentially increases the tension and unsettling effect on the viewer. Deren was a pioneer of experimental film, traveling across the United States with her films and book, *An Anagram of Ideas on Art, Form and Film* (1946), giving lectures and promoting the growing independent film industry.

Cinema not only uses the technique of cutting between scenes in order to tell a story or convey an emotion; the medium of cinema itself has become one of the greatest projection surfaces ever for the human mind, perhaps only surpassed by its younger siblings: the television and computer screens. Film is a medium almost entirely based on scansion – manipulating the cut to achieve the desired suspension of disbelief. In extension, the techniques of cinema have also been co-opted and transformed by advertising and propaganda. Nowadays, film theory is one of the realms where contemporary psychoanalytic theory thrives most. That said, this is an enormous field of study – one which I will need to "cut down to size" for the project at hand. Even the "cutting edge" is incredibly vast, so I have cherry-picked a few revealing examples rather than striving for a comprehensive overview.

Experimental filmmaking has evolved alongside conventional cinema since the beginning. Unfortunately, many of the earliest films have been lost or destroyed, mostly because of wartimes and political chaos. Hans Richter's (1888–1976) *Rhythmus 21: Film is Rhythm* (1921)[2] is one of the earliest experimental films that has survived, outside the scope of the general experimentation and innovation of earlier cinematic pioneers like Georges Méliès (1861–1938). Richter's avant-garde film consists of a series of black and white squares, rectangles and bars, changing size and

shape, morphing and moving about on the screen on alternating black and white backgrounds in a hypnotizing fashion. This theme continues in his *Rhythmus 23* (1923), with the shapes morphing ever more into and out of one another. Richter also utilized a technique called *direct animation*, when the artist paints directly onto and/or scratches into the film stock itself. A few years later, Richter created a film called *Vormittagsspuk* ("Ghosts Before Breakfast") (1928), which he described as a "rebellion of objects."[3] An amusing film, it includes a number of special effects: clocks ticking away, flying bowler hats, ties undoing themselves, faces and objects multiplying and becoming negatives of themselves, the reversal of the fronts and backs of heads. The version of the film that remains begins with the statement, "The Nazis destroyed the sound version of this film as 'degenerate art.' It shows that even objects revolt against regimentation."[4]

Early experimental filmmaker Len Lye (1901–1980) was one of the pioneers of working with direct animation. Lye created *Rainbow Dance* in 1936, a bright, psychedelic film in which a figure dances in front of layers of ever-changing rainbow colors. First, the figure is holding an umbrella and the colors seem to be raining on him; once the weather apparently clears, he hikes through an ever-changing landscape of color and form, engaging in a variety of activities from dancing and playing sports to dreaming. To create the film, Lye filmed the figure in black and white, adding colors during the process of developing and printing the film. He also utilized a variety of painted and stenciled patterns. *Rainbow Dance* is full of striking effects such as the figure leaving behind a trail of colored silhouettes as he moves. Lye was working at the British General Post Office (GPO) at the time, which funded the film on the condition that it include an advertisement for the GPO Savings Bank, which is placed in the end credits.[5]

Using more traditional filmmaking techniques but constantly subverting them was the key to Luis Buñuel's (1900–1983) genius. After having watched Fritz Lang's (1890–1976) *Der Müde Tod* (1921) in Paris, Buñuel replaced Catholicism with cinema, and used the latter to criticize the former throughout his life and career; of note, *Der Müde Tod* translates to "The Tired Death," but the English title of the film became "Destiny." As Buñuel already knew Salvador Dalí as a teenager in Madrid, it was only natural that they should try to find creative expression together. Their film collaborations in *Un Chien Andalou* ("An Andalusian Dog") (1929) and *L'Age d'Or* ("The Golden Age")

(1930) arguably summed up surrealism in a more powerful way than scattered, periodic exhibitions were able. Audiences were exposed to eroticism, criticism of Catholicism, shocking symbols and gestures – like a woman's eye being cut with a razor – and an all-around attitude of aesthetic provocation. The films were basically their ticket into the world of André Breton-approved surrealism, and have perhaps more than any other films become surrealist icons.

Avant-garde filmmaker Harry Smith (1923–1991)[6] was another proponent of the technique of direct animation. When projecting his films to live audiences, Smith often played them at varying speeds, accompanied by improvised, live jazz soundtracks. Some of his first films commonly referred to as the *Early Abstractions* (1939–1956) "were produced by Smith physically manipulating the plasticity of celluloid without the use of a camera" (Sargeant, 1997, p. 93). Later on in his career, Smith created films much as one would create a collage: animating figures cut from books, newspapers and magazines, which he placed upon various backgrounds. Additionally, Smith often created audio collages to accompany the films: a juxtaposition of sounds, including the howling of animals, cries of infants and screams of women, glass shattering, sirens wailing and alarm bells ringing, alongside noises of the city, as factories, machines, automobiles and trains clanged and reverberated:

> The soundtrack mirrors the cut-up style of the images, cutting between one series of noise, to the next, in a manner analogous to "musique concrete."
>
> (Sargeant, 1997, p. 96)

Smith created *Late Superimpositions* (1964–1965) from unedited 100-feet-long reels of superimposed footage, including footage of the Kiowa people, shot in Oklahoma, possibly when Smith was assisting Conrad Rooks (1934–2011) with *Chappaqua* (1966) (Sargeant, 1997, p. 98). *No 18*, also known as *Mahagonny* (1980), was shot on 16 mm between 1970 and 1980 at various hotels in which Smith lived, including the Chelsea Hotel in New York, and includes footage of a variety of famous friends and associates in the art and literary scene of the time. These portraits are intermingled with scenes of the city, as well as techniques of animation and superimposition. Like the surrealists, Smith consciously aimed at working in ways that allowed for his process to be as automatic as

possible: attempting to bypass the psychic censor, wishing to remove ego-oriented, logical thought processes as much as possible.

> His films are characterized by a singular poetic vision, and were integral to his life, in a manner similar to that of the Beat writers, who attempted to break down the false division between life and art.
>
> (Sargeant, 1997, p. 98)

Smith was a strong source of inspiration for a number of filmmakers, including Robert Frank (1924–2019) – if nothing else, in attitude. Smith's fearless use of anything he had access to, in order to refine it and integrate it in his vision, echoes the readymade psychology put forth by Marcel Duchamp, Joseph Cornell and others. Allowing chance free rein within the creative process, Smith created universes of his own based on small means, using his creative impulse and intuitive decisions.

> I think he was totally aware of his power, of his intelligence, of his memory, of his knowledge, and he was suffering a lot. But I think that the many things that he was curious about and lived took care of a lot of the misery in his life, and made it possible for him to go on and on despite the horrible way he chose to live. I don't know why he subjected himself to so much hardship.
>
> (Frank, 1996, p. 119)

Kenneth Anger (b. 1927) is another innovative American filmmaker of note, who worked with superimpositions and the direct cutting and splicing of the film itself. However, in contrast to the aforementioned, Anger insists that in his films every detail is meticulously planned and laid out, leaving nothing to chance, thus following the causative editing theories of Soviet filmmaker Sergei Eisenstein (1898–1948), who specialized in what could be described as manipulating the emotional response of the audience via calculated editing.

Born and raised in Los Angeles, Anger's first official film was *Fireworks* (1947), for which Harry Smith coordinated one of the first screenings in 1948, at the Art in Cinema Society in San Francisco. Anger works mostly in silent films, focusing on the imagery, stating, "I'm closer to dance, the way ballet can tell a story without using speech" (Abrahamsson, 2013, p. 123). In 1950, Anger moved to Paris to work as an assistant for Henri

Langlois (1914–1977), the director of la Cinémathèque Française, where he remained for 12 years. There, Anger met Jean Genet (1910–1986) and Jean Cocteau (1889–1963), among others. Cocteau's work inspired Anger to create *Rabbit's Moon*, which he constructed using scraps of film leftover from other productions, including Cocteau's *Orphée* (1950). Fashioning the costumes himself, Anger cajoled actors from a local mime school in Paris to work in the film, and filmed the entire project in an empty studio nearby during the month of August while everyone was away. Despite being filmed in 1950, *Rabbit's Moon* was not deemed completed until 1972.

Throughout his career, Anger experienced the attempted censorship of his films. *Fireworks* (1947) was deemed to be too homoerotic when it was released; *The Love That Whirls* (1949) was confiscated and destroyed by the company who developed the film, Eastman Kodak; while *Scorpio Rising* (1963) was seized by police from the theater in which it premiered and the manager arrested. None of these claims held up in court, but nevertheless such episodes constituted an ongoing battle for Anger. Also of note, *Scorpio Rising* (1963) was the first film to use pop music as the soundtrack, leading to a revolution in the film industry that is the standard today: for instance, in the contrapunctual use of music in Martin Scorsese's (b. 1942) films.

In 1938, Orson Welles (1915–1985) shot to international fame as the narrator and director of the radio broadcast based on H.G. Wells's (1866–1946) *War of the Worlds* (1898), which caused widespread panic as many listeners thought the radio broadcast and alien attack were real. This was an incredible moment in American history, displaying the malleability of belief and reality, as well as the immediate effect that mass media may have on the public at large. Never before or since has something like that been done. The event was a deep cut indeed into the fabric of the American psyche, and also one which catapulted Welles into notoriety.

Welles's first feature film was *Citizen Kane* (1941), which is consistently ranked as one of the greatest films ever made. Within it, Welles created a fake documentary, introducing the life of the protagonist Charles Foster Kane, played by Welles himself. He utilized a similar technique in his final film *The Other Side of the Wind* (2018), which was completed and released only recently with the help of close friends and colleagues. In this film, Welles filmed various scenes repeatedly over years, so when the audience views the final cut, we are seeing a scene shot then spliced

with another scene filmed years, even decades later, layer upon layer. The documentary *They'll Love Me When I'm Dead* (2018), which was released concurrently with *The Other Side of the Wind*, outlines this process as it documented the production of Welles's final masterpiece. In it, Welles states that he believes in divine accidents, and calls directors the "choreographers of accidents."[7] Although these two films are essentially posthumous creations, Welles's ideas and concepts of conscious, narrative upheaval could be discerned in his *F For Fake* (1973). This docudrama about an art forger is a miasmic trip into chaotically juxtaposed narratives that constantly deceive the viewer, while also uncannily facilitating awareness that some sort of manipulation is ongoing. Each cut in celluloid and narrative becomes a cut also in apprehension, creating a "suspension of belief" rather than the classically desired cinematic suspension of disbelief.

The New York independent/underground film scene was primarily articulated via the journal *Film Culture*, founded in 1955 by brothers Jonas Mekas (1922–2019) and Adolfas Mekas (1925–2011). Born in Lithuania, the Mekas brothers were displaced by the war, and emigrated to New York City in 1949. The following year, Jonas bought his first Bolex camera and immediately began filming the Lithuanian immigrant community in which he lived, which is captured in the time capsule of a film, *Williamsburg, Brooklyn* (1950–2003).[8] From this point onward, Mekas continued to film his day-to-day life, creating a sort of film diary.

As a young man, Jonas Mekas attended film classes taught by Hans Richter, bringing two generations of experimentalists together. Moving to Manhattan in 1953, Mekas began screening avant-garde films at Gallery East. Then, in 1962, he founded the Film-Makers' Cooperative, also known as the New American Cinema Group, along with Shirley Clarke (1919–1997), Stan Brakhage (b. 1933) and others, which continues to be the largest distributor of avant-garde films in the United States to this day. This led to the founding of the Anthology Film Archive in 1970, of which Mekas remained director until his death.

With his unique way of working, Mekas cut scenes from the fabric of his own life and strung them together in new ways to create another kind of narrative. His films are like portals into another time and place: voyeuristic scenes, as we gain glimpses into the mind of another. Mekas used the cut in a variety of ways in his filmmaking; as he filmed scenes from his daily life, he took a step out of the stream of the day-to-day to cut out a slice

of time, similar to the way in which a photographer captures an instant. Mekas filmed crowds of strangers as he walked the streets of New York City; he filmed friends on vacation, at birthday parties and picnics, as well as scenes of nature and architecture. He then cut it up, rearranged and reassembled these scenes and images in surprising new ways.

Mekas's films invoke memories and the affect associated with them. When one remembers something, that memory is brought to the present, into the current situation in which one is remembering. Thereby, that memory is infused with the present moment. Whether that moment occurs on a street corner, while viewing a film, or in an analytic session, that memory forms new connections to symbols and signifiers of the moment in which it was remembered. Furthermore, when one recalls that memory again in the future, it will then be infused with signifiers, as well as the scenery and situation in which it is recalled at that time; and so on and so forth. When considered in this way, memory may be seen through a similar lens, as fragments cut from time, place, scene and situation, reassembled in new ways, imbued with new meanings, connections, significance and signifiers in a layered web, like a collage, montage or assemblage of consciousness. Films such as Mekas's mimic and mirror this work of memory. This aspect of his work is captured beautifully in the poignantly titled film, *As I Was Moving Ahead, Occasionally I Saw Brief Glimpses of Beauty* (2000).

> So let us be beat and angry, and perverse: if that helps to dethrone the falsity and rottenness of morality and the puked way of living. It is more honest today to be confused than to be sure (when the time is for dethroning). It is more honest to destroy than to build (there is not yet a clean place for building). It is more honest to be delinquent (and juvenile) than to learn and accept the ways of living in lies[.]
> (Mekas, 2015, p. 15)

Contemporary American artist Katelan Foisy (b. 1979) cites Jonas Mekas as one of the greatest influences on her film work.[9] In a similar manner, Foisy films scenes of her daily life, whether it be frolicking by a lake or river, rituals of tarot and tea leaves, or strolling the boardwalk of Coney Island. Taking this a step further, Foisy adds an intentional dimension to her work. For example, if she wishes to create a specific situation or outcome in her day-to-day life, she will first create the desired situation in a film by splicing together fragments and scenes of films she has previously

recorded. Or if she wishes to change her current situation and move to a new place, for instance, she'll facilitate this by cutting herself out of her current location – via film – and moving herself to a desired place or situation. By visualizing this in her film work, she is better able to envision it in her day-to-day life. Another aspect often seen in Foisy's films are scenes of what she calls "time travel." For these pieces, Foisy films a location as it appears today – for example, the Las Vegas strip – and then splices her footage together with archival material of the same place, accentuating the evolution of a place from then until now, as well as blurring the boundaries of time. Like Mekas, Foisy invokes memory and emotion, playing with time, place, scene, setting and situation.

When Robert Frank's book of photographs *The Americans* was published in 1959, with an introduction by Jack Kerouac (1922–1969), it caused quite an uproar. Critics tore the book apart, exclaiming that anyone who liked America would never shoot portraits like these. Frank was born in Switzerland and emigrated to the United States in 1948. When he traveled across America and took the photos that would come to form *The Americans,* he gleaned an outsider's view of the United States. First considered to be decidedly un-American, the book was published by Robert Delpire (1926–2017) in 1958 in Paris and Rome under the title *Les Américains,* before being published the following year by Grove Press in New York. Of course, Frank's book is now a classic of American photography, and many of these images have become iconic of American culture. Like the images of Henri Cartier-Bresson, Frank's aesthetic snapshots always seem to tell a story beyond the apparent. The photographic cut is made with a genuine respect for the human beings and environments Frank encountered, and when exhibited as a group the main impression becomes a mosaic of insight and understanding.

The film *Pull My Daisy* (1959), directed by Robert Frank and Alfred Leslie (b. 1927), became an immediate mainstay in the independent, underground American cinema scene. After *On the Road* was published in 1957, Jack Kerouac was approached to write a play, which he did, called *The Beat Generation.* The piece never came to fruition in the theater, but Leslie, Frank and Kerouac decided to make a film together based upon it, which evolved into *Pull My Daisy*. The main location of the film was set in Leslie's loft apartment in Manhattan. Utilizing Jack Kerouac, Gregory Corso (1930–2001), Allen Ginsberg (1926–1997) and Peter Orlovsky (1933–2010) to appear in the film as themselves blurred the lines between

reality and fantasy. The characters were cut from life and inserted into the film, enacting events based on actual occurrences. The film was shot in such a way as to give the viewer the feeling of being one of the members of the group, hanging out with the gang in a friend's loft, getting high and talking about art and poetry; at times the camera was even positioned as if in the place of the person speaking. The film was recorded silent, and Kerouac narrated the entire soundtrack improvised after the film had been edited to its final form.

Pull My Daisy premiered in 1959 at Amos Vogel's (1921–2012) cinema, alongside John Cassavetes's (1929–1989) similarly groundbreaking film *Shadows* (1959). Film critic James Lewis Hoberman (b. 1948) has suggested that this event was the moment at which "The Underground announced itself" (Sargeant, 1997, p. 18), and Mekas claimed that *Pull My Daisy* was the first ever truly Beat film. When Mekas created the *Film Culture* Independent Film Award in 1959, he presented the first award to *Shadows* and the second to *Pull My Daisy*.

Robert Frank also created the film *Me and My Brother* (1969) with Allen Ginsberg and Peter Orlovsky, which captured the relationship between Orlovsky and his until-then-institutionalized brother, Julius. The couple took Julius with them on a Beat poetry tour of the Midwest, which in itself caused quite a stir. Lines become blurred as scenes cut: from what appears to be a documentary to what seems to be fantasy or fiction; between "real" life and film; the actor playing Julius and Julius himself. At times the voices of certain actors come out of the mouths of others. It becomes difficult to tell which scenes are staged for the film and which are cut from real life, what is waking life or a dream.

In the opening scene, a pornographer disseminates every type of sex that has happened in that room, including necrophilia and bestiality. After this shocking way to begin, the discomfort only increases, as the audience is forced to confront disturbing and conflicting feelings arising around "allowing" Julius into the world, where he is confronted with drugs, alcohol, sex, music, freedom, poetry and life in all its ambivalence and chaos. The audience is taken on a journey through the trials and tribulations the Orlovsky brothers face throughout the film. As Julius maintains his silence, Peter struggles, wishing to do right by his brother, while being confronted with the difficulties and realities of daily life. He feels his limits being pushed as he tries his best to help his brother live free in society after being in an inpatient psychiatric ward for 13 years, where he was given

sedating antipsychotic medications and electroconvulsive therapy (ECT) repeatedly. Through his cinematography and cutting style, Frank's direction induces intense visceral responses and experiences in the viewer. We, as the audience, are made to feel uncomfortable as we witness the struggle and discomfort of these two brothers. In addition, we are overwhelmed with sensory experiences and the bizarre fantasies of others, including those of the medical doctor and social worker in the film.

In the end, Julius speaks. He speaks of never understanding why he was given ECT, illuminating the lack of agency and autonomy individuals have once an authority decides they are no longer able to care for themselves. The abuses of the health care system in the United States – and the mental health care system in particular – are glaring in this film, and *Me and My Brother* has been credited as being the first film to criticize the dominant mental health care practices in America.

The mid-20th century was undoubtedly a vital time for creative and groundbreaking filmmaking, and the work of experimental, avant-garde artists such as Maya Deren, Harry Smith, Kenneth Anger, Robert Frank, Jonas Mekas and the New American Cinema have certainly influenced generations of filmmakers since. British filmmaker Derek Jarman (1942– 1994) was a pioneering artist, writer and gay activist. Throughout his career, Jarman worked on set, directing feature films and commercial music videos while concurrently creating a series of less narrative and more experimental film works, including *The Angelic Conversation* (1985), *The Last of England* (1987) and *Glitterbug* (1994), with soundtracks by Coil, Simon Turner (b. 1954) and Throbbing Gristle, respectively.

The Angelic Conversation follows an erotic journey of a pair of gay lovers, portraying a series of missed encounters. Despite the lovers' presence together they seem somehow distant, disconnected. As soon as their connection is imminent, they're intruded upon, illustrating the continual failure of the sexual relation that nevertheless perseveres. Jarman elucidates a tension, alluring yet painful, all the while overlain with Judi Dench's (b. 1934) lulling yet provocative recitation of Shakespearean sonnets. *The Last of England* is known to be a turning point in Jarman's life and career, encompassing both his HIV+ diagnosis as well as the death of his father. The final scene is unforgettable as Tilda Swinton (b. 1960) wrestles with her wedding dress, cutting it off with oversized scissors as she struggles along the beach with a bonfire blazing in the background, as the screeching vocals of Diamanda Galás (b. 1955) are heard overhead. *Glitterbug*[10] was

Jarman's final film. Reminiscent of the work of Jonas Mekas and Harry Smith, the film consists of a collection of Super 8 footage Jarman had shot over the years, spliced together to capture personal moments with friends, fellow artists and collaborators, the soundtrack a fitting exploration of cut-up sound collage techniques, providing an ethereal soundscape.

Fellow British audiovisual pioneer Vicki Bennett (b. 1967) is an influential figure in the ever-expanding realm of sampling and remix. Working under the moniker People Like Us, Bennett specializes in the manipulation and reworking of original sources, using film, music and radio archives. She is a proponent of open access to archives for creative use. Cutting-up and splicing together found footage, she collages audio, visual and film work, pulling from a range of sources from the experimental to mainstream pop culture. For example, in *The Sound of the End of Music* (2010),[11] Bennett mixes the classic scene from the *Sound of Music* (1965) of Julie Andrews (b. 1935) famously singing on the hilltops, with visions of bombs exploding from Francis Ford Coppola's (b. 1939) *Apocalypse Now* (1979), as the soundtrack of *The End* by the Doors plays.

Bennett describes herself as an editor, cutting through time and space to bring new, never-before-seen situations and scenarios to life. She considers her work to be in the vein of a folk art tradition, as folk artists work with the materials that surround them – the elements that make up the fabric of their culture – as opposed to a fine artist who might have a patron providing ideas, time, space and materials:

> I'm not someone who works with things in a more traditional sense being paint or sculpture, but I use media as my palette in order to create collage works in many fields, whether that'd be moving image, sounds, radio or stills and I kind of treat them all the same way because they are all for the senses ultimately, and I don't believe in dividing the senses up into particular genres.[12]

Notes

1 *In the Mirror of Maya Deren*. (2001) [Film]. Martina Kudláček (dir.). Austria: ARTE, Dschoint Ventschr Filmproduktion AG, Filmfonds Wien, Navigator Film, TAG/TRAUM Filmproduktion & Österreichisches Filminstitut.
2 *Rhythmus 21*. (1921) [Film]. Hans Richter (dir.). In *Early Works*. (2008) [DVD]. France: Re:voir.

3 *Free Radicals: A history of experimental cinema.* (2011) [Film]. Pip Chodorov (dir.). USA: Re:Voir & Sacrebleu Productions.
4 *Vormittagsspuk/Ghosts Before Breakfast.* (1928) [Film]. Hans Richter (dir.). Germany. Available at https://vimeo.com/34809672 (Accessed: August 25, 2019).
5 Len Lye Foundation. (2014) "Rainbow Dance (1936)" [Online]. Len Lye Foundation. Available at www.lenlyefoundation.com/films/rainbow-dance/24/ (Accessed: August 25, 2019).
6 Much of Harry Smith's biographical info and technique from Sargeant, J. (1997). *Naked Lens: Beat cinema.* London: Creation Press. pp. 91–100.
7 Trailer for *They'll Love Me When I'm Dead.* (2018) [Online]. Available at www.imdb.com/video/vi2377693721 (Accessed: August 25, 2019).
8 *Williamsburg, Brooklyn* (1950–2003). In *Short Film Works* (2012) [DVD]. Jonas Mekas (dir.). USA: Re:voir.
9 Foisy, K. (2018) "Film" [Online]. Mistress of Magic – Katelan Foisy. Available at www.katelanfoisy.com/film (Accessed: December 16, 2019).
10 Gallagher, P. (2012) "*Glitterbug*: Derek Jarman's final film" [Online]. Dangerous Minds. Available at https://dangerousminds.net/comments/glitterbug_derek_jarmans_final_film (Accessed: December 16, 2019)
11 *An Art Apart: People Like Us – Nothing can Turn into a Void.* (2015) [Film]. Carl Abrahamsson (dir.). Sweden: Trapart Film.
12 *An Art Apart: People Like Us – Nothing can Turn into a Void.* (2015) [Film]. Carl Abrahamsson (dir.). Sweden: Trapart Film.

Bibliography

Abrahamsson, C. (2013) *Reasonances.* London: Scarlet Imprint.
Battcock, G. (ed.) (1967) *The New American Cinema: A critical anthology.* New York: E.P. Dutton & Co.
Deren, M. (1946) *An Anagram of Ideas on Art, Form and Film.* Yonkers, NY: The Alicat Book Shop Press.
Deren, M. (1970) *Divine Horsemen: The living gods of Haiti.* New York: McPherson & Company.
Farthing, S. & Webb-Ingall, E. (eds.) (2013) *Derek Jarman's Sketchbooks.* New York: Thames & Hudson.
Frank, R. (2008) *The Americans.* Göttingen: Steidl.
Frank, R. (1996) In Igliori, P. (ed.) *American Magus Harry Smith: A modern alchemist.* New York: Inandout Press.
Igliori, P. (ed.) (1996) *American Magus Harry Smith: A modern alchemist.* New York: Inandout Press.

Mekas, J. (2015) *Scrapbook of the Sixties: Writings 1954–2010*. Leipzig: Spector Books.
Nuttall, J. (2019) *Bomb Culture*. Cambridge: The MIT Press.
Rabinowitz, Lauren (1991) "Maya Deren and an American avant-garde cinema." *Points of Resistance: Women, power and politics in the New York avant-garde cinema, 1934–1971*. Urbana: University of Illinois Press. pp. 49–91.
Sargeant, J. (1997) *Naked Lens: Beat Cinema*. London: Creation Press.
Vogel, A. (1974) *Film as a Subversive Art*. New York: Random House.
Wells, H.G. (1898/2005) *The War of the Worlds*. London: Penguin Classics.
Zupančič, A. (2008) *The Odd One In: On comedy*. Cambridge: The MIT Press.

Filmography

An Art Apart: People Like Us – Nothing can Turn into a Void. (2015) Carl Abrahamsson (dir.). Sweden: Trapart Film.
An Art Apart: Cinemagician – Conversations with Kenneth Anger. (2019) Carl Abrahamsson (dir.). Sweden: Trapart Film.
As I Was Moving Ahead Occasionally I Saw Brief Glimpses of Beauty. (2000) Jonas Mekas (dir.). USA: Canyon Cinema.
Citizen Kane. (1941) Orson Welles (dir.) USA: RKO Radio Pictures & Mercury Productions.
Experimental Films. (2008) [DVD]. Maya Deren (dir.). France: Re:voir.
Free Radicals: A history of experimental cinema. (2011) Pip Chodorov (dir.). USA: Re:Voir & Sacrebleu Productions.
Glitterbug. (1994) Derek Jarman (dir.). England: Basilisk Communications & BBC.
In the Mirror of Maya Deren. (2001) Martina Kudlácek (dir.). Austria: ARTE, Dschoint Ventschr Filmproduktion AG, Filmfonds Wien, Navigator Film, TAG/TRAUM Filmproduktion & Österreichisches Filminstitut.
Me and My Brother. (1969) Robert Frank (dir.). USA: Two Faces.
Pull My Daisy. (1959) Robert Frank (dir.). USA: G-String Enterprises.
Rhythmus 21: Film Is Rhythm. (1921) Hans Richter (dir.). Germany.
Rhythmus 23. (1923) Hans Richter (dir.). Germany.
Short Film Works. (2012) Jonas Mekas (dir.). USA: Re:voir.
The Angelic Conversation. (1985) Derek Jarman (dir.). England: Channel Four Films & British Film Institute.
The Last of England. (1987) Derek Jarman (dir.). England: Anglo International Films, Tartan Films, British Screen Productions, Channel Four Films & Zweites Deutsches Fernsehen.
Vormittagsspuk/Ghosts Before Breakfast. (1928) Hans Richter (dir.). Germany.

Chapter 10

The cut-up method of the Beats

Given its nickname by American poet Gregory Corso, "The Beat Hotel" described the residential hotel located at 9 rue Gît-le-Cœur in Paris, run by proprietors Monsieur and Madame Rachou since 1933. The couple hailed from Giverny and harbored a fondness for artists and other creatives; Mme Rachou had served tables since the age of 12 at a country inn frequented by Claude Monet (1840–1926) and thereby met a variety of celebrated artists and writers who would come to visit with him (Miles, 2014, p. 316). The Rachous even allowed guests to pay with paintings at times. After M. Rachou's death in 1957, Mme Rachou continued to run the hotel and bistro on her own.

In 1958, British-Canadian artist-writer Brion Gysin was living at the Beat Hotel when he discovered by chance what he later called the cut-up method:

> While cutting a mount for a drawing in room #15, I sliced through a pile of newspapers with my Stanley blade and thought of what I had said to Burroughs some six months earlier about the necessity for turning painters' techniques directly into writing.
> (Burroughs & Gysin, 1978, p. 43)

Gysin immediately began picking up raw words and phrases accidentally cut from the newspaper and started piecing them together into texts that would end up becoming "First Cut-Ups."[1] He noticed that although they weren't created intentionally, the phrasing and sentences that came together through this seemingly haphazard methodology seemed to make a certain kind of sense.

At the time I thought them hilariously funny and hysterically meaningful. I laughed so hard my neighbors thought I'd flipped. I hope you may discover this unusual pleasure for yourselves.

(Burroughs & Gysin, 1978, p. 44)

He shared this discovery with creative collaborators and fellow Beat Hotel residents William Burroughs, Gregory Corso and Sinclair Beiles (1930–2000), and the group worked together with the method for a period, creating the first cut-up publication *Minutes to Go* (1960). Burroughs and Gysin continued their work with cut-ups long after the group left the Beat Hotel; in fact, both men continued to work with the technique for the rest of their lives. They experimented with using the cut-up method in a variety of media and methodologies, including text, audio and visual imagery, outlining their early experiments and creative practice together in *The Third Mind* (1978), in which they state:

The cut-up method brings to writers the collage, which has been used by painters for fifty years. And used by the moving and still camera.

(Burroughs & Gysin, 1978, p. 29)

Along with Corso, Burroughs, Gysin and Beiles, Allen Ginsberg, Peter Orlovsky, Jack Kerouac, Herbert Huncke (1915–1996) and Neal Cassady (1926–1968) became known as "the Beats" or "the Beat generation." In the 1940s, "beat" meant exhausted, poor, tired, worn out, and even suggested homelessness. As British scholar Jack Sargeant (b. 1968) outlines in his rigorous study *Naked Lens: Beat Cinema* (1997), when the Beats took on the term, they meant to capture this dimension but also to expand the notion; Ginsberg posited that their interpretation of beat not only implied the run-down, weary or impoverished aspect of the term, but also captured a sense of possibility, awe, wonder and humility: in essence, "a state in which one was open [...] and thus 'receptive to vision'" (Sargeant, 1997, p. 5). Kerouac cast many key figures of the Beat movement as characters in his breakthrough novel *On the Road* (1957): William Burroughs as Old Bull Lee, Allen Ginsberg as Carlo Marx, Neal Cassady as Dean Moriarty and Kerouac himself as narrator Sal Paradise. Kerouac expanded the vision of beat even further, describing his characters as beat, and noting that beat is also the root of "beatific" and "beatitude," recalling "the meek" as achieving spiritual illumination, supreme blessedness and exalted happiness.[2]

The term Beat is reminiscent of Dada, in that it is an essentially meaningless term that nonetheless captures the essence of a movement, the origins of which are also unclear and/or debated. Like the Dadaists, the Beats did not feel their art was separate from their lives but saw the two as intimately intertwined. Their reaction to the conservatism of 1950s America manifested through radical actions and exploration of sexuality, identity, psychedelic drugs and travel. As a movement – and another way they were similar to Dada – the Beats did not share a single overarching vision but rather espoused the importance of individuals creating new and uniquely personal forms of writing and artwork. They were also adamantly anti-censorship.

Ginsberg wrote poetry that described his life in extreme candor; Kerouac attempted to create unmediated prose, which would flow from him onto the page as he typed in ecstatic marathon sessions in an attempt to catch his own authentic, personal voice; Burroughs traveled through various styles, until he came to experiment with the nature of textuality itself by exploring the very limits of the role of author via the process of the cut-up method and other related experiments, such as *the fold-in, the grid*, and *permutation poems*.[3] Gysin experimented extensively with permutation poems, and eventually came to the conclusion that the author himself was altogether dispensable. Taking a phrase of four or five words, Gysin would place each word in every possible combination with the others. He developed a system for creating these permutation poems, finding that a poem of five words could be altered in a total of 120 ways:

> Words thank you for your collaboration, but they can also create themselves on their own; thus [...] a 120-line poem without an author. Where is the poet Brion Gysin?
>
> (Burroughs & Gysin, 1978, p. 10)

The Beats did not believe that an artist or writer should be limited to one medium. For example, Ginsberg was a poet but also worked with photography and music; Burroughs wrote and worked with collage, montage, photography, filmmaking, cut-ups and painting; Gysin painted but also worked with poetry, film and sound; Kerouac wrote, painted and worked in film and narration; Taylor Mead (1924–2013) was an actor, filmmaker and poet; the list goes on and on. This willingness to explore creative practices across various media led to a multitude of collaborations between

Beat writers and other artists, expanding the idea of the Beat generation from solely a literary phenomenon to a wider, more general manifestation in and of art and culture.

Antony Balch (1937–1980) was the first filmmaker to collaborate with William Burroughs,[4] as well as the first to recognize the inherent cinematic potential of the cut-up method. Balch initially met Brion Gysin at a friend's apartment across the street from the Beat Hotel where Gysin was living at the time. After meeting Gysin, Balch was subsequently introduced to Burroughs and Ian Sommerville (1941–1976) and began to work on films with the residents of the Beat Hotel. Balch had experience in the film industry, with commercials, subtitling, grading, editing, cutting and lighting, as well as working as a film distributor in London. At the time he met Gysin, Balch was in charge of programming films for two central London cinemas.

Balch's *Towers Open Fire* (1963) was the first collaborative project with the Beats to be cinematically released. Filmed over a year in Paris, Gibraltar and London, Sargeant describes it as "a cinematic interpretation of several of Burroughs's major themes" (1997, p. 170). The film opens with Burroughs relaying a lecture his father likely gave him, informing him that he needed to stop hanging out with the "underclasses" and had to "straighten out" and make something of himself in this world, insisting that he wouldn't be able to escape his bloodline. By this, he was referring to our protagonist's grandfather, for whom he was named. (William S. Burroughs I [1857–1898] was an American inventor, who patented a calculating machine in 1885, which went on to make the family a fortune.) This scene relaying Burroughs's supposed hereditary destiny is followed by a recitation of his infamous "Curse Go Back" ritual, overheard while various masks and reels of tape are exhibited, which then cuts to a scene of Balch masturbating.

Comprising a conglomeration of scenes that could be summarized as "the breakdown of control [...] intercut with various other images of autonomous liberation" (Sargeant, 1997, p. 170), the film itself as a whole was not created through the cut-up method per se, but it does contain a section that was devised using the cut-up method. *Control* is a term Burroughs often used to describe the overarching systems and structures in place, including societal norms, as well as government. The idea is that these entities or constructs often have their own interests in mind, rather than the best interest of the individual or citizen. Therefore, human life

and integrity tend to be eaten up and spat out, so to speak, by the greater machine, not dissimilar to Sigmund Freud noting that the individual is "a cog in the gigantic machine of war" (1915, p. 275), as well as Michel Foucault's (1926–1984) notions of *biopolitics* and *biopower*.[5] Scenes from the film include: a boardroom full of businessmen; signs indicating the stock market crash, war and destruction; a figure breaks and enters armed with a weapon and gas mask. Such scenarios are juxtaposed with footage of Burroughs armed with his tape recorder, the flicker of the *dreammachine*,[6] text being cut into strips, and instructions of how to create cut-ups. Burroughs shoots up heroin while pharmaceutical advertisements and warnings are recited; audio recordings are played backward and overlaid with ritual drumming. At the end, the businessmen in suits are cut from the scene, as their plans and papers blow down an open road, while a young man dances in the street; he then pauses to look up at the sky, which has filled with bright colors. Youth, ideals and free-thinking seem to have won the day, until the armed figure in a gas mask returns in the final frame.

As the story goes, while in Paris, Balch saw Tod Browning's (1880–1962) *Freaks* (1932) at La Cinémathèque française. The film had never before been screened in the UK as it had been previously considered unsuitable for release. Through American filmmaker Kenneth Anger, who had worked at the Cinémathèque, Balch learned who owned the film rights and was able to raise the funds to create a print of the film. He then curated a program screening *Freaks* and *Towers Open Fire* together in west London. Another project Balch and Burroughs worked on together was a revival and reworking of the Swedish silent film *Häxan* (1921), which Balch retitled *Witchcraft through the Ages* and commissioned Burroughs to narrate for its British release in 1968.

According to Sargeant, Balch intended to create a film called *Guerilla Conditions* following *Towers Open Fire*, and for this production he shot footage of Burroughs and Gysin in and around various hotels in which they lived from 1961 to 1965, including: the Beat Hotel in Paris; Hotel Villa Muniria, Tangier; the Empress Hotel, London; and the Chelsea Hotel, New York. The film was intended to be a 23-minute silent documentary; however, it was never completed, and some of the footage ended up in his next film: *The Cut Ups* (1967).

The Cut Ups (1967) was the first film to be intentionally created completely using the cut-up method as developed by Gysin and Burroughs. Once all of the material was shot, Balch cut all of it into four sections, just

as is instructed in *The Third Mind*,[7] and then handed all of this footage over to a woman who was instructed to take one foot from each roll and join them together in a systematically randomized way. In this way:

> the editing was purely a mechanical task, most importantly "nobody was exercising any artistic judgment at all. The length of the shots (except for the last) was always a foot."
>
> (Sargeant, 1997, p. 171)

Balch chose the length of a foot feeling that this amount would be enough time for the audience to view the scene being projected but not long enough to be able to consciously examine the scene in detail. Balch also varied the speed at which the film was projected. The soundtrack is dominated by Burroughs and Gysin repeating permutations of the phrases: *Yes. Hello. Look at that picture. Does it seem to be persisting? Good. Thank You.* "The soundtrack was constructed by Ian Sommerville, Gysin and Burroughs, and was based on a Scientology auditing test" (Sargeant, 1997, p. 172).

Following *The Cut Ups* (1967), Balch collaborated with Burroughs on *Bill and Tony* (1972), which included the pair reading from a Scientology manual, as well as from the script for *Freaks*. Gysin had been doing "expanded cinema" performances where film was projected onto his body; for example, a film of a naked Gysin was projected onto a clothed Gysin, or vice versa; or one person's head was projected onto another person's body. *Bill and Tony* was influenced by this, as Burroughs's and Balch's heads were projected onto one another as they slowly mutated into each other:

> The film – and the performances – were all experiments which radically challenged the concept of fixed identity, allowing the collaborators to use light in order to become one another.
>
> (Sargeant, 1997, p. 173)

In 1964, Gysin and Balch developed a script for Burroughs's breakout novel *Naked Lunch* (1959).

> The cut-up method was used in (on?) *Naked Lunch* without the author's full awareness of the method he was using. The final form of *Naked*

Lunch and the juxtaposition of sections were determined by the order in which material went – at random – to the printer.

(Burroughs & Gysin, 1978, p. 43)

Gysin worked on the script while Balch devised elaborate storyboards for the film. The crew wrangled in Terry Southern (1924–1995) to work with them, and even gained interest from Mick Jagger (b. 1943). However, despite receiving interest as early as 1971, Gysin's *Naked Lunch* screenplay never came to fruition.

American filmmaker Conrad Rooks was the next to apply the cut-up method as developed by Gysin and Burroughs directly to film, in his feature film *Chappaqua* (1966), with Robert Frank as cinematographer. The result is a psychedelic journey through the life of an addict's last days before he checks himself into rehab and endures the symptoms of withdrawal from alcohol and narcotics. The film is loosely based on Rooks's own life, and he cast Burroughs as the medical director of the inpatient facility.

Rooks grew up in Chappaqua, a small town in upstate New York. Once a sacred site, a place of "running waters" where indigenous peoples cleansed and buried their dead, Chappaqua is now a town as suburban as any other. "The Natives are all gone, just their arrowheads remain [...] but they used to dance there."[8] In the film, the main character, Russell Harwick, played by Rooks, takes a variety of psychedelic substances to help him withdraw from his alcohol addiction. The film merges waking reality with dream sequences and altered states, creating a disjoined experience inside the state of the viewer, as scenes cut from a hospital room to a desert, a cafe to a roadway, the streets of Times Square to flying high over the city. It's difficult to tell if we're in a pleasant dream or confused drug-addled state, in pain from withdrawal or experiencing relief. It seems in this shifting of scenes, Rooks was able to communicate to the audience feelings and experiences he himself endured in his own struggle with alcohol and drug addiction and subsequent withdrawal, recreating them in a sense in the audience. The soundtrack is also a distinct cut-up, featuring different types of music including the sounds of Ornette Coleman (1930–2015), Moondog (1916–1999), Ravi Shankar (1920–2012), Allen Ginsberg and Peter Orlovsky.

Rooks actually commissioned Burroughs for cut-up lessons, during which Burroughs taught Rooks the technique in depth, illustrating

the multitude of variations in which the technique could be utilized and applied to various media:

> I finally paid Bill to teach me the cut-up technique. I started doing that with him for hours and hours in his little room in the Beat Hotel in Paris, four to five hours at a time. He'd paste stuff up on the wall. People even called him "The Professor," that was one of his nicknames.[9]

The cut-up method reflects something essential about the nature of the self, and the construction of identity and interpersonal relationships: the cut-up is aggregated in conventional life. It is in our speech, what we read, what we watch, how we watch it, and what we create. The cut is, at the same time, physical and symbolic. A simple blink of an eye is a cut in itself – the cut between sight and darkness. The cut-up manifests itself through daily activities such as reading the newspaper; the eye is reading one article yet peripherally skimming the entire page. When reading or writing, we're always bringing in other stimuli; we bring in sounds from the street, as well as sights, smells and textures within the room. Memories and associations are brought up into conscious awareness, and integrated with what you are doing now. You are not only bringing that memory up from the past into the present time, but also each and every time you have experienced that memory before. So, for example, if you're remembering something from 15 years ago, there are 15 years of recalling that memory and every single street corner you were standing on or situation you were in when you remembered it times before. Such moments provide opportunities where one may begin to rewrite memory, history and narrative.

Moments from the past are brought up into the present; this can be thought of as a cut in time. This cut then connects moments of the past, present and future in a new way, which then affects the other pieces of information – whether they be memories, impressions, words or signifiers – which are also now in relation to one another in a new way. This process is ongoing and never-ending, as fragments of memory and other unconscious material are continually being placed in new and ever-changing formations. Each time one of these cuts is made, an opportunity is presented for something new to transpire. One may think of it as a kind of collage of consciousness.

The cut-up is integrated in the art of filmmaking, music, collage, dance, writing and performance art: really, every art form.

All writing is in fact cut-ups. A collage of words read heard overheard, What else? Use of scissors renders the process explicit and subject to extension and variation.

(Burroughs & Gysin, 1978, p. 32)

The deconstruction of the cut-up method lays bare the dynamics at play underneath the surface, giving us a glimpse of our real fragmented state, which we weave into a cohesive narrative through our use of dreamwork, identification and fantasy. Perhaps this mirroring or mimicking of the underlying processes of the unconscious causes cut-ups to often feel resonant in a way that feels uncanny. We use fantasy to make ourselves feel whole, while our underlying sense of self and body feels fragmented. All the while we are constantly experiencing a barrage of external and internal stimuli, sensory perceptions and internal conflicts. We are constantly managing all of this input, while simultaneously turning it into a cohesive narrative for ourselves in an attempt to make ourselves feel safe and whole, when in reality we are bombarded with images, memories, fragments, words and perceptions from within and without, all the time. "Cut-ups make explicit a psycho-sensory process that is going on all the time anyway" (Burroughs & Gysin, 1978, p. 4).

The cut-up method makes this experience explicit, and literal. We cut up language, text or image and reconfigure it. Whether by chance or with more intention, we recreate the narrative, tying it all together again in a new way, creating another sort of sense. This process mirrors mechanisms that we are already utilizing all the time in our daily lives to provide a sense of security in the midst of the chaos of internal and external reality. In this way, the artists who use the cut-up method are also "questioning the nature of 'perceived reality' through the cut-up process, (re)creating 'separate realties' and thus exposing existing 'truths' as constructions" (Sargeant, 1997, p. 176).

Burroughs was adamant that we all need to be paying more attention to our surroundings; that we should become more aware of what is happening around us all of the time. He very much viewed all of life as a cut-up. You may be riding on a train and notice that the conversation you overhear from the couple sitting next to you reflects what you are reading; rather than feeling paranoid about this coincidence, Burroughs felt we should make note of it. He kept scrapbooks documenting connections such as these, which he called *intersections*. If he found a newspaper article

reflected something he was writing about, he would cut out the article and keep it in his notebook.

Burroughs described his process of journal-keeping in *The Third Mind* (1978). He always had a notebook that he kept with him, and he divided his writing into three columns: the first was an account of what occurred on the journey: the flight, what he overheard others speaking about on the flight, the cab ride, what he noted on the radio in the car, the hotel, what was said upon checking in, etc. In the second column, Burroughs noted any associations that occurred to him during his day: thoughts, memories or reflections that may have arisen, or fragments of dreams. In the third and final column, he recorded notes from whichever book he was reading at the time: direct quotes from the book, as well as reflections on it.

> Either-or thinking just is not accurate thinking. That's not the way things occur, and I feel the Aristotelian construct is one of the great shackles of Western civilization. Cut-ups are a movement toward breaking this down.
>
> (Burroughs & Gysin, 1978, pp. 5–6)

As described, Burroughs and Gysin experimented with the cut-up method in quite a methodical fashion. They kept notes of the directions they gave themselves for their series of experiments and meticulously documented the results of their cut-up investigations. The results of these eventually became their book *The Third Mind*, for which the dedication reads, "To and for all our collaborators at all times third minds everywhere." The concept of the "third mind" was delineated by Burroughs and Gysin over the course of their creative collaboration. The pair felt that working so intimately together with another artist over an extended period of time creates a sort of third mind between the two individuals that eventually takes on a creative life of its own. This process was perpetuated by the continuous cutting up and reconstruction of language, image and sound. By applying the cut-up method to their own words and images, the artists felt there was a breakdown of the illusory sense of self – the fantasy of the individual – and a reassembly of themselves and their creations. In this manner, the cut-up method may also aid in breaking down the systemic structures imposed on us by culture, media, political systems, religion, class, gender, ethnicity, and expectations of our m/Other, significant others

and family, but also of those internal structures we have created over our lifetime: that is, our ego, superego and identifications. The cut-up method provides an opportunity to invent something new by supplying a methodology for implementing the cut – opening up a space, a gap within which we may (re)situate ourselves.

British artist David Bowie (1947–2016) was a friend of Burroughs' and utilized the cut-up method in his work as well. A colleague of Bowie's even developed a computerized cut-up generator for him to aid songwriting.[10] With this instrument, Bowie was able to deposit phrases as they came to him through inspiration, and then later have the machine cut up and rearrange the fragments into a seemingly infinite assortment of potential song lyrics – yet another example of technology being put to use in the creation of art. Bowie was also a master of cutting up identity, often experimenting with different personas, altering his look, sound and performance style. Bowie was a pioneer of creative expression, illuminating the malleability of identity, as he expressed a range of gender presentations and sexual preferences.

Contemporary artists continue to utilize these techniques. American artist Elijah Burgher (b. 1978) deconstructs language in his work creating what are called *sigils* – abstract designs formed from the dissolution of words and sentences that have an intention imbued within them. In his work, Burgher merges the magical and mundane, conscious and unconscious, language and flesh, desire and drive, placing himself and figures from his life into scenes that are at once intimate settings and symbolic realms.[11] In this breaking down of language, Burgher dislocates meaning, untethering us. As we fall further from the conscious intention of the work, we land in the realm of signifiers, dropped into the web of the unconscious, sexuality and death. The way Burgher places nude figures in these spaces seems to allow for layers of meaning, connections and associations to form. It is almost as if we are given a peek into the space between: that liminal, transitional space where creation happens – the space of subjectivity, play, sex and invention.

Notes

1 "First Cut-Ups" by Brion Gysin in Beiles, S., Corso, G., Gysin, B. & Burroughs, W.S. (1960/1968) *Minutes to Go.* San Francisco: Beach Books, Texts & Documents.

2 Dictionary.com lexicographers (2009) "Beatitude" [Online]. Dictionary.com. Available at www.dictionary.com/browse/beatitude (Accessed: February 23, 2020).
3 Instructions of these processes may be found in Burroughs, W.S. & Gysin, B. (1978) *The Third Mind*. New York: Viking Press.
4 Information regarding the film collaboration between Antony Balch and William S. Burroughs pulled from Sargeant, J. (1997) *Naked Lens: Beat cinema*. London: Creation Press. pp. 169–176.
5 Adams. R. (2017) "Michel Foucault: Biopolitics and Biopower" [Online]. Critical Legal Thinking. Available at http://criticallegalthinking.com/2017/05/10/michel-foucault-biopolitics-biopower/ (Accessed: February 23, 2020).
6 An artistic creation by Brion Gysin, meant to be viewed with eyes closed.
7 Burroughs, W.S. & Gysin, B. (1978). *The Third Mind*. New York: Viking Press. p. 31.
8 *Chappaqua* (1966) [Film] Conrad Rooks (dir.). USA: Minotaur.
9 Abrahamsson, C. (2013). *Reasonances*. London: Scarlet Imprint. p. 115.
10 Marshall, C. (2019) "How David Bowie used William S. Burroughs' cut-up method to write his unforgettable lyrics" [Online]. Open Culture. Available at www.openculture.com/2019/05/how-david-bowie-used-william-s-burroughs-cut-up-method-to-write-his-unforgettable-lyrics.html (Accessed: August 24, 2019).
11 Honigman, A.F. (2014) "As art and Magic: An interview with Elijah Burgher" [Online]. ArtSlant. Available at www.artslant.com/ny/articles/show/38626-as-art-and-magic-an-interview-with-elijah-burgher (Accessed: December 16, 2019).

Bibliography

Abrahamsson, C. (2013) *Reasonances*. London: Scarlet Imprint.
Bandera, S., Castiglioni, A. & Zanella, E. (eds.) (2018) *Kerouac: Beat painting*. Milan: Skira.
Beiles, S., Corso, G., Gysin, B. & Burroughs, W.S. (1968) *Minutes to Go*. San Francisco: Beach Books, Texts & Documents.
Breyer P-Orridge, G. & Christopherson, P. (2018) *Brion Gysin: His name was Master*. Stockholm: Trapart Books.
Burroughs, W.S. (1995) *My Education: A book of Dreams*. New York: Viking Press.
Burroughs, W.S. & Gysin, B. (1978) *The Third Mind*. New York: Viking Press.
Dwyer, S. (ed.) (1989) *Rapid Eye: Art, occult, cinema, music*. Brighton: R.E. Publishing Ltd.

Freud, S. (1920). "Beyond the pleasure principle." *The Complete Standard Edition of the Psychological Works of Sigmund Freud (SE)* XVIII. London: Hogarth Press. pp. 1–66.

Freud, S. (1915) "Thoughts for the times on war and death." *SE* XIV. London: Hogarth Press. pp. 273–300.

Geiger, J. (2005) *Nothing is True, Everything is Permitted: The life of Brion Gysin.* New York: The Disinformation Company, Ltd.

Ginsberg, A. (2001) *Howl and Other Poems.* San Francisco: City Lights Books.

Ginsberg, A. (1961) *Kaddish and Other Poems, 1958–1960.* San Francisco: City Lights Books.

Ginsberg, A. (1972) *The Fall of America: Poems of these states, 1965–1971.* San Francisco: City Lights Books.

Grauerholz, J. (ed.) (2000) *Last Words: The final journals of William Burroughs.* London: Flamingo.

Gray, K. (2015) *Brion Gysin: Unseen collaborator.* London: October Gallery.

Gysin, B. (1988) *The Process.* London: Paladin Books.

Gysin, B. (2010) *Alarme.* New York: Printed Matter, Inc.

Gysin, B. & Wilson, T. (1982) *Here to Go: Planet R-101.* London: Quartet Books.

Harris, O. (1993) *The Letters of William S. Burroughs, 1945–1959.* New York: Viking.

Heil, A. & MacFadyen, I. (2013) *William S. Burroughs/Cut.* Cologne: Verlag der Buchhandlung Walther König.

Hibbard, A. (1999) *Conversations with William S. Burroughs.* Jackson, MS: University Press of Mississippi.

Kuri, J.F. (ed.) (2003) *Brion Gysin: Tuning in to the multimedia age.* London: Thames & Hudson.

Lacan, J. (2006) "The mirror stage as formative of the *I* function as revealed in psychoanalytic experience." In *Écrits: The first complete edition in English.* Translated by B. Fink. New York: W.W. Norton & Co. pp. 75–81.

McGowan, T. (2019) "The sex in their violence: eroticizing biopower." In Sinclair, V.R. & Steinkoler, M. (eds.) *Psychoanalysis and Violence: Contemporary Lacanian perspectives.* London: Routledge. pp. 47–60.

Miles, B. (ed.) (1986) *Allen Ginsberg: Howl.* New York: Harper & Row Publishers.

Miles, B. (2014) *William S. Burroughs: A life.* London: Weldenfeld & Nicolson.

Sargeant, J. (1997) *Naked Lens: Beat cinema.* London: Creation Press.

Sinclair, V.R. & Foisy, K.F. (2017) "The cut in creation." In Sinclair, V.R. & Abrahamsson, C. (eds.) *The Fenris Wolf,* vol 9. Stockholm: Trapart Books. pp. 67–76.

Vale, V. (ed.) (1982) *RE/Search #4/5: William S. Burroughs, Brion Gysin and Throbbing Gristle.* San Francisco: RE/Search Publications.

Verhaeghe, P. (1999) *Love in a Time of Loneliness: Three essays on drive and desire*. London: Karnac.
Vogel, A. (1974) *Film as a Subversive Art*. New York: Random House.
Walker, R. & Burroughs, W.S. (1984) *New York: Inside out*. Toronto: Oxford University Press.
Weiss, J. (2001) *Back in No Time: The Brion Gysin reader*. Middleton, CT: Wesleyan University Press.
Wilentz, E. (ed.) (1960) *The Beat Scene*. New York: Corinth Books.
Zupančič, A. (2008) *The Odd One In: On comedy*. Cambridge: The MIT Press.

Filmography

Cut-Up Films. (2005) [DVD] Anthony Balch (dir.). USA: RaroVideo US.
Chappaqua. (1966) Conrad Rooks (dir.). USA: Minotaur

Part IV

When art becomes life (and death)

Part IV

When art becomes life (and death)

Chapter 11
Acting out
Pop, street and performance art

Artists, poets and filmmakers near and far were influenced by the antics of the Beats. Inspired by the film *Pull My Daisy* (1959), which turned life into art by making art of out life, American experimental filmmaker Ron Rice (1935–1964) and actor Taylor Mead set out on their own adventure. The pair met in San Francisco, and Mead ended up starring in Rice's *The Flower Thief* (1960) after the person who was meant to act in the film disappeared. *The Flower Thief* was created in an off-the-cuff manner, basically a film of Mead being followed around the city. Rice chose various locations to shoot and encouraged the actors to improvise, allowing for spontaneity, chance and inspiration to enter the scene. Rice described his actors as *dadazendadaists* (Sargeant, 1997, p. 85).

Mead met Andy Warhol in 1963, his underground cult status preceding him. Soon after, Warhol invited Mead to drive cross-country with him, American poet Gerard Malanga (b. 1943) and visual artist Wynn Chamberlain (1927–2014) from New York to Los Angeles, where Warhol was having his first major exhibition. A wonderful travelogue of this cross-country adventure, pieced together from the diaries and receipts of these fellow travelers, is detailed in Deborah Davis's (b. 1952) *The Trip: Andy Warhol's Plastic Fantastic Cross-Country Adventure* (2015). Over the course of their relationship, Mead starred in a number of Warhol's films, including *Tarzan and Jane Regained... Sort Of* (1963), *Couch* (1964), *Taylor Mead's Ass* (1964), *Nude Restaurant* (1967), *Lonesome Cowboys* (1967) and *San Diego Turf* (1968). Some of Warhol's other films included *Flesh* (1968), *Trash* (1970) and *Women in Revolt* (1971), all of which feature trans* superstars Candy Darling (1944–1974), Jackie Curtis (1947–1985) and Holly Woodlawn (1946–2015). Bending gender along with David Bowie, Lou Reed (1942–2013), Iggy Pop (b. 1947) and the

New York Dolls, among others, this period of sexual liberation and shattering of gender stereotypes led up to the modern day LGBTQ civil rights movement as we know it, formally launched following the Stonewall uprising in Greenwich Village in 1969.[1]

Living in New York City, Taylor Mead was a staple of the East Village art and literary scene since the late 1950s. He arrived in San Francisco in 1960, right at the height of excitement following Allen Ginsberg's monumental reading of *Howl* (1956). Mead recalled:

> Kerouac's *On the Road* put me on the road and Allen's *Howl*, which had just come out, had a big effect on me.
>
> (Sargeant, 1997, p. 80)

Throughout his career, Mead acted, painted, wrote and performed poetry at various venues, including the Gaslight Cafe alongside the likes of Bob Dylan (b. 1941), Allen Ginsberg and Gregory Corso, to name a few. Mead documented his life experiences in his writing, resulting in such publications as his three volume collection *Excerpts from the Anonymous Diary of a New York Youth* (1968) and later *Son of Andy Warhol* (1986). Mead continued performing poetry in the Village at the Bowery Poetry Club up until his death in 2013.[2]

Warhol has influenced contemporary culture in countless ways, facilitating change in the way we see and relate to art, artists, gender and identity, as well as the mainstream media, advertising, production and the commercial. He took the everyday and turned it into art, with his renditions of household products, dollar bills, car crashes cut from newspaper articles, and photos of celebrities taken from magazines. All of this had been unheard of until this point. Marcel Duchamp had already turned the everyday into works of art with his collection of readymades; Warhol took this a step further by taking these readymade objects and not only claiming them as works of art but using them as artistic subject matter, embellishing, screen-printing and multiplying them. Just as an industrial factory churns out countless numbers of soup cans and the U.S. Mint produces dollar bills, so Warhol painted and silk-screened the same images over and over again in his Factory. Not only did he sell these as individual reproductions, but he often displayed many of the same item together as one artwork: for example, 25 Campbell's soup cans shown together, each being an original work of art with slight differences; perhaps the name on

a soup can differs from the one next to it (one is cream of mushroom while the other is tomato), just as labels differ slightly and dollars have varying serial numbers.

Warhol was born in Pittsburg to a working class family, and originally headed to New York City after college to pursue a career in advertising. He was successful in his profession, which clearly influenced the way he looked at art and the art world, as well as at life in general. The influence he has had on our present day society is ever-present, showing us that marketing is ubiquitous and we as individuals each have our own brand. As cynical as it may seem, it certainly seems to have relevance when we look at the influence of social media on our everyday lives and the real world effects it has on society, culture and politics.

Warhol turned the lens around to focus on the artist's life and persona. Rather than solely considering the works of art produced, he demonstrated that life itself can be a work of art. At the same time, it is well known that Warhol was obsessed with becoming famous. He wanted to know what the neo-Dadas – Robert Rauschenberg and Jasper Johns – had that he didn't have (yet). He was obsessed with Truman Capote (1924–1984) and even showed up on his doorstep (Davis, 2015, p. 40). What some found to be taboo, Warhol indulged in without shame. He felt he often got his best ideas and inspiration from chance encounters and moments triggered from outside stimuli. He often asked others what they thought he should create next, sometimes upon just meeting them:

> The object is just to keep people talking, because sooner or later a word gets dropped that throws me on a different train of thought.
> (Warhol & Hackett, 1980, p. 17)

During the era of the Warhol all-stars, many young up-and-coming artists flocked to New York City. Patti Smith (b. 1946) and Robert Mapplethorpe (1946–1989) first met there in 1967. Mapplethorpe was attending Pratt when Smith accidentally stumbled into his room while looking for friends who also attended the art school. Each living the quintessential artist's life, the pair moved in together quickly. In June of 1968, when Valerie Solanas (1936–1988) shot Warhol, Smith recollects that Mapplethorpe was beside himself, considering Warhol the greatest living artist and admiring the way he merged art and life (Smith, 2010, p. 69). Smith was less enthused, but at times the pair would pool their money to go hang out at Max's Kansas

City, decked out in their best looks in hopes of running into Warhol and his crew. At that time, no one knew whether Smith and Mapplethorpe were friends, siblings, lovers, roommates, gay, straight, bi or all of the above. Needless to say, after the near fatal shooting, Warhol didn't go out much.

Mapplethorpe photographed Smith for the cover of her debut album *Horses* (1975), as well as for her later albums *Wave* (1979) and *Dream of Life* (1988). Her androgynous image staring directly into the camera in stark black and white – in a collared white button-down shirt, with an undone tie and jacket thrown over her shoulder – was a huge contrast to the typically feminine album covers and psychedelic post-flower-child looks of the time. As Smith has said, "As far as I'm concerned being any gender is a drag" (Levine, 1998, p. 55).

As their careers progressed, Mapplethorpe focused on celebrity and society portraits, as well as images of the gay S&M scene of Manhattan's Meatpacking District. He met female bodybuilder Lisa Lyon (b. 1953) in 1979, and the two collaborated on a series of over 200 images from 1980 to 1983, detailed in what became the book *Lady: Lisa Lyon* (1983). The pair described their collaboration as a succession of fantasies where Lyon deconstructed the shackles of the feminine stereotype, donning a wide variety of guises ranging from feminine to androgynous and masculine, playing the bride, seductress, choirgirl, fashion model, motorcycle chick, dandy and male bodybuilder.

Warhol and Mapplethorpe both explored gender identity and sexuality in their lives and work. Over the years, they each took portraits of the other, in addition to photographing various friends and acquaintances, as well as creating their own self-portraits. Many of these works have been collected together for the exhibition and accompanying publication *Warhol and Mapplethorpe: Guise and Dolls* (2015), including Mapplethorpe's iconic photograph of Candy Darling from 1973 and Warhol's *Ladies and Gentlemen* (1974) series. These sessions continued on through the 1980s, with Warhol and Mapplethorpe documenting their peers, selves and each other, finally culminating in Mapplethorpe's 1986 portrait of Warhol (with halo).

During this same period of time, performance art was taking over gallery spaces. It then began leaving the gallery walls behind altogether and stepping out into the streets in *actions* and *happenings*. At the turn of the 20th century, there had been performances connected to Bauhaus and Dada, for example, which had futuristic themes, involving technology

juxtaposed with more traditional aspects of performance and ballet. But in the performances of the 1960s and 1970s, there seemed to be a return to the body with a focus on exploring the ways in which the body could be used in art and performance.

The Viennese Actionists, a collective of artists including Hermann Nitsch (b. 1938), Günter Brus (b. 1938), Rudolf Schwarzkogler (1940–1969) and Otto Muehl (1925–2013), often took the body to extremes with their performances. Although they did not constitute an entirely homogenous group, there were certainly enough similarities between them to be regarded as one entity or movement by art history. Each artist practiced a form of confrontation through his art. In particular Nitsch's *Aktionen,* as well as the resulting forms of documentation (paintings, videos, CDs), have been deemed extreme, perverse and at the very least unsettling and uncomfortable. Nitsch's use of nudity and ample amounts of blood, as well as the carcasses and entrails of animals in his actions, has been the most controversial aspect of his work. Regarding this, Nitsch has said:

> I want my work to stir up the audience, the participants of my performances. I want to arouse them by the means of sensual intensity and to bring them an understanding of their existence.[3]

Japanese artist Yoko Ono (b. 1933) works with her body and the cut quite directly in the performance *Cut Piece* (1965), a shockingly intimate and expressive work in which her clothing is cut away, piece by piece, bit by bit, unraveling the layers as she is laid bare both literally and symbolically. In this performance piece, Ono remains seated on the stage as various participants come up to her and cut away her clothing: a man cuts her sleeve, a woman her collar. Another woman cuts the front of her sweater open; her buttons come undone. The scissors sit on the stage in front of Ono, tension building as audience and artist alike await the next move; wondering who will be the next to approach her, take the scissors and cut.

In 1976, British performance art collective COUM Transmissions made headlines with their *Prostitution* show. Prior to COUM, Genesis P-Orridge had been exploring identity, pushing limits and breaking boundaries through performance art since he/r earliest work with the Exploding Galaxy commune in 1969, where any semblance of routine or structure was completely dismantled. The interior walls of the building were literally torn down as much as possible, including the walls surrounding the

bathrooms. Members were not to sleep in the same location two nights in a row. Meals were cooked at irregular times throughout the day. No one had their own money. All clothing was kept in the center of the room with a first come, first served policy each morning. This disrupted attachment to material possessions, personal space and privacy, as well as blurred boundaries between self and other. When it was discovered that leaders were not abiding by the same rules as the others in the house, P-Orridge left and founded COUM Transmissions. As part of COUM, P-Orridge developed a practice of adopting various identities and living fully as each character for days on end, whether or not s/he liked or agreed with the belief system of the person chosen.

This type of experimentation continued in the performance art of P-Orridge and early collaborator Cosey Fanni Tutti. For example, the pair's "Orange and Blue" performance pieces began with the male-bodied person dressed from head to toe in orange with all of his orange belongings on one side of the room, while the female-bodied person dressed in all blue with her collection of blue items. Throughout the course of the performance, they would slowly exchange items and clothing with one another over several hours, until they had switched over to the other's attire and accoutrements completely. In this way, the pair was already exploring the idea of gender and identity as performative in 1969, something not brought to the fore in academia until decades later.[4]

Serbian artist Marina Abramović (b. 1946) also entered the realm of performance art during this time, provoking with pieces such as her *Rhythm* (1973–1974) series, in which she tested the mental and physical limitations of her own body.[5] This included her playing a Slavic knife game, in which she cut herself over 20 times, recording and repeating the action, in an attempt to replicate, while also exploring the impossibility of repetition itself. During another extreme performance, Abramović lost consciousness and almost died after lighting a five-pointed star on fire, cutting her hair and nails in an act of ritual purification and then leaping inside the perimeter of the flames. Fortunately, others in the space noticed she appeared not to be moving and pulled her body out from the midst of the flames. In another action, Abramović stood by a table that contained a variety of objects, including knives, scissors, a gun, one single bullet and candles (76 objects in total), and allowed audience members to do whatever they would like to her using said objects. In the beginning someone brushed her hair, put makeup on her, handed her a rose; however, this quickly devolved

as audience participants took the thorns from the rose and stuck her with them, cut off her clothes with the scissors, sliced her skin with a razor blade and fondled her breasts. One person placed the bullet in the gun and put the gun to her temple; another took the gun away and wrestled with the first. Abramović has said:

> The women would tell the men what to do, and the men didn't rape me because it was just a normal opening, and it was the art public, and they're there with their wives.[6]

At the age of 12, Ana Mendieta (1948–1985) fled to the United States from the political turmoil of her native Cuba, together with her sister and thousands of other displaced persons and unaccompanied children. Working in visual art, sculpture, video and performance art, Mendieta worked with this displacement through a variety of methods and materials. Often using her own body as a canvas or resource, Mendieta challenged conservative notions of gender, identity, nationality, belonging, language, place and space. Some of her best-known works are the *Silueta Series* (1973–1977), wherein she imprinted her body into natural landscapes in the United States and Mexico; then subsequently filled her outline with sand, flowers, leaves, branches and other natural treasures, as well as with gunpowder and fire. Mendieta has said of her work:

> My exploration through my art of the relationship between myself and nature has been a clear result of my having been torn from my homeland during my adolescence. The making of my silueta in nature keeps (makes) the transition between my homeland and my new home. It is a way of reclaiming my roots and becoming one with nature. Although the culture in which I live is part of me, my roots and cultural identity are a result of my Cuban heritage.
>
> (Moure, 1998, p. 108)

American artist Jean-Michel Basquiat (1960–1988) shifted the history of art by bringing art from the streets into the gallery. Basquiat first gained recognition as a graffiti artist when he covered the Lower East Side of Manhattan with poetry. He soon began creating and selling painted and collaged postcards, a few of which he sold to Warhol after approaching him in a Manhattan cafe. Basquiat quickly gained notoriety in the New York

art world, selling out even his earliest shows; at this time, he painted many pieces on found objects, such as discarded doors.

> Basquiat took in everything he perceived with his five senses, from all around him. He collaged from his surroundings, from his everyday life. It is the appropriation of the everyday, the coincidental as well as the ostensibly significant that makes his art so unmistakable, so unique.
>
> (Buchhart, 2018, p. 20)

Basquiat practiced cut-up and collage techniques in his own way, often working on multiple canvases at the same time. He paid respect to the artists, writers, musicians and thinkers who inspired him by painting them into his works, as well as creating pieces in homage to them. Basquiat is known to have said, "I don't think about art while I work. I try to think about life."[7] In this way, he created his works from the collage of his life, so to speak. In so doing, Basquiat is an incredible example of how the personal *is* political: embodying the impact an individual can have when one allows oneself to truly speak through the medium of the creative process.

Many contemporary artists work with performance both within and without the gallery setting. One such is Swedish performance artist Gustaf Broms (b. 1966), who executes actions on the streets of Stockholm, as well as throughout the world. Broms lived in New York City for nine years, where he worked for Richard Avedon (1923–2004), who incidentally created the famous portrait of Warhol post-surgery after he had been shot by Solanas in 1968. Broms then moved to India where he began working with art installations as opposed to photography. This began as a necessity, as he had no means by which to process his photographs in this new land. Instead he began to take the objects around him and assemble them in new and interesting ways. This launched a new way of working for Broms, as he collected bones, earth and fragments from his surroundings and re-envisioned them. He then photographed these installations, displaying the photographs as artworks, as well as recreating the assembled scenes in gallery and alternative spaces when he returned to his native Sweden. In these exhibitions, Broms played with the lighting to illuminate these objects and installations in ways that would pull in the audience, prompting viewers to encounter and confront the work in more immediate and tangible ways.

Broms describes the importance of bringing art out into the world, rather than keeping it contained in gallery spaces. In the delineated space of an exhibition, the audience comes to the gallery or museum with the explicit intention of viewing and experiencing artwork; they are expecting it, and they are oftentimes artists themselves working in a similar manner or context. However, Broms notes, when an artist works outside in a public space, the viewers are not expecting to encounter a performance artist on their commute or on the way to the grocery store; there is an element of surprise, which may facilitate the artwork having more of an effect on the viewer. There is also a chance that the artist will encounter and affect many more people, as well as different kinds of people, potentially producing a sort of ripple effect through them, albeit unconsciously.

Notes

1 Lorenzo, I. (2019) "The Stonewall uprising: 50 years of LGBT history" [Online]. Stonewall. Available at www.stonewall.org.uk/about-us/news/stonewall-uprising-50-years-lgbt-history (Accessed: February 23, 2020).
2 Foisy, K. (2019) "Taylor Mead: Diamond in a Grey City" [Online]. Mistress of magic. Available at www.katelanfoisy.com/the-vardo/2019/5/7/taylor-mead-diamond-in-a-grey-city (Accessed: August 26, 2019).
3 ArtNet. (2017) "Hermann Nitsch" [Online]. ArtNet. Available at www.artnet.com/artists/hermann-nitsch/ (Accessed: March 5, 2020).
4 Butler, J. (1990) *Gender Trouble: Feminism and the Subversion of Identity*. London: Routledge.
5 Parry, C. (2015) "Rhythm Series – Marina Abramović's first series of performance art (1973–1974)" [Online]. Available at https://blogs.uoregon.edu/marinaabramovic/category/rhythm-series/ (Accessed: August 28, 2019).
6 Abramović, M.(2015) "An art made of trust, vulnerability and connection," [Video, Online]. TED Talk. Available at www.ted.com/talks/marina_abramovic_an_art_made_of_trust_vulnerability_and_connection/discussion (Accessed: August 28, 2019).
7 Unit London (2018) "Graffiti as high art: Jean-Michel Basquiat" [Online]. Unit London. Available at https://theunitldn.com/blog/70/ (Accessed: March 5, 2020).

Bibliography

Bluttal, S. et al. (eds.) (2006) *Andy Warhol "Giant" Size*. London: Phaidon Press Limited.

Brus, G. (2000) *Irrwisch*. Kalgenfurt: Ritter Verlag.
Buchhart, D., et al. (2018) *Jean-Michel Basquiat*. Paris: Fondation Louis Vuitton.
Colacello, B. (1990) *Holy Terror: Andy Warhol close up*. New York: Cooper Square Press.
Davis, D. (2015) *The Trip: Andy Warhol's Plastic Fantastic Cross-Country Adventure*. New York: Atria Paperback.
Ford, S. (1999) *Wreckers of Civilisation: The story of COUM Transmissions and Throbbing Gristle*. London: Black Dog Publishing.
Ginsberg, A. (1956/2001) *Howl and Other Poems*. San Francisco: City Lights Books.
Ginsberg, A. (1961) *Kaddish and Other Poems, 1958–1960*. San Francisco: City Lights Books.
Ginsberg, A. (1972) *The Fall of America: Poems of these states, 1965–1971*. San Francisco: City Lights Books.
Hapgood, S. (1994) *Neo-Dada: Redefining art, 1958–62*. New York: The American Federation of Arts.
Hickson, P. (ed.) (2015) *Warhol and Mapplethorpe: Guise and dolls*. Yale University and the Wadsworth Museum of Art.
Johnson, D. (2015) *The Art of Living: An oral history of performance art*. London: Palgrave.
Lambrecht, I. (2014) *Sangoma Trance States*. Auckland, New Zealand: Create Space.
Levine, M. (1998) *Gay Macho*. New York: New York University Press.
Mapplethorpe, R. (1983) *Lady Lisa Lyon*. London: Blond & Briggs.
Mead, T. (1968) *Excerpts from the Anonymous Diary of a New York Youth*. New York: Boss Books.
Mead, T. (1986) *Son of Andy Warhol*. New York: Hanuman Books.
Moure, G. (1998) *Ana Mendieta*. Barcelona: Poligrafa.
Nilsson, B. et al. (2004) *Andy Warhol: The late work*. Munich: Prestel Verlag.
Nitsch, H. (2004) *Das Orgien Mysterien Theater*. München: Verlag des O.M. Theaters.
Ono, Y. (2000) *Grapefruit: A book of instruction and drawings*. New York: Simon & Schuster.
Ono, Y. (2016) *Woman Power*. Lund, Sweden: Bakhåll.
Sargeant, J. (1997) *Naked Lens: Beat cinema*. London: Creation Press.
Schmitz, B. (ed.) (2016) *Günter Brus: Störungs-zonen*. Berlin: Martin-Gropius-Bau.
Sinclair, V.R. (2016) "Polymorphous perversity and pandrogeny." In Abrahamsson, C. (ed.) *The Fenris Wolf*, vol. 8. Stockholm: Trapart Books. pp. 10–17.
Smith, P. (2010) *Just Kids*. New York: HarperCollins.
Smith, P. (2015) *M Train*. New York: Alfred A. Knopf.

Smith, P. (2017) *Devotion*. New Haven, CT: Yale University Press.
Warhol, A. (1975) *The Philosophy of Andy Warhol*. San Diego: Harcourt Brace Jovanovich, Publishers.
Warhol, A. & Hackett, P. (1980) *POPism: the Warhol sixties*. San Diego: Harcourt, Inc.

Filmography

An Art Apart: Genesis Breyer P-Orridge – Change Itself. (2016) Carl Abrahamsson (dir.). Sweden: Trapart Film

An Art Apart: Gustaf Broms – The Mystery of Life. (2016) Carl Abrahamsson (dir.). Sweden: Trapart Film.

Chapter 12

Cut from the collective

Alternative communities

We live in a world of systems, of structure. We are raised to believe this is inevitable, the natural order of things. But what happens when we start to question this order? If we dare to challenge it? What would happen if we break it down, disassemble it, cut it up? "The first step in re-creation is to cut the old lines that hold you right where you are sitting now" (Burroughs & Gysin, 1978, p. 28).

There are two pieces in which Freud delineated his mythology of the installation of the patriarchy: *Totem and Taboo* (1913) and *Moses and Monotheism* (1939). In *Totem and Taboo,* Freud described a primal father, who possessed everything. He had control of all of the women and all the young men, including and perhaps especially, his sons. The sons were terrified of him and made impotent, as the domineering father maintained control of all of the resources. Eventually, the young men realized the power they had in numbers and came together to overthrow the father. This shift in power was only a momentary thrill, however. The sons quickly experienced guilt and fear once again, as they felt overwhelmed that they themselves had overturned and dismantled the very foundation of their own society. This sense of guilt and fear led the sons to attempt to prop up a father figure again, and to establish the taboos that prohibit sex with the mother and the killing of the father.

This is the way Freud imagined the foundation of our current social structure: the murder of the primal father. As the structure of myth is fundamental to human society, Freud advanced this as a creation myth of sorts for Western society. When Freud revisited this in *Moses and Monotheism* (1939), written at the end of his life and published posthumously, he delved in to greater depth regarding the spread of patriarchy through the foundation of monotheism. At this point, the reinstated primal father had

been elevated to divine status, resulting in a patriarchy with an omnipotent, omniscient and omnipresent Father, more vengeful and demanding than ever before.

At present we are experiencing a crisis of authority as the patriarchy and the many systemic structures that hold it in place are being challenged and confronted like never before. On the one hand, we have activism and attempts to dismantle the predominant power structures, as well as increased concern for nature, the planet and its inhabitants that includes all creatures, as we move away from anthropocentrism, human superiority and exceptionalism. On the other hand, we are seeing a rise in fascism and totalitarianism across the globe, as some again attempt to reinstate the authority of the all-powerful father figure in the face of a crumbling and evolving social structure.

Of course, this is not the first time this has happened; for example, the mid-20th century saw a rise in similar concerns. At that time, the burgeoning field of performance art was expanding, as actions and happenings exploded onto the streets. These performance art collectives were part and parcel of the growing phenomenon of living in alternative communities popular during these times. This spilled over from the more psychedelic movement of the hippies in the 1960s, into the punk era with groups like Crass forming the epitome of what was possible as far as living outside the system. Founded in 1977, Crass was a punk band/art collective residing in a rural communal setting in England called Dial House. Members of Crass created anarchist propaganda in the form of Heartfieldian-type collage and photomontage, publishing their own flyers, zines and records, while experimenting with tape-editing, sound collage and film. The group intentionally performed in unexpected settings as a way to break from the conventional even further, adding the elements of surprise and confrontation, all the while espousing the view that "there is no authority but yourself."[1]

Penny Rimbaud (b. 1943) and Gee Vaucher (b. 1945) were already living together in Dial House when they met Steve Ignorant (b. 1957). Ignorant describes seeing the punk band The Clash perform and feeling that these were working-class men like himself, saying what he wanted to say; at the end of the performance, they shouted, "If you think you can do this better, start your own band!" which inspired Ignorant to do just that.[2] Ignorant approached Rimbaud with the idea, and the pair founded

Crass with Rimbaud as drummer and Ignorant on vocals. Ignorant claims they took the name from the David Bowie song "Ziggy Stardust" in which Bowie sang, "The kids were just crass."[3]

Ignorant proclaims Rimbaud helped him take what he was feeling – all the anger and angst of a young man – and channel it into poetry. The band evolved in much the same way those in Dial House lived: operating on an open door policy, people could come and go as they please, join the band or exit the group of their own volition, giving individuals a sense of autonomy, agency and personal responsibility. As is the case with many of the artists and movements investigated throughout this study, Rimbaud espouses there is no difference between life and art. With Crass, everything that happened in the house affected the music and legacy of the band; as the recording studio was a room in the house, heading to the studio to record was not an experience separated from the daily lives of band members.

One could say the pinnacle of Crass's anarchy was a doctored tape they cut and spliced together from political speeches, creating a mock phone call between then President Ronald Reagan (1911–2004) and Prime Minister Margaret Thatcher (1925–2013) in which they seemed to discuss classified information. The American press quickly picked up the story, assuming the tapes were from Soviet intelligence agency the KGB, and it spread like wildfire. Rimbaud recalls that the group was eventually contacted by the actual KGB, and it was at that point they felt their ambitions had become more palatable for the mainstream – but also decidedly more dangerous.

To this day, Rimbaud and Vaucher continue to live in and run Dial House as an open communal space where everyone – no matter their creed, class or background – is welcome. They see their work as having grown and expanded; they used to speak out against the greed of capitalism, whereas now it's the ever expanding problem of globalization. The fact that the pair has been able to remain in the house for more than 50 years is a feat in itself, having battled for their right to stay as developers attempt to re-envision the village as a golf-course community for the ultrawealthy. All these years, Dial House has remained a commune with organic farming and composting. The group is self-sustainable, and their way of life is decidedly a cut in itself – cut from the social in an act of rebellion, an assertion of their own authority over their lives, truly practicing what they preach.

Singer and visual artist Annie Bandez (b. 1960), also known as Little Annie/Annie Anxiety, lived with Crass for a period. Bandez utilizes the cut-up method and collage in her work, in both her audio and visual art.

> I had started doing cut-ups pretty early on, even though I didn't know what cut-ups were. I've always been fascinated with speech patterns and cadence. I'd find myself putting things together on the basis of their percussive merit.[4]

Her first gig was at Max's Kansas City. As the promotional poster for the event, she created a collage of hundreds of celebrity faces with their eyes rubbed out. Much of her musical performance in those early days consisted of howling and screeching over cut-up sound recordings and tape loops played on a four-track tape recorder. Bandez performed with an ever-changing series of musicians under an ever-changing number of monikers and looks. "I kept changing my name – along with my hair color and my mind."[5]

In 1978, Bandez was standing outside her new apartment in the East Village, when Steve Ignorant walked by, turned around and introduced himself. He was in New York on tour with his band Crass. They hung out all night, took the Staten Island ferry and strolled around the city. Bandez attended the Crass show the following night:

> It was alien and intriguing. It also seemed to me intensely serious […] much more political than what we were writing about in New York […] I'm not saying we were singing about nice spring days in the park here, but our very existence outside the American dream made us political whether we were aware of it or not […] Crass's anger seemed mainly focused on the government while we were just plain old alienated misfits […] Crass fascinated me. The music, though punky, had an atonal jazz thing going, with a delivery that I can only describe as militaristic, with gunfire drumming and buzz saw rhythm guitars.[6]

Bandez soon moved to England with Ignorant and lived with the Crass collective. She eventually worked with other British musicians of the time, including "England's Hidden Reverse" – Coil, Nurse With Wound and Current 93 – as well as Adrian Sherwood (b. 1958) and the reggae/dub collective On-U Sound Records.

Another group inspired by the Zeitgeist of alternative communities and creative networks was Thee Temple ov Psychick Youth (TOPY). Founded in 1981 by Genesis P-Orridge and friends, TOPY existed for approximately a decade – a mix between a think tank, network, magical order, archive, experiment and performance art collective. Center stage in this new hybrid was a video group that also made music called Psychick Television (PTV). With early members including P-Orridge, Peter Christopherson, Jhonn Balance, Alex Fergusson (b. 1952) and David Tibet (b. 1960), PTV took advantage of the unlikely success and infamy of predecessor Throbbing Gristle, and the group secured record deals with major labels like Warner and CBS. Working together with filmmakers such as Derek Jarman, John Maybury (b. 1958) and Cerith Wyn Evans (b. 1958), PTV created realms of cinematic, televisual footage and poetic propaganda. The group displayed their video work in art galleries, while the musical component took them on the road touring as a rock band, able to have a foot in both worlds, so to speak. PTV recorded music and created videos that became an integral part of TOPY and its philosophy.

Inspired by artistic movements like surrealism and Dada, actions and happenings, and the cut-up method of Beat iconoclasts William Burroughs and Brion Gysin, TOPY's philosophy also integrated aspects of shamanism, ritual and celebrated occult artists Aleister Crowley (1875–1947) and Austin Osman Spare (1886–1956). The goal was to grow as a communal, non-hierarchical entity, rather than a traditional stratified order with subordinates and followers. The core ideal of the group aimed to support individual members in their own endeavors to locate and implement their will; to foster this process through experimental creative processes, utilizing artistic, literary and ritual methods to cut-up, disassemble and deconstruct those structures of control imposed upon the individual by society, parents and family, in order to facilitate change through creativity.

Beginning in England, TOPY soon spread out of the UK, creating nodes in North America, Scandinavia and other parts of Europe, eventually reaching tens of thousands of members and subscribers to their frequent newsletters and information bulletins. Like Crass, TOPY worked in a Heartfieldian fashion, creating their own flyers, newsletters, zines and publications in a collage-based do-it-yourself manner. Unlike Crass, the members of TOPY didn't conceptualize themselves as explicitly political at the time; however, they actively promoted individual liberty on all levels

and also fought for environmental and social issues like wildlife protection and animal rights.

Those actively engaged in the development of TOPY were also encouraged to create their own psychosexual, intention-infused artwork, and send it into the local headquarters. This archival collection of contemporary talismanic art – ranging in styles from total abstraction to refined draftsmanship, including collage, mixed media, painting and sculpture – is totally unique. Another interesting aspect of this TOPY-produced art is that it was in many ways an anti-art; it wasn't created specifically for other people to see or experience, and therefore doesn't fit in with the contemporary ideals of pleasing an art market. Today it would likely be considered what is called outsider art.

Many of the TOPY "Access Points," or regional headquarters, were involved in releasing material for distribution. The Scandinavian center TOPYSCAN was founded by Swedish author-artist Carl Abrahamsson (b. 1966), who went on to run TOPY EUROPE. Abrahamsson created the company Psychick Release, publishing books, audio and video cassettes, CDs and vinyl records, as well as arranging workshops, lectures, rituals, concerts, film and video screenings for the group.

All in all, TOPY produced a great deal of material. Moreover, there was a heavy focus on the unhampered sharing of information. This theme of availability became a bedrock, an essential foundation. All one had to do was let one's interests and areas of research be known through newsletters and other channels, and one was certain to receive something of interest: a secondhand book, long out of print; a compendium of xeroxes from someone's equally enthusiastic archive; a cassette tape copy of some recordings never released on record or broadcast on radio. Almost every TOPY Station or Access Point created an organized way of producing printed matter, records and videos, making out-of-print books available in photocopies to members, and disseminating forgotten music via cassette tapes. Previously impossible-to-find items were suddenly made available: a sort of pre-internet network for sharing information.

Danish scholar Kasper Opstrup (b. 1975) thoroughly outlines the unfolding of various alternative communities and underground academies in his 2017 study, *The Way Out: Invisible Insurrections and Radical Imaginaries in the UK Underground (1961–1991),* tracing a line of alternative thought from the Sigma Project and the London Antiuniversity to Academy 23 and TOPY. Opstrup writes:

> In common for all my case studies was an idea that in order to make change happen, it was necessary to found a new university which would produce new knowledge and a new type of behavior and disseminate both [...] The way out was thus first and foremost a way in, leading towards self-transformation.
>
> (Opstrup, 2017, pp. 206–207)

Many of the individuals involved in various aspects of the TOPY network continued their work as innovative artists, including poet and percussionist Z'EV (1951–2017), Ossian Brown (b. 1969) of Coil and Cyclobe, the aforementioned Vicki Bennett, and Val Denham. Denham worked extensively with PTV and Throbbing Gristle early in her career, creating record covers and merchandise for both of these groups, as well as for Marc Almond (b. 1957), Black Sun Productions, Cyclobe and many others. Her art is surrealist, incorporating dreamscapes and images from a world of her own creation. She has described creating art in her dreams, finding herself painting, drawing, writing or making music. Upon waking, she often incorporates the pieces envisioned in dream states into her current work. Just as she seamlessly blends waking and dream lives, Denham walks between worlds as a multimedia artist, blending classical and modern techniques. She describes herself as kaleidoscopic, working in a multitude of media and methods. Dynamic not only across media – visual art, performance, music, writing, poetry, painting and drawing, working with collage and montage, as well as watercolor, oil and acrylic – Denham also crosses genres as she moves from hyperreal to abstract, life drawing to surrealism. This is expressed in her style and identity as well, as she can be said to be her own work of art; both age-defying and gender-bending, the exploration of her transition has been well documented through her artwork, and collected into the volumes *Dysphoria: the Art of Val Denham* (2013) and *Tranart* (2015).

Denham feels compelled to create artwork every day, for herself, by herself. She claims that there is no division between her life and work. In this way, she has been described as an outsider artist, although she was formally trained at Bradford College and the Royal College of Art in London. Denham's artwork and methods bring to mind the fantasy involved in creating narratives in both waking and dreaming states. Dream material itself is fragments of associations, memories and affects condensed and

displaced into the manifest content of the dream that we recall. We are able to observe a similar process in our daily waking lives, which are largely composed in this way as well. The difference is not so much in quality of waking and dream states, but in quantity or ratio. Just as we incorporate material our senses pick up from the external environment into our dreams while we sleep, we also engage in a similar action while awake, only the ratio varies. In waking life, we face a higher proportion of sensory input from our physical environment but continue to receive input from our unconscious as well. Unconscious material increasingly gains more prominence in altered states, fantasies, daydreams, creation of artworks and, of course, in our dream lives. We may think of our dream and waking states as varying ratios of awake-asleep and conscious-unconscious, running on a continuum constantly in flux, rather than as a binary of either/or. In a similar way, we may understand gender as a continuum with an infinite array of gradations and variations across the spectrum.

Notes

1 *Crass: There Is No Authority But Yourself* (2006) [Film] Alexander Oey (dir.). Netherlands: Submarinechannel & Vrijzinnig Protestantse Radio Omroep.
2 *Crass: There Is No Authority But Yourself* (2006) [Film] Alexander Oey (dir.). Netherlands: Submarinechannel & Vrijzinnig Protestantse Radio Omroep.
3 *Crass: There Is No Authority But Yourself* (2006) [Film] Alexander Oey (dir.). Netherlands: Submarinechannel & rijzinnig Protestantse Radio Omroep.
4 Bandez, A. (2012) *You Can't Sing the Blues While Drinking Milk: The autobiography of Little Annie AKA Annie "Anxiety" Bandez* [Kindle edition]. Coventry: Tin Angel Records.
5 Bandez, A. (2012) *You Can't Sing the Blues While Drinking Milk: The autobiography of Little Annie AKA Annie "Anxiety" Bandez* [Kindle edition]. Coventry: Tin Angel Records.
6 Bandez, A. (2012) *You Can't Sing the Blues While Drinking Milk: The autobiography of Little Annie AKA Annie "Anxiety" Bandez* [Kindle edition]. Coventry: Tin Angel Records.

Bibliography

Abrahamsson, C. (2013) *Reasonances*. London: Scarlet Imprint.
Abrahamsson, C. (2018) *Occulture: the Hidden Forces that Drive Culture Forward*. Rochester, VT: Inner Traditions.

Bandez, A. (2012) *You Can't Sing the Blues While Drinking Milk: The autobiography of Little Annie AKA Annie "Anxiety" Bandez*. [Kindle edition]. Coventry: Tin Angel Records.

Bandez, A. (2016) *Meditation in Chaos*. Toulouse: Timeless Editions.

Breyer P-Orridge, G. (2010) *Thee Psychick Bible: The Apocryphal Scriptures ov Genesis Breyer P-Orridge and Thee Third Mind ov Thee Temple ov Psychick Youth*. Washington: Feral House.

Burroughs, W.S. & Gysin, B. (1978) *The Third Mind*. New York: Viking Press.

Denham, V. (2013) *Dysphoria: The art of Val Denham*. Toulouse: Timeless Editions.

Denham, V. (2015) *Tranart*. Toulouse: Timeless Editions.

Freud, S. (1913) *Totem and Taboo*. In *The Complete Standard Edition of the Psychological Works of Sigmund Freud (SE)* XIII. London: Hogarth Press. pp. vii–162.

Freud, S. (1939) *Moses and Monotheism*. In *SE* XXIII. London: Hogarth Press. pp. 1–137.

Keenan, D. (2016) *England's Hidden Reverse: A secret history of the esoteric underground – Coil, Current 93, Nurse with Wound*. London: Strange Attractor Press.

Opstrup, K. (2017) *The Way Out: Invisible insurrections and radical imaginaries in the UK underground 1961–1991*. New York: Minor Compositions.

Sinclair, V.R. (2019) "Inventing ourselves: a daily practice of cut-ups." In Ansell, R. et al. (eds.) *Black Mirror 2: Elsewhere*. London: Fulgur Press. pp. 33–51.

Verhaeghe, P. (1999) *Love in a Time of Loneliness: Three essays on drive and desire*. London: Karnac.

Verhaeghe, P. (2009) *New Studies of Old Villains: A radical reconsideration of the Oedipus complex*. New York: Other Press.

Filmography

An Art Apart: Genesis Breyer P-Orridge – Change Itself. (2016) Carl Abrahamsson (dir.). Sweden: Trapart Film.

An Art Apart: People Like Us – Nothing can Turn into a Void. (2015) Carl Abrahamsson (dir.). Sweden: Trapart Film.

Crass: There Is No Authority But Yourself. (2006) Alexander Oey (dir.). Netherlands: Submarinechannel & Vrijzinnig Protestantse Radio Omroep.

Chapter 13

Body modification, polymorphous perversity and Pandrogeny

We are born into a story, an already existing narrative. Even before we are born, our parents, family and society have ideas of who we will be, what we will do, how we will succeed, and what trials we may face, all before we have even left our m/Other's body. We are subjugated *in utero*. Our identity is prescribed, and not with us in mind. It is mapped out for us, structured, put into play, and is largely based on gender. The first question asked about us, "Is it a boy or a girl?" leaves no room for ambiguity – boys have penises, girls do not. We are all well aware of the atrocities that have taken place in the early assignment of gender to children born intersex and what catastrophic repercussions this often has. Yet rather than exalt the androgynous, as has been done in times past, we continue to force people into categories we've deemed socially acceptable. The system is built on dichotomy: male/female, active/passive, 1/0, master/slave. But what happens when we begin to break down this system, push boundaries, surpass borderlines and transgress limits?

Around the turn of the 20th century, Freud released his seminal work, *Three Essays on the Theory of Sexuality* (1905), in which he introduced his theory of childhood sexuality outlining the oral, anal and genital stages for the first time, and claiming we are all born bisexual and intrinsically polymorphously perverse. The expert on sexuality and perversions at the time was Richard von Krafft-Ebing (1840–1902), who believed – as did society at large – that sex was solely for procreation and any sexual act falling outside of the reproductive intention was considered to be perverse. Freud actually agreed with this definition of perversion but stated that perversion is our natural inclination and is the norm; it even precedes the norm. Humans are sexual beings. Children are sexual beings. We are all perverse, and the entire body is sexual, not just the genitals and erogenous

zones. Any part of the body can become eroticized, as can the gaze, smell or voice.

In *The Ego and the Id* (1923), Freud stated our ego is first and foremost a body-ego. We learn about ourselves and the world via our bodies, especially through our orifices as these are the spaces where we exchange inside and out, ingest and discharge, are penetrated and expel. These sites are holes, openings, gaps, but also limits, boundaries and surfaces: the rim of the mouth, anus, urethra, vagina, nostrils, nipples, eyes and ears. What is the difference between those that seal versus those that remain open or rather, unable to close? We may even consider the pores of the skin to be countless numbers of orifices: tiny mouths opening and closing more quickly or slowly depending on our state, mood, and level of stimulation or relaxation.

In *Gender, Sex and the Sexual* (2011), Jean Laplanche (1924–2012) differentiated gender, sex and sexuality in the following way: Gender is plural. It is oftentimes seen as dual, as in masculine-feminine, but it is not so by nature. It is actually plural, existing on a continuum. Sex is dual. It is so by virtue of sexual reproduction and also by virtue of its human symbolization, which sets and freezes the duality as presence/absence or phallic/castrated. The sexual is multiple, polymorphous. It is the object of psychoanalysis.

For Laplanche, sexuality and the unconscious may be seen as being one and the same. Sexuality is intrinsically subversive, and sexual identity may change over a person's lifetime or circumstances. Sexuality is fluid and does not have a prescribed object, objective or path. The drive doesn't work on the whole person or body but rather is focused on fragments or individual activities. There is only one libido, and therefore there is no psychic representative of the opposition masculine-feminine in the unconscious.

The subject is inserted into h/er sexual nature. Sexuality precedes the ego or identity, and for Laplanche, any attempts to grasp onto an identity may be seen as grappling with sexuality, with our intrinsic sexual nature, in an attempt to categorize, restrict and contain it – give it a limit in an effort to control it. This effort to normalize is where pathology enters, as normalization fixes desire. Normalization constrains the mobility of desire, orienting it in increasingly limiting ways, and thus freezing fragments of the unconscious ever more into an identity. What are you? Who are you?

How can we categorize you so that we may separate ourselves from you? This results in an overpathologization of the human experience: you are not like us, you have an illness, a disease, you are an addict, an other. If we pin down the problem, we can prescribe a solution. However, normalization fails. All paths that sexuality may take are equally valid and complex. In fact, Lacan called the heteronormative prototype, "the delusional 'normality' of the genital relation" (Dean, 2006, p. 272).

Laplanche felt the displacement of the question of sexual identity onto the question of gender identity conceals the fundamental Freudian discovery, which does not lie in gender identity, sex or the sexed, but in the sexual, sexuality and the polymorphous:

> When Freud speaks of enlarged sexuality, the sexuality of the *Three Essays*, it is always the *sexual* [...] It is a sexuality that has been called 'non-procreative' and even primarily non-sexed, as distinct from what is called precisely 'sexed reproduction.' The *sexual*, then, is not the sexed; it is essentially perverse infantile sexuality.
> (Laplanche, 2011, p. 161)

For Lacan, sexuality is not in the realm of nature or nurture, as it is not constricted to nor constructed by either. The unconscious shows how both society/culture and biology are limited; how they fail. We are situated in the space, the gap between nature and nurture. Deconstructionists argue that as bodies, corporeal matter must be realized through the social process of embodiment. However, Lacan authorizes neither the constructionist nor deconstructionist arguments any more than the biological. He insists that psychoanalytic logic remains fundamentally irreducible to these terms (Dean, 2006, p. 266).

The concept of the individual is a product of power. Identity is a regulatory norm. Freud's conceptualization of the subject as divided (conscious/unconscious) undermines the possibility of a seamless identity, sexual or otherwise. Identity is illusory. Historicism relegates identity to cultural and social practices. A society's ideology of individuality ensures maximum freedom as long as one conforms. The ego is the internalized ideals of our parents, as was theirs and those before them, connecting dimensions of social identification and exclusion through generations. "Queer theory and politics began with a critique of identity and identity politics"

(Dean, 2006, p. 267). Queer is opposed to normalization. Liberating sexuality, gender identity and sexual expression is thereby a key to subverting control.

As discussed, in the sexual relation, no matter if it is overtly sadomasochistic or not, there is always an inevitable element of dominance and submission. Even in the sexual relation with oneself, in masturbation, we are the one doing the beating as well as the one being beaten. We perform the act on ourselves and therefore occupy both positions – dominant and submissive. We gain pleasure engaging in this activity, which is nonetheless an aggressive action. Furthermore, we witness the act being done by ourselves to ourselves, thereby entering a third position as well: the witness. So no matter if it is autoerotic, homosexual, heterosexual, trans*, queer, top/bottom, dominant/submissive, sadomasochistic, 1/0, oral, anal, genital, polyamorous, orgiastic, or anything in between – no matter in which position we might be – we may concurrently take the stance of the other(s) as well, and therefore occupy both (and all) positions at once. We are voyeur and exhibitionist. We are being seen while enacting and observing the scene, exposing ourselves as we bear witness to the exposure.

The position of the Third allows for this metonymy, otherwise the pair may be trapped in a mirror relation. The figure of the Third/father/Law is essential to enforce this separation. This emphasizes the need for a break, a cut, a space, which language also provides. Language separates and distances. Paul Verhaeghe (b. 1955) thusly re-envisions the traditional Oedipal complex, moving the focus from the interpretation of a boy in love with his mother and at war with his father, to a shift in positioning from the trap of a two-person mirror relation to the mobility or metonymy possible in a relation of three (or more) positions.

The m/Other is everyone's original love object, regardless of gender or circumstance. In the original relationship with the m/Other or primary caregiver, s/he has complete power over the infant, while at the same time feeling totally beholden to this small person, and the pair are deeply engaged in a power struggle. In this dynamic, any other figure that enters the scene or attempts to intrude, any Third, is immediately experienced as a threat. In traditional Freudian theory, the father was this Third, assigned the role of the divisive authoritarian, coming between the m/Other and child. Lacan's reinterpretation of Freud identifies the father or the Third with language and the Law. Language introduces culture and separates us from nature. Culture insists on relation to the other. The m/Other or

primary caregiver is the original love object, and the father or Third is a second choice, making any subsequent partner at least a third choice.

Separation is essential to subjectivity. Every human being must abandon this original imagined unity with the m/Other, and by extension the nuclear family, in order to affect a new union elsewhere with a different group. The function of separation has been historically ascribed to a single figure, that of the father. Yet, as Verhaeghe points out, the father or Third – as an actual person – can only exercise this function on the basis of the authority of an underlying symbolic structure, which in recent history in the Western world has been the patriarchal, monotheistic social structure of which he has been representative. Fortunately, this system is currently being deconstructed and there is a real push not to maintain the status quo. Rather than the well-worn cycle of replacing the king with another king, let's not look to the past for what we may construct in the future. It is time to invent new ways of being in the world, rather than simply regurgitating the same old tropes that have failed time and time again.

When we think back, the identificatory environment that many previous generations formed within was quite different from the world we have today. In Freud's time, for example, there was no television, internet or computers at home. Photography and electricity were newly accessible. Most people grew up with their immediate family members – siblings, parents and possibly grandparents – with few other adult figures to reference or with whom to identify beyond perhaps a doctor, teacher, store clerk or extended family members. Children were exposed to very few people outside their immediate family, and even fewer outside their village or town; fewer still were exposed to other cultures or nationalities.

Today the situation is incredibly different. Young people growing up now have a multitude of people to admire and with whom they may identify, of all abilities, genders, sexualities, races, cultures, nationalities, positions in society, levels of education, choices of career and so on. This not only illuminates the beautiful variety and diversity of humanity, but also highlights the potential malleability of identity, not only from person to person, but possibly evolving over an individual's own life span.

In the 1980s, there began a movement of body modification as tattooing and body piercing were becoming more widespread through the underground and countercultural scenes. Alan Oversby (1933–1996), also known as Mr. Sebastian, who was involved with Thee Temple ov Psychick Youth (TOPY), was charged with obscenity and inflicting bodily harm.

Genesis P-Orridge and other TOPY members showed public support for Mr. Sebastian, attending his trial and court hearings. This brought extra attention to P-Orridge and TOPY, leading to ever increasing scrutiny, which eventually culminated in the raiding of TOPY UK headquarters and the subsequent expulsion of P-Orridge and family from the country. P-Orridge fled to California, which already had what was coming to be known as a thriving "modern primitives"[1] scene of its own.

The cutting of the real of the body has an effect on the psyche, as we experience ourselves through the interface of our bodies. The body is inserted into culture through language. During this process, signifiers – the building blocks of language – are inscribed into the body. As we enter the world, we are bombarded with a myriad of sensations, impressions and experiences, both from within and from the environment. As we attempt to make sense of these experiences, we begin to construct a world of our own, which we come to inhabit. Of course, we have been born into a world that already exists, full of constructed symbolic structures. Our inner world meets this world of social discourse; subjectivity lies between.

The world we construct via our bodies does not align with any particular, prescribed notions. Of course, we are all affected by the family and society into which we are born, but our reaction to and, therefore, interaction with these constructs is unique to each of us. The map of signifiers inscribed onto our bodies does not necessarily align with a particular blueprint, nor with the specific functions of the body in the physical sense. The whole body is sexual. Freud described this as polymorphous perversity in his *Three Essays on the Theory of Sexuality* (1905). This is how fetishes and erogenous zones come to be. There may be particular areas of the body that generally tend to be cathected with libido, but each and all parts of a person have an equal chance of becoming charged. Therefore, manipulating the physical body – reforming and reconstructing the body – whether it be through the prick of a needle, the cut of a knife or the surgeon's scalpel – may have profound effects on the mind and identity of the individual, in more ways than we may currently understand.

The west coast of the United States was home to such characters as performance artist Fakir Musafar (1930–2018), tattoo artist Don Ed Hardy (b. 1945) and photographer Charles Gatewood (1942–2016). Gatewood considered himself a sort of anthropologist of underground America, capturing the vibrant scenes of the modern primitives and San Francisco LGBTQ BDSM through his photographs. Simultaneously, Gatewood's journalistic

impulse drove him to take some of the most iconic images of celebrities like Bob Dylan, Allen Ginsberg, William Burroughs, Brion Gysin, Al Green (b. 1946), Carlos Santana (b. 1947) and Tiny Tim (1932–1996).

Gatewood's first collection of photographs, *Sidetripping* (1975), was met with critical acclaim. However, due to the nature of the content of many of his images, most of Gatewood's books remained self-published throughout his lifetime, as is the case with many cutting-edge artists and authors, forward-thinking and set upon disrupting the narratives of their times. *Sidetripping* included texts by William Burroughs alongside Gatewood's striking images:

> Charles Gatewood the sidetripping photographer, takes what the walker didn't quite see, something or somebody he may have looked quickly away from and the photo reminds him of something *deja vu* back in front of his eyes.
>
> (Gatewood & Burroughs, 1975, p. 7)

Genesis P-Orridge remained in the United States ever since being pushed out of the United Kingdom in the early 1990s. S/he met he/r second wife, Jacqueline Breyer (1969–2007), also known as Lady Jaye, in New York. Over time, the pair immersed themselves in performance art and their own experimentations, donning the moniker "Breyer P-Orridge" as an expression of their dedication and commitment to their mutual endeavor. Together, Breyer P-Orridge explored contemporary ideas of identity, the body, consciousness, gender and sexuality at a depth few have dared to traverse. In an effort to break down prescribed notions of themselves as individuals so that they may come together more fully as one, the pair underwent a series of surgical, medical, chemical, psychological, spiritual and behavioral procedures. Influenced by the cut-up method as espoused by Brion Gysin and William Burroughs, the pair took the process that much further, applying the cut-up method not only to word, sound and image but to the very real of their own bodies and selves, in a *Third Mind*-esque project of their own that they coined "Pandrogeny." In *The Pandrogeny Manifesto* (2006), Breyer P-Orridge state:

> Some people feel they are a man trapped in a woman's body. Some people feel they are a woman trapped in a man's body. Breyer P-Orridge just feel trapped in a body.[2]

The way Breyer P-Orridge went to such lengths to break down their individual senses of identity in order to relate to each other as mirror reflections is reminiscent of the way in which Lacan described we first form our identity via what he called *the mirror stage*. To review, for Lacan our ego or identity – that with which we are identified, what we consider to be our perception of ourselves – is first formed during the period between the ages of 6–18 months. Around that time, the infant looks into a mirror and sees he/r own image reflected back to he/r. As this image s/he sees in the mirror appears to be whole, the underlying assumption is that *appearing* whole equates with *feeling* whole, too; experiencing *wholeness*. As the child's experience of self as situated in he/r own body feels essentially fragmented, this wholeness that s/he imagines the image in the mirror to experience is then internalized and integrated. Once the child has introjected this imagined wholeness, s/he then begins to identify with this fantasy of a whole sense of self. This then forms the original template or underlying structure of our ego.

Throughout our lifetime, we are constantly attending to, working and reworking our internalized ego or sense of self, as we continually come into contact with others, introjecting and integrating aspects of them we enjoy or wish to emulate. In this way, our identity may be seen as an ongoing creation that we work on or play with throughout our lives. It is essentially malleable. Furthermore, when the formation of identity is conceptualized in this manner, it may be more readily understood how the altering of one's external self or projected mirror image may aid in developing or augmenting one's own internal sense of self. Understanding the originary process of identity formation may be useful in exploring the myriad ways we are able to mold our identities today with regard to sexuality and gender, as well as all other aspects of identity that make us who we are. With this is mind, we may better see the ways in which we may use technology, including digital media and the internet, as tools in constructing ourselves in more intentional ways, by working directly with our image in the interface or mirror.

Breyer P-Orridge seem to have recreated this experience of the origin of the formation of identity by cutting up their own selves as individuals, thereby recreating this fragmentation in a sense, while concurrently creating a mirror image in one another. Through this, they could more fully identify with the wholeness of the mirror image in one another, creating a new sense of identity for the pair, facilitating their union as "Pandrogyne."

> We see the *I* of our consciousness as a fictional assembly or collage that resides in the environment of the body. One of the central themes of our work is the malleability of physical and behavioral identity. The body is used by the mind as a logo for the self before we are able to speak language.[3]

The cut mirrors the formation of our subjectivity. There is an original trauma or separation through which our ego is formed. Our ego is our symptom. Freud coined this original event *primary repression.* In the event of this primary repression, a boundary is formed around the split, hole or gap. This structure becomes our ego and protects us from this void. Our ego or symptom formation continues to circle this void throughout our lifetime. This may help us to understand why we are not able to completely rid ourselves of our symptom. We cannot completely rid ourselves of our ego. By understanding this, we may be better able to manage our ego–symptom formation or structure, rather than feeling controlled by it or as if it is imposed upon us. Understanding our patterns of functioning, this fundamental fantasy that informs our relationships, as well as our way of relating to society and the world at large, may aid us in better harnessing our abilities.

Brion Gysin and William Burroughs's cut-up method shows that the cutting up of language creates the space for something new to form. Breyer P-Orridge illustrate that this also occurs with the cutting up of image, body and behavior. Whether the cut of the scissor or the surgeon's scalpel, a gap or space is created in which something new may transpire. Just like ritual cuts us out of our day-to-day narrative, creating room for us to imagine a new reality, psychoanalysis does the same. By challenging and disrupting repetition of narratives, a space is created where we are able to produce something new. We are situated in the gap. We may fill this space with our self, consciousness, creative energy, will or intention. The cut-up has proven to be effective not only when applied to word, image and sound but also to self, identity, gender and sexuality, by exposing the dynamics at play underneath the surface. People should be able to self-determine, to create themselves in any way they imagine themselves to be. Why experience oneself as limited, one-dimensional? Sexuality is inherently subversive and is at our core. It is foundational to the essence of every subject. Ergo, the best way to subvert normalization is through disruption of the narrative of sexuality and, thusly, identity and gender.

Notes

1 Vale, V. & Juno, A. (eds.) (1989) *Modern Primitives: An investigation of contemporary adornment and ritual.* San Francisco: RE/Search Publications.
2 *The Pandrogeny Manifesto* (2006) [Film]. Dionysos Andronis & Aldo Lee (dirs.). Greece and France. Available at www.movieranker.com/talent/2JGsvVySaL5n82c/Dionysos-Andronis (Accessed on August 29, 2019).
3 *The Pandrogeny Manifesto* (2006) [Film]. Dionysos Andronis & Aldo Lee (dirs.). Greece and France. Available at www.movieranker.com/talent/2JGsvVySaL5n82c/Dionysos-Andronis (Accessed on August 29, 2019).

Bibliography

Abrahamsson, C. (2007) *Olika Människor.* Umeå, Sweden: Bokförlaget h:ström.
Abrahamsson, C. (2013) *Reasonances.* London: Scarlet Imprint.
Abrahamsson, C. (2018) *Occulture: The hidden forces that drive culture forward.* Rochester, Vermont: Inner Traditions.
Bornstein, K. (1994) *Gender Outlaw: On Men, women, and the rest of us.* New York: Vintage Books.
Breyer P-Orridge, G. (2009) *30 Years of Being Cut-Up.* New York: Invisible-Exports.
Breyer P-Orridge, G. (2010) *Thee Psychick Bible: The Apocryphal Scriptures ov Genesis Breyer P-Orridge and Thee Third Mind ov Thee Temple ov Psychick Youth.* Washington: Feral House.
Breyer P-Orridge, G. (2019) *Closer as Love (Polaroids 1993–2007).* Miami, FL: MATTE Editions and Nina Johnson Gallery.
Breyer P-Orridge, G. (2020) *Sacred Intent: Conversations with Carl Abrahamsson (1986–2019).* Stockholm: Trapart Books.
Burroughs, W.S. & Gysin, B. (1978) *The Third Mind.* New York: Viking Press.
Butler, J. (1990) *Gender Trouble: Feminism and the subversion of identity.* London: Routledge.
Dean, T. (2000) *Beyond Sexuality.* University of Chicago Press.
Dean, T. (2006) "Lacan meets queer theory." In Nobus, D. & Downing, L. (eds.) *Perversion: Psychoanalytic perspectives, perspectives on psychoanalysis.* London: Karnac Books. pp. 261–322.
Freud, S. (1905) *Three Essays on the Theory of Sexuality.* In *The Complete Standard Edition of the Psychological Works of Sigmund Freud (SE)* VII. London: Hogarth Press. pp. 123–246.
Freud, S. (1912) "The dynamics of transference." *SE* XII. London: Hogarth Press. pp. 97–108.
Freud, S. (1915) "The unconscious." *SE* XIV. London: Hogarth Press. pp. 159–215.

Freud, S. (1919) "'A child is being beaten': a contribution to the study of the origin of sexual perversions." *SE* XVII. London: Hogarth Press. pp. 175–204.

Freud, S. (1920) "Beyond the pleasure principle." *SE* XVIII. London: Hogarth Press. pp. 1–66.

Freud, S. (1923) "The ego and the id." *SE* XIX. London: Hogarth Press. pp. 1–66.

Gatewood, C. (1993) *Charles Gatewood: Photographs*. San Francisco: Flash Publications.

Gatewood, C. (2003) *Photography for Perverts*. Oakland, CA: Greenery Press.

Gatewood, C. & Burroughs, W.S. (1975/2004) *Sidetripping*. San Francisco: Last Gasp.

Gherovici, P. (2010) *Please Select Your Gender: From the invention of hysteria to the democratizing of transgenderism*. New York: Routledge.

Johnson, D. (2015) *The Art of Living: An oral history of performance art*. London: Palgrave.

Lacan, J. (1978) *The Four Fundamental Concepts of Psycho-analysis*. Translated by A. Sheridan. New York: W.W. Norton & Co.

Lacan, J. (1991) *The Seminar of Jacques Lacan, Book II. The Ego in Freud's Theory and in the Technique of Psychoanalysis (1954–1955)*. Translated by S. Tomaselli. New York: W.W. Norton & Co.

Lacan, J. (1999) *The Seminar of Jacques Lacan, Book XX. On Feminine Sexuality: The limits of love and knowledge (1972–1973)*. Translated by B. Fink. New York: W.W. Norton & Co.

Lacan, J. (2006) "The mirror stage as formative of the *I* function as revealed in psychoanalytic experience." In *Écrits: The first complete edition in English*. Translated by B. Fink. New York: W.W. Norton & Co. pp. 75–81.

Lacan, J. (2016) *The Seminar of Jacques Lacan Book XXIII. The Sinthome (1975–1976)*. Translated by A.R. Price. New York: W.W. Norton & Co.

Laplanche, J. (2011) *Freud and the Sexual: Essays 2000–2006*. Translated by J. House, J. Fletcher & N. Ray. New York: IP Books.

Leader, D. (2000) "Beating fantasies and sexuality." In Salecl, R. (ed.) *Sexuation*. Durham: Duke University Press.

Neill, C. (2011) *Without Ground: Lacanian ethics and the assumption of subjectivity*. London: Palgrave Macmillan.

Sinclair, V.R. (2016) "Polymorphous perversity and pandrogeny." In Abrahamsson, C. (ed.) *The Fenris Wolf*, vol. 8. Stockholm: Trapart Books. pp. 10–17.

Sinclair, V.R. (2019) "Inventing ourselves: a daily practice of cut-ups." In Ansell, R. et al. (eds.) *Black Mirror 2: Elsewhere*. London: Fulgur Press. pp. 33–51.

Vale, V. & Juno, A. (eds.) (1989) *Modern Primitives: An investigation of contemporary adornment and ritual*. San Francisco: RE/Search Publications.

Verhaeghe, P. (1997) *Does the Woman Exist? From Freud's hysteric to Lacan's feminine*. New York: Other Press.

Verhaeghe, P. (1999) *Love in a Time of Loneliness: Three essays on drive and desire*. London: Karnac.

Verhaeghe, P. (2001) *Beyond Gender: From subject to drive*. New York: Other Press.

Verhaeghe, P. (2004) *On Being Normal and Other Disorders: A manual for clinical psychodiagnostics*. New York: Other Press.

Verhaeghe, P. (2009) *New Studies of Old Villains: A radical reconsideration of the Oedipus complex*. New York: Other Press.

Filmography

An Art Apart: Charles Gatewood – Once the Toothpaste is Out of the Tube. (2015) Carl Abrahamsson (dir.). Sweden: Trapart Film

An Art Apart: Genesis Breyer P-Orridge – Change Itself. (2016) Carl Abrahamsson (dir.). Sweden: Trapart Film

The Pandrogeny Manifesto. (2006) Dionysos Andronis & Aldo Lee (dirs.). Greece and France.

Chapter 14

Technology, morbidity, death and the unexpected

As has been seen throughout this book, working with the cut is a way to engage in the necessary separation/individuation process inherent in the formation of human subjectivity. The artistic process mirrors a process that is fundamental and foundational to ourselves as subjects. This necessary split provides a gap, while at the same time a border, boundary or limit: a liminal, transitional space neither fully inside nor out, yet encompassing both – a place of creativity and invention where the usual rules need not apply.

Some artists choose to work with this space quite literally, creating work via direct modification of their bodies or delving into the morbid: working with blood, disease, disfigurement, death, decay, war, trauma and technology. The work of American artist Joel-Peter Witkin (b. 1939) is immediately recognizable, as he composes surreal scenes from death, disfigurement and the unexpected, creating haunting and beautiful imagery that once witnessed can hardly leave the viewer's mind, in some ways evoking a mix of the eeriness of the work of Diane Arbus and *vanitas*-type still-life motifs of high-medieval painting, reminding the viewer of the fragility of life:

> Inevitable death and our agony to attain Utopia have made existence a form of pathology [...] When the time arrives, when every moment is transcendent, then the images presented here will be seen as they truly were [...] photographs from a time resplendent in the atrocity we once called life.
>
> (Witkin, 1994, p. 9)

In the ultradetailed, colorful portraits he creates, American artist Joe Coleman (b. 1955) displays a kaleidoscope of memories, phrases and

scenes from the lives of his subjects, surrounding them with a patchwork of memorabilia: pieces of the puzzle that have come together to create the person being portrayed, captured in this moment in time by this meticulous artist. Many of the scenes memorialize traumas or critical life experiences, such as the death of loved ones, divorce, addiction, violence and abuse, as well as shocking or instrumental events that occurred in society at large during the life of the individual – political events and inventions, such as the atomic bomb, serial killers at large, mass shootings, war and other massacres – thereby inescapably affecting the subject. Coleman's work is emotionally and experientially charged in this way, placing the both audience and subject at the intersection of societal conflicts, personal memories, ideas, histories, collective events and ruptures in worldviews. Incredibly detailed, each piece takes years to create as Coleman paints using a jeweler's loupe. His work has culminated in perhaps his most personal works to date: evocative, impressive portraits of both himself and his wife, *Doorway to Joe* (2010) and *Doorway to Whitney* (2015).[1]

Contemporary Chinese artist Cai Guo-Qiang (b. 1957) works with explosives, creating work ranging from breathtaking displays of fireworks to canvases left with the charred remains of gunpowder explosions. His works on canvas are particularly striking in that they are the result of an event that has already occurred, and what the viewer is left with is akin to a shadow or scar. It is interesting to note how he came to work with fire and explosions, as he describes in the recent documentary *Sky Ladder* (2016). Cai grew up during the time of the communist revolution. His father worked at a government bookstore and spent all of his earnings on books, telling his son that one day he would understand the importance of books: that they are like treasure. When Mao Zedong (1893–1976) came to power, Cai's father had to burn his fortune of books, with his young son assisting him in the process.

The process of the creation of artworks in any media is often a way to work with or through traumatic events that have occurred in one's life, with that which is often otherwise left unsymbolizable. Italian artist Alberto Burri (1915–1995)[2] is another who worked through traumatic life events via his artistic practice. Raised in Umbria, his study of medicine was interrupted at the age of 19, forced to join Mussolini's army in the invasion of Ethiopia. When he finally returned to his studies, graduating with a degree in medicine and surgery, he was called once again to the front lines during

the Second World War, this time as a surgeon. Captured and incarcerated in a US internment camp for Italian prisoners of war (POWs) for three years, Burri began to practice art there. When art supplies in the POW camp were scarce, he turned to salvaging burlap sacks, stretching them like canvas. "I painted every day. It was a way of not having to think about the war and everything around me" (Braun, 2016, p. 30).

When he was released, Burri returned to his native Italy only to find his homeland completely destroyed; centuries-old cathedrals demolished; homes, streets and squares in ruin. Burri maintained his artistic practice until his death. He continued to work with burlap, often incorporating found objects, earth, tar, pumice, sawdust, metals and plastics, along with more traditional materials such as oil and polymer paints, enamel, wood and paper. At times he would cut or burn the pieces, creating wounds in the works, which he would often suture with cord or twine. Uncanny, striking and surreal, these works seem to emulate the cut, torn and burnt flesh of the soldiers he worked on and with during the war:

> Burri saw (and heard) the carnage of war, but he also felt the bodily trauma of others. Doctors in the field suffered their own kinds of stress brought on by the challenge of operating nonstop, the responsibility for evaluating mental fitness in others, and the moral imperative to save lives […] They were exposed to seemingly endless streams of bloodied bodies for which the only possible response was pragmatic and merciful acts of repair.
>
> (Braun, 2016, p. 36)

In much of his work, it seems as if Burri attempted to recreate and then heal these wounds. Several pieces have material sown in and together, highlighting his careful surgeon's hand in what must have been an overwhelming onslaught.

In *Ethics: An Essay on the Understanding of Evil* (2000), Alain Badiou (b. 1937) implores us to:

> Do all you can to persevere in that which exceeds your perseverance. Persevere in the interruption. Seize in your being that which has seized and broken you.
>
> (Badiou, 2000, p. 47)

This notion resonates in the work of Francis Bacon. A visit to his studio[3] (transported from London to his hometown of Dublin after his death) gives one a sense of the inner workings of this artist's mind: reflective of the canvases he created, strewn with rags, scraps, violent strokes of paint and blurred faces. Bacon discussed his artistic process in depth in *Interviews with Francis Bacon* by David Sylvester (1924–2001), describing his work as "a kind of tightrope walk between what is called figurative painting and abstraction" (2019, p. 12).

Bacon recounted his lifelong endeavor of continually attempting to harness the creative potential of chance as an inspirational tool, which he then worked from in a more intentional way. The more figurative aspects of Bacon's work were largely inspired by classical artists and artwork; for example, he used the work of Diego Velázquez (1599–1660) as influence for his series of Popes. Bacon became obsessed by Velázquez *Pope Innocent X* (1650) and collected together as many reproduced images of this specific work of art as he could find. Photographs, postcards and books were scattered about his studio – on tables, easels and the floor – and inevitably wound up covered with scratches, scrapes, folds, creases, and even shoe prints, not found in the original work; these additional marks and disruptions then became shards of inspiration for Bacon and were integrated into his paintings. Bacon also drew upon the figures of Eadweard Muybridge when executing his figurative work; the tense, twisted bodies of the wrestlers in particular can be found in the forms of many of Bacon's lovers.

Bacon emphasized the importance of art in conveying a fuller description of a subject than traditional figurative presentation, which may often fall flat. In his work, Bacon attempted to capture the essence of the person in the moment, whether this be a moment of pain, confusion, elation, struggle, life, love or death. Bacon claimed that he was at all times very aware of the excitement of life, yet also of impending death, which comes through in his work. He expressed a desire to live life to the fullest in all its aspects – exalted, demeaning, decadent, luminous, painful, hilarious, grotesque and beautiful – persistently attempting to pull back the veil to reveal what he called the "true violence" of life:

> When talking about the violence of paint, it's nothing to do with an attempt to remake the violence of war. It's to do with an attempt to remake the violence of reality itself.
>
> (Sylvester, 2019, p. 94)

Bacon described a persistent search for the creation of a perfect work of art. With this, Bacon illustrated that he was truly driven to create his artwork. Our drives themselves are caught in a perpetual state of repetition. Surely, we have all had the experience of working toward a goal, but upon achieving it we are left with a sense of dissatisfaction. We cannot quite put our finger on it but for some reason the result is not as we had imagined it would be. We thought that this was finally it – *the* thing we had been looking for – yet upon achieving our objective, the satisfaction we imagined we desired was lacking. Somehow it just didn't quite hit the mark; something was not quite right.

We may shift our understanding from believing that we actually desire to achieve the specific aim, goal or object we have in mind, to realizing that what we truly desire is the process itself. We desire the process of working towards the goal. Therefore, we repeatedly arrange circumstances for ourselves so that we may continue to work towards *something*. While this process perpetuates an experience of dissatisfaction, it is also this feeling of dissatisfaction that motivates us to continue to work towards *something else*. It is not the goal itself we desire; rather, our desire is to keep on desiring.

While driven to attain this moment he knew was impossible, Bacon continued to work towards it nevertheless. This drive towards an unattainable perfection was truly what Bacon was searching for – something he recognized later on in his life. He felt his best work often came from moments of despair, when he desired to manifest a creative work he held within his mind's eye. However, the impossibility of expressing the work to its fullest, of being able to convey it perfectly, frustrated him no end, and it was in these moments of hopelessness and castration that the work was able to finally find its form. Bacon often threw paint onto the canvas, working directly on the canvas with scraping tools and rags to bend and blur the lines and images, in an attempt to allow the subject to escape from the constraints of form, thereby allowing for the "truth" of the subject to come into view:

> [T]he hopelessness in one's working will make one just take paint and just do almost anything to get out of the formula of making a kind of illustrative image – I mean, I just wipe it all over with a rag or use a brush or rub it with something or anything or throw turpentine and paint and everything else onto the thing to try to break the willed articulation of the image[.]
>
> (Sylvester, 2019, pp. 180–181)

Bacon was notorious for destroying his paintings when coming to a point of frustration with the work. In his quest to capture what he calls these "true" moments or "facts" of life, at times he would inadvertently overwork the painting after feeling the work had just achieved this moment or glimpse of perfection. Of course, this moment could have been realized only retrospectively once the work had moved past that point and was irretrievably altered – we'll never know. What we do know is that Bacon destroyed a great many of his works, especially earlier in his career, often feeling that they had once achieved what they were meant to, and then he had veered off course. He described wishing a few of the destroyed works still remained, stating that once a work had culminated in what it was meant to reveal, it left traces within him which haunted him.

The work of German artist Kurt Schwitters is also a powerful reflection of this sentiment. Schwitters often worked with debris and discarded scraps he found on the street, turning garbage and waste into beautiful, poignant works of art. Schwitters often worked with collage and assemblage, culminating in the creation of his most ambitious work, *Merzbau* (1923–1937); what began as a single vertical column built of scraps of cardboard, newspaper and various other items, eventually grew into a structure encompassing the entirety of Schwitters's living space and studio. Unfortunately, we'll never know exactly what this momentous work was like, as it was destroyed along with so much else during the Second World War.[4]

Contemporary Japanese artist Yuji Agematsu (b. 1956) also works with found objects. Taking daily walks through the streets of his adopted city of New York:

> [...] since 1997, Agematsu collects bric-a-brac off the ground and places it into a box of cellophane, the kind usually used to wrap packs of cigarettes.[5]

As he continuously scans the sidewalks for items to include in his installations, Agematsu's works include everything from cigarette butts, chewed gum, leaves and flowers to matchbooks, ticket stubs, fragments of discarded packaging and scraps of ripped cloth. Agematsu typically displays these items lined up meticulously, exhibiting the surprising treasures of all 365 days of a year together with the findings from each day contained within their own transparent walls.

Originally hailing from New Zealand, contemporary artist Charlotte Rodgers (b. 1965) works with death quite literally, as she collects bones, trinkets and remnants of animals she discovers on her daily walks around her adopted town of Bath, England. Reassembling these items, Rodgers combines the fragments she finds to create sculptural compositions that resemble creatures themselves, which seem to have a life of their own. Rodgers describes her art as animistic, bringing new life to the once dead and discarded:

> Everything holds life-force, energy and potential. I work with the memory held in remnants of the dead, the forgotten, the discarded and the rejected. I honour these memories through acknowledgment, then use the past as a foundation for new directions and realities.[6]

This idea of creation from destruction, being and becoming evolving out of death and decomposition is as old as human history and continues to find new forms to this day.

Not only does Rodgers work directly with remnants of death, she has also written extensively on her work with her own blood. In her book *The Bloody Sacrifice: A Personal Experience of Contemporary Blood Rites* (2011), Rodgers describes a history of artists working with their own "tainted" blood; specifically the work of artists exploring the newfound disease of HIV+ in the 1980s and 1990s.

> As blood related illness affected various parts of my life, I was given a chance to explore blood ritual in a very different way and this led to my contact with various HIV positive artists […] documenting this part of the journey was vital to help create an understanding of what blood rites are and where they can take you and also give an insight into the concept of "dis-eased" blood such as AIDS, HIV and HCV, and its effects[.]
>
> (Rodgers, 2011, p. 8)

Carrying on in the tradition of working with the cut upon the body, Rodgers explores the value of working with her blood, both venous and menstrual, outlining the differences she has found between them, as well as what she takes from the experience of working with her own blood and bodily fluids – the potential of transforming dis-ease.

Morbidity is a term that could be thought of and used in a variety of ways: related to disease or death; reflecting inertia, repetition, depression or stasis; pertaining to the death drive, mourning and melancholia; characterized by or appealing to an abnormal or unhealthy interest in disturbing and unpleasant subjects; fascination with death; the dark side, the shadow, the underbelly; an attitude, quality or state of mind of being morbid;[7] marked by excessive gloom; ghoulish, macabre, gruesome, unwholesome; weird, abnormal, aberrant, disturbing, worrisome; infirm, sickly, diseased, unhealthy, malformed; of or pertaining to the body. In medical terms and clinical psychology, *co-morbid* means having multiple diseases, illnesses or pathologies concurrently. *Morbidity rates* are the tallied incidents of a certain illness or symptom cluster, and *morbid anatomy* pertains to diseased parts of the body, organs or tissues. In itself, corporeality implies morbidity: the two are inescapably intertwined. The human body remains our most important filter or interface. By engaging with and exploring the body – its abilities and limitations, possibilities and restrictions, strengths and weaknesses – we explore morbidity and corporeality, movement and stagnation, dance and stasis, life and death.

We are living in the midst of amazing scientific and technological discoveries that not only promise to prolong life, but also to make our lives "easier." All the while, our ever increasing reliance on outer technology continues, as our lives and life spans seem ever more dependent on machines and our ability to control them. There is an uncanny interaction between the essential and the non-essential, the organic and inorganic, flesh and technology. Perhaps this is especially pertinent when it comes to our own times of "artificial intelligence."

Technologies throughout the ages have been inextricably linked to human development. Through dreams, art, tools, technology, life, love, grief, bondage, restriction, excess, intellect, flesh, metal, difference in ability, the cut, disruption, creation, destruction, disease and death, we learn about ourselves through exploration of the body, subjectivity and the unconscious. Creative potential may be explored by pushing the boundaries of body and mind via expressions of physicality, performance, dance, eroticism, philosophy and intellectual scholarship – understanding that these various expressions and fields of study are not opposing forces but rather a dynamic interplay of processes that ebb and flow in a relative continuum.

Australian performance artist Stelarc has been working with body modification techniques for decades. He explores what he calls "alternate anatomical architectures," interrogating issues of agency, identity and the post-human. He claims he has always been interested in the human body, not only as a medium of expression but also as a mode of experience. In performance, the body is not only represented as an image, symbol or metaphor but is experienced directly, its possibilities as well as its limitations. He plays with the physical architecture of the body, imploring that if we adjust the physicality of the body, we concurrently adjust awareness.

In his work, Stelarc has experimented with a myriad of technologies: helmets and goggles to alter his perceptions; inserting himself into various compartments and structures, modifying his body in space as well as the ability and reach of his body. In this way he explores the experience of the artist when the perception of the body itself is altered and the resulting effects that has on consciousness. Between 1973 and 1975, Stelarc created three films of the inside of his own body – inside his stomach, lungs and colon – an exploration of the physical parameters of the body, both internal and external. Over time, he turned his focus to suspension of the body using hooks and ropes, extending the body's form by literally stretching the skin. These actions were usually part of performances that also involved sensory deprivation and other physically difficult feats. Furthermore, Stelarc has even grown an ear on his arm using stem cell research technology.

Stelarc's work is not concerned with utopian ideas of a perfect world, nor dystopian scenarios of computers and artificial intelligence taking over. He emphasizes that there are multiple and differing scenarios that are possible and may be imagined:

> Technology from the very beginning determines what it means to be human. We have never been biological bodies, really. We have always been prosthetically augmented bodies. What it means to be human is to make artifacts and to use language. In a way then, we have always been cyborgs. We fear the involuntary, we fear the automatic but we fear what we have always been and what we have already become. We have always been zombies and we have already become cyborgs.[8]

Stelarc posits that perhaps we have seen an increased interest in body modification and piercing in the more mainstream cultures of the West

as we increasingly live in a virtual world. He sees this as an attempt at a return to the body and the physical. On the other hand, he notes, we may also see these modifications and piercings as a cyborgian impulse, meshing metal with flesh, simultaneously a primal and cyborgian gesture.

Contemporary videographer Ed Atkins (b. 1982) reveals an obsession with the unpredictable aspects of the body – its breakdowns, imperfections and susceptibility to invasion – through his work, often elaborated through intense and ornately detailed narration and visual motifs. *The Trick Brain* (2013) is built around archival footage of André Breton's personal space, including rare books, paintings and artifacts that became associated with the surrealist movement. Breton's collection was left virtually untouched in his Parisian home for more than three decades after his death, but was eventually auctioned off in a controversial sale (Gioni & Bell, 2016, p. 54). *The Trick Brain* seems to attempt to preserve the collection in its own way with this constellation of images and objects, coupled with narration commenting on the death of objects, human cadavers and the breakdown of bodies. It's a wonderful example of how matter and works of art themselves may be repurposed and displayed in a new light.

Susan Hiller (1940–2019) worked in a multitude of media, including installation art, video, photography, performance and writing, as well as with a range of subject matter. Hiller began her career as an anthropologist, inspired by the writing of Margaret Mead (1901–1978) and the field's professional opportunities for women. Over time, Hiller came to realize that anthropological studies had been used to justify countless atrocities, including the Vietnam War. She then turned to the arts as a form of activism and social engagement, feeling more freedom of expression in creative work and decreased pressure from being subjected to preexisting academic prejudices.

For *The Last Silent Movie* (2008), Hiller compiled audio clips of endangered and extinct languages; the voices were sourced from university, online and personal archives. The screen is stark black, disrupted only by white subtitles elucidating a soundscape consisting of adjoining yet distinct stories, memories, lists and lullabies. Hiller was able to create an intimate atmosphere, extending the invitation to the audience to bear witness to this collective tragedy. We are provided with this opportunity to experience the beauty in these people and languages, which many of us have not heard before and may never hear again, while at the same time experiencing the result of our own brutality and carelessness. In this work, Hiller

attempted to capture something ethereal that is all but lost, as histories slip through our fingers like grains of sand. The first speaker in the piece – who is also the last known speaker of the K'ora language – begins: "Today you will get to know me through my tongue."[9]

Artists have an uncanny way of addressing the matters that many of us, in our day-to-day lives, tend to ignore. By inhabiting a realm that is a liminal space of sorts, one between dream and waking reality, artists are in a position to be able to say what the masses cannot say quite yet. Their ability to speak these truths pokes holes in our daily dialogue, fostering space for growth and allowing for the alteration of discourse. All art does this in some way, as the creation of a work of art in and of itself indicates a separation from nature, a cut from the day-to-day in the form of a brushstroke, carving, action or photograph.

The cut is another royal road to the unconscious. It allows us to dislocate and derail the narrative so that we may understand ourselves and our past in a different light and rewrite our future in a new way – a way which we desire, rather than the way predestined for us based on our histories, families and societies. The deconstructive process explored throughout this study:

> first explored by early Futurists, then adopted by the Dadaists, to finally become a characteristic of all the historical avant-gardes, is what really lies on the threshold between the 19th and 20th centuries.
> (Black, 2012, p. 7)

When most think of the cut-up, they think of the cutting up and reassembling of words and language – the cut-ups of the Dadas, Brion Gysin and William Burroughs. But these artists also cut up tapes, sounds, images, photographs, and eventually thoughts, concepts, bodies and minds – cutting one piece out of its prescribed position and reanimating it in a new way, giving it new life.

When we take the time to create a piece of artwork, meditate or attend the next analytic session – when we exit our daily program – we're cutting ourselves out of our day-to-day narrative. The space created creates space so when we reenter the scene, returning to the everyday, we've created room for something new to transpire: a cut opening a gap, creating space that we may utilize to reprogram ourselves, inventing ourselves the way we wish to be rather than the way we're destined to be based on our

upbringing, parents, social conditioning, culture and societal standards. This act creates room for the subject, and the practice of this repeated ritual has a cumulative effect.

In the act of creation itself, as well as in the work of psycho analysis, the artist or analysand is cut from the narrative stream to allow space for expression. This act in itself is a cut. The people we remember are those who dared to speak, even if that speech disrupted their own personal narrative or the greater cultural norms – perhaps even especially so. Practically all forward-thinking, cutting-edge, avant-garde art has involved a cut that disrupts the status quo upheld until that moment, bringing a change in perspective and allowing space for increased possibilities to emerge. So let us then, "Persevere in the interruption!"[10]

Notes

1 Coleman, J. (2019) "Catalogue Raisonné" [Online]. Joe Coleman. Available at https://joecoleman.com/paintings (Accessed: December 31, 2019).
2 Biographical information from Braun, E. (2016). *Alberto Burri: The trauma of painting*. New York: Guggenheim.
3 Edwards, J. & Ogden, P. (2001) *7 Reece Mews: Francis Bacon's studio*. New York: Thames & Hudson.
4 The Art Story Foundation. (2016) "Kurt Schwitters Artworks: German Painter, Collagist and Writer" [Online]. The Art Story. Available at www.theartstory.org/artist/schwitters-kurt/artworks/ (Accessed: December 18, 2019).
5 Shen Goodman, M. (2015) "Yuji Agematsu, Real Fine Arts, New York, USA" [Online]. Frieze. Available at https://frieze.com/article/yuji-agematsu (Accessed: March 2, 2020).
6 Rodgers, C. (2016) "Artwork" [Online]. Charlotte Rodgers. Available at http://charlotte-rodgers-caya.squarespace.com/artwork (Accessed: February 7, 2020).
7 Merriam-Webster lexicographers (2020) "Morbidity" [Online]. Merriam-Webster Dictionary. Available at www.merriam-webster.com/dictionary/morbidity (Accessed March 9, 2020).
8 Abrahamsson, C. (2007) *Olika Människor*. Umeå, Sweden: Bokförlaget h:ström. p. 239.
9 Gioni, M. & Bell, N. (eds.) (2016) *The Keeper*. New York: The New Museum. p. 180.
10 Badiou, A. (2000) *Ethics: An essay on the understanding of evil*. New York: Verso. p. 47.

Bibliography

Abrahamsson, C. (2007) *Olika Människor.* Umeå, Sweden: Bokförlaget h:ström.
Badiou, A. (2000) *Ethics: An essay on the understanding of evil.* New York: Verso.
Black, C. (ed.) (2012) *The Art of Noise: Destruction of music by futurist machines.* London: Sun Vision Press.
Boothby, R. (1991) *Death and Desire: Psychoanalytic theory in Lacan's return to Freud.* London: Routledge.
Braun, E. (2016) *Alberto Burri: The trauma of painting.* New York: Guggenheim.
Bucklow, C., Leader, D. et al. (2019) *Bacon and the Mind: Art, neuroscience and psychology.* London: Thames & Hudson.
Coleman, J. (1992) *Cosmic Retribution: The infernal art of Joe Coleman.* Portland, OR: Feral House.
Deleuze, G. (2002) *Francis Bacon: The logic of sensation.* Translated by Daniel W. Smith. Minneapolis: University of Minnesota Press.
Edwards, J. & Ogden, P. (2001) *7 Reece Mews: Francis Bacon's studio.* New York: Thames & Hudson.
Gioni, M. & Bell, N. (eds.) (2016) *The Keeper.* New York: The New Museum.
Laplanche, J. (1970) *Life and Death in Psychoanalysis.* Translated by J. Mehlman. Baltimore: The Johns Hopkins University Press.
Rodgers, C. (2011) *The Bloody Sacrifice: A personal experience of contemporary blood rites.* Oxford: Mandrake of Oxford.
Rodgers, C. (2014) *The Sky Is a Gateway Not a Ceiling: Blood, sex, death, magick and transformation.* Italy: Il Labirinto Stellare.
Rutberg, J. (ed.) (2014) *Twin Visions: Jerome Witkin and Joel-Peter Witkin.* Los Angeles: Jack Rutberg Fine Arts, Inc.
Sinclair, V.R. & Lambrecht, I. (2016) "Ritual and psychoanalytic spaces as transitional, featuring Sangoma trance states." In Carl Abrahamsson (ed.) *The Fenris Wolf,* vol. 8. Stockholm: Trapart Books. pp. 281–289.
Spielrein, S. (1994) "Destruction as the cause of coming into being." *Journal of Analytical Psychology,* 39. pp. 155–186.
Sylvester, D. (2019) *Interviews with Francis Bacon.* London: Thames & Hudson.
Witkin, J-P. (ed.) (1994) *Harm's Way: Lust and madness, murder and mayhem.* Santa Fe: Twin Palms Publishers.
Witkin, J-P. & Borhan, P. (2000) *Disciple and Master.* New York: Fotofolio.

Filmography

Tangerine. (2015) Sean Baker (dir.). USA: Duplass Brothers Productions & Through Films.

Index

Abrahamsson, Carl 193
Abramović, Marina 14, 182–183
abstraction 49–50, 212
Academy 23 193
Acéphale 9, 12, 122–123
actions 180, 189
Adolf the Superman (Heartfield) 89
Af Klint, Hilma 10, 48–50, 102
Africa 95
Agematsu, Yuji 214
agency 23, 157
Aktionen (Nitsch) 181
Albers, Josef 94, 95
Almond, Marc 194
alternative communities 188–195;
 Academy 23 193; Dial House 189–190;
 London Antiuniversity 193; Sigma
 Project 193; TOPY 192–193
American Psychoanalytic Association
 (APsaA) 126, 128
Americans, The (Frank) 155
Amerika, Mark 68–69
anatomy 8
Andreas-Salomé, Lou 87
Angelic Conversation, The (film) 157
Anger, Kenneth 13, 151–152, 157, 165
animal rights 193
Anthology Film Archive 153
anthropology 218
Aphex Twin (Richard D. James) 11, 65
Apocalypse Now (film) 158
Aragon, Louis 119

Arbus, Diane 32–33, 209
Arensberg, Walter 104
Armory Show 103
Arnauld, Céline 73, 81–82
Arp, Jean (Hans) 73, 74, 77, 86, 91
art: abstract 49–50; avant-garde 8, 87, 220;
 brutalist 38; constructivist 92–93; cubist
 8, 10, 57, 85, 87, 102–103; cut-outs 48;
 Dada 8, 58, 87, 119, 129, 136, 192, 219;
 expressionist 10, 44; fauvist 8, 10, 47,
 101–102; futurist 8, 10, 57–58, 87, 103,
 219; graffiti 183; impressionistic 10;
 installation 184, 218; lithographs 39, 43,
 85; modern 10, 37–51; nature of
 106–107; neo-Dadaist 94, 179; outsider
 193, 194; performance 13–15, 63,
 180–185, 189, 202, 217, 218; and
 photography 10; pop 14; post-
 impressionist 44; Pre-Raphaelite 10,
 37–38; printmaking 39; realist 10;
 secessionist 10; street 14, 183–184;
 surrealist 9, 12, 13, 26–27, 38, 78, 91,
 106, 115–129, 192, 194; symbolist 10,
 43; synthesism 42–43; talismanic 193;
 woodblock printing 39; woodcuts 43;
 see also assemblage; collage; cut-ups;
 readymades
art collectives 9, 14; *see also* alternative
 communities
artificial intelligence 216
art installations 184, 218
Art of Noises, The (Russolo) 59–60

Index

As I Was Moving Ahead, Occasionally I Saw Brief Glimpses of Beauty (film) 154
assemblage 11, 94, 95, 106, 214
Assouline, Pierre 26
Athey, Ron 137
Atkins, Ed 218
automatic writing 58, 79, 118–119
autonomy 15, 23, 122, 157, 190
avant-garde: in art 8, 87, 220; in the cinema 13, 147–158; and fragmentation 16; in music 61, 62–64, 66; in the Soviet Union 92–93
Avedon, Richard 184

Bacon, Francis 15, 95, 212–214
Badiou, Alain 211
Balance, Jhonn (Geoffrey Rushton) 64, 192
Balch, Antony 13–14, 164–166
Ball, Hugo 11, 72–73
Bandez, Annie (Little Annie/Annie Anxiety) 14, 191
Barthes, Roland 25
Basquiat, Jean-Michel 14, 183–184
Bataille, Georges 12, 122–123
Baudeliare, Charles 10, 43–44
Bauhaus group 76, 92, 94, 180
Beach, Sylvia 119
Beard, Peter 95–96
Beat generation 9, 13–14; collaborations with other artists 164; and cut-ups 161–171; influence of 177; similarity to Dada 163
Beat Generation, The (play) 155
Beat Hotel 13, 161–162, 164, 165, 168
bebop music 62
Beiles, Sinclair 162
Bellmer, Hans 13, 116, 139–142, 144
Benjamin, Walter 27
Bennett, Vicki 13, 158, 194
Benson, Tom 138
Bentley, Wilson 28–29
Berger, John 22
Bergstein, Mary 23

Berlin Dada Club 89
Bicycle Wheel (M. Duchamp) 104
Bill and Tony (film) 14, 166
biopolitics 165
biopower 7, 165
Black Sun Productions 194
Bleuler, Eugen 59
Blixen, Karen 95
blood 15, 95, 181, 209, 215
blues 62
Boccioni, Umberto 57
body modification 9, 15, 201–202, 209, 217–218
body piercing 201, 217
Bonaparte, Marie 87, 117
Bowie, David 171, 177, 190
Box-in-a-Suitcase (M. Duchamp) 105
Box of 1914 (M. Duchamp) 105
Brakhage, Stan 153
Braque, Georges 57, 102–103
Breton, André 12, 118–119, 122, 133, 136
Breyer, Jacqueline 203
Breyer P-Orridge 15, 137, 203–205
British Psychoanalytical Society 123
Broms, Gustaf 184–185
Brown, Ossian 194
Brownie camera 10, 22
Browning, Tod 165
Brus, Günter 181
brutalism 38
Buffet-Picabia, Gabrièle 104
Bulletin Dada (periodical) 81
Buñuel, Luis 149–150
Burgher, Elijah 171
Burri, Alberto 15, 210–211
Burroughs, William S. 13, 63, 69, 96, 162, 164–170, 192, 203, 205, 219; *The Third Mind* 13, 69, 162, 166, 170, 203
Butler, Judith 107
Buzzi, Paolo 61

Cabaret Voltaire 8, 11, 72–73
Cage, John 11, 61, 62
Cai Quo-Qiang 15, 210

calotypes 21
Camus, Albert 41
Caoutchouc (Picabia) 76
Capote, Truman 179
Carotenuto, Aldo 88
Carrington, Leonora 115–117
Carter, Chris 63
Cartier-Bresson, Henri 26–27, 155
Cassady, Neal 162
Cassat, Mary 103
Cassavetes, John 156
Chamberlain, Wynn 177
Chance Meeting on a Dissecting Table of a Sewing Machine and an Umbrella (album) 64–65
Chappaqua (film) 14, 150, 167
Charcot, Jean-Martin 24
Chessa, Luciano 59–60
Chessboard (Arnauld) 82
choreography 148
Christopherson, Peter 63, 64, 192
cinema: avant-garde 13; and the Beat generation 164–165; direct animation 149, 150; expanded 166; experimental 9, 13, 147–158, 148; New York underground 153–154; silent film 151, 165; surrealism in 149–150
Cinémathèque Française 152, 165
Citizen Kane (film) 152
clang associations 80
Clarke, Shirley 153
Cocteau, Jean 152
Coil 11, 64, 157, 191, 194
Coleman, Joe 15, 209–210
Coleman, Ornette 167
collage 11, 14, 89, 91, 94, 95, 96, 103, 106, 117, 184, 214; automated 93
Communist Manifesto (Marx & Engels) 37–38
communities, alternative *see* alternative communities
constructivism 92–93
Coppola, Francis Ford 158
Cornell, Joseph 100, 106

Corso, Gregory 155, 161, 162, 178
Couch (film) 177
COUM Transmissions 14, 63, 181–182
Crass 14, 189–191, 191
Cronenberg, David 88
Crotti, Jean 76, 105
Crowley, Aleister 192
cubism 8, 10, 57, 85, 87, 102–103
Current 93 191
Curtis, Jackie 177
cut-outs 48
Cut Piece (Ono) 181
cutting: various meanings of 7; *see also* scansion
cut-ups 68–69, 78, 161–171, 184, 203, 205, 219; in art 191; in film 165–171; influence of 192; in music 191; in songwriting 171
Cut Ups, The (film) 14, 165–166
Cut with the Kitchen Knife Through the Last Weimar Beer-Belly Cultural Epoch in Germany (Höch) 87
Cyclobe 194

Dada 8, 58, 87, 119, 129, 136, 192, 219; in Berlin 90, 92; in Cologne 91, 92; influence of 192; and the machine 75–76; and performance art 180; and psychoanalysis 11, 72–83; similarity to Beats 163; supranational aims of 80–81; and surrealism 78; *see also* cut-ups
Dada (journal) 81
DadaGlobe (anthology) 81
DadaGlobe Reconstructed 81
dadazendadaists 177
Daguerre, Louis 21
daguerreotypes 21
Dalí, Salvador 12, 31, 38, 95, 118, 122, 133; collaborations with Buñuel 149; enthusiasm for Freud 120–121; and Lacan 120–121
Dangerous Method, A (film) 88
Darling, Candy 177, 180
Das Unbehagen 12, 126–129

Davis, Deborah 177
death drive 88
Debussy, Claude 61
deconstruction 62, 87, 106–107, 169, 171, 180, 192, 199, 201, 219
Delaunay, Robert 102
Deleuze, Gilles 41–42
Delpire, Robert 155
Dench, Judi 157
Denham, Val 14, 137, 194–195
Derain, André 47, 101
Deren, Maya 13, 147–148, 157
Der Müde Tod (film) 149
Deutsch, Helene 87
Dial House 189–190
disruption: in art 46–47, 212; of the expected 100; in film 218; in music 65, 66–67; of the narrative 2, 4, 32, 50, 60–61, 68, 205, 220; in photography 9, 203; in psychoanalysis 30; and scansion 5, 8, 15; and technology 216
Dix, Otto 92
DJ Spooky, That Subliminal Kid (Paul D. Miller) 68
dolls: of Molinier 139–141; of Ovartaci 143
Doorway to Joe (Coleman) 210
Doorway to Whitney (Coleman) 210
doubles: in art 133, 136, 139, 142, 144; in film 147; gender 12–13
Down Below (Carrington) 117
dream analysis 6, 119, 135–136; and waking life 6–7
dreammachine 165
dream material 194–195
Dream of Life (album) 180
Dreier, Katherine 104
drive-dialectic 88
Dubuffet, Jean 61
Ducasse, Isidore 65
Duchamp, Marcel 12, 76, 100–110, 118, 129, 133, 142, 178; and Dalí 120–121; femme identity of 107
Duchamp, Suzanne 73, 75, 101, 105

Duchamp-Villon, Raymond 12, 101, 103
duo drawings 77
Dylan, Bob 203

Early Abstractions (H. Smith) 150
Eastman Kodak 10, 22
ego-psychology 125
Eisenstein, Sergei 151
Éluard, Paul 117, 133
Engels, Friedrich 37–38
England's Hidden Reverse 65, 191
Ernst, Max 12, 81, 91, 115–117, 118, 122, 133
Étant donnés (M. Duchamp) 100, 108, 142
Evans, Cerith Wyn 192
Excerpts from the Anonymous Diary of a New York Youth (Mead) 178
Exploding Galaxy commune 181–182
explosives 210
Exposition Internationale du Surréalisme 133
expressionism 10, 44
exquisite corpses 119

Factory (Warhol) 14, 178
Fanni Tutti, Cosey 63, 182
Fantastic Art, Dada, Surrealism (exhibition) 106
fauvism 8, 10, 47, 101–102
Fellig, Arthur "Weegee" 30–31
Ferenczi, Sandor 59
Fergusson, Alex 192
Festival Dada (Salle Gaveau) 82
fetishism 141, 202
F For Fake (film) 153
Film Culture (journal) 153
Film-Makers' Cooperative 153
film theory 148
Fini, Leonor 116
Fireworks (film) 151, 152
fireworkx 210
First Heavenly Adventure of Mr. Antipyrine, The (Tzara) 82
First International Dada Fair 92

Flammarion, Camille 28
Flesh (film) 177
Flower Thief, The (film) 177
Fodgers, Charlotte 15
Foisy, Katelan 154–155
fold-ins 163
Foucault, Michel 165
found objects 214
found sounds 64
Fountain (M. Duchamp) 105
4'33" (Cage) 62
framing 33, 45–46
Frank, Robert 13, 151, 155–157, 167
Freaks (film) 165, 166
free association 5, 79, 115, 129
Freud, Anna 87, 109, 117, 123, 125
Freud, Sigmund: on art and artists 1, 45; Dalí's enthusiasm for 120–121; on dream analysis 6, 135; on the ego 134–135, 198, 205; empowerment of analysands by 22–23; endorsed by Lacan 125; on evenly-suspended attention 5; on free association 5; on the patriarchy 188–189; and photography 23–24; on primary repression 205; on psychoanalysis 129; relationship with Jung 58–59; relationship with Spielrein 88; on repetition 41–42; on sexuality 197–198, 200, 202; on sexual perversion 109; and surrealism 12; and the unconscious 29; and the Vienna Psychoanalytic Society 58–59; on war and death 74, 165; during World War II 117; *see also* Freud, Sigmund, writings
Freud, Sigmund, writings: "'A Child is Being Beaten': A Contribution to the Study of the Origin of Sexual Perversions" 109; *Beyond the Pleasure Principle* 39, 134; *Das Unbehagen in der Kultur* 126; *The Ego and the Id* 198; *Fragment of an Analysis of a Case of Hysteria* 59; *Inhibitions, Symptoms and Anxiety* 40; *The Interpretation of Dreams* 59; *Moses and Monotheism* 188; "The Moses of Michelangelo" 1; *The Psychopathology of Everyday Life* 79; *The Question of Lay Analysis: Conversations with an Impartial Person* 123, 128; *Remembering, Repeating and Working-through* 39; *Three Essays on the Theory of Sexuality* 197, 199, 202; *Totem and Taboo* 188; *The Uncanny* 39, 133
Friedlander, Erik 66
Fromm, Eric 118
Fromm-Reichmann, Frieda 118
frottages ("rubbings") 117
futurism 8, 10, 57–58, 87, 103, 219; in music 58

Galás, Diamanda 157
Galassi, Peter 26
Gatewood, Charles 202–203
Gaugin, Paul 10, 42–43, 46
gender identity 107–108, 136–137, 142, 144, 171, 180, 182, 194, 197, 199, 199–200, 203, 204, 205
Genet, Jean 152
Ginsberg, Allen 13, 155, 156, 162, 163, 167, 178, 203
Glitterbug (film) 157–158
graffiti 183
Graves, Milford 66
Green, Al 203
Green Box, The (M. Duchamp) 105, 106, 107
grids 163
Griswold, J. F. 103
Grosz, George 89
Guerilla Conditions (uncompleted film) 165
Guggenheim, Peggy 100–101, 118
Gunkel, David 68
Gysin, Brion 13, 63, 161–167, 192, 203, 205, 219; *The Third Mind* 13, 69, 162, 166, 170, 203

Hall, G. Stanley 59
Hammid, Alexander 147

happenings 180, 189
Hardy, Don Ed 202
Hausmann, Raoul 85–86, 89
Häxan (film) 165
Heartfield, John 11, 89
Hemus, Ruth 73, 77, 82
Hennings, Emmy 11, 72–73, 136
Hertz, Heinrich 28
Herzfelde, Wieland 89
Hevesi, Ludwig 47
Hiller, Susan 218–219
Hilma af Klint: Paintings for the Future (exhibition) 49
Hoberman, Lewis 156
Höch, Hannah 11, 73, 85–87, 89, 136
Hopper, Edward 103
Horses (album) 180
Howl (Ginsberg) 178
Hülsenbeck, Richard 73, 74, 90
Huncke, Herbert 162
Hundred Headless Woman, The (Ernst) 91
Hunt, William Holman 38
hysteria 24–25, 119

identity: formation of 134, 201, 204; mirror stage 134; as performance 107–108; *see also* gender identity
Ignorant, Steve 189–190, 191
impressionism 10
industrialism 90
industrial music 63
Inn of the Dawn Horse, The (Self-Portrait) (Carrington) 115–116
installation art 184, 218
Institute of Contemporary Arts (ICA; London) 63
intelligent dance music (IDM) 65
International Exhibition of Modern Art (New York) 103
International Psychoanalytical Association (IPA) 59, 123–124, 126
intersections 169–170
intonarumori 10–11, 60–61

Inventing Abstraction: 1910–1925 (exhibition) 49

Jacobson, Edith 118
Jagger, Mick 167
James, Richard D. (Aphex Twin) 11, 65
Janco, Marcel 73
Jarman, Derek 13, 157–158, 192
jazz music 61–62
Johns, Jasper 94, 179
Jones, Ernest 117
Joyce, James 119
Jung, Carl Gustav 58–59; relationship with Freud 59; *see also* Jung, Carl Gustav, writings
Jung, Carl Gustav, writings: *Diagnostic Association Studies* 59; *Psychoanalysis and Association Experiments* 59; *The Psychology of Dementia Praecox* 59

kaleidoscopic visions 194
Kandinsky, Wassily 50, 102
Kernberg, Otto 126–127
Kerouac, Jack 13, 155, 162, 163
Kerr, John 88
Kierkegaard, Søren 41
Klein, Melanie 87, 123
Klimt, Gustav 46–47
Klint, Hilma af 10
Klutsis, Gustav 90
Krafft-Ebing, Richard von 197
Kupka, František 102

Lacan, Jacques 119–120; call for "return to Freud" 125; on identity formation 134; on the mirror stage 204; on the psychic censor 6; on repetition 41–42; on scansion 2; on sexuality 199, 200; on signification 79–80; on the unconscious 79; use of seminars 124–125; use of variable-length sessions 3, 123–124
Lady: Lisa Lyon (Mapplethorpe & Lyon) 180
L'Age d'Or (film) 149

Lang, Fritz 149
Langlois, Henri 151–152
Laplanche, Jean 198
Large Glass, The (M. Duchamp) 105–106, 107, 108
Lartigue, Jacques-Henri 28
Last of England, The (film) 157
Last Silent Movie, The (Hiller) 218–219
Late Superimpositions (H. Smith) 150
Lautréamont, Comte de (Isidore Ducasse) 65
Leduc, Renato 118
Left (Journal of the Left Front of the Arts) 91
Leonardo da Vinci 1, 122
Les Fleurs du Mal (Baudelaire) 43
Leslie, Alfred 155
LGBTQ civil rights 178
lighting 184
liminal space 27, 144, 171, 209, 219
literature: automatic writing 58, 79, 118–119; detective novel 28; modernist 43; symbolist 43; *see also* poetry
lithographs 39, 43, 85
Little Girl Dreams of Taking the Veil, A (Ernst) 91
London Antiuniversity 193
Lonesome Cowboys (film) 177
Love That Whirls, The (film) 152
Luxury (Matisse) 103
Lye, Len 149
Lyon, Lisa 180

Mahagonny (No 18) (film) 150
Malanga, Gerard 177
Malevich, Kazimir 50, 102
Mallarmé, Stéphane 43
Manifestation Dada de la Maison d'Oeuvre 82
Manifesto of Futurist Musicians (Pratella) 58
manifestos: in art 14; at Cabaret Voltaire 73; communist 37; Dada 59, 81, 90; futurist 58; in Höch's collection 86; in music 10, 61; pandrogeny 203; surrealist 59, 119, 122; by Tzara 78
Mapplethorpe, Robert 179–180
Marcel's Unhappy Ready-made (S. Duchamp) 105
Marey, Étienne-Jules 57
Marinetti, Filippo 58, 61
Marx, Karl 37–38, 41
mash-ups 68
Masson, André 118, 122–123
Matisse, Henri 10, 47–48, 101, 102, 103
Mayakovsky, Vladimir 93
Maybury, John 192
Mead, Taylor 163, 177, 178
Me and My Brother (film) 13, 156–157
Mekas, Adolfas 153
Mekas, Jonas 13, 153–154, 157
Méliès, Georges 148
Mendieta, Ana 14, 183
Merzbau (Schwitters) 214
Meshes of the Afternoon (film) 147–148
Metamorphosis of Narcissus, The (Dalí) 121
Metropolitan Museum of Art 66
Michelangelo 1
Military Guards (Taeuber-Arp) 76
Millais, John Everett 38
Miller, Lee 115
Miller, Paul D. (DJ Spooky, That Subliminal Kid) 68
Millions Stand Behind Me: The Meaning of Hitler's Salute (Heartfield) 89–90
mime 152
mind-body system 8
Minotaure 9, 120
Minutes to Go (cut-up publication) 162
mirror stage 134, 204
modernism 43; *see also* art, modern
Moholy-Nagy, László 92
Molinier, Pierre 13, 136–139, 144
Mondrian, Piet 50, 102
Monet, Claude 161
Monnier, Adrienne 119

montages 137–138
Moondog 167
morbidity 15, 209, 216
Morris, William 10, 38–39
Most Dangerous Method, A: The Story of Jung, Freud and Sabina Spielrein (Kerr) 88
Muehl, Otto 181
Munch, Edvard 10, 39, 42, 43
Musafar, Fakir 202
Museum of Modern Art 106
music: African American 61–62; avant-garde 61, 62–64, 66; bebop 62; blues 62; contemporary experimental 10; deconstruction of 62; electronic 65; experimental 61, 62–63; experimental electronic 67; as film soundtracks 152; found sounds 64; industrial 63; intelligent dance music (IDM) 65; jazz 61–62; noise genre 11, 61, 65; postmodern 68; ragtime 62; remix 68; scansion in 5; as soundtracks for films 157, 158, 167; surrealist 65; use of sampling in 64; world 67
Muybridge, Eadweard 24, 57, 212

Naked Lunch (Burroughs) 166
Naked Lunch (film) 166–167
Navas, Eduardo 68
neo-Dadaism 94, 179
Neues Sehen ("New Vision") 92
New American Cinema Group 13, 153, 157
New York Dada (journal) 81
New York Dolls 178
Nielsen, Johannes 142
Niépce, Nicéphore 21
Nietzsche, Friedrich 41
Nitsch, Hermann 181
No 18 (Mahagonny) (film) 150
noise: as music 11, 61; poetics of 60
Nude Descending a Staircase (M. Duchamp) 103, 106
Nude Restaurant (film) 177

Nurse With Wound (NWW) 11, 64–65, 191

Oedipal complex 200
Ohtake, Shinro 96
Oliveros, Pauline 67
O'Neill, Ray 121–122
Ono, Yoko 14, 181
On the Road (Kerouac) 162, 178
On-U Sound Records 191
Oppenheim, Meret 116
Opstrup, Kasper 193–194
optical unconscious 27
Orlovsky, Julius 156–157
Orlovsky, Peter 13, 155, 156, 162, 167
Orphée (film) 152
Other Side of the Wind, The (film) 152–153
Ovartaci 13, 142–144
Oversby, Alan (Mr. Sebastian) 201–202

Pandrogeny project 15, 203–205
Paris Air (M. Duchamp) 105
patriarchy 188–189
Patton, Mike 66
Penrose, Roland 115
People Like Us 13, 158
perfection 213
performance art 13–15, 63, 180–185, 189, 202, 217, 218
permutation poems 163
photograms 92
photography 13; aesthetic use of 21; as art 10, 184; Brownie camera 10, 22; bureaucratic use of 21–22; calotypes 21; daguerreotypes 21; use of doubles in 13; early work in 21–34; Frank's *The Americans* 155; freeze-frame 24; by Gatewood 203; kaleidoscopic visions 31; perspective and power of 9–10; and psychoanalysis 25–27, 29–30; "slice of life" 30–33; of snowflakes 28–29; in the Soviet Union 92–93; and surrealism 26–27; using plastic lenses 31
photomatter 86

photomicrography 29
photomontage 11, 14, 85–87, 89, 94, 95; and Dada 90; in the Soviet Union 92; and technology 90
photoplastics 92
Piaget, Jean 88
Picabia, Francis 11, 76, 81, 92
Picasso, Pablo 38, 57, 102–103
Plastique (journal) 77
Poe, Edgar Allen 43, 44
poetry 190; accidental poems 11; at Cabaret Voltaire 73; Dada 78; by Ginsberg 163; permutation poems 163; as propaganda 192; scansion in 4
Pollock, Jackson 50, 66
polymorphism 199, 202
Pop, Iggy 177
Pope Innocent X (Velázquez) 212
pop movement 9, 14
P-Orridge, Genesis 63, 64, 181–182, 192, 202, 203; *see also* Breyer P-Orridge
Portrait of Max Ernst (Carrington) 117
post-impressionism 44
postmodernism 68
Pratella, Francesco Balilla 58
Pre-Raphaelites 10, 37–38
printmaking 39
propaganda 11, 86, 148, 189, 192
Prostitution (exhibition) 63, 181
psychic censor 6
Psychick Release 193
Psychick Television (Psychic TV/PTV) 64, 192, 194
psychoanalysis: and the artist 93; cut session 3; as cut-up 205; and Dada 11, 72–83; divergent views of 125–129; and evenly-suspended attention of the analyst 5; founding of 8; genesis of 8; and the idea of scansion 4; and identity formation 134; and photography 25–27, 29–30; repetition in 40; short session 3; spread of 59; and surrealism 115, 120; timing of sessions 2–3; as transitional space 30; in the United States 125, 127–128
psychoanalysts: in New York 118; persecution of 117; training/formation of 126–129; *see also* Freud, Sigmund; Jung, Carl Gustav
psychoanalytic theory 148
psychosexual fluidity 137
psychosis 135
Pull My Daisy (film) 13, 155–156, 177

Rabbit's Moon (film) 152
Rachou, Madame et Monsieur 161
ragtime music 62
Rainbow Dance (film) 149
Rank, Otto 133
Rauschenberg, Robert 94, 179
Raven, The (Poe) 43
Ray, Man 76, 81, 94, 104, 133
rayograms 94
readymades 12, 100, 104, 108, 151, 178
Reagan, Ronald 190
realism 10, 42
Reed, Lou 177
Reich, Wilhelm 118
Reik, Theodor 123
remix 68–69
repetition 39–41, 182; in art 42; in daily living 41; in psychoanalysis 40
repetition compulsion 40
resistance 50, 60–62, 79
ResoNations: An International Telematic Music Concert for Peace 68
Rhythm (Abramović) 182
Rhythmus 21: Film is Rhythm (film) 148
Rhythmus 23 149
Rice, Ron 177
Richter, Hans 148–149, 153
Rimbaud, Arthur 43
Rimbaud, Penny 189–190
Rodchenko, Alexander 92
Rodgers, Charlotte 215
Röntgen, Wilhelm 28
Rooks, Conrad 13–14, 150, 167–168

Roosevelt, Teddy 103
Rossetti, Dante Gabriel 38
rotoreliefs 104, 108
Roudinesco, Élisabeth 119
Rousseau Institute 88
Rushton, Geoffrty (Jhonn Balance) 64
Russolo, Domenico 60–61
Russolo, Luigi 10–11, 59–60, 64, 66–67

Salpêtrière Hospital 24–25
sampling 63, 64, 68–69, 158
Sanatorium Burghölzli 59
San Diego Turf (film) 177
Santana, Carlos 203
Sargeant, Jack 161–171, 164, 165
Saussure, Ferdinand de 79
scansion: as aid to reinvention of self 7; in art 8, 15; in film 148; Lacan's concept of 2, 5; in music 5, 60, 61, 62; in poetry 4; in psychoanalysis 3, 4, 5, 7, 60
Schad, Christian 93
Schaeffer, Pierre 61
Schiele, Egon 10, 45–46
Schlemmer, Oskar 76
Schwarzkogler, Rudolf 181
Schwitters, Kurt 15, 86, 214
Scorpio Rising (film) 152
scrapbooks 95–96, 169
Scream, The (Munch) 39
sculpture 13, 77, 94, 96, 116, 158; use of doubles in 13; Freud's appreciation of 1; kinetic 104; by Mendieta 183; by Ovartaci 143–144; TOPY-produced 193
secessionism 10
Secret Symmetry, A: Sabina Spielrein between Jung and Freud (Carotenuto) 88
Sélavy, Rrose 107
self-reflection 23, 37
sexuality 197–199, 200
sexual relations 108–110
Shadows (film) 156
shamanism 192
Shankar, Ravi 167
shell shock 77

Sherman, Cindy 137
Sherwood, Adrian 191
Short, Elizabeth 142
Sidetripping (Gatewood) 203
sigils 171
Sigma Project 193
signification 79, 154, 171
Silueta Series (Mendieta) 183
Sinnreich, Aram 68
Sky Ladder (documentary) 210
Smith, Grafton Elliot 77
Smith, Harry 13, 150–151, 157
Smith, Patti 179–180
smoking phantoms 143
Société des artistes indépendants (Society of Independent Artists) 103, 104–105
Société Française de Psychanalyse (SFP) 124
Société psychanalytique de Paris (SPP) 124
Society of Independent Artists (Société des artistes indépendants) 103, 104–105
Solanas, Valerie 179, 184
Sommerville, Ian 164, 166
Songs of Maldoror, The (Ducasse) 65
Son of Andy Warhol (Mead) 178
Sound of Music, The (film) 158
Sound of the End of Music, The (film) 158
Soupault, Philippe 119
Southern, Terry 167
Spare, Austin Osman 192
Spielrein, Sabina 87–88, 117–118
Stapleton, Stephen 64–65
Stelarc 15, 137, 217
Stella, Joseph 104
Stonewall uprising 178
Stravinsky, Igor 61
Street, Julian 103
street art 14, 183–184
sublimation 30, 141
surrealism 9, 12, 38, 91, 106, 115–129, 133, 194; and Dada 78; in film 149–150; and Freud 12; and identity 13; influence of 192; in music 65; and photography 26–27; and psychoanalysis 115, 120

Surrealist Manifesto 119
Swinton, Tilda 157
Sylvester, David 212
symbolism 10, 42, 43
synchronicity 8, 96, 115, 76, 92
synthesis 42–43
synthesizers 60, 65

Taeuber-Arp, Sophie 73, 76–77, 136
Talbot, William Henry Fox 21
Tanguy, Yves 118
Tarzan and Jane Regained. Sort Of (film) 177
tattooing 201, 202
Taylor Mead's Ass (film) 177
technology: and art 37–51, 216, 217; and the First World War 15–16; and the modern age 92; and music 65, 67–68; and photomontage 90
10 Recipes for Immortality (Dalí) 121
Thatcher, Margaret 190
Thee Splinter Test (P-Orridge) 64
Thee Temple ov Psychick Youth (TOPY) 14, 192–193, 201–202
They'll Love Me When I'm Dead (film) 153
Third Mind, The (Burroughs & Gysin) 13, 69, 162, 166, 170, 203
Throbbing Gristle 11, 62–63, 64, 157, 192, 194
Through Light to Night (Heartfield) 89
Tibet, David 192
time travel 155
Tiny Tim 203
To Make a Dadaist Poem (Tzara) 78
Tomkins, Calvin 100
Totentanz (Ball) 73
Towers Open Fire (film) 14, 164–165
transitional space 30, 143, 144, 171, 209
Trash (film) 177
Traveler's Folding Item (M. Duchamp) 105
Trick Brain, The (Atkins) 218
Turner, Simon 157
23 Dada Manifestos 81

Two Dancers (Matisse) 48
Tzara, Tristan 11, 13, 73, 78, 81, 93–94

uncanny 9, 12, 15, 33
Un Chien Andalou (film) 149
unconscious: and the dream state 136; Freud's theory of 29; Lacan's description of 79; material in art 195; optical 27; revelations of 3; scansion as access to 5; in surrealism 115; in van Gogh's art 44

van Gogh, Theo 44
van Gogh, Vincent 44–45, 46
Varèse, Edgar 61
Vaucher, Gee 189–190
Vauxcelles, Louis 47
Velázquez, Diego 212
Verhaeghe, Paul 200–201
Verlaine, Paul 43
videography 218
videotape 64
Vienna Psychoanalytic Society 58–59
Viennese Actionists 14, 181
Viennese Secessionists 47
Villon, Jacques 12, 101, 103
Vogel, Amos 156
Voltaire Artists' Society 72
Vormittagsspuk (film) 149

Warhol, Andy 14, 41, 95, 177, 184; films by 177; and gender identity 180; influence of 178–179
War of the Worlds radio broadcast 152
Wave (album) 180
Wedgwood, Thomas 21
Week of Kindness, A (Ernst) 91
Welles, Orson 13, 152–153
Wells, H.G. 152
Whistler, James 103
Who the #$&% Is Jackson Pollock? (film) 50
wildlife conservation 95, 193

Williamsburg, Brooklyn (film) 153
Winnicott, Donald W. 30
Witchcraft through the Ages (film) 165
Witkin, Joel-Peter 15, 209
women: and the Dada movement 73, 81–83; as psychoanalysts 87
Women in Revolt (film) 177
woodblock printing 39
woodcuts 43
Woodlawn, Holly 177

Woodman, Francesca 33–34
word salad 80
world music 67

Z'EV 194
zines 14, 189, 192
Zorn, John 11, 65–67
Zupančič, Alenka 41–42
Zürn, Unica 13, 139, 144
Zweig, Arnold 121

Taylor & Francis eBooks

www.taylorfrancis.com

A single destination for eBooks from Taylor & Francis with increased functionality and an improved user experience to meet the needs of our customers.

90,000+ eBooks of award-winning academic content in Humanities, Social Science, Science, Technology, Engineering, and Medical written by a global network of editors and authors.

TAYLOR & FRANCIS EBOOKS OFFERS:

A streamlined experience for our library customers

A single point of discovery for all of our eBook content

Improved search and discovery of content at both book and chapter level

REQUEST A FREE TRIAL
support@taylorfrancis.com